John Ruskin, or the Ambiguities of Abundance

JAMES CLARK SHERBURNE

John Ruskin
or the Ambiguities
of Abundance

A Study in Social and Economic Criticism

Harvard University Press Cambridge, Massachusetts 1972

To My Mother and Father

Contents

Preface

There is a wide discrepancy between the original intention and final form of this book. My hope had been to outline briefly Ruskin's social and economic criticism and then to focus on the question of Ruskin's influence. As it is, the second problem is hardly mentioned. To paraphrase Coleridge, I remained sunk in Ruskin like a toad in a rock, trying to decide what he has to say on social and economic matters and discovering much that needed to be examined before any study of his strangely refracted influence could be undertaken. Although Ruskin has been the subject of as many interpretations as any leading Victorian, his social and economic thought has been far from thoroughly explored. Ruskin students seem prone to several diseases.

The first of these might be described in Carlylean terms as hero-worship. The chief symptom is a tendency to be gulled by Ruskin's rhetoric and to substitute quotations or summaries for analysis. I must confess to this symptom myself. There is justification for letting Ruskin have his say since many of his social insights have their source in purely verbal distinctions. The verbal flavor, however, should be savored only as part of an attempt to grasp his insights in their varying degrees of blindness and brilliance. In the following pages, I attempt to integrate quotations and critical analysis and to break the tendency to accept Ruskin's inconsistent statements at their face value. More generally, I try to avoid granting Ruskin the title of prophet without examining his credentials. In spite of self-imposed skepticism, I fear that a vein of unabashed admiration for Ruskin runs through the book. If this is the case, it is admiration not of an omniscient prophet but of a tragically flawed one struggling against himself and, in the end, losing.

The second aspect of *morbus Ruskinianus* is a reluctance to relate Ruskin's ideas to those of other Victorian or pre-Victorian thinkers. This symptom resembles the first, for one of the principal qualities of a nineteenth-century social "prophet" is his originality. Ruskin, himself, admits his debt to earlier thinkers and declares that he is only repeating the wisdom of Plato, Dante, and Carlyle. Most stu-

dents attribute his admission to magnanimity and refuse to pursue the matter further. Ruskin encourages them by mentioning his immediate predecessors, with the exception of Carlyle, very infrequently and with hostile intent. Indeed, one suspects that his habit of deferring to the ancient Greeks, the Biblical writers, or Carlyle is a way of placing himself among the "greats." This suspicion is unjust, for Ruskin did confine his reading to a remarkable extent to premodern authors. Still, he was no recluse. The reason for Ruskin's unwillingness to acknowledge the efforts of his contemporaries remains unclear. Egotism cannot be overlooked, for Ruskin's denials of originality are balanced by assertions of his own superior vision. Whatever the reason, there is no excuse for students of Ruskin to compound the error. By doing so, they give a false picture of the Victorian period and perpetuate the injustice done by Ruskin to men like John Stuart Mill. They also fail to identify those respects in which Ruskin is truly original—those respects in which, at great cost, he breaks out of the Victorian "frame of mind." In this book, I attempt to relate Ruskin to his time and to point out the precursors of his social and economic criticism. My purpose is not to determine who influenced Ruskin but to sketch a background for the gnarled body of his thought. On certain points, the background will be of more interest than the main subject.

The third and most recent malady of Ruskin scholars is an obsession with the great Victorian's biography and a neglect of his ideas. There are several reasons for this. The first is Ruskin's frankness, his tendency to put on paper everything which entered his consciousness. Even today the mine of letters and diaries continues to grow. The second is the fascinating complexity of Ruskin's psychic life—a complexity which sounds a siren's call to those who wish to test the latest tools of psychological analysis. Finally, there is a feeling among scholars that the only ground to be broken in Ruskin studies is biographical. My essay is an attempt to dispel this conviction. This is not to say that Ruskin's biography is unimportant but to suggest that, recently, the biographical aspect has been emphasized at the expense of the thought of the man, "the divine part," as Ruskin himself put it. To be sure, it is difficult to distinguish the biographical from other elements in Ruskin's writing, and the attempt to do so is futile, for the confessional aspect of his work sheds an important light on the ideas presented. There is, however, a difference between

viewing a man's ideas as symptoms of his biography and making the biographical data contribute to a better understanding of his ideas. In this book, I have followed the second course. Putting aside an intense interest in Ruskin's biography, I have applied a psychological interpretation to his thought only where it sheds light on the form and content of his ideas. The result is a suspicion that Ruskin's psychological difficulties had their source at least partially in his inability to hold together several conflicting strands of thought.

The organization of the book is both chronological and topical. The first chapter attempts to place Ruskin in the tradition of Romanticism. It examines the "organic" approach which gives a significant shape to his varied interests and which confirms his position as the Victorian who most thoroughly applies Romantic modes of thought to social and economic subjects. It also attempts to capture the peculiar quality of Ruskin's organicism—his lack of interest in growth or process and his tendency to restrict the organic approach to the surface of things. The second, third, and fourth chapters are arranged chronologically. In them, an effort is made to discover the roots of Ruskin's social criticism in his studies of art and architecture and to trace his disillusionment with art criticism and his sharpening social awareness to the point in *The Political Economy of Art* (1857) when he makes explicit his pioneering assumption that a society of abundance is an imminent possibility. Chapters five through eleven are organized more topically than chronologically. That is the best way to gain a purchase on the chaos of Ruskin's later social criticism, where the only unifying theme is his attempt to draw out the implications of his vision of abundance. Even so, the topics are arranged to coincide as much as possible with the center of Ruskin's interest as it shifts, for example, from economic theory in *Unto This Last* and *Munera Pulveris* to the problems of exploitation, war, imperialism, and the construction of the welfare state in later writings. Separate and somewhat more general chapters, nine and eleven, are devoted to his ambiguous view of the means of social reform and to his equally ambiguous but very exciting view of the quality of human life and personality in the society of abundance.

This outline startles me. It is an *ex post facto* construction, not a blueprint, for the book grew awkwardly much like Ruskin's own work. Perhaps it was the result of reading too much Ruskin or perhaps it was the result of desiring a false sense of freedom. Although

my approach deserves no better name than "groping," it is the only way I could enter into the writings of so intuitive a thinker as John Ruskin.

If my groping has been blind, it is not for want of assistance. I am exceedingly grateful to John Clive of Harvard University for reading the manuscript twice since the summer of 1968. His advice and encouragement have been invaluable to me. I would like to thank Harvard University itself for providing the facilities and opportunity for research. It was my undergraduate tutor Daniel M. Fox who first turned me to Ruskin and who taught me much about the study of history. For more recent assistance of a formidably practical sort, I wish to thank Carol Morgan of Boston University. Finally, I am conscious of a debt to Ruskin's editors at the beginning of this century, E. T. Cook and Alexander Wedderburn.

<div align="right">J. C. S.</div>

John Ruskin, or the Ambiguities of Abundance

I Purity

The thirty-nine volumes of Ruskin's work seem, at first sight, a chaotic assemblage in which chronology alone supplies the unifying element. After further study, the impression of chaos remains, but it is a chaos of vitality, not of disintegration, or rather of the struggle between the two. Whether Ruskin writes on art, nature, or economics, there are the inevitable digressions and irrelevancies. These are never mere padding. They are alive and often the start of another unfinished book. Their vitality stems not from their immediate context but from their relation to a more general theory or point of view. This holds true also for the larger division between Ruskin's art and social criticism. The former carries within it the seeds of its own demise. The shift from art to society involves no new approach but an extension of the same approach to a new field and the use of many of the same arguments.

This quality of "wholeness" is a remarkable feature of Ruskin's work. Every thinker, after scholarly tailoring, comes to be cut of whole cloth. With Ruskin, the interwoven temper of his mind immediately strikes one. More remarkable is the fact that the formal wholeness of Ruskin's thought finds a reflection in the specific content of his theories on nature, art, architecture, and society. It is as though his elaboration of theory and the much less conscious pattern of his intellectual processes are singularly fused. In the shaping of doctrines for public consumption, Ruskin does not take the usual steps of detachment from the inner workings of his mind. The pulse of his thought is there on the page, to be felt. For whatever reason, he seems inspired to rationalize or idealize an instinctively adopted mode of thought—his sense of the whole as a living unity. The purpose of this chapter is to examine the mode of thought and Ruskin's rationalizations of it in the light of his participation in the Romantic tradition.

2

Ruskin's general approach, as "realized" in his specific theories, stresses interdependence, continuity, and unity. Whether deliberately

or not, he follows Coleridge's dictum that the mind employs method when it studies "the relation of things." Such a search for wholeness characterized most of the great minds of the Romantic movement. Schelling, Hegel, and Coleridge himself, for example, attempt to find a deeper coherence beneath the contrasting forms of human knowledge and criticize the Enlightenment for achieving a superficial harmony. Ruskin would have sympathized with Coleridge when he declared, "The universe itself! What but an immense heap of little things? . . . My mind feels as if it ached to . . . know something *great,* something *one* and *indivisible.*" Although Ruskin's search for wholeness fails in the end, it gives to the chaotic surface of his thought a deeper unity which justifies his efforts.[1]

The tendency to see each thing as "itself a living part of a live whole," or, to use William Blake's phrase, "to see a World in a Grain of Sand," leads Ruskin into a dimension where phenomena refuse to stand as impenetrable, self-contained entities. Each subject that he studies appears now as the integral part of a larger whole and now as a whole composed of lesser parts. In each case, the relationship of part to whole is one of vital interdependence: the part cannot exist in isolation from the whole, nor can the whole survive without its sustaining part. "It is all a Tree: circulation of sap and influences, mutual communication of every minutest leaf . . . with every other greatest and minutest portion of the whole." Carlyle's metaphor captures the essence of Ruskin's attempt to relate the chief counters of his discussion—nature, art, society, man—and his sometimes exaggerated identification of art and morality or art and life. The term organicism best describes this method of seeing all things in relation. Although a difficult word, its choice is sanctioned by Ruskin's use of the adjective "organic," his preference for natural metaphors, and his participation in the Romantic tradition of organicism. By "organic," Ruskin never means a purely physical relation. For him, as for his Oxford friend, the naturalist William Buckland (1784-1856), nature reflects or is penetrated by a realm of spiritual significance. Art, society, and man follow nature in this respect.[2]

Ruskin's organicism appears early in the discussion of "Typical Beauty" in volume two of *Modern Painters* (1846). He defines "Typical Beauty" as "that external quality of bodies . . . which may be shown to be in some sort typical of the Divine attributes." Two of the attributes or ideas suggested by the material qualities of things are "unity" and "purity." Although Ruskin's terminology is a confusing blend of the Platonic and the Christian, his description of

unity and purity reveals his insistence on seeing things as wholes composed of living, interdependent parts. Ruskin's second classification of beauty, "Vital Beauty," reinforces the concepts of unity and purity from a different angle.[3]

The importance of "unity" for Ruskin is evident in the tendency of his discussion to veer from beauty to "general perfection." Paraphrasing the theologian Richard Hooker (1554-1600), he writes:

Hence the appearance of separation or isolation in anything, and of self-dependence, is an appearance of imperfection; but all appearances of connection and brotherhood are pleasant and right, both as significative of perfection in the things united, and as typical of that Unity which we attribute to God ... that Unity which consists ... in the necessity of His inherence in all things that be.... (4.92)

After noting various superficial or mechanical forms of unity, Ruskin turns to "Essential Unity" or "unity of membership." This is the "unity of things separately imperfect into a perfect whole ... the great unity of which other unities are but parts and means." Since "unity of membership" demands an integral fusion of parts, it is impossible without a "difference and opposition" in the members. The work of art should possess this unity. Ruskin compares the harmony of an artistic whole to that of a tree painted by Turner. If we break off "the merest stem or twig of it, it all goes to pieces.... There is not so much as a seed of it but it lies on the tree's life...."[4]

Ruskin's description of unity echoes Aristotle's view that, "if the presence or absence of a thing makes no visible difference, it is not an integral part of the whole." Although Ruskin had read Aristotle carefully, he does not refer to him here but turns to the Romantics. Coleridge defines beauty as "Multeity in Unity" or "that in which the many, still seen as many, becomes one." A true poem possesses a living unity which can only result from the fusion or interpenetration of its parts. For Wordsworth, the excellence of Shakespeare's dramas lies in the fact that "his materials, ... heterogeneous as they often are, constitute a unity of their own...." In order to distinguish "organic" unity from the mechanical organization or "uniformity in variety" valued by eighteenth-century literary criticism, Coleridge, Carlyle, and Hazlitt anticipate Ruskin in stressing the "contraries," the "difference and opposition," of the members of the whole. Coleridge defines unity as "the reconciliation of opposite and discordant qualities" and makes this the first principle of his literary criticism. Ruskin traces his own view of the reconciliation of opposites to Plato's *Timaeus* as well as to the Romantics.[5]

As the adjective "organic" implies, the Romantic concept of artistic unity has its source in a vision of nature and life. The similarity of the terms used by Romantics to describe art and nature appears clearly in Coleridge's fragment on *The Theory of Life*. He defines life as "the principle of unity in multeity" or "the power which unites a given *all* into a whole." The key to the "process and mystery of production and life" is the reconciliation of opposites. A similar view of nature and art forms the basis of Carlyle's use of the organic metaphor. The work of art is not a "divisible Aggregate" but a "living indivisible whole" bound together by "organic filaments," an aesthetic conviction to which the structure of *Sartor Resartus* (1833) gives ample testimony. Ruskin's emphasis on "unity of membership" is not original. Behind it, there lies a tradition of Romantic theorizing which views organic unity as the characteristic of living things and the key to the transference of metaphors from the realm of nature to that of art. In Ruskin, this tradition is reinforced by a much older tradition of Platonists, Aristotelians, and Christian philosophers like Richard Hooker and Jeremy Taylor who view oneness or unity as the attribute of ultimate reality. Ruskin inherits these traditions in a haphazard fashion, selects what he finds useful, and creates his own vocabulary of organicism.[6]

The most important word in this vocabulary is "purity," the key to organic unity and a crucial element in typical beauty. In his discussion of purity, the "type of Divine energy," Ruskin is pointing to the unifying ground which makes possible the fusing of apparent contraries in nature and art. Romantics describe this ground or energy in terms which blend the spiritual and the physical. The word most often chosen is "life." Coleridge speaks of the "one life within us and abroad," and Wordsworth of the "one interior life that lives in all things." For both poets, this life is transcendental. In the tradition of Plotinus, Bishop Berkeley, and the German Romantics, they describe it as a "spiritual underpresence," the "Soul of all the Worlds," and identify it with mind, spirit, or God.[7] To avoid the extremes of pantheism and traditional religion, the Romantics often write vaguely of "the sentiment of Being," an "active Principle" at work in all things, "something far more deeply interfused," or, in the case of Carlyle, simply of "force" and "power." Of the terms used to describe the unifying ground in nature and art, "energy" is the one Ruskin prefers. He speaks of the quality which distinguishes "nature and Turner from all their imitators" as "this fulness of character

absorbed in universal energy." In his choice of words, he resembles Blake, who identifies "energy" with life and makes it the chief counter in his battle with mechanism. Blake, in fact, is the only writer before Ruskin to relate energy and purity. Elsewhere in Romantic thought and poetry and the tradition of Platonic and Christian philosophy, purity leads a tenuous existence as one of many qualities of the ground of Being.[8]

Ruskin's discussion of purity in volume two of *Modern Painters* owes its vagueness and brevity to the fact that here he is touching on the living root of his organic approach. Here he is reaching an awareness of the materialistic basis of the organic metaphor. While other elements of typical beauty—infinity, moderation, symmetry, repose, unity—are desired because they express divine attributes, purity is desired for its material condition. Purity is not essentially a moral or spiritual term: "the original notion of this quality is altogether material," and "the use of the terms purity, spotlessness, etc., in moral subjects, is merely metaphorical." Ruskin demonstrates the material origin of the concept by studying ideas of impurity. These ideas refer to

conditions of matter in which . . . the negation of vital or energetic action is most evident; as in corruption and decay of all kinds, wherein particles which once, by their operation on each other, produced a living and energetic whole, are reduced to a condition of perfect passiveness, in which they are seized upon and appropriated, one by one, piecemeal, by whatever has need of them, without any power of resistance or energy of their own. (4.129)

Ruskin's description of impurity reminds one of Blake's fear of "Ulro," the Newtonian universe of dead matter, and Wordsworth's fear of a world where everything is "in disconnection, dead and spiritless," where everything "meets foes irreconcilable and at best doth live but by variety of disease." For Ruskin, purity is the opposite of death, disconnection, and isolation. It is an "active condition of substance" and depends on a "vital and energetic connection among particles." "Thus the purity of the rock, contrasted with the foulness of dust or mould, is expressed by the epithet 'living,' very singularly given to rock, in almost all language (singularly, because life is almost the last attribute one would ascribe to stone, but for this visible energy and connection of its particles). . . ." Similarly, the purity of color is dependent on "the full energizing of the rays that compose it."[9]

Light itself is Ruskin's preferred analogue for the purity or energy

which pervades living wholes. In this, he is heir to a long line of thinkers, including the Cambridge Platonists, Berkeley, and Carlyle, who conceive of the principle of "life" or the divine "under-presence" in terms of light or "Living Fire." Earlier thinkers, however, make no attempt to suggest a material origin for the energy pervading the universe. Light, for them as for Coleridge, is the "material symbol of an Idea" and is chosen because it is the least earth-bound of possible symbols. Ruskin confronts directly, if only momentarily, the possibility that energy or purity is essentially a material condition—that it is *really* light and that the spiritual terms used to describe it are metaphors for a physical reality.[10]

Ruskin cannot rest in this interpretation. With the transcendental urge of a Schelling or a Coleridge, he escapes to higher realms. "And so in all cases," he writes, "I suppose that pureness is made to us desirable, because expressive of that constant presence and energizing of the Deity by which all things live and move, and have their being; and that foulness is painful as the accompaniment of disorder and decay, and always indicative of withdrawal of Divine support." At the end of his discussion, Ruskin identifies purity and spirituality by declaring the essential characteristic of matter to be inertia and by placing the energy or purity which overcomes this on the side of spirit.[11]

The materialistic root of Ruskin's concept of purity distorts his theoretical divisions and causes purity to overlap with "Vital Beauty." "Vital Beauty" characterizes only living phenomena. Ruskin defines it as the "appearance of felicitous fulfilment of function in living things"—the appearance of "happiness." It results from the complete unfolding of an inner principle of life which adapts the functions of parts to the purpose of the whole. In a beautiful plant, "every leaf and stalk is seen to have a function, to be constantly exercising that function, and as it *seems, solely* for the good and the enjoyment of the plant." Man's inherent vitality leads to the conscious development of his intellectual and spiritual life as well as the natural development of his physical propensities. Although vital beauty resembles Aristotle's notion of form as the "actuality of the thing," Ruskin could have derived the idea from many sources. Coleridge asks: "May not the sense of Beauty originate in our perception of the fitness of the means to the end in and for the animal itself?" With its suggestion of healthy energy and proper functioning of parts,

Ruskin's concept of vital beauty has important social implications.[12]

The inner vitality which generates vital beauty is identical with the energy of "purity." It has a positively physical basis. Again, Ruskin resists a materialistic interpretation and points to the moral or spiritual significance of the degrees of vitality found in organisms. The poet George Herbert (1593-1633) praises the "orange tree, that busy plant." So Ruskin can declare that "there is not any organic creature but, in its history and habits, will exemplify to us some moral excellence or deficiency." "Of the outward seemings and expressions of plants, there are few but are in some way good and therefore beautiful, as of humility, and modesty, and love of places and things. . . ." In a similar vein, he speaks of the "earnest ant" and "unwearied bee," the "foulness of the sloth," or the "sweetness and gentleness" of the gazelle and ox. The shift from a material to a spiritual level of interpretation here and in the chapter on "purity" is significant. Ruskin's descriptions of plants and animals suggest that this fault or seam in his organic approach permits the incursion of traditional Victorian morality.[13]

Though unstable, the organic basis of Ruskin's view of unity and purity cannot be doubted. It appears again in volume five of *Modern Painters*, where he makes "The Law of Help" the most important principle of artistic composition. In the following passage, one can see the organic metaphor at work and the interesting use of the word "pure." One can also see, in Ruskin's choice of the words "clean" and "holy," his tendency to shift from the material to the moral or spiritual plane:

Composition may be best defined as the help of everything in the picture by everything else. . . .

In substance which we call "inanimate," as of clouds, or stones, their atoms may cohere to each other, or consist with each other, but they do not help each other. The removal of one part does not injure the rest.

But in a plant, the taking away of any one part does injure the rest. . . . If any part enters into a state in which it no more assists the rest, and has thus become "helpless," we call it also "dead."

The power which causes the several portions of the plant to help each other, we call life. Much more is this so in an animal. We may take away the branch of a tree without much harm to it; but not the animal's limb. Thus, intensity of life is also intensity of helpfulness—completeness of depending of each part on all the rest. The ceasing of this help is what we call corruption; and in proportion to the perfectness of the help, is the dreadfulness of the loss. . . .

The decomposition of a crystal is not necessarily impure at all. The fermentation of a wholesome liquid begins to admit the idea slightly; the decay of leaves yet more; of flowers, more; of animals, with greater painfulness and terribleness in exact proportion to their original vitality; and the foulest of all corruption is that of the body of man. . . .

When matter is either consistent, or living, we call it pure, or clean; when inconsistent or corrupting (unhealthful), we call it impure, or unclean. The greatest uncleanliness being that which is essentially most opposite to life.

Life and consistency, then, both expressing one character (namely, helpfulness of a higher or lower order), the Maker of all creatures and things, "by whom all creatures live, and all things consist," is essentially and for ever the Helpful One, or in softer Saxon, the "Holy" One. . . .

A pure or holy state of anything, therefore, is that in which all its parts are helpful or consistent. . . . The highest or organic purities are composed of many elements in an entirely helpful state. The highest and first law of the universe— and the other name of life is, therefore, "help." The other name of death is "separation." Government and co-operation are in all things and eternally the laws of life. Anarchy and competition, eternally, and in all things, the laws of death. (7.205-207)

The word "energy" occurs later in the passage: "Also in true composition, everything not only helps everything else a *little,* but helps with its utmost power. Every atom is in full energy; *all* that energy is kind."[14]

This passage is very important. It places Ruskin in the tradition of Romantic organicism and reveals his application of the organic metaphor to painting. Ruskin's hierarchy of organic entities—crystals, plants, and animals—echoes Coleridge's criteria of organic evaluation: "extension," that is, the number and variety of the component parts, and "intensity," the degree of their interdependence. His comparison of organic unity with various states of corruption, disorganization, or impurity also strikes a familiar note. Behind this comparison lies the Romantic distinction between "organic" and "mechanical" form, or, to use Blake's terms, between "Living Form" and "Mathematical Form." As Coleridge explains it, mechanical form is fabricated or imposed *ab extra,* while organic form is generated or evolved *ab intra.* In mechanical form, the component elements are juxtaposed externally, not fused internally. They fall easy prey to corruption or disorganization. Coleridge's distinction leads in turn to the crucial one between "mechanical" and "vital" philosophy. The former knows only of "the relations of unproductive particles to each other." It can hold good only for a "dead nature." In an organic or vital philosophy, elements "actually interpenetrate" one another to

form a living whole. Early in his career, but late in the Romantic movement, Ruskin enters the lists on the side of Blake, Coleridge, and Carlyle against a "Mechanico-corpuscular Philosophy" of death.[15]

Ruskin's participation in the battle is important, for he applies the organic approach not only to art and nature but also to man, society, and economics. One might recall his preference for the word "help" in the long passage on composition. It is not the only time that a playful etymological speculation is the bearer of a real advance in Ruskin's argument. As Francis Townsend remarks, one could substitute "society" for "nature" and "men" for "parts" and have the essence of Ruskin's social criticism. His ideal state resembles nature and art in that it joins its members, each fully developed yet each individually imperfect, into a vital unity—"fulness of character absorbed in universal energy." In volume two of *Modern Painters,* Ruskin points the way to his social ideal by suggesting that every individual is born defective in some respects so that mankind as a whole can cultivate the virtues of fellowship and love. This is the source of his vision of Gothic architecture and his critique of economic competition.[16]

Ruskin is not the first Romantic to perceive the social implications of organicism. Coleridge and Carlyle precede him in applying the organic approach to society. Wordsworth moves in a similar direction although without the philosophical preoccupations of Coleridge. After declaring that a true poem, like nature,

> reconciles
> Discordant elements and makes them move
> In one society,

he turns his attention to national societies in *The Convention of Cintra* (1809). Edmund Burke (1729-1797) in England and Johann Gottfried von Herder (1744-1803) in Germany pioneer in the social application of the organic metaphor. Burke describes society as a delicate organism and speaks of the "great contexture of the mysterious whole." He is intensely aware of the interdependence of elements in the Empire, in the constitution, and in the "commonwealth" of Europe. With more radical intent, Blake also grasps the social relevance of the distinction between organism and machine. If Ruskin is not the first to see the broader ramifications of the organic approach, he is the most thorough in applying his perception to

social and economic phenomena. His statement, "Government and co-operation are in all things and eternally the laws of life. Anarchy and competition, eternally, and in all things, the laws of death," forms a constant refrain in his social criticism.[17]

<div align="center">3</div>

Although derivative, Ruskin's organic approach to art, nature, and society has a distinctive bias. No more than Burke or Coleridge can Ruskin accept all of the implications of organicism. While they balk only when the organic approach impinges upon traditional religion, Ruskin's organicism is more arbitrarily warped. In his case, the question of a conflict with religion never arises. His organicism is, to a remarkable extent, divested of its dynamic implications and restricted to the surface of things. By neglecting the problems of growth and development usually associated with the organic approach, Ruskin escapes the suggestions of natural determinism which disturb a Burke or a Coleridge.

Ruskin's organicism of the surface is the most distinctive element in his version of Romanticism. The formal unity of a "whole," natural, artistic, or social, interests him more than the process of its formation and growth. In his writings, one finds few echoes of Coleridge's assertion, "All is growth, evolution, genesis," or of Carlyle's emphasis on ceaseless change and the world of "becoming"—*das Werdende.* Ruskin prizes those aspects of nature and art which convey impressions of order, calm, and permanence. Even purity, the type of divine "energy," is more a static or circular force binding together the parts of a fully developed whole than a dynamic energy of growth and process. The static connotation of purity and vital beauty encourages Ruskin to move from the material to the spiritual plane and to make physical conditions symbolic of absolute moral values. All too often, this shift involves a confusion of the "purity" of energy with the "purity" or "holiness" of Evangelical piety. When Ruskin avoids such confusion, one can assume that he is holding insecurely to a vision of dynamic energy.[18]

Ruskin's neglect of organic process reveals itself in the style and form of his argument in the first two volumes of *Modern Painters.* The long periods and the static language of "types" and "attributes" of God seem closer to the style of Richard Hooker and Jeremy Taylor than to the dynamic fires of a Blake or Carlyle. They mark him, in this respect at least, as a Romantic *manqué.*[19] So does Rus-

kin's method of analysis in the early volumes. His elaborate divisions and marginal summaries and his almost Linnaean trust in the virtues of detailed classification give an un-Romantic rigidity and symmetry to his work. One is reminded of the many writers from the Scholastics through John Locke, Jeremy Bentham, and Adam Ferguson who adopt Aristotelian methods of organization. The first two volumes of *Modern Painters* are especially evocative of Locke's *Essay Concerning Human Understanding* (1690), which Ruskin quotes frequently. Ruskin's style of argument and his citations of Locke do not signify a disagreement with Romantic modes of thought. They are symptomatic of the distinctive nature of Ruskin's Romanticism—his failure to emphasize the aspect of organic growth.[20]

Ruskin's static organicism bears a superficial resemblance to the neoclassical ideal of harmony. It allows him to cut across the traditional boundaries of Romanticism and neoclassicism. It allows him to quote Addison and Samuel Johnson on matters of aesthetics, to include among his "typical" qualities of beauty symmetry and repose as well as infinity and unity, and to use the word purity with its strong classical coloring to describe his very Romantic notion of vital energy. In this way, he suggests an interpenetration of neoclassicism and Romanticism and reveals his debt to much early reading in eighteenth-century sources. As Ruskin becomes aware of the far-reaching aesthetic and social implications of the shift from neoclassic to Romantic, he binds himself more firmly to the Romantic fold. He continues to slight the dynamic side of the organic approach but adopts a more hostile attitude toward neoclassical aesthetic theory. In later works, his style of argument also changes. He feels less compelled to smother his subject with a grid of classification and follows with increasing abandon the Romantic preference for organic chaos and variety. The last three volumes of *Modern Painters* are a confusing tribute to Ruskin's desire to escape the pattern of organization adopted in volumes one and two. Nonetheless, the presence of a superficially classifying style in the early volumes and in later works like *Munera Pulveris* attests to the peculiar bent of his organicism.

Ruskin's unwillingness to dwell on the dynamic implications of the organic metaphor reveals itself in the content as well as the form of his thinking. Ruskin spent the greater part of his life in an effort to discover the best method of portraying the surface of nature. His interest is not in origins, internal structure, or processes of growth but in the present appearance of nature—in "truth of aspect," not

"truth of essence." That the two are related he conveniently over-looks. Ruskin declares himself uninterested in the "obscene processes and prurient apparitions" of propagation and condemns scientists whose "dirty curiosity" leads them to dissect living creatures to de-termine their internal structure. Paradoxically, the "biological revolu-tion" never touched the organicist Ruskin. When he does turn to the problem of change in a living creature or landscape, he deals with it usually in terms of a decline from an earlier perfection, a growing old, or, in geological terms, an erosion. It is significant, perhaps, that Ruskin's favorite teacher, William Buckland, was one of the last and most famous of those geologists who argued for a universal Deluge.[21]

Ruskin's antigenetic bias has important, though ambiguous, impli-cations for his later thought. On the one hand, it foreshadows his distrust of social change as being at best a decay and inspires him to make *The Stones of Venice* a history of the decline and fall. On the other hand, it foreshadows his distrust of *laissez faire*—the belief that the members of society will *grow* together, unconsciously following "nature's holy plan" as do the branches of a tree or trees in a forest. Ruskin's distrust of the Wordsworthian version of Mandeville's *Fable of the Bees* foreshadows his critique of the original and his call for social management of the "streams" of wealth. Like Coleridge, Rus-kin wishes to avoid the deterministic implications of the organic approach in art and society. Unlike Coleridge, he does this as much by ignoring the aspects of the organic metaphor which point to gestation and growth as by maintaining a faith in free will and con-scious control. The subjective side of Ruskin's organicism, his theory of imagination, reveals a similar bias.[22]

4

Ruskin's discussion of the imagination in volume two of *Modern Painters* (1846) and in later passages is, in a sense, a self-analysis—an attempt to explain his organic approach in its subjective dimension. Although the description in volume two suffers from youthful ab-straction, certain themes stand clear. Ruskin describes the imagina-tion as a form of contemplation leading to the intuitive vision of integral relationships and organic wholes. More specifically, he calls this contemplation "theoria" when referring to the spectator's per-ception of wholes in art or nature and "imagination" when referring to the artist's creative vision. Imagination is the higher function, for it goes beyond reverent, "theoretic" contemplation to the "utterly

mysterious" creation of a new, self-consistent reality out of the impressions of past experience. Through its "penetrative" power, the imagination sees "into the TRUE nature of the thing" and establishes the "awful first moving principle" which controls the creative act; through its unifying power, the imagination fuses imperfect, potentially discordant elements into a living whole possessing "unity of membership." Ruskin contrasts the imagination and the fancy. He views the latter as a lesser, mechanical power. The merely fanciful poet or painter is unable to inform his materials with the "helpfulness" and "passion" of life because he is unable to penetrate to the level of reality where all things, however diverse, are permeated by one vital energy. Unlike the "creator," he must rely on a "talented" juxtaposition or association of superficially related elements.[23]

The distinction drawn by Ruskin between imagination and fancy, between organic unity and mechanical arrangement, is central to the Romantic tradition. Coleridge deals most explicitly with this distinction and makes it the pivot of his discussions of poetry, philosophy, and psychology. Imagination is the "creative, productive life-power of inspired genius." To describe the imagination's ability to fuse "multitude into unity of effect," Coleridge uses adjectives such as "permeative," "assimilative," and "synthetic." Wordsworth also distinguishes between imagination and fancy and views the former as "that awful Power," "that chemical faculty by which elements of the *most different* nature and *distant* origin are blended together into one harmonious whole." By its "conferring, abstracting, and modifying" powers, it brings images into a creative interaction in which they "invariably modify each other." The fancy, on the other hand, "does not require that its materials . . . be susceptible of change in their constitution from her touch." Both Coleridge and Wordsworth view the fancy as a lesser, "mechanical" or "passive" power, acting only "by a sort of juxtaposition." They condemn the tendency of eighteenth-century writers to identify the imagination with the "associative" fancy based on memory, a tendency which Ruskin attacks in the persons of Archibald Alison and Dugald Stewart. The Romantic distinction between fancy and imagination is aimed at freeing the mind from the sterile bonds of associationism and making it truly creative. Ruskin plays a derivative role in this endeavor and carries the Romantic crusade into painting. He acknowledges his debt to the earlier Romantics and especially to Wordsworth whose "Preface of 1815" he paraphrases and Leigh Hunt whose *Imagination and Fancy* (1844) he considers an "admirable piece of criticism."[24]

The distinction between imagination and fancy is not original with Coleridge and Wordsworth, although Coleridge develops it with revolutionary thoroughness. The sources of the distinction can be found in Plotinus, Jacob Boehme, Immanuel Kant, and, among the English, Berkeley, William Collins, and Joshua Reynolds. Of these, Reynolds is the most relevant to one interested in Ruskin. Ruskin read the *Discourses* thoroughly, although, in his usual fashion, he mentions Reynolds chiefly to criticize him. As early as 1772, Reynolds distinguishes between Raphael, the man of "Taste and Fancy," who can create only a "combination of parts, not an original whole," and Michelangelo, the man of "Genius and Imagination." Reynolds identifies the imagination with a "kind of intuition," a "habitual reason" higher than "partial reasoning," and boldly declares the imagination to be the autonomous "residence of truth." On these points, the young Ruskin echoes Reynolds and in the same words.[25]

What Ruskin adds to the formulations of Reynolds, Coleridge, and Wordsworth is the distinction between "imagination" and "theoria." Though confusing at first glance, the distinction is very useful. It improves upon earlier theories by allowing Ruskin to stress both the "knowing" and "making" functions of the imagination. "Theoria" refers solely to the intuitive "seeing" or appreciation of existing wholes in nature and art, while imagination refers to the harder task of creating original wholes, a task which presupposes "theoria." This distinction averts the chief danger of Coleridge's formulations, his tendency to stress the cognitive side of the imagination at the expense of poetic production and expression. Such a tendency was not unusual with Romantics. Wordsworth considers the poet to be primarily a "knower," a genius who intuits significant truth, and secondarily a "maker" of verse to express this truth. The poet as "knower" of truths unattainable by ordinary modes of perception is an important figure in the application of Romanticism to social problems, as Coleridge's *On the Constitution of Church and State* (1830) demonstrates. But the poet or artist as "maker" is also necessary if a Romantic critique of society is to be fully expressed. To Ruskin, the poetic function is "pre-eminently the deed of human creation," and the poet is primarily "a person who produces—the creator or maker"—as opposed to one who only "knows." Ruskin's distinction between theoria and imagination places the emphasis on "making," an emphasis more difficult to overlook in painting than in poetry. In an indirect way, it foreshadows Ruskin's own efforts to "remake" English society.[26]

"Unstable as water, thou shalt not excel" is a fitting epitaph for the distinction between imagination and fancy. Coleridge never wins his battle to establish a strict division between the powers. Even Wordsworth fails him by declaring the fancy to be "creative" as well as "associative" and the imagination to be "associative and aggregative" as well as "creative." Wordsworth's vocabulary, as Coleridge recognized, tends to blur the distinction between organic imagination and mechanical fancy. Wordsworth's failing is a common one with nineteenth-century Romantics who do not work from Coleridge's elaborate, if hardly firm, philosophical foundation. Ruskin is a typical Romantic. His early discussion of the imagination and fancy follows Wordsworth, not Coleridge. He describes imagination as "associative" as well as "penetrative" and suggests that, at its highest levels, fancy may assume some of the functions of imagination. The distinction between the two powers disappears entirely in his social criticism where it would have been more of a hindrance than a help. In 1883, he advises the reader of *Modern Painters* "not to trouble himself with the distinctions, attempted and alluded to, between Fancy and Imagination. The subject is jaded, the matter of it insignificant, and the settlement of it practically impossible. . . ."[27]

Although Ruskin's theoretical distinctions degenerate, he continues to affirm the essential elements of the Romantic theory of imagination. The most important is a belief in the creative power of the human mind. This represents a real revolution over eighteenth-century conceptions. John Locke, David Hume, and David Hartley agree that the mind, including the emotions, is the product of sense impressions linked mechanically by the laws of association. Romantics, on the other hand, view the mind as a source of energy, contributing actively to its perceptions and to its own development. This change in viewpoint is accompanied by an important change in the metaphor used by poets to describe the mind, a change from the mind as mirror to the mind as fountain or lamp. Blake's poetry expresses the psychological revolution most radically and relates it to man's new conception of himself as "creator" in political and social as well as artistic endeavors. Blake equates the creative vision of his poet-prophet with the "pure" fire of vital energy—the fire of life, joy, and love, but also the fire of revolution and destruction. Indeed, the revolution against the fancy with its "fixities" and "definites," its rules and proprieties, is part of a larger revolution against social, economic, and political "fixities."[28]

Although Ruskin is farther from the battle against the psycholog-

ical mechanists, he is equally explicit on the subject of the mind's creativity. He agrees with Shelley that impressions "invariably receive the reflection of the mind under whose influence they have passed." He exposes the insufficiency of William Taylor's definition of imagination in *English Synonyms Discriminated* (1813). "A man has imagination," writes Taylor, "in proportion as he can distinctly copy in idea the impressions of sense; it is the faculty which images within the mind, the phenomena of sensation." Ruskin follows Wordsworth's earlier attack on Taylor and refuses to call the simple mirroring of impressions imagination. The most important characteristic of the imagination is its power to transform sense impressions and fuse them into an organic unity. Ruskin's belief in the creativity of the human mind, like Hazlitt's and Carlyle's, takes the form of a special emphasis on the "God-given supremacy" of the genius whose "gigantic, incommunicable facility" can bring about a "new creation."[29]

Ruskin and the Romantics agree that the heights of imaginative creativity can be scaled only by the whole man. They apply the organic metaphor to the poet as well as to the poem and reject the psychological atomism of the associationists. According to Locke and Hume, the elementary constituents of the mind, the ideas derived from sense, are impenetrable units combined in sequences by the "gentle force" of association, the laws of which resemble Newton's laws of motion. To account for invention or design, associationists posit a mental agent—judgment, understanding, or fancy—which makes a deliberate selection from the ideas stored in the memory and organized by the mechanical process of association. To Romantics, this view of invention destroys the ineffable mystery and wholeness of the creative act. Their reaction to the fancy or mental artificer resembles their reaction to the cosmic artificer of the deistic world-machine. To restore the creative act to its mysterious primacy, Blake, Coleridge, and Hazlitt view it as the highest of man's achievements. It calls forth "the whole soul of man" and is hardly definable in terms of association, memory, and judgment. For Ruskin, it is "the entire operation of the Humanity within us" and causes "the whole man to stand in an iron glow."[30]

How to define the "whole soul of man" remained a persistent problem for Romantics. Although they were moving toward an organic conception of mental processes, they were still bound by the terminology of faculty psychology. Their descriptions suggest a synthesis of intellect, sense, and will with a special emphasis on the emotions,

which were thought to have been neglected by the eighteenth century. The imagination is viewed as an active force welding the poet's faculties into a creative synthesis in which the distinctions between body and soul, sense and reason, are overcome. Ruskin follows the Romantics closely. He views the imagination as a function of the whole man in all his energy and vital beauty. With both Romantics and Evangelicals, he stresses the emotions: "the want of passion is perhaps the truest death or 'unmaking' of everything. . . ." The fancy is limited to "the outsides of things" because it is "one of the most purely and simply intellectual" of the faculties and "can never feel." If the imagination is the product of the "whole soul of man," including the emotions, its mode of action will say something about the quality of a man's life. This is the basis of Ruskin's description of the imagination and the work of art as "moral." Ruskin's view of the imagination as a function of man in his most healthy, most organic, and most moral condition becomes of crucial importance when he applies criteria of imaginative creativity to the life of the ordinary worker. Ruskin's use of the word "moral" to describe this condition is also fraught with significance. Although he uses the word in a "broad, human sense" to signify health or organic "purity," the seeds of future contention between "moral" in this sense and "moral" in the sense of Victorian respectability or Evangelical "purity" are sown here.[31]

The use of organic metaphors to describe the wholeness of the human mind in the creative act suggests a similarity between man and nature which for Romantics is not fortuitous. The metaphors are grounded in a literal similarity and actual relationship. The belief in a special "affinity" between "nature in the highest sense and the soul of man" is a staple of Romantic poetry and criticism. In the preface to *The Excursion,* Wordsworth makes this "exquisite" relationship the basis of the poet's creativity. He describes the "ennobling interchange of action from without and from within" in terms of confluent streams. The mingling of external and internal is made possible by the similarity of structure which nature and the soul display. As Coleridge puts it, the laws of the mind and of nature are "correlatives that suppose each other." Freedom, activity, organic unity, and reconciliation of opposites are the terms used to describe both inner and outer landscapes.[32]

Although Ruskin is less explicit on the similarity of structure to be found in nature and man's mind, he does declare that the genius

intuitively knows the laws of nature because "they are his own na-
ture." One of the fruits of a journey to Italy in 1845 is his discovery
that the human mind and body are under the dominion of the same
laws which govern the forms of nature. Ruskin makes this discovery
at Lucca beside a tomb designed by Jacopo della Quercia. It marks
the real beginning of his social criticism, for, henceforth, he expects
the same nobility and harmony in man as in nature. This theoretical
insight stands against a vast amount of evidence that Ruskin himself
felt a special affinity with nature. His diaries are filled with descrip-
tions of natural phenomena and their effect upon his "Heart and
Intellect." Throughout his life, Ruskin's moods are largely deter-
mined by the condition of the landscape and the sky.[33]

To Romantics, the relationship between nature and man's mind
suggests that both have "the same ground" and are permeated by a
single power or energy. Coleridge and Wordsworth believe that the life
or active principle which "in nature acts as nature" finds its highest,
most conscious expression in the poet's imagination. Once again, the
physical analogue of this power is light, now shining most brightly in
the human mind, the "auxiliar light" or "fountain-light of all our
day." For both man's soul and nature, Carlyle writes, "the beginning
of Creation is—Light." The existence of one light or life in nature
and man makes possible the reconciliation of subject and object,
thought and being, the internal and the external. Although Ruskin
does not favor terms derived from Kant or Schelling, he believes that
the energy or purity pervading nature and the work of art also per-
vades the human mind. Adapting Aristotle to his own purpose, he
describes the imaginative act as an "energy of Contemplation," a
form of "love" in which man overcomes his selfishness and merges
his vital energy or purity with the energy or purity of nature. One is
reminded of Blake:

> Each outcry of the hunted Hare
> A fibre from the Brain does Tear.[34]

The social implications of this view of the imagination are obvious.
The "energy of Love" or "great social principle of life" which per-
vades nature and the poet can be recognized in all men. The reconcil-
iation of subject and object which characterizes the artist's relation
to nature can characterize the relation of man to man in society.[35]
Blake, in fact, describes his ideal of "forgiveness" as the recognition
of every individual's "peculiar Light" or energy. He points to the city

of imagination as the source of the revolution of love and forgiveness. Wordsworth also believes that "the poet binds together by passion and knowledge the vast empire of human society." It is William Hazlitt who is most interested in the imagination's ability to follow in others "the germs of every faculty and feeling." Building on the suggestions of eighteenth-century thinkers like Lord Shaftesbury, Edmund Burke, and Alexander Gerard, he makes the sympathetic imagination the basis of his theory of criticism. Hazlitt is well aware of the significance of the concept for morals and politics: "Whoever, therefore, has a contempt for poetry has a contempt for himself and for humanity."[36]

Ruskin resembles Hazlitt in his belief that sympathy is an essential attribute of the artist and critic. Both theoria and imagination require an "unselfish fulness of heart" if they are to act effectively. Only "those who have the keenest sympathy" can "plunge into the very central fiery heart . . . and drink the very vital sap" of that which they contemplate. "On the other hand," Ruskin continues, "those who have so pierced and seen the melancholy deeps of things are filled with the most intense passion and gentleness of sympathy." Sympathy allows the poet-artist to understand other men and to grasp, in words which echo Coleridge, "every circumstance or sentence of their being, speaking, or seeming . . . from within." Such imaginative comprehension is made possible by the existence of a "common and vital, but not, therefore, less Divine, spirit, of which some portion is given to all living creatures." Ruskin believes that all men are capable, to an extent, of participating in the "energy of Contemplation" which inspires feelings of sympathy and love. Mankind as a whole can experience unity of membership. From here it is a short step to his vision of social harmony and his critique of competition and exploitation.[37]

Important as is Ruskin's debt to the earlier Romantics, there is, finally, one aspect of their theory of imagination which he cannot accept. Just as he neglects the dynamic side of the organic metaphor in its application to artistic beauty, so, now, he studies the "wholeness" of the creative mind in its highest activity and in its relationship with the external world but slights the organic process by which it achieves such wholeness, the "evolving of the germ within." Rarely in Ruskin's writing does one find the kind of speculation concerning the genesis and growth of a work of art in the mind of the artist which characterizes the thought of Edward Young or Coleridge. Rus-

kin also neglects those theories which view the unconscious as the source of the creative process. The recognition of the unconscious, first by the Germans Leibnitz, Schelling, and Jean-Paul Richter and subsequently by Coleridge, Shelley, and Carlyle, is one of Romanticism's important legacies to later psychology. In Coleridge's view, the artist works with the "unconscious" purposefulness of a plant and displays a similar "coinstantaneity of plan and execution." Carlyle, too, stresses the unconscious roots of the imagination. "In even the wisest soul," he writes, "lies a whole world of internal Madness . . . a mysterious-terrific, altogether *infernal* boiling up of the Nether Chaotic Deep." Coleridge avoids such rhetoric and seems more sensitive than Carlyle to the dangers of assigning a deterministic role to the unconscious. Conscious control—the "narrow neck of the bottle"—is very important to him. Even so, he displays in his writings and notebooks a personal interest in the unconscious which is far more courageous than Carlyle's overwrought exclamations.[38]

Ruskin, writing much later, shows neither the interest nor the rhetoric. His diaries, not to speak of his published writings, recount the decline of a great mind struggling with very real and graphically described phantoms but seldom penetrate beneath the surface of emotions and reactions. Perhaps, Ruskin is more bound by traditional morality than Coleridge, or, perhaps, the pain is too great for detached introspection. Occasionally, he describes imaginative creation as the result of an "inspired unconsciousness" or "divine instinct." He can even agree with Carlyle that "for all our best work a certain degree of this insanity is necessary, and the first incurring conceptions are uncommanded, as in dreams. . . ." Compared to Carlyle or Coleridge, however, Ruskin minimizes the role of the unconscious. His personal struggle to maintain control is too intense to allow any slackening of the conscious censor symbolized by his motto "Today."[39]

5

Ruskin knows better what he opposes than what he supports. For him, as for the earlier Romantics, the chief threat to the organic approach and the imagination is "mechanism." He opposes any mode of thought or perception which yields a mechanistic view of the world, from the associationism of Alison and Stewart to the "insolent" utilitarianism of Bentham and James Mill. Mechanistic modes of thought reach their apogee in the "bastard science" of classical

economics which views man as a machine whose functions can be isolated one from another and society as a machine whose parts are separate, competing atoms. Industrial machinery is only the most concrete manifestation of a way of thought which renders both art and life "impure." Ruskin has no difficulty describing the mechanical "Medusa" of the modern mind. He borrows from the verbal arsenal of Blake, Coleridge, Wordsworth, and, much earlier, Dean Swift, whose assaults on Hobbes and Descartes foreshadow the Romantic critique of mechanism.[40]

Blake's denunciation of the mechanistic viewpoint, the "Lame Philosophy," is the most striking. For him, the battle is between the "Poetic and Prophetic Character" and the "Philosophic and Experimental," between "Los" and "Urizen." Urizen, the "lord of the understanding," is the reason exalted by the eighteenth century, man's power "to compare and judge of what he has already perceived." It is Urizen who has delivered the restrictive "philosophy of the five senses" into the hands of Newton and Locke. Under his regime, man has sacrificed creative vision and "closed himself up," "infinite brain" in "narrow circle," able only to reason, analyze, and restrain. Blake attributes all repression to a fallacious mode of perception: seeing "with" the eye instead of seeing "thro' the eye." Seeing "with" the eye or "single vision" results in the frightful spectacle of rationalistic man, cut off from his inner source of energy and living as an "unorganized" particle in a mechanical universe of dead, "Satanic Wheels." Only poetic vision, seeing "thro' the eye," can restore man and the universe to a condition of organic interdependence.[41]

Coleridge and Wordsworth express their hostility to the "mechanic philosophy" in less visionary terms and rely on the distinctions drawn by earlier philosophers. The most important is that between the reason and the understanding. In various guises, this distinction can be found in Plato, Milton, Kant, and the German Romantics. For Coleridge, it plays the same role in his religious and ethical thought as the distinction between fancy and imagination in his literary theory. He describes the imagination and the highest reason in similar terms. Reason is not a faculty but a light which intuitively illuminates the essential unity of things. The understanding, on the other hand, is the "faculty of thinking and forming judgments on the notices furnished by sense." It views nature as an "immense heap of little things" and comes into action only when "we think of our-

selves as separated beings, and place nature in antithesis to the mind, as object to subject, thing to thought, death to life." When exalted as man's highest power, the understanding mistakes its abstract theories and classifications for an exhaustive account of reality. Materialism, atheism, and utilitarianism result. Wordsworth, too, fears the usurping predominance of that "inferior Faculty" which "pries" and "pores" by logic and "minute analysis." When not subordinated to the mind's "excursive power" or "Reason in her most exalted mood," the calculating understanding destroys the life of the imagination. Wordsworth's fear of the "false secondary power by which we multiply distinctions" is not hypothetical. In books ten and eleven of *The Prelude*, he recounts the disastrous psychological effects of his reliance on the "meddling intellect." The similar crises of John Stuart Mill and Carlyle attest to the psychological reality of a mechanistic "universe of death."[42]

Ruskin first skirmishes with the devils of mechanism in the late 1830's. By then the basic issues have been stated and the major distinctions drawn. The attitudes, if not the theories, of Coleridge and Wordsworth have entered the mainstream of the Victorian outlook. Charles Lamb, Leigh Hunt, and William Hazlitt helped disseminate these attitudes. It is Carlyle, however, who carries the attack on mechanism into the heart of the Victorian period. In "Signs of the Times" (1829) and essays on the German Romantics, he urges incessant warfare against a "Mechanical Age" with its scientific materialism and utilitarian "Motive grinding" and repeats, often with more heat than light, the distinctions between organic and mechanical, reason and understanding, intuition and prudential calculation. Even Utilitarianism in the person of John Stuart Mill accepts the need for a "cultivation" of the feelings to balance the analytic side of man's nature and to form the basis of the imaginative sympathy "whereby one mind . . . throws itself into the feelings of another mind."[43]

In the dissemination of Romantic attitudes, the theoretical distinctions of Coleridge soon disappeared. Coleridge represents the flowering into system of what, both before and after the sage of Highgate, was a variable galaxy of attitudes centering upon a distrust of abstract reason and a reliance on more intuitive modes of perception. As it developed and expanded in the nineteenth century, this set of attitudes turned full circle until the views of many of the leading Victorians came in their unsystematic quality to resemble those of Burke, Chesterfield, and even Hume, each of whom deplores the rationalistic methods of "theorists" and "alchemistical legislators."

Among Victorians who typify the diffusion of Romantic modes of cognition are Newman, Dickens, George Eliot, and Matthew Arnold. However different in other respects, they are at one in rejecting mechanical modes of thought which rely on "mere logic" to produce the "frigid" abstractions of a "generalizing age." They describe cognition as an intuitive "seeing" dependent on an intimate union of heart and intellect. Newman's distinction between "notional assent" and "real assent" is, perhaps, the most elaborate version of this diffused Romanticism and the version which shows itself most conscious of its Christian lineage.[44]

Ruskin is an important figure in the diffusion of the Romantic critique. In his writings, Coleridge's distinction between the higher and lower faculty of reason has degenerated into a much vaguer one between the artist and the rational scientist. The scientist works in a "reflective, logical, sequential" fashion. Like the merely fanciful poet and like the political economist, he neglects emotions and divides up mechanically what he sees. He reduces nature to anatomy and truth to rules and studies only those things "which can be systematized, catalogued, and taught to all painstaking mankind." The artist, on the other hand, works with "perceptive, sensitive, retentive" faculties and directs himself to "whatever is immeasurable, intangible, indivisible." He relies on sense impression, moral feeling, and imagination to see things as they affect the human soul. Much earlier, Hazlitt had summed up the difference: "Science depends on the discursive or *extensive*—art on the intuitive and *intensive* power of the mind." Ruskin respects the scientific method but agrees with Wordsworth that its truth is less important than the truth of the imagination. It is a truth of fact and demonstration, without special relevance to man, while imaginative truth speaks directly to the human condition and is "carried alive into the heart by passion." The truth of art can be grasped only by "intensity of gaze," not by "reasoning or report." The artist must keep the "lucid field of his soul," Blake's "doors of perception," free of the mechanical knowledge which obstructs vision and deadens the imagination. When Ruskin turns to social and economic criticism, he does not abandon his epistemological preferences.[45]

6

Ruskin's description of the imagination and his distrust of the "reasoning power" are interesting. Still, one cannot turn to Ruskin from Coleridge without feeling cheated. One hopes to find a new

treatment of these matters or at least evidence that the old treatments have been thought through closely. One does not. Ruskin assimilates the Romantic tradition without question and without awareness of his reluctance to think in terms of process and growth. Ruskin's organic approach, although distinctively biased, is not original. He does not re-examine his roots. His true originality lies in his application of Romantic modes of thought to painting and, more important, to society and economics. Even here, Coleridge, Wordsworth, Southey, and Carlyle had pointed the way. Ruskin, however, surpasses them in that power of social intuition which makes his mind a sensitive register of changes in his society's largely unconscious assumptions.

To say that Ruskin shapes to his own purpose a prefabricated style of thought is not to imply that it suits him the less perfectly. Indeed, it is tempting to view Ruskin's formal discussion of the imagination as a rationalization of his own mental processes. His diaries are full of passages describing attempts to look at nature with the illuminating "grasp" of the imagination. In every field, Ruskin's mind works intuitively. He can pierce quickly to the heart of a matter, gaining a sound grasp of first principles and organic relationships. He is much less capable of the slow step-by-step testing of propositions which the scientist and scholar endures. In art, history, or political economy, Ruskin reaches his basic principles very early in his study and spends much time restating, preaching, and applying. Just as his formal theory of the imagination slights the process of growth—the evolving of the germ within—so, in his own thinking, Ruskin seems unable to nurture a single idea or develop a single argument over a long period of time. He either sees it all or sees nothing. Soon, he turns to something else.

Why Ruskin adopts an organic approach is a difficult question and one beyond the scope of a book attempting to resist the seduction of Ruskin's biography. Several sources come to mind. One is his urgent and typically Romantic need to preserve some sort of meaningful relation among things in a time of decaying religious and social traditions. Ruskin's organicism of the surface only partially fills this need and often aggravates it by stressing the dangers of decay, not the possibilities of growth or development. Beyond this, there is, perhaps, a more desperate need to re-establish an originally "pure" relationship with the source of life—to recover an organic vitality which Ruskin feels to be corrupted in his own nature but admires fearfully

in the little girl at Turin "with her black hair over her eyes and half-naked, bare limbed to above the knees and beautifully limbed— lying in the sand like a snake. . . ."[46] The barren machine-universe of Ruskin's horror is, one suspects, a projection of his own "impurity." His adoption of a static organicism, which fails him in his encounter with the machine, betrays a fear that his own life's stream, like the Alpine torrent of his later fantasies, can flow in but one direction from its pure source—downhill, to waste.

The tragedy of Ruskin's life is that he knows there is another way, a way of positive, upward growth. He is not satisfied with an organicism of the surface which represses the possibility of growth and views change as decay. Between the lines of every page, one can read the record of his struggle against it and his awareness of a higher ideal—an ideal of healthy, energetic growth and development. Although Ruskin's vision of this ideal has a profound impact on his social criticism, he cannot maintain it consistently or carry it victoriously into the center of his thought. All too frequently, he retreats to a static organicism which lacks the seeds of hope. Ruskin never gives up until the scene of the struggle, his own mind, is destroyed. To the end, the dichotomy in his thought remains and renders frighteningly ambiguous such words as purity and morality. This dichotomy does not falsify the impression one gains of the wholeness of Ruskin's work, for his inner conflict pervades every aspect of his thought just as planes of force pervade a crystal or a disease pervades the body.

II Drive to Humanity

Organicism is a formal principle—a principle of method. Logically, one might ask, "Organicism for what?" Does Ruskin see phenomena as organic wholes for their own sake without concern for their content, or is there a definite thrust or direction to his organic approach? Ruskin is heading toward an emphasis on man. To be sure, he can discuss the organic quality of a painting or tree without reference to man, but he does so less and less frequently as his career progresses. He draws connections between art and the artist, art and morality, architecture and society. One comes to suspect, in fact, that Ruskin's organic approach is a means of rationalizing guilt feelings over his aesthetic pleasure and convincing himself that art is related to important human concerns. In a letter to his friend the Reverend Osborne Gordon (1844), he writes, "I am not engaged in selfish cultivation of critical acumen, but in ardent endeavour to spread the love and knowledge of art among all classes. . . ." He maintains that he is "directing the public to expect and the artist to intend an earnest and elevating *moral* influence." It is this drive to humanity which carries Ruskin from art to social criticism and inspires him to attack the classical economists in the same fashion as he attacks those who isolate aesthetics from man as a whole. The purpose of the present chapter is to trace the expression of this drive in his theories of art and architecture. The focus will be less on the originality or accuracy of the theories than on their position in Ruskin's movement toward social and economic criticism.[1]

2

Ruskin's tendency to relate all things to man's life sets the tone of his aesthetic theories. As Henry Ladd has demonstrated, Ruskin broadens and humanizes the concept of art by abandoning the formal emphasis on beauty. He enlarges the concept to include a wide range of human experience, of "vital or spiritual fact." Beauty occupies a less central position and is made symbolic of moral values. To complement beauty, truth—in the sense of true impressions of appearance and sincere expression of emotion—is made an element of art. Also included are what Ruskin calls "Ideas of Relation" or

"thoughts." Art is "a noble and expressive language, invaluable as the vehicle of thought but by itself nothing." He rejects the neoclassical obsession with laws of style and studies art in relation to the men who create or see it.[2]

Ruskin's interest in the human dimension of art leads him to emphasize the expressionistic function of artistic language. In his writings on architecture and in the later volumes of *Modern Painters,* art becomes less the representation of God in nature and more an expression of the *"God-made great man"* who creates it and whose entire being stands forth in it with a "solemn 'Behold, it is I.'" Ruskin extends to art criticism the change in literary theory from the classic view of a poem as the mirror of a perfect reality to the Romantic view of literature as an expression of the personality and feelings of the author. Ruskin experienced this change in personal terms. At Chamonix in 1835, he felt his soul become annihilated through contemplation of the beauty of God's creation. In 1849, he writes of a similar scene: "I felt that the human soul was all—the subject nothing." This development is very important for the future direction of his career.[3]

Oddly enough, the word utility best describes Ruskin's vision of the role of art. He believes that art is useful. It serves purposes of expression and communication beyond itself. To be sure, he can stress the nonutilitarian, disinterested quality of a work of art and the enjoyment derived from its contemplation, but the contradiction is only between two definitions of utility. True utility enables man "fully to perform the functions" appointed to him by the Creator. False utility is that narrow, materialistic concept used by men "who insolently call themselves Utilitarians" while reducing all human motives to "brutal appetites." They speak as if "Sight, Thought, and Admiration" were profitless. In the true sense of the term, art has a usefulness "addressed to the weightiest of human interests."[4]

The "utility" of art lies first in its beneficent influence upon those who contemplate it. Art is an "instrument of gigantic moral power," and Ruskin's task as an art critic is "to display the use, force, and function of a great body of neglected sympathies." His concern with the moral effect of a painting parallels the Romantic poets' concern with communication and their crusade to make poetry not merely decorative but a means of changing man and society. Shelley puts it clearly in his essay on the *Defence of Poetry* (1821). Poets are "lawmakers unacknowledged by the world." It is Ruskin's belief that he has failed in the important role of art teacher which drives him to

social criticism, where he repeats the distinction between true and false utility.[5]

The turn to social criticism is made easier for Ruskin by the emphasis on expression which accompanies his vision of the scope and "usefulness" of art. Ruskin's critique of neoclassical laws and his growing conviction that art is the expression of the artist's life and society do not lead him into aesthetic relativism. He believes that he can distinguish good from bad art and that good art is the expression of a good man. A good man, in turn, can be the product only of a good society. Ruskin's argument is circular. Great art is an "instrument of gigantic moral power," but great art can be appreciated and produced only by morally "whole" individuals living in a healthy social environment. Ruskin admits the circularity and declares,

You must have the right moral state first, or you cannot have the art. But when the art is once obtained, its reflected action enhances and completes the moral state out of which it arose. . . . (20.73)

The circle is lopsided. The basic element in the creation and appreciation of art is the "moral state" of society. When Ruskin concludes that the circle has been broken and that either great art is not being produced or that existing art is not having an "exalting" influence, we may expect him to examine the condition of society. This is the path which he follows to social criticism.[6]

Ruskin's view of the relation of art to society rests on a Romantic premise. It is that the artist is an integral part of a social whole. His art expresses not only his own personality but also the nature of his society—its climate, its national traditions, its religion, and its economy. The concept of a cultural whole, and, indeed, the very word "culture," is one of the most important discoveries of Romantic thinkers. It inspires their rejection of the cosmopolitanism of the Enlightenment and their interest in national consciousness, history, and the Middle Ages. The tendency to view art as a social product, or, as H. A. Needham puts it, the development of a sociological aesthetic, is a part of this movement. Among the thinkers who precede Ruskin in fashioning such an aesthetic are, in Germany, Herder and Schiller; in France, Madame de Staël and Louis de Bonald; and, in England, Coleridge, Shelley, Hazlitt, and Carlyle. The English Romantics seem, in this case, to have relied heavily on their Continental, especially their German, counterparts. Although not original, Carlyle's views are interesting because of their similarity to Ruskin's. For Carlyle, man is an organic whole and lives in a society whose

members are mysteriously bound together by "organic filaments." An artist's creativity cannot be separated from the other facets of his personality or from his social environment. Carlyle gives this perception a place in his social criticism. When the spiritual quality of the members of society deteriorates, he writes, "all their arts . . . are corrupted to their very heart by an infectious poison."[7]

On several points, Carlyle may have been influenced by the Saint-Simonians as well as by the German Romantics. The Saint-Simonians and the French social critics Charles Fourier (1772-1837), Pierre Joseph Proudhon (1809-1865), and Auguste Comte (1798-1857) seem in many ways closer to Ruskin than do the literary Romantics. More consistently than Carlyle, the French thinkers make their view of the relationship of art to society a part of their social critiques. Each writer expects a new and socially oriented art to rise from the society of the future. The versions of this society proposed by the Saint-Simonians and Comte bear a striking resemblance to Ruskin's own hopes. Like them, he believes that the art of the future will be related to the interests and needs of all members of society. Ruskin shows no evidence of having read the French authors and developed his ideas independently.[8]

When one tries to discover the real sources of Ruskin's sociological aesthetic, one is surprised to find him referring as much to eighteenth-century or earlier thinkers as to Romantics. Indeed, Ruskin's eclecticism is an excellent antidote to the temptation to accept the usual categories of scholarly interpretation. Ruskin had studied Plato, Aristotle, and Reynolds. He was familiar with the writings of Montesquieu, Hume, and the German critic Johann J. Winckelmann. Plato and Aristotle view art as an integral part of the social and moral environment. They encouraged Ruskin's organic approach to society and its cultural products. Among eighteenth-century thinkers, Shaftesbury and Reynolds attempt to relate the aesthetic and the moral or social faculties of man. The Scottish social theorists Adam Ferguson (1723-1816) and John Millar (1735-1801) also have a clear sense of the interwoven "fabric" of society and of the interdependence of all phenomena from art to economics. In a passage which suggests that the organic metaphor was by no means confined to Romantics, Ferguson writes, "The fine arts too . . . spring from the stock of society, and are the branches or foliage which adorn its prosperity. . . ." It is Montesquieu, Hume, and Winckelmann who express most clearly the idea that the artist is dependent on the "circumstances" of his epoch.[9]

The difference between the earlier thinkers and the Romantics is one of fine shading and emphasis. It is more a matter of style than of content, or, rather, it is only through style that one can reach the difference in content. The Romantics' enthusiastic assertion of the mysterious wholeness of culture differs from the earlier writers' prosaic analysis of the effect of "circumstances" on the production of art. The doctrine of "circumstances" suggests a mechanical and associationist view of mental processes which differs radically from the Romantics' organic approach. The Romantics are more aware than their predecessors of growth and relativity in cultural phenomena. It was Herder who first brought the doctrine of "circumstances" within the fold of organicism. Although Ruskin's enthusiasm and his organic approach place him firmly in the Romantic camp, his organicism of the surface makes him suspicious of cultural growth and relativity. It brings him closer to thinkers like Ferguson than one might expect.[10]

What really distinguishes Ruskin from both Romantics and eighteenth-century authors is his extraordinary emphasis on the word "moral." He formulates his sociological aesthetic in terms of the "moral" effect of art on society and of the work of art's expression of the "morality" of the artist and his society. Although Ruskin's first intention is to broaden the scope of art and relate the visual sense to the quality of man's emotional life, he seldom resists giving a more specific connotation to the word "moral." The ambiguity of the word encourages him to shift from a morality of "healthy vital energy" and organic "purity" to a morality of Victorian respectability. This shift is symptomatic of a deeper conflict within Ruskin himself and, perhaps, within his Victorian audience.[11]

The two sides of Ruskin's sociological aesthetic—his view of art as a moral influence and his view of art as an expression of the social or moral environment—interact dynamically in his art criticism. Ruskin is torn between an optimistic view of the artist leading his fellow men to higher ground and a pessimistic view of the artist bound by his social environment. In the first two volumes of *Modern Painters,* he is concerned with enlarging the sphere of art and noting its salutary effect on the spectator. He suggests only briefly the artist's socially conditioned nature. As Ruskin comes to doubt the usefulness of art, he places more emphasis on the deterministic side of his aesthetic theory. He implies that good art will be possible only when the social and economic structure has been changed. In his works on architecture, in the final volumes of *Modern Painters,* and in various

lectures of the fifties, his view of art as a social product becomes increasingly apparent. This is not to say that he abandons his optimistic position. The struggle between the two aspects of his thought continues up to and beyond his plunge into social criticism. Ruskin never gives up the struggle but merely transposes it from an aesthetic to a social key. In his social criticism, he is torn between a belief in the creative influence of the moral "word" upon the hearts of men and a Marxian belief in the necessity of a change in the social environment before any "word" can be heard. At the social level, Ruskin's belief in the power of moral influence wins out. At the aesthetic level, it does not. As early as *The Stones of Venice,* he suspects that art criticism is useless and that criticism of society is the thing needed. In the following sections, an effort is made to trace Ruskin's growing conviction that art is an expression of the life of the artist and his society. It is this conviction which channels his aesthetic disillusionment into social criticism.

3

In the first volume of *Modern Painters* (1843), Ruskin introduces the structure of his work. His purposes are to investigate the facts of nature, to analyze the emotions of the beautiful and sublime, and, most important, to trace the effect of art on man. To demonstrate the moral usefulness of art, he describes it as a form of language whose task is to convey "the greatest number of greatest ideas." Ruskin mentions truth, beauty, power, imitation, and relation. His use of the word "ideas" is confusing since he means impressions and feelings as well as ideas in the intellectual sense. The latter fall into the category of "Ideas of Relation" or thoughts. Ruskin's interest in "ideas" reflects a belief that art conveys meaning to the spectator beyond sensual pleasure in shape and color.[12]

The remainder of volume one examines ideas of truth. Although the focus is on truth to nature, Ruskin notes the exalting effect of truthful art on the spectator. By portraying nature, the artist reveals God's creation and inspires noble emotions. The performance of this task requires rare qualities of sympathy, discipline, earnestness, and sensitivity. Ruskin implies that truthful art expresses the artist's personality and feelings, his "energy and passion," but only in later volumes does he dwell on the expressive function of art. At present, the perception and representation of truth hold his attention. In one remarkable passage, however, Ruskin looks to the future: "The artist

not only *places* the spectator, but *talks* to him; makes him a sharer in his own strong feelings and quick thoughts; hurries him away in his own enthusiasm; guides him to all that is beautiful . . . and leaves him . . . ennobled and instructed, under the sense of having not only beheld a new scene, but of having held communion with a new mind, and having been endowed for a time with . . . the impetuous emotions of a nobler and more penetrating intelligence."[13]

In the second volume of *Modern Painters* (1846), Ruskin turns from ideas of truth to ideas of beauty and to the faculties of "theoria" and imagination which perceive beauty. His purpose is to make the beautiful symbolic of higher moral conditions. He does this, for example, through the concept of typical beauty. In addition to unity and purity, beauty suggests other "types" or attributes of the Divinity. What is important is that Ruskin dwells more on the artist's and spectator's appreciative vision and less on the objective qualities of beauty. The act of "theoretic" or imaginative contemplation has been discussed, but not in the context of Ruskin's drive to humanity. Contemplation is "the healthy, voluntary, and necessary action of the highest powers of man." It depends for its acuteness on intensity of feeling. In fact, it is sympathy or "love" which makes theoria the "exulting, reverent, and grateful perception" of beauty and elevates it above "aesthesis," an "animal consciousness" of line and color. This explains Ruskin's belief that only a moral man can perceive or create beauty. At the same time, imaginative vision reacts upon man, inspiring him to harmonize his personal desires with the types or moral values intuited. Contemplation is "human life at its best," and Ruskin's discussion of it in volume two reveals his growing concern for the human dimension of art.[14]

Not everyone, of course, can experience the highest joys of theoria, and even fewer men can use their imaginations to create works of art. Ruskin shares in the Romantic elitism which makes genius a rare quality of birth. A healthy moral development is not enough. One must have the inborn capacity and nurture it carefully. At this point, Ruskin's interest in social criticism becomes apparent, for nurturing depends on environment and education, although these alone do not produce genius. How can one appreciate natural beauty if nature has been polluted, and how can one conceive of vital beauty in man if no one achieves a "felicitous fulfilment of function?" Education, too, is necessary: historical knowledge provides food for the imagination, and scientific training helps one understand the appearance of "or-

ganic form." The theoretical source of Ruskin's concern with educa-
tion and environment lies here in the early volumes of *Modern
Painters.*[15]

4

Ruskin's architectural studies, *The Seven Lamps of Architecture*
(1849) and *The Stones of Venice* (1851-53), mark an important
advance in his attempt to relate art and life. In the first two volumes
of *Modern Painters,* he has suggested that the creation and apprecia-
tion of art depend on the condition of the artist's or spectator's life.
Ruskin follows the same path in his architectural studies. Architec-
ture is a more communal activity than painting. It is a "political art"
involving workers of various talents and viewed by a wide spectrum
of the public. It is not surprising that Ruskin's ideas develop in the
direction of a broader social critique. For example, his belief that art
reflects the moral condition of the artist becomes, in *The Seven
Lamps* and *The Stones of Venice,* the principle that architecture
expresses the ethos of the society producing it. His concern for the
quality of life of the artist becomes a concern for the quality of life
of the ordinary workman. This shift from artistic genius to ordinary
worker is the most important in all of Ruskin's writings, for, in the
course of it, he does not alter his view of what constitutes healthy
life and work. At most, he abandons the distinction between imagi-
nation and fancy. He now uses the term imagination in a more gen-
eral sense—a sense in which it can describe the activities of the ordin-
ary man. Ruskin's study of architecture leads him to apply to the life
of the worker in nineteenth-century England some of the standards
by which he judges the creative activity of the greatest artists.[16]

The acute social critique which follows this shift from art to archi-
tecture and from genius to ordinary worker is made more acute by
Ruskin's secular approach. In spite of his Biblical rhetoric, he refuses
to accompany A. W. Pugin (1812-1852) and the Cambridge "Ecclesi-
ologists" down the road of religious revivalism. Although he agrees
with Pugin and John Neale (1818-1866) that good architecture, that
is, Gothic architecture, depends on the moral quality of those build-
ing it, Ruskin does not care to make England either Catholic or
High-Church. He attempts to give a Protestant and national interpre-
tation to the Catholic architecture of the Middle Ages. As one might
expect, this leads him to focus on the secular use of Gothic and on
the reform of the secular social and economic values of nineteenth-

century England. Something more complicated and difficult than a religious revival is needed. Nonetheless, Ruskin follows Pugin in his insistence that there is one best form of architecture, Gothic, and one best way of life from which this architecture springs.[17]

The movement of Ruskin's thinking here is most interesting. From one point of view, he is following in the tradition of Herder, Burke, and Coleridge who insist upon the interwoven texture of human affairs and who view cultural artifacts as the fruit of a peculiar soil, "spirit of the time, of the people, of feeling, of language." Ruskin applies this view to art and architecture and makes it one of the sources of his social criticism. He refuses, however, to accept the cultural relativism implicit in this interpretation and recognized, to an extent, by earlier thinkers. He yields to his fear of change and makes Gothic a universal cultural criterion. Ruskin's interest in the "moral" conditions of the work of art is the sticking point. While defining "moral" to mean the healthy energy of the whole man as it expresses itself within a certain society, he allows the word to become infused with the universal and absolute emphasis of Evangelicalism. That this emphasis is not unlike the cosmopolitan viewpoint of the "age of reason" seems to confirm Blake's suggestion that both moralistic and rationalistic absolutism spring from a faulty mode of perception—seeing "with" the eye. Ruskin's rejection of cultural relativism and his adoption of the Gothic Revival are the first fruit of his organicism of the surface. They reveal that tendency to confuse "purity" as energy with "purity" as spotlessness which comes easily to one blessed with a "puritanical" upbringing. In Ruskin's early works on architecture, the central ambiguity of his thought is not apparent. It lurks in the background, waiting to play its destructive role at a time when his powers of synthesis are greatly weakened.[18]

5

The extension of Ruskin's art criticism to a broader social field appears first in *The Seven Lamps of Architecture.* In this important work, Ruskin concerns himself less with the representation of truth and beauty and more with the relation of art to man. His choice of the metaphor "lamp" recalls the Romantic poets' use of this term to describe the mind as an expressive, creative source, not a classical mirror of external reality. In a sense, the book expands the theme of Ruskin's youthful essay "The Poetry of Architecture" (1837-38). It is that certain states of "national character" lie behind great architec-

ture. The architect is not a technician or engineer but a "poet" expressing his feelings and values.[19]

In the introduction to *The Seven Lamps,* Ruskin warns that the technical aspect of architecture is overshadowing the imaginative, expressive aspect. Ruskin hopes to right the balance and demonstrate "that all architecture proposes an effect on the human mind" and "receives impressions from human power." He begins by making the controversial distinction between architecture and building, ornament and construction. For him, architecture is ornamentation, and the building only a "dead" frame for sculpture and color. Just as Romantic poets deny that poetic beauty consists in "talented" arrangement, so Ruskin denies that architecture consists in the "disposition of masses" and the "art of proportion." Sculpture and painting are the "divine part" of architecture because they alone call forth the creative spirit of man and express "ideas." Ruskin's emphasis on ornament, color, and detail at the expense of construction parallels his organicism of the surface and his lack of interest in the internal structure and processes of plants and animals.[20]

"The Lamp of Sacrifice" reveals Ruskin's preference for ornament: "it prompts us to the offering of precious things merely because they are precious, not because they are useful." The reward of this spirit, if revived by Victorian builders, would be "an impulse given to art such as it has not felt since the thirteenth century." The revival of art is not Ruskin's only aim in "The Lamp of Sacrifice." Beneath his emphasis on the spirit of the builder, there lies a more subtle motive. As Francis Townsend has noted, one of Ruskin's purposes in writing *The Seven Lamps* is to break the Catholic or High-Church monopoly on the Gothic Revival and to convince Protestants that they could enjoy both magnificent religious architecture and good consciences. He does this by shifting attention from the building to the builder, from the "visible splendour" to the "spirit that would build it." While admitting that the church "does not need" imposing architecture, he declares, "It is not the church we want, but the sacrifice ... not the gift, but the giving." From our point of view, Ruskin's redoubtable forensic dodge in Protestantizing the Gothic Revival should not obscure the important advance which he makes in relating architecture to the attitudes and emotions of those building it.[21]

In "The Lamp of Truth," Ruskin's interest in the life of the builder leads him to the problem of machine production. After an intriguing

discussion of structural and surface "deceits," in which he demands that form follow function, Ruskin turns to "operative deceits"—the substitution of machine work for that of hand. A concern for creativity inspires his "unconditional" rejection of machine work. The source of an ornament's attractiveness, he writes, is "our consciousness of its being the work of poor, clumsy, toiling man . . . the record of thoughts, and intents, and trials, and heartbreakings." This is the worth of a thing. Machinery destroys this worth by removing the element of human power. Since a machine-made ornament pretends to a worth it has not, it is a "lie" and a "sin." "Down with it to the ground!" Ruskin cries. On the next page, he modifies his position. First, he notes that, with ductile materials, stamping and casting are permissible since it is expected and not dishonest. Second, and more important, he admits that "it is, indeed, possible and even usual, for men to sink into machines themselves so that even handwork has all the characters of mechanism." This perception draws Ruskin deeper into the thicket of the quality of work.[22]

Ruskin has shifted almost unconsciously to an expressionistic position. Although, in "The Lamp of Beauty," he insists that architecture must follow the lines of organic form, his inclination is to place the significance of architecture in its expression of human power and feeling. Truth to nature is giving way to sincerity of expression. "The Lamp of Life" continues this tendency. In it, Ruskin turns from his diatribe against machine work to the more interesting problem of the distinction between living and dead work in general and the danger of men turning themselves into machines. This leads to his "happiness of the worker" criterion and his critique of overrefined workmanship—keys to his famous chapter in *The Stones of Venice*, "The Nature of Gothic."

Ruskin begins "The Lamp of Life" by stating that beauty depends on "the expression of vital energy in organic things" or "the subjection to such energy of things naturally passive." This qualification reveals Ruskin's growing interest in the expressionistic function of art. More simply, he continues, "Things . . . are noble or ignoble in proportion to the fulness of life which either they themselves enjoy, or of whose action they bear evidence. . . . And this is especially true of all objects which bear upon them the impress of the mind of man." Architecture is one of these. Having no life of its own, it "depends . . . upon the vivid expression of the intellectual life which has been concerned in its production." The importance of art or

architecture for Ruskin now lies less in its symbolic suggestion of Divine attributes than in its expression of human vitality. Typical beauty in art and nature is yielding to vital beauty in man or, better, the expression of man's vital energy in the inanimate materials to which he lays his hand.[23]

Ruskin next turns to the question of what is life in man and what is not. Since he is less than explicit on the point, it is best to let him speak:

His [man's] true life is ... the independent force by which he moulds and governs external things. ... His false life is, indeed, but one of the conditions of death or stupor. ... It is that life of custom and accident in which many of us pass much of our time in the world ... that life which is overlaid by the weight of things external to it ... that, which instead of growing and blossoming under any wholesome dew, is crystallized over with it, as with hoarfrost, and becomes to the true life what an arborescence is to a tree, a candied agglomeration of thoughts and habits foreign to it, brittle, obstinate, and icy, which ... must be crushed and broken to bits, if it stand in our way. (8.190-191)

Ruskin follows Blake and Wordsworth in his use of "frost" as a metaphor for custom. When he speaks of the life of a nation, he prefers lava—flowing and then hardening into rigid impotence. Behind the rhetoric, Ruskin identifies life in man with the exercise of the mind, heart, and will. "So long as men work *as* men, putting their heart into what they do ... it matters not how bad workmen they may be, there will be that in the handling that is beyond all price...."[24]

Ruskin's desire to engage the whole man in work inspires his striking suggestion that the quality of architecture depends on the happiness of the worker. "I believe the right question to ask, respecting all ornament, is simply this: Was it done with enjoyment—was the carver happy while he was about it? It may be the hardest work possible, and the harder because so much pleasure was taken in it; but it must have been happy too, or it will not be living." Here Ruskin brings his definition of vital beauty as the "appearance of happiness" in living things to bear upon his belief that architecture expresses human "life." Ruskin describes a new Gothic church near Rouen, elaborately decorated but all "as dead as leaves in December ... not one warm stroke on the whole façade." The workers' unhappiness, their lack of vital beauty, reveals itself in the coldness of the carving and design. Ruskin's "happiness of the worker" criterion is an excellent example of his attempt to apply to the ordinary man standards

drawn from artistic creativity. Although he nowhere makes the happiness of the genius the test of a great work of art, he does state that such a work is the expression of the whole man in his most healthy, most vital condition. Ruskin feels justified in emphasizing the happiness of the ordinary workman because his work does not have the subduing and humbling effect of true creative vision.[25]

If Ruskin describes happiness vaguely as the full engagement of man's highest qualities, he has no difficulty discerning its expression in architectural ornament. Two criteria serve him: first, the nature of imitation and, second, the nature of "finish." Imitation is not a sign of deadness if it chooses carefully from other styles. Vital imitation involves "frankness" and "audacity"—a willingness to admit openly the sources of its harmony and confidence in its power to renew whatever it adopts.[26]

The second criterion is the surer sign of vitality. In "The Lamp of Life," Ruskin begins his persistent concern with "finish." A progressive or vital style shows a "certain neglect or contempt of refinement in execution, or, at all events, a visible subordination of execution to conception." In a living architecture, one will find "marks ... of intense impatience; a struggle towards something unattained which causes all minor points of handling to be neglected." Perfect finish reflects a lack of vitality or happiness in the work. "I cannot *too* often repeat," he writes, "it is not coarse cutting ... that is necessarily bad; but it is *cold* cutting—the look of equal trouble everywhere.... If completeness is thought to be rested in polish ... we may as well give the work to the engine lathe at once." There is an important difference between Ruskin's criticism of over-refinement and his earlier discussion of "moderation" as an element of typical beauty, "the type of government by law." Moderation, Ruskin writes in volume two of *Modern Painters,* shows itself in careful craft and finish which resemble "the working of God whose 'absolute exactness,' says Hooker, 'all things imitate....'" Clearly Ruskin's Romanticism has broken through the classical tone of some of his remarks in the early volumes of *Modern Painters.* His contempt for superficial polish and his belief in a restless striving for the unattainable suggest that he is well aware of alternatives to a static organicism.[27]

Nowhere is the living wholeness of Ruskin's work more evident than in "The Lamp of Life." The reader cannot follow the author's argument step by step but must grasp it as a *gestalt*—a flash of vision

illuminating many recesses simultaneously. Ruskin links his view of finish to the rest of his work in four ways. First, he relates it to his enlargement of art to include "ideas" and a broader range of experience than the appreciation of formal laws of beauty: "*Right* finish is simply the full rendering of the intended impression . . . and it is oftener got by rough than fine handling." Second, he relates the "carelessness of execution" and the "departures from symmetrical regularity" which characterize vital architecture to his view of organic beauty in the first two volumes of *Modern Painters.* Ruskin sees in nature an abundant variety or, to use John Rosenberg's expression, an irregular regularity. He sees the same in "Living Architecture": "There is sensation in every inch of it . . . with a determined variation in arrangement, which is exactly like . . . the structure of organic form." Ruskin's vision is not original. Goethe, Wordsworth, and Coleridge use the metaphor of a cathedral, and, significantly, a Gothic cathedral, to describe the living, organic quality of the best poetry.[28]

The third and fourth ways in which Ruskin relates "The Lamp of Life" to his thought point to the future. The first concerns machinery. At the end of the chapter, Ruskin returns to his critique of machinery in "The Lamp of Truth." Now he considers machine-finished ornament a symptom of death as well as falseness and insists that it will only make us "shallower in our understandings" and "colder in our hearts." He concludes "The Lamp of Life" with a sentence which looks back to his critique of mechanical modes of perception and forward to his attack on industrialism and his vision of "The Storm-Cloud of the Nineteenth Century": "There is earthiness enough, and sensuality enough in human existence, without our turning the few glowing moments of it into mechanism; and since our life must at the best be but a vapour that appears for a little time and then vanishes away, let it at least appear as a cloud in the height of Heaven, not as the thick darkness that broods over the blast of the Furnace, and rolling of the Wheel." Already, Blake's "dire mills" loom on the horizon.[29]

The second link to the future is Ruskin's conviction that Gothic architecture best expresses the vital needs and impulses of man. Through his selection of examples, he makes it clear that, in Gothic, the lamps of sacrifice, truth, beauty, and power burn most brightly while, in neoclassical architecture, they are extinguished. In "The Lamp of Life," he uses early Gothic as the prime example of a living

architecture where the worker's creativity is not obstructed by demands for surface perfection. Ruskin's hostility to the "foul torrent of the Renaissance" parallels his growing sympathy for the Gothic Revival.[30]

The remaining lamps of architecture—memory and obedience—light the path to Ruskin's full acceptance of Gothic in *The Stones of Venice.* Ruskin describes architecture as "the centralizer and protectress" of memory. It provides a contrast to the transitional nature of all things and "half constitutes the identity . . . of nations." Man has two duties: to make present architecture historical and to preserve, not restore, old buildings. Gothic is particularly valuable since it encourages a richness of record or "ideas." Moreover, it is Gothic which needs preserving. Here Ruskin sees the possibility of using a revived Gothic architecture to buttress the sense of national community which Burke, Coleridge, and Wordsworth wished to encourage.[31]

"The Lamp of Obedience" takes up these suggestions and demands the subjection of architecture to national law. Several advantages would result. First, since the other arts depend on architecture, the adoption of a national style would inspire an artistic revival. Released from the burden of free choice, the architect would be able to focus his energy on improving the adopted style and the arts connected with it. This is a new position for Ruskin, suggesting that his turn to architecture is a tactic in his attempt to demonstrate the usefulness of art criticism. More important, the creation of a universal architecture would stimulate building and provide employment. Ruskin moves easily from art to work. In his view, the real cause of the revolution of 1848 in France was idleness. What men need is occupation, not just "in the sense of bread," but "in the sense of mental interest."[32] England seems less afflicted with idleness, but Ruskin wonders whether the usual forms of employment really improve men:

We have just spent, for instance, a hundred and fifty millions, with which we have paid men for digging ground from one place and depositing it in another. We have formed a large class of men, the railway navvies, especially reckless, unmanageable, and dangerous. We have maintained besides . . . a number of iron-founders in an unhealthy employment . . . we have, in fine, attained the power of going fast from one place to another. Meantime we have had no mental interest or concern ourselves in the operations we have set on foot. . . . Suppose, on the other hand, that we had employed the same sums in building beautiful houses and churches. We should have maintained the same number of men, not

in driving wheelbarrows, but in a distinctly technical, if not intellectual employment; and those who were more intelligent among them would have been specially happy in that employment, as having room in it for the development of their fancy. . . . Meantime we should ourselves have been made happier and wiser by the interest we should have taken in the work. . . . (8.263-264)

Ruskin goes on to broach one of the most original themes of his social criticism—the need for a consumer ethic. He urges consumers to ask whether their demand for a product gives healthy employment: "It is not enough to find men absolute subsistence: we should think of the manner of life which our demands necessitate. . . ." Ruskins stops here because, he says, "I have some strange notions about it which it is perhaps wiser not loosely to set down." The way to "The Nature of Gothic" in *The Stones of Venice* is open.[33]

<div align="center">6</div>

The Stones of Venice is the best organized of Ruskin's works. It is an original form of cultural history—a history of the "moral temper" and hence the destiny of Venice as reflected in her architecture. But Ruskin is not satisfied with history. The preacher in him must find expression and does so in two directions. First, the book is a glowing tribute to Gothic and a detailed condemnation of the Renaissance. Second, it contains the most famous of Ruskin's critiques of the quality of the worker's life. The blend of polemic, history, and architectural study is so "organic" that it is impossible to separate one from another.

The Stones of Venice reinforces earlier themes and applies them to the nineteenth century. It marks a high point in Ruskin's tendency to view the work of art as an expression of the artist's life and enjoyment. In volume one, *The Foundations*, he asserts that good architectural ornament expresses "strong liking" and that this liking should be for God's creation. The criterion of natural beauty is still here, but the important fact is that man delights in this the most. By carving natural forms, the sculptor expresses his enjoyment and felicitously fulfills his function. "A picture or poem," Ruskin writes, "is often little more than a feeble utterance of man's admiration of something out of himself; but architecture approaches more to a creation of his own, born of his necessities, and expressive of his nature." At the same time, Ruskin continues to relate art and work and to apply to the ordinary worker standards drawn from his study of artistic creativity. In *The Stones of Venice*, architecture becomes

the "work of nations." Since no nation is full of great sculptors, the architect must cooperate with inferior men. He must fit his design to their less elevated intelligence and "leave this to rejoice . . . in its vitality if not in its science." "This is the glory of Gothic architecture," Ruskin declares, "that every point and niche of it affords room, fuel, and focus for individual fire." Gothic resembles nature and the work of Turner in its "fulness of character absorbed in universal energy."[34]

In "The Nature of Gothic," the "most important chapter in the whole book," Ruskin sets out to demonstrate that, in Gothic, the creativity of the ordinary man as well as the universal truths of nature finds its highest expression. Besides pointed arches, a Gothic building has various "moral elements" or characteristics of "Mental Power or Expression." These are savageness, changefulness, naturalism, grotesqueness, rigidity, and redundance. In the minds of the workers, they are rudeness, love of change, love of nature, disturbed imagination, obstinacy, and generosity. Ruskin believes that these are basic human impulses. The most important is savageness or rudeness.[35]

By savageness, Ruskin means that roughness of finish which figures prominently in "The Lamp of Life." Following Madame de Staël, he first relates the rudeness of Gothic to its origin in northern climes. He goes on to give it wider significance as an index, "not of climate, but of religious principle." Through its roughness, Gothic expresses a cardinal Christian attitude: the recognition of the value of the individual soul and of its imperfection—its "lost power and fallen nature." The ancient Greek and Assyrian refused to admit man's fallen state and demanded perfection of every worker. Their architecture is characterized by "servile ornament." The execution of the inferior workman is ruled by the intellect of the higher and confined to mechanical operations. Christianity, on the other hand, recognizes man's weakness and accepts the feeble efforts of every individual in a spirit of forgiveness. It frees the worker by saying: "Do what you can, and confess frankly what you are unable to do." Gothic architecture is Christian architecture. It forgives weakness and, like the artist's imagination or nature herself, "out of fragments full of imperfection, indulgently raises up a stately and unaccusable whole." By making the higher statuary abstract or symbolic and the lower more fully realized, it allows every workman to express himself without destroying the unity of the building.[36]

Ruskin is no dour Calvinist, dwelling on man's fallen state. He makes Christian humility serve a Blakean sense of dignity, for he believes that awareness of man's limited ability gives free scope to what powers and talents remain. Only through the humility and frank admission of weakness found in Gothic can man attain vital beauty. The classical or Renaissance artist, Browning's Andrea del Sarto, debases man by denying the Fall. He aims at polished perfection of a lower order instead of "shattered majesty." *"The demand for perfection,"* Ruskin argues, *"is always a sign of a misunderstanding of the ends of art."* The great artist works until his powers of execution falter before the demands of his conception. The same should hold for the ordinary craftsman. Ruskin's view of art or sculpture as a "language" for expressing "ideas" is as relevant here as it is in his discussion of finish in *The Seven Lamps.* Nature too can be cited, for Ruskin claims that imperfection is "in some sort essential to all that we know of life." The higher the form of nature the more susceptible it is to decay or imperfection. "So also in works of man," he writes, "those which are more perfect in their kind are always inferior to those which are in their natures liable to more faults."[37]

Ruskin's distrust of too perfect finish reflects a wide spectrum of Romantic concerns. Coleridge, for example, suspects the clarity of the lower faculty of understanding and asks: "Whether or no the too great definiteness of Terms in any language may not consume too much of the vital and idea-creating force in distinct, clear, full made Images and so prevent originality. . . ." He insists upon the necessity of a fertile indistinctness in the action of the imagination and complains that, under the modern "despotism" of the eye, "nothing is deemed a clear conception, but what is representable by a distinct image." Both Coleridge and Wordsworth see a relation between indefiniteness and strength of feeling. This resembles Ruskin's concern in "The Lamp of Life." In fact, Coleridge associates "life" and indistinctness.[38]

The thinker who approaches Ruskin's view in "The Nature of Gothic" is Edmund Burke. A persistent theme in Burke's writing is the need to "make a liberal allowance for our common and inevitable infirmity." "He censures God, who quarrels with the imperfections of man." Burke warns of the evils produced by legislative attempts at "theoretic perfection." Only a frank recognition of "the ordinary frailties of human nature" will permit the achievement of man's highest, but always imperfect, good. Beneath these sentiments lies

Burke's belief in what Arthur O. Lovejoy has called the "great chain of being"—a belief which inspires Pope and Swift to condemn man's vain attempt to claim a place higher in the Scale of Being than belongs to him. In Burke's treatise *Of the Sublime and Beautiful* (1757), which Ruskin had studied closely, an awareness of man's limitations leads to the distinction between conception and execution in the work of art. The more powerful the conception, the greater the likelihood of roughness in execution. All art is divided between the "sublime," great conceptions imperfectly executed, and the "beautiful," triumphs of execution without evidence of genius. Although the young Burke is considered an exponent of Lockean psychology, the ideal of the sublime which he and other eighteenth-century writers propound is an important signpost to English Romanticism. Certainly it had an influence upon Ruskin. Ruskin takes the emphasis on man's limitations, which in Burke is conservative, and gives it a radical application to the quality of the worker's life.[39]

The second mental element of Gothic, changefulness or variety, serves a similar purpose. It results from allowing the inferior workman a sphere of independent action. When all parts of a building are identical in perfect execution, it is a sign of the enslavement of the worker—a sign that he has been subjected to the "same dull round" of Blake's "Satanic Wheels." The spectator cannot enjoy a building made on fixed rules like a product of manufacture. True architecture, like Romantic poetry and nature herself, will say new and different things and not be bound by convention. This is the source of its power and, Ruskin hoped, its moral influence. Just as Gothic receives "help from every character of mind in the workman," so it can "address every character of mind in the spectator." It can become the property of all men.[40]

The third mental element, naturalism, is the love of natural objects and the effort to represent them frankly. This, too, springs from the freedom allowed the Gothic worker, for "so soon as the workman is left free . . . he must look to the nature that is around him for material and will endeavour to represent it as he sees it." Ruskin's Gothic worker, like Wordsworth's peasant, is assumed to feel a sympathetic bond with nature. Since his love of truth involves the willing confession of nature's imperfection, it is further evidence of the Christian humility found in Gothic. Ruskin now views truth to nature as an expression of man's personal and cultural condition. The Gothic love of truthfully carved vegetation is a "softer element"—the sign of

a gentler existence, of "a rural and thoughtful life." Ruskin escapes the relativism implicit in this attitude by asserting Gothic and the way of life from which it springs to be superior to all others. Still, his position indicates a growing conviction that "art is valuable or otherwise, only as it expresses the personality . . . of a good and great human soul."[41]

Love of the grotesque is the fourth characteristic of Gothic. Ruskin's elaborate discussion of the grotesque in the third volume of *The Stones of Venice* need not concern us. What is important is his view of it as a form of jesting which encourages the expression of those instincts of the ordinary worker which can find no outlet in his daily labor. The grotesque is a form of "necessary play," the fruit of a "rejoicing energy in uncultivated minds," and does not strive for perfect execution. Its delightfulness, Ruskin writes, consists less in its own merit than in the enjoyment of him who produced it.[42]

The final two elements of Gothic, rigidity and redundance, also reflect the worker's freedom of expression. Ruskin's definition of rigidity resembles his definition of "purity." By rigidity, he means an *"active* rigidity"—"the peculiar energy which gives tension to movement and stiffness to resistance," a stiffness "analogous to that of the bones of a limb or fibres of a tree; an elastic tension and communication of force from part to part." As Ruskin develops his definition, he shifts the meaning of the word to the extent that rigidity becomes an important counter in his attempt to Protestantize the Gothic Revival. How he does this is fascinating. Rigidity, he continues, reflects the habit of hard and rapid working in a cold climate and love of signs of cold. Hence, it reflects the worker's "strength of will and independence of character," his incipient Protestantism. In later years, when Ruskin turns against the rigidity and "obstinacy" of Protestantism as too cold and narrow and comes to see the possibility of a new man not bound by the Protestant ethic, he can still use the term "rigid" to denote active "energy." With rigidity as with purity, Ruskin's conflict of meaning is fought out within the confines of a single term. He seems to assume that the tension will disappear if he does not name the conflicting parties. For him, words are not signs but idols holding the keys to the gate of reality.[43]

The element of "redundancy" is less subtle than that of rigidity. It reveals itself in a generous accumulation of ornament which "disguises the failure of the feeble, and wins the regard of the inatten-

tive." Like the roughness of Gothic, it testifies to a humility which "admits the aid, and appeals to the admiration, of the rudest as well as the most refined minds." The Gothic style's abundance of decoration expresses other values close to Ruskin's thought and to the Romantic tradition: enthusiastic striving after an ideal, unselfish sacrifice, and sympathy with the abundant wealth of nature. The opposite of this humble, redundant Gothic is the "haughty" simplicity of Renaissance architecture which "implies, in offering so little to our regards, that all it has offered is perfect."[44]

Ruskin's hostility to Renaissance "perfection" forms an underground current in his discussion of the mental elements of Gothic. In the final volume of *The Stones of Venice,* the "foul torrent" flows into the open and encompasses *The Fall* of Venice. Ruskin's critique of the Renaissance draws on a long tradition of Romantic animosity. What classicism is to Blake, Jacobinism to Burke, and mechanism to Coleridge, Wordsworth, and Carlyle, the Renaissance is to Ruskin. The chief error of the Renaissance is its "pride of science"—its "unwholesome demand for perfection, at any cost." It means for the ordinary workman the end of life and energy. Ruskin admits that Ghiberti and the leaders of the Renaissance were able to combine perfect execution with emotion, "finish with fire." Their followers, like Andrea del Sarto, saw only the finish or technique and pursued this at the expense of their humanity. The result is a mechanically imitative and polished art. It appeals to a cold, aristocratic taste and shows little sympathy for the happiness of Wordsworth's peasant or Ruskin's Gothic worker. A Romantic impulse also inspires Ruskin to attack the Renaissance's "pride of system"—its "pharisaical" adherence to "academical" formulas. In architecture, the chief culprit is the five orders of Vitruvius. Gothic denies legalistic pride. It is a human architecture of "vital practice," created with the delight of a child. Ruskin's rejection of the Renaissance's "pride of system" in *The Stones of Venice* might be construed in part as a renunciation of his own pride of system in *Modern Painters.*[45]

Ruskin's final and, by now, obvious criticism of the Renaissance is that it is anti-Christian. Its pride negates Gothic humility. Its luxury encourages sensuality. Ruskin devotes much of *The Stones of Venice* to demonstrating how paganism encroached on Christian faith during the Renaissance. As Francis Townsend has remarked, the religious element in Ruskin's critique owes much to his study of the French author Alexis Rio's *De la poésie chrétienne* (1836). A supporter of

the Catholic Revival, Rio follows Chateaubriand in holding the religion of a society responsible for the quality of its art. To prove that the paganism of the Renaissance debased art, he ranks primitive painters like Giotto above Raphael, whom he accuses of a barren display of knowledge and technique. Ruskin's aversion to the Renaissance resembles Rio's. In the second volume of *Modern Painters* and in *The Stones of Venice,* he shows a new respect for the Italian primitives and deplores the effect of Renaissance learning on the religious idealism of Raphael and Michelangelo. Even in Ruskin's analysis of Gothic, Rio's influence can be seen. According to Rio, the rudest works of early Christianity are valuable because they express the emotions and faith of common people. The Christian end or conception justifies any inferiority of execution. The step from here to "The Nature of Gothic" is not a long one.[46]

Ruskin's view of Renaissance and neoclassical art takes on a further dimension when placed beside William Biake's earlier criticism. Like Ruskin, Blake condemns the Renaissance for relying on rules and for confusing science with art. He, too, prefers Gothic and is one of the precursors of the Gothic Revival. He praises its variety and exuberant grotesqueness and contrasts the "Living Form" of Gothic with the dead symmetry and "Mathematic Form" of neoclassical architecture. Blake, however, disagrees with Ruskin on one crucial point. He cannot consider vagueness or rudeness of finish to be qualities of good art. He condemns Turner for exhibiting these qualities in an extreme form and sees in Gothic a clarity and sharpness of outline. Blake refuses to admit any split between conception and execution in the creative process. "Mechanical Excellence is the Only Vehicle of Genius." In a passage which could have been written for Ruskin's benefit, he declares:

I have heard many People say, "Give me the Ideas. It is no matter what Words you put them into," & others say, "Give me the Design, it is no matter for the Execution." These People know Enough of Artifice, but Nothing of Art. Ideas cannot be Given but in their minutely Appropriate Words, nor Can a Design be made without its minutely Appropriate Execution.

Blake opposes those like Ruskin who wish, through roughness of execution, to "leave something to the imagination." He sees in Burke's distinction between conception and execution the aesthetic reflection of Locke's "false" theory of knowledge with its separation of subject and object. Subject and object, conception and execution, should be unified in the creative act. Although Blake is neither

entirely fair to Burke nor a pure example of Romanticism himself, his remarks cast an interesting light on Ruskin's appreciation of the roughness of Gothic. They confirm the suggestion that Ruskin and Wordsworth are closer to eighteenth-century aesthetic theory than the distinction between Romantic and classic implies.[47]

7

The Stones of Venice presents a tightly framed case against a straw Renaissance. The real case is to come. In "The Nature of Gothic," Ruskin makes the connection between the classical or Renaissance periods and nineteenth-century England in their effect on *"the life of the workman."* He carries his drive to humanity into the present. After describing the "servile ornament" of Greek architecture, Ruskin writes, "But the modern English mind has this much in common with the Greek, that it intensely desires, in all things, the utmost completion or perfection." This search for precision makes of man an "animated tool." It smothers his soul, "blights and hews into rotting pollards the suckling branches of his human intelligence, and makes his flesh and skin . . . into leather thongs to yoke machinery with. . . ." Ruskin urges his contemporaries "not to esteem smooth minuteness above shattered majesty." Work, like art, is an expression of personality. It depends for its value not on perfect finish or "mechanism" but on "the quantity of humanity that has been put into it":

Now, in the make and nature of every man, however rude or simple . . . there are some powers for better things, some tardy imagination, torpid capacity of emotion, tottering steps of thought. . . . And this is what we have to do with all our labourers; to look for the *thoughtful* part of them, and get that out of them . . . whatever faults and errors we are obliged to take with it. (10.191)

How far Ruskin's early emphasis on the "ideas" in a painting has developed, and how easily his circular vision of the relation of art and society shears off into contemporary social criticism! Here the identification of art and life or art and work implicit in Ruskin's definitions of purity and vital beauty bears practical fruit.[48]

Extreme division of labor is one of the more serious results of the English desire for a mechanical and superficial perfection. In a famous passage, Ruskin writes,

It is not, truly speaking, the labour that is divided; but the men:—Divided into mere segments of men—broken into small fragments and crumbs of life. . . . (10.196)

What the mechanical "reasoning power" of the scientist does to the wholeness of nature, industrial machinery does to man himself. The most dangerous manifestation of this is the division between hand-labor and mind-labor:

> We are always in these days endeavouring to separate the two; we want one man to be always thinking, and another to be always working, and we call one a gentleman, and the other an operative; whereas the workman ought often to be thinking, and the thinker often to be working, and both should be gentlemen, in the best sense. As it is . . . the mass of society is made up of morbid thinkers, and miserable workers. . . . There should not . . . be a trenchant distinction of employment, as between idle and working men, or between men of liberal and illiberal professions. All professions should be liberal. . . . (10.201)

This theme returns in Ruskin's later writings. It inspires the road-making experiment at Hincksey. His demand that all professions be "liberal" foreshadows his attempt to make commerce a gentleman's profession in *Unto This Last.*

Writing soon after the revolution of 1848, Ruskin insists that the "universal outcry" against nobility and wealth springs from the division between mind-work and hand-work and the degradation of the laborer into a machine:

> It is not that men are ill-fed, but that they have no pleasure in the work by which they make their bread . . . they feel that the kind of labour to which they are condemned . . . makes them less than men. (10.194)

Against the specialization of labor, Ruskin holds up the ideal of the Gothic worker whose "happiness" reveals the "humanity" of his work. Behind him stands the creative artist whose painting demands a unified "energy" of body and soul, mind and hand.

Ruskin's vision of the dehumanization of the worker in industrial society is not original. Blake's later poetry is filled with images of mills and furnaces, symbolizing the mechanical philosophy of New-ton and Locke and the destruction of life by real machines. Blake fears that industrialism will "turn that which is Soul and Life into a Mill or Machine" and the "Arts of Life" into the "Arts of Death." "A Machine is not a Man nor a Work of Art," he writes in 1810, anticipating the decay of his engraver's craft. Even the radicals Mary Wollstonecraft, William Godwin, and Thomas Paine, who exalt the "reason" which Blake believes to be the cause of mechanization, lament the effects of the new industry. In his novel *Fleetwood* (1805), Godwin describes the monotony of machine labor in terms reminiscent of Blake's "bones and sinews, all strings and bobbins"

and of Ruskin's "leather thongs to yoke machinery with." "A mechanic," Godwin writes, "becomes a sort of machine; his limbs and articulations are converted, as it were, into wood and wires." In a remarkable demonstration of the blurring of traditions on this point, Coleridge deplores the fact that workers are "mechanized into engines" and treated "like lifeless tools." Carlyle insists that man is not "a mere Work-Machine," and Dickens, in a speech at Liverpool in 1840, regrets that laborers are "permitted to degenerate into machines themselves." Stephen Blackpool tells Bounderby in *Hard Times* (1854) that the cause of the workers' discontent is not material but psychological: ". . . reg'latin 'em as if they was figures in a soom, or machines: wi'out loves and likens, wi'out memories and inclinations, wi'out souls to weary and souls to hope. . . ."[49]

E. P. Thompson, in his pioneering study, *The Making of the English Working Class,* suggests that Stephen is right. During the hard years after the Napoleonic Wars, the workers' most frequent complaint was not low wages but the quality of their life—the fact that they were made to work as "a sort of machine." The workers did not misinterpret the motives of some of their employers. Dr. Andrew Ure (1778-1857), a well-known defender of the new industry, urges the mill-owner to "organize his moral machinery on equally sound principles with his mechanical." He praises Arkwright for training men "to identify themselves with the unvarying regularity of the complex automaton." Even the enlightened manufacturer Josiah Wedgwood attempted to "make such machines of the men as cannot err."[50]

Ruskin's specific attack on the division of labor also lacks originality. Robert Owen, Charles Hall (c. 1745-1825), William Thompson (1785-1833), and the Christian Socialist John M. Ludlow each deplore the "torpor" or "vacuity" caused by specialization. To provide variety in work, they urge the integration of physical and mental labor and the joining of agriculture and industry. Hall and Thompson point to Adam Smith as the first to diagnose the effects of the division of labor. In temperate language, Smith makes the same point as Ruskin many years later:

In the progress of the division of labour, the employment . . . of the great body of the people comes to be confined to a few very simple operations. . . . The man whose whole life is spent in performing a few simple operations, of which the effects are perhaps always the same, has no occasion to exert his understanding or to exercise his invention. . . . The torpor of his mind renders him not only incapable of relishing or bearing a part in any rational conversation, but of conceiving any generous, noble, or tender sentiment. . . .

Smith attributes the superiority of the agricultural laborer to the healthy conditions and variety of his work. To remedy "Mental mutilation," he proposes a national system of education.[51]

As Karl Marx happily points out, Smith was not alone in his vision of the dangers of the division of labor. At the same time, Adam Ferguson was making the "separation of arts and professions" one of the keys to his *Essay on the History of Civil Society* (1766). While aware that the "separation of callings" lies behind modern progress, he warns of its tendency to stifle human capabilities and to "dismember the human character." The division between "liberal" and "mechanical" professions destroys the "virtuosity" of the lower classes. "It may even be doubted," he writes,

whether the measure of national capacity increases with the advancement of the arts. Many mechanical arts . . . succeed best under a total suppression of sentiments and reason. . . . Reflection and fancy are subject to err; but a habit of moving the hand or the foot, is independent of either. Manufacturers, accordingly, prosper most, where the mind is least consulted, and where the workshop may . . . be considered as an engine, the parts of which are men. (p. 280)

Ferguson's fellow Scot John Millar also complains that industrial workers are becoming "like machines" and are characterized by "an habitual vacancy of thought." Like Ruskin, he sees these "degraded" workers as a dangerously volatile element in the social structure. At the end of the century, Dugald Stewart summarizes the views of the earlier Scottish philosophers. He fears the creation of a class of "living automatons" and urges education.[52]

Of the Scottish writers, Ruskin had read Stewart and Smith, although his thorough study of *The Wealth of Nations* did not occur until later. It is possible, however, that Ruskin came upon the ideas of the Scotsmen refracted through the German Romantics and Carlyle. The surprising impact which the views of Smith and especially Ferguson had upon Humboldt, Fichte, Schiller, and Goethe in the years after 1792 has been revealed by Roy Pascal. While the Scottish thinkers point out the dangers of specialization in passing and are disturbed by its effect on social stability, the Germans take the problem more seriously. They fear that specialization will destroy the quality of personal life and cause a separation of human powers or *Kräfte.* Indeed, the German concept of *Bildung* was fashioned in response to a new awareness of the one-sidedness or *Einseitigkeit* which specialization brings in its train. Like the Germans, Ruskin is chiefly concerned with the effects of the division of labor on the individual. The difference is that Ruskin studies the condition of the

ordinary worker, while the Germans focus on the professional man or man of culture.[53]

Before leaving the division of labor, one is tempted to relate Ruskin to three of his contemporaries: Karl Marx, Friedrich Engels, and John Stuart Mill. Marx regards the division of labor as one source of the worker's alienation from the product of his work. Although, for Marx and Engels, the concept has many more theoretical overtones than it does for Ruskin, their descriptions of the phenomenon are similar. In his *Anti-Dühring* (1878), Engels echoes Ruskin: "In the division of labor, man is also divided. All other physical and mental faculties are sacrificed to the development of one single activity." Marx, too, declares in 1875 that the "enslaving subordination" of the "detail worker" contradicts the "integral development of the individual." Under conditions which divorce physical from mental labor, the worker becomes a "mere machine . . . broken in body and brutalized in mind." As the division of labor becomes more intense, devices are introduced which "mutilate the worker into a fragment of a human being." The similarity of Marx's rhetoric to Ruskin's is remarkable. More remarkable to one familiar with Ruskin's diatribes against Mill is the following passage from *On Liberty* (1859):

Supposing it were possible to get houses built, corn grown, battles fought . . . by machinery—by automatons in human form—it would be a considerable loss to exchange for these automatons even the men and women who at present inhabit the more civilized parts of the world. . . . Human nature is not a machine to be built after a model, and set to do exactly the work prescribed for it, but a tree, which requires to grow and develop itself on all sides. . . . (p. 73)

Although no mention is made of the division of labor, this passage would not be out of place in "The Nature of Gothic." It is striking evidence of the diffusion of Romanticism, a diffusion in which Marx shared through his reinterpretation of Hegel.[54]

If Ruskin's diagnosis of the division of labor is not original, his solution to the problem of *"the life of the workman"* is. The problem can be solved by a strict consumer ethic—"by a determined sacrifice of such beauty or cheapness as is to be got only by the degradation of the workman; and by equally determined demand for the products of healthy and ennobling labour." Here Ruskin begins that concern with the quality of consumption which makes much of his later writing a prolonged effort at consumer education and which gives to his best social criticism a sharp edge of contemporary rele-

vance. He lays down three rules for consumers to follow:

1. Never encourage the manufacture of any article not absolutely necessary, in the production of which Invention has no share.
2. Never demand an exact finish for its own sake, but only for some practical or noble end.
3. Never encourage imitation or copying of any kind, except for the sake of preserving records of great works. (10.196-197)

Every young lady who ignores these rules and buys glass beads is encouraging slavery.

Ruskin's mention of finish and invention in his consumer "guide-lines" reveals the close connection between his art and social criticism. What he has earlier demanded of the art-purchasing public, he now demands of the purchasing public in general. The criteria of good, creative work remain constant, whether applied to Turner or the lowest builder. Ruskin's critique of machinery and the division of labor follows this pattern. It is rooted in his view of Gothic and Renaissance architecture and in his organic approach. What is new about the machinery of the industrial revolution is only its size and potentiality for destruction. It is not an apocalyptically new thing, but an extension of the faulty modes of perception and dangerous attitudes of pride characteristic of all periods of bad art. Neither machinery nor consumption is a stick picked up hastily by Ruskin for use against the orthodox economists in *Unto This Last* and *Munera Pulveris.*

In conclusion, there is one aspect of "The Nature of Gothic" which students of the Victorian period overlook. The chapter is a liberal tract. Every one of the "mental elements" of Gothic admired by Ruskin reveals the ordinary worker's freedom of expression. More-over, his critique of the division of labor focuses, not on the exploitation of the worker by an unjust ruling class, but on the enslavement of the worker by machine production and by consumers' demands for "perfection." Ruskin's emphasis on machinery and the consumer allows him to avoid the sort of radical critique of the owning classes which he later undertakes. At the same time, it prevents him from falling into the familiar pattern of demanding an end to injustice at the expense of liberty. "The Nature of Gothic" marks the zenith of Ruskin's liberal concern. In his later social criticism, the demands of justice far outweigh the demands of liberty, and a most "illiberal" Ruskin takes the place of the author of "The Nature of Gothic." Ruskin's early liberalism can be exaggerated. His choice of a

Gothic setting renders his plea ambiguous. As Ruskin recognizes, the Gothic worker lived in a hierarchical society and was "allowed" freedom by the master-builder on condition that he confine his creativity to ornament and not disrupt the larger plan with its dutiful subordination of parts. Gothic architecture embodies "The Lamp of Obedience" as well as "The Lamp of Life." In "The Nature of Gothic," the dynamic implications of Ruskin's thought only partially break through his organicism of the surface.

8

Before leaving *The Stones of Venice,* one should grasp the personal dimension of Ruskin's view of Gothic and critique of the nineteenth century. There is a strange similarity between the mental characteristics of Gothic and Ruskin's own. Changefulness or "disquietude," redundance, roughness, and even a certain rigidity of structure are to be found in Ruskin's work. Roughness is the most obvious quality. Ruskin cannot work in a precise, "scientific" fashion. He makes many "small errors" but believes he is "entirely right" on the "main points." In other words, the idea is noble, but the execution lags behind as in a living architecture. When one recognizes Ruskin's inability to put a smooth finish on his writings, a failing he shares with Coleridge, Carlyle, and other Romantics, his criticism of machinery for making man "precise and perfect" takes on a new dimension. "If you will make a man of the working creature, you cannot make him a tool." Ruskin's view of creative work is partly a rationalization of his own manner of thinking and writing. Similarly, his criticism of the Renaissance's "pride of science" is an attempt to compensate for the inferiority he feels vis-à-vis specialists in the fields in which he is at best a brilliant amateur—geology, botany, history, philology, and economics.[55]

A second example of the part rationalization plays in Ruskin's writing is his "happiness of the worker" criterion. As his American friend Charles Eliot Norton wrote, "the deepest currents of his life . . . did not run calmly and their troubled course became manifest in extravagances of action and paradoxes of opinion." Although exaggerating the influence of Ruskin's psychological difficulties on his writing, R. H. Wilenski has shown, in a book which remains one of the most exciting on Ruskin, that his mental life was characterized by a cyclical pattern of hyperconfidence and morbid depression. In times of severe depression, he could not concentrate on the work at

hand. He could not do "good work." When he was writing *The Seven Lamps* and *The Stones of Venice,* he was in good spirits. *The Stones of Venice* took shape in Venice where Ruskin could do as much architectural drawing and research as he desired. He was happy, was enjoying his work, and was doing good work since he was preserving for posterity a record of architecture which seemed doomed to destruction. Ruskin could not feel happy for long without pangs of conscience. His letters in the early 1850's reveal a new awareness of the condition of the poor. The result, it may be argued, was the "happiness of the worker" criterion by which Ruskin justified his own happiness by universalizing it and demanding it as a condition of all "serviceable" work.[56]

What is one to make of this personal dimension of Ruskin's writing? At times, it leads him into unbelievable pettiness, as in his later assaults on Mill. On the whole, it does not detract from his efforts. It gives his criticisms an integrity of feeling, an existential edge, which they would otherwise lack. The reader feels that Ruskin, with his blocked paths and intuitive brilliance, is there on the page. There is no game of hide and seek, no pretense. This quality will become evident in the next chapter where Ruskin's growing doubts concerning the usefulness of art and nature study are discussed, doubts which lead him in the late 1850's to return to the social criticism of "The Nature of Gothic" and to pursue further the implications of his sociological aesthetic. The disintegration of Ruskin's circular vision of the relation of art and society is not simply an intellectual process.

III Broken Circle

"The Nature of Gothic" marks a high point in Ruskin's social concern of the fifties. He now returns to *Modern Painters,* which his father has been urging him to finish, while social criticism leads a shadow existence in his writings and lectures. The last three volumes of *Modern Painters* (1856-1860) are the record of Ruskin's struggle with himself over his usefulness as an art critic. He is aware that his ideas about the social order can no longer be borne on the slender thread of art criticism. He must find a more effective medium.

In the final volumes of *Modern Painters,* Ruskin's view of art as a social product is reinforced by new themes. They are, first, an emphasis on man as the subject of works of art; second, a revised ideal of truth as requiring a perception of the good *and* evil in nature; and, third, a new assessment of man himself as a creature with great potential for dignity. In other words, Ruskin's interest in the human dimension of art is combined with a new view of man's position in relation to nature. In the early volumes, man is overshadowed by the glories of nature. When Ruskin does allow man to enter his pages, it is often to point in Evangelical fashion to his degradation. In the later volumes, Ruskin takes an ambivalent view of both nature and man. Nature is seen to contain darkness as well as light, and man to contain great powers for good as well as for evil. Man, in fact, supplants nature as the highest manifestation of Deity. This development coincides with an awareness of social conditions which pervert man's divinity and more frequent and finally incapacitating doubts about the utility of art work and art criticism. The digressions on social questions become uncontrollable. By 1860, Ruskin is a social critic.

This interpretation is not original. It owes much to the researches of Francis Townsend and John Rosenberg. The most this chapter can attain is a quality of "vital imitation" by fashioning their suggestions into a briefer and more coherent picture of Ruskin's development in the fifties. The details are similar; the perspective is different. An attempt is made to view Ruskin's changes in the period as intellectual and emotional adjustments to the inner logic of his thought. This is

not to say that the adjustments are unimportant or inevitable. Without them, Ruskin's path to social criticism might have been permanently blocked. It is only to suggest that they are not the chief reason for Ruskin's interest in social problems. They are enabling, not determining, factors. The path to Ruskin's later work does not begin with the configuration of changes described in this chapter. It starts in a deeper "drive to humanity" which shapes his art criticism and organic approach and gives rise to the awkward circle of his sociological aesthetic.[1]

<div align="center">2</div>

Ruskin's view of art as an expression of the artist's life and personality prevails in the later volumes of *Modern Painters.* "Great art," he writes in volume three, "is produced by men who feel acutely and nobly; and it is in some sort an expression of this personal feeling." Ruskin now defines "greatness of style" in terms of qualities which exercise all powers of the human soul. Style is more than technique, or, better, technique itself is an exponent of personality. It reflects the health, sensitivity, discipline, and "purity" of the artist and should not be confused with a mechanical finish or polish. Style cannot be taught: "It is pre-eminently and finally the expression of the spirits of great men." In a chapter entitled "The Use of Pictures," Ruskin explains the superiority of a painting to a window with a view. Unlike a window, a painting ennobles the beholder because it is the "expression of the power and intelligence of a companionable human soul." This marks a change from the early volumes of *Modern Painters* where art is the treasured record of God's spirit in nature.[2]

Ruskin's new attitude colors his art criticism. He seldom discusses the content of paintings but goes immediately and sometimes unfairly to the personal characteristics revealed by an artist's work. Claude, for example, is sincere but lacks earnestness, humility, and masculinity. Rubens is "an entirely well-intentioned man, earnestly industrious . . . high-bred, learned and discreet . . . a healthy, worthy, kind-hearted, courtly-phrased—Animal—without any clearly perceptible traces of a soul." Indeed, all Dutch painters are insensitive and vulgar. In volume five, Ruskin applies this form of criticism to Turner. Earlier, Turner had been a high priest of nature, a "preacher" praising the glory of God's work and revealing His attributes. Now he is a man with faults and virtues, achieving greatness in spite of ob-

stacles and expressing his own mixed nature in his painting. Ruskin
dwells on these obstacles in an interesting chapter entitled "The Two
Boyhoods," a comparison of Giorgione's upbringing in Venice with
Turner's in the slums of London. Turner would have been greater if
his social environment had been more "healthful" or "helpful."[3]

<div align="center">3</div>

Ruskin's interest in human life and personality inspires a change in
his view of the sources of beauty and the proper subject of art. In the
first two volumes of *Modern Painters,* Ruskin places beauty in Hea-
ven and searches nature for "types" or emblems of a higher reality.
The artist's task is the representation of typical beauty in landscape.
Although in the second volume he discovers the Venetians and
admires their painting of the human figure, nature holds first place.
Now, after his study of architecture, an art devoted to man's use and
reflecting man's history, Ruskin shows greater interest in the human
sources of beauty. In volume five, for example, he declares that "all
true landscape . . . depends primarily for its interest on connection
with humanity" and on "subjection to the human soul." "Man is the
sun of the world; more than the real sun." Only by sympathizing
with the spirit of man in nature can the landscape painter become
something better than a "scientific mechanist." Turner does this,
especially in his later period. He paints landscape not for its own
beauty but for its expression of "human power, desolation, or soft
pensiveness." He sees in nature types of human as well as divine
existence.[4]

Ruskin admits to an apparent inconsistency. He repeats the view
that "all great art is the expression of man's delight in God's work,
not in *his own.*" "But observe," Ruskin continues, "he [man] is not
himself his own work: he is himself precisely the most wonderful
piece of God's workmanship extant. In this best piece . . . he is
bound to take delight. . . ." Man, not nature, is the highest manifesta-
tion of God. "That flesh-bound volume is the only revelation that is,
that was, or that can be. In that . . . is the promise of God revealed."[5]

Since man is "the soul of things," it will follow, Ruskin writes, that
"all his best work must have something to tell about himself." He
believes that the distinctive character of his own writings is "their
bringing everything to root in human passion or human hope." They
have been shaped throughout, "even warped and broken, by digres-
sions respecting social questions, which had for me an interest ten-

fold greater than the work I have been forced into undertaking." This is true of the later volumes of *Modern Painters* but not of the early volumes. There the "aspect" of nature rules. Ruskin's remarks suggest that, in the fifties, he has become fully conscious of the drive to humanity which gives *The Seven Lamps* and *The Stones of Venice* their inner dynamism and which induces him to judge architecture by its "influence on the life of the workman." In these books and in the final volumes of *Modern Painters,* he does indeed bring everything to root in human passion.[6]

If art has reference to man, it must be "under a true conception of his nature." Ruskin's view of man has changed since he wrote the following passage in volume two of *Modern Painters:*

No longer among the individuals of the race is there equality or likeness . . . but evil diversity, and terrible stamp of various degradation: features seamed by sickness, dimmed by sensuality, convulsed by passion . . . branded with remorse: bodies consumed with sloth . . . dishonoured in foul uses; intellects without power, hearts without hope, minds earthly and devilish; our bones full of the sin of our youth, the heaven revealing our iniquity, the earth rising up against us, the roots dried up beneath, and the branch cut off above. . . . (4.176-177)

Fourteen years later, in volume five, Ruskin declares that human nature is "nobly animal, nobly spiritual. . . . All great art confesses and worships both." A change in artistic preference follows his "true conception" of man's nobility. Ruskin revises the opinion of Fra Angelico and Giotto expressed in volume two. Now he criticizes the "purist religious schools" for denying man's animal nature. As the purists fall, the Venetian painters rise, for they admire the divine "purity" of man's sensual passion and abundant physical life. They recognize that man is both a spiritual being and a "perfect animal." Here Ruskin makes explicit the positive view of human dignity implicit in "The Nature of Gothic." The impulse which led him to dwell on the fortunate consequences of man's fallen state now inspires him to question the Fall itself.[7]

4

Ruskin's new vision of man is accompanied, first, by a less enthusiastic vision of nature and, second, by a painful awareness of conditions which degrade man. In both cases, the criterion is truth. By truth, Ruskin no longer means the faithful portrayal of an unblemished nature, but the opening of one's eyes to the darkness and evil as well as the good.

Ruskin arrives at this more sophisticated position gradually. In an unpublished version of volume two of *Modern Painters,* he urges man to gain insight into the "great perpetual operations of death and pain" in the universe. However, this note does not prevail until the fourth volume. In *The Stones of Venice,* he stresses the need for *real* truth only in a general way by suggesting that art requires a sense of "largeness," an imaginative grasping of the ugly as well as the beautiful, God's wrath as well as his beneficence. He insists that nothing in nature is irredeemably evil if one could "see far enough into its uses," but there is a change of tone. There is an interest in the grotesque and in aspects of nature which inspire fear and awe.[8]

Volume three of *Modern Painters* continues this theme as Ruskin condemns those who sacrifice truth to beauty. Truth is the more important. Great art, fulfilling the "Naturalist Ideal," does not deny "the facts of decrepitude." It accepts nature as she is and relies on the imagination to forge her weaknesses into a noble whole. As in a Gothic cathedral, "the imperfection of each several part is not only harmless, but absolutely essential." The "False Ideal" omits or alters all that is disagreeable. It abuses the imagination, using it to escape from the painful present to a realm of "decorative lies." Even the "Purist Ideal" of religious art fails to grasp the harder realities, for it allows no expression of evil and sorrow. Ruskin regrets, in a Carlylean vein, the energy wasted by artists and authors in pursuit of "senseless fiction" and "discontented dreams" instead of "sifted truth" and "real human histories of the people round us." He also condemns the "pathetic fallacy," in which intense emotion distorts true perception. The imagination for Ruskin, as for Coleridge, is not an escapist faculty but "the most accurate and truth-telling faculty, which the mind possesses." The truths of science and political economy are truths of "the husk and surface, hard and shallow," compared to the truth of the imagination. The question of credentials will not concern Ruskin when he studies economics.[9]

In volume four, Ruskin turns specifically to nature in search of *real* truth. Mountains are no longer, without exception, the cathedrals of God. Parts of them are "very nearly types of all that is most painful to the human mind":

Vast wastes of mountain ground . . . breaking continually into black banks of shattered slate, all glistening and sodden with slow tricklings of clogged, incapable streams; the snow water oozing through them in a cold sweat, and spreading itself in creeping stains among their dust; ever and anon a shaking here and there, and a handful or two of their particles or flakes trembling down . . .

leaving a few jagged teeth, like the edges of knives eaten away by vinegar . . . and soon sinking again into the smooth, slippery, glutinous heap, looking like a beach of black scales of dead fish, cast ashore from a poisonous sea. (6.158-159)

"I know no other scenes," he adds, "so appalling as these in storm or so woeful in sunshine."

In a chapter aptly entitled "The Mountain Gloom," Ruskin goes beyond noting "conditions of ugliness and disorder" in mountain scenery. He finds a sense of radical evil and destructive power in the mountains. He describes the Swiss town of Sion in the Valais as follows:

It is in the midst of a marshy valley, pregnant with various disease; the water either stagnant, or disgorged in wild torrents charged with earth; the air, in the morning, stagnant also, hot, close, and infected; . . . while less traceable plagues than any of these bring on the inhabitants . . . violent affections of goitre, and often in infancy, cretinism. (6.411)

Ruskin warns his readers against the temptation to "pass by on the other side" shunning the manifestations of "God's wrath."[10]

Ruskin's dual vision of nature appears more consistently in the fifth volume. Here he criticizes the "purist" schools for ignoring death and decay or considering them simply as "momentary accidents." There are two sides to things, and God "intended us to see both." He refutes a Scottish clergyman who had described an idyllic scene in the Highlands to show the goodness of God. In Ruskin's Highlands, John Rosenberg notes, Darwin's nature, not Wordsworth's, has been at work. There is "the carcass of a ewe, drowned in the last flood . . . its white ribs protruding through the skin raventorn." As Ruskin's view of nature changes, so does his view of Turner's greatness. Once the high priest of a perfect nature, Turner is now the faithful portrayer of dying trees and polluted streams.[11]

Ruskin's pessimism reflects an important change in his personal response to natural beauty. As early as 1847, Ruskin shows signs of losing his intense feel for landscape. He is aware of this loss and notes the similarity to Wordsworth's position years earlier. In letters to friends, he complains that he has ceased to feel pleasure in nature. He speaks of the Lake District as a "rubbishy place" and of volume one of *Modern Painters* as "my rubbishy book." Worst of all, he has "lost delight in the Alps." Ruskin is in a depressed condition in this period preceding his marriage and, in later years, can produce descriptions of nature worthy of his first efforts. Still, he has lost something. He can no longer rely on natural beauty to soothe his mind. Signifi-

cantly, the year 1847 is the year Ruskin first becomes preoccupied with social problems—a preoccupation which bears fruit in his discussion of employment in "The Lamp of Obedience."[12]

Ruskin's tempered response to nature coincides with a serious change in his religious attitudes. He finds less to enjoy in the book of nature because God Himself has withdrawn into obscurity. Ruskin's attitude resembles Carlyle's in *Past and Present.* His positive view of man owes much to the shadows clouding God's perfection. So does his appreciation of a rude, "human" architecture and his emphasis on the worker's creative self-expression in *The Stones of Venice.* As God's attributes become less obvious, it is logical that Ruskin should view art more as an expression of "felicitous fulfilment" in man than as a revelation of divine "types."[13]

The evidence for Ruskin's loss of his early faith has been much discussed by biographers. The crucial years are those between 1851 and 1853. On Easter Sunday, 1852, Ruskin describes his dilemma: "No scientific difficulty can ever be cast in my teeth greater than at this moment I feel the geological difficulty: no moral difficulty greater than . . . prophecies so obscure that they may mean *any*-thing. . . ." Scientific discoveries and Biblical criticism make the demands which Ruskin's Evangelical faith places on the Bible seem extravagant. His religious doubts, not to mention his interest in Roman Catholic art, create tension in his relationship with his parents. Neither his loss of faith, his delight in the sensuality of the Venetians, nor his tendency to "digress" from his God-appointed art work into social criticism pleases his parents. Indeed, the changes which Ruskin's attitudes toward nature, God, and man undergo in the late forties and early fifties constitute a belated rebellion against his parents' domination, a rebellion temporarily thwarted in 1852 when Ruskin's father refused to send to the *Times* his son's first efforts at social criticism.[14]

<center>5</center>

Finding less to admire in nature and more in man, Ruskin reacts to conditions which destroy man's vital beauty. Ruskin seldom mentions human distress in his early writings. In the late fifties, his social awareness develops a sharp edge which cuts through the manifest content of *Modern Painters.* As in the case of nature so now in the case of the human condition, he demands to see things as they really are, good and evil.

Again, "The Mountain Gloom" in volume four occupies a crucial position. Gloom describes not only the mountains themselves but also the lives of the peasants who live among them. Ruskin deplores the idealization of peasant life on the stages of London. Real peasant villages are "foul with that gloomy foulness that is suffered only by torpor," and the peasant's cottage is a "plague-like stain in the midst of the gentle landscape." There is no knowledge or love of beauty, no hope or passion, but only a "horrible apathy" and "settled obscurity in the soul." Turning abruptly to England, Ruskin notes the case of a rich man who has "devoted the powers of his soul, and body . . . to the spoiling of houses . . . and the oppression of the poor." Human suffering exists in the world, and men must choose between the good and the evil.[15]

This theme gathers strength in the fifth volume. Ruskin condemns "purist religious schools" for ignoring human suffering in the belief that what appears evil "must eventually issue in a far greater and enduring good." Ruskin's picturesque Highlands contain people as well as dead ewes. The people are starving. The lesson he draws from the shadows in life is that one must "stoop to the horror" and let natural beauty, for the present, take care of itself. Ruskin proceeds to rank artists in a different fashion. His criterion is the artist's ability to "gaze without shrinking into darkness" and conquer it. Venetian art stands at the pinnacle, for it struggles courageously with human sin and death and emerges victorious. In the lowest rank are the neoclassicists Claude and Poussin, who escape a sense of spiritual destitution by portraying a "perfect worldly felicity."[16]

Turner remains the greatest painter. Indeed, a most intriguing study of Ruskin's art criticism could be entitled "The Many Faces of J. M. W. Turner." Now Turner's power springs from his sincerity in portraying the truth of human sorrow. From his boyhood in the slums near Covent Garden, Turner became well acquainted with dirt, poverty, and vice in a way which had a secret attraction for Ruskin whose own boyhood was so sheltered and "purist." Unlike Giorgione, living in "a golden city, paved with emerald," Turner can see only the "meanness, aimlessness, unsightliness" of a tragically flawed humanity.[17] To find beauty, Turner looks to nature. But he does not shrink from painting the toil and death of men, "the great human truth visible to him," especially the death:

The English death—the European death of the nineteenth century—was of another range and power; more terrible a thousand-fold in its merely physical grasp

and grief; more terrible, incalculably, in its mystery and shame. What were the robber's casual pang, or the range of the flying skirmish, compared to the work of the axe, and the sword, and the famine, which was done during this man's youth on all the hills and plains of the Christian earth, from Moscow to Gibraltar?

 ... Not alone those blood-stains on the Alpine snow, and the blue of the Lombard Plain. The English death was before his eyes also. No decent, calculable, consoled dying. . . . But the life trampled out in the slime of the street, crushed to dust amidst the roaring of the wheel. . . . Or, worst of all, rotted down to forgotten graves through years of ignorant patience, and vain seeking for help from man, for hope in God—infirm, imperfect yearning, as of motherless infants starving at the dawn; oppressed royalties of captive thought, vague ague-fits of bleak, amazed despair.

 A goodly landscape this, for the lad to paint, and under a goodly light . . . strewn bright with human ashes . . . all blinding-white with death from pole to pole . . . death, not once inflicted on the flesh, but daily fastening on the spirit; death, not silent or patient, waiting his appointed hour, but voiceful, venomous; death with the taunting word, and burning grasp, and infixed sting. (7.386-388)

Little wonder that Ruskin can no longer immerse himself in the joy of "theoretic" contemplation. He is aware that the possibility of this joy depends on the social environment.

<div align="center">6</div>

 As nature deteriorates and man's condition calls for attention, Ruskin's doubts about the value of art and nature study become more explicit. When he urges the reader "to stoop to the horror, and let the sky, for the present, take care of its own clouds," he is addressing himself. His doubts concern his own vocation. In volume three, they take the form of an increasing lack of patience with bad art and a conviction that most artists would be better employed in work of practical charity. Ruskin criticizes the "false idealist" for taking pleasure "in fanciful portraits of rural or romantic life . . . without the smallest effort to rescue the living rural population of the world from its ignorance or misery." He also condemns metaphysicians for "entangling *good* and *active* people." He makes significant exceptions of Carlyle and Plato—thinkers with a "practical purpose."[18]

 Ruskin's sense of the "terrific call . . . of human misery for help" leads to a tortuous debate in his mind over the value of landscape art. He asks himself in volume three of *Modern Painters* whether landscape painting is not "an idle and empty business." The answer to this question engages him in what Francis Townsend describes as a study of the "landscape feeling." Ruskin believes that landscape

painting appeals to novel sensibilities in modern man. In previous ages, man cared chiefly for divinities or for himself and was interested in the natural world only insofar as it influenced him. Now, man has no positive idea of God or himself. Instead, he has a deep interest in wild, uncultivated nature. Ruskin's study of Venetian art makes him regret the modern tendency to view men "as ridiculous or ugly creatures." In several chapters of volume three, he sets out to determine whether this change from men to mountains is progress and whether his own attempt to use landscape art as "an instrument of soul culture" is justified.[19]

Ruskin begins his investigation by studying man's response to nature in the classical and medieval periods. The ancient Greek or the medieval Christian valued landscape for its evidence of man's work. There is no "pathetic fallacy" or substitution of love of nature for love of man. Ruskin turns to the modern landscape feeling, a "curious web of hesitating sentiment . . . and wandering fancy," and relates it to the "characteristics of the modern mind." Ruskin's study reveals more about himself than about his contemporaries. It is significant that he emphasizes characteristics on the Romantic side of the spectrum and relates love of nature to despondency, restlessness, loss of religious faith, and nostalgic admiration of the past. Ruskin implies that the nineteenth century's love of nature and picturesque Gothic ruins is a "romantic" attempt to escape from the monotony of modern life, manners, and architecture—from the "dullest modern principles of economy and utility." The idea first occurred to him in *The Stones of Venice.* Ruskin concludes his discussion on an uncertain note: "We find that landscape has been mostly disregarded by great men, or cast into a second place, until now; . . . and there seems great room for question still, whether our love of it is a permanent and healthy feeling, or only a healthy crisis in a generally diseased state of mind."[20]

Ruskin confronts this question in the next chapter, "The Moral of Landscape." He asks of the modern love of nature: "May we wisely boast of it, and unhesitatingly indulge it? or is it . . . a feeling which disinclines us to labour, and confuses us in thought; a joy only to the inactive and the visionary, incompatible with the duties of life. . . ." The author of *Modern Painters* finds considerable ground for the latter view and suggests that "our love of nature has been partly forced upon us by mistakes in our social economy." Glancing at the "starry crowd of benefactors to the human race," he notices that "dreaming love of natural beauty . . . has been more or less checked

by them all, and subordinated either to hard work or watching of *human* nature." Delight in nature is not an attribute of men of the highest mental power or purest moral principles. In them, it is sub-ordinated to "reason," "stern energy," and "breadth of humanity." The lovers of nature, who "see and feel without concluding or act-ing," occupy a middle position. They are superior to the "sordid and selfish who neither see nor feel" but inferior to the highest, "who lose sight in resolution, and feeling in work." Ruskin is discussing his own place in the world's scheme of useful action.[21]

Somewhat defensively, Ruskin goes on to consider what effect love of nature has on those minds to which it belongs. He is explicitly autobiographical and speaks of his landscape feeling as though it were a thing of the past. He notes that his love of nature decreased as he grew older, that it was "dependent on contrast with a very simple and unamused mode of general life," and that it was never indepen-dent of historical association. He defends its value: "It was, accord-ing to its strength, inconsistent with every evil feeling . . . but would associate itself deeply with every just and noble sorrow, joy, or affection." He admits, however, that,

as it only acted by setting one impulse against another, though it had much power in moulding the character, it had hardly any in strengthening it; it formed temperament but never instilled principle. . . . (5.367)

Its presence is "an invariable sign of . . . justness of moral *perception,* though by no means of moral *practice.*" At the end of the chapter, Ruskin quiets his doubts by praising the higher contemplation of natural beauty which occurs "when the active life is nobly ful-filled."[22]

The matter is far from settled in Ruskin's mind. The important chapter in volume four, "The Mountain Gloom," reveals his misgiv-ings in a more radical form. Here the question is not the effect of love of nature on a man's character. It is the effect of that aspect of nature designed by God for "the delight, the advantage, or the teach-ing of men"—mountains—on the well-being of those who live among them. Ruskin is forced to conclude that much of the peasants' torpor, disease, and morbidity is the result of their mountainous surroundings or, at least, that these surroundings, in the absence of healthy education and employment, do nothing to improve the qual-ity of the peasants' lives. The problem moves one stage back. Not only is the love of nature not a characteristic of the greatest men, but nature herself does not always inspire love. She can inspire a perverse

delight in decay and death. Ruskin does not entertain such thoughts for long. The next chapter is entitled "The Mountain Glory." Again, mountains are "the schools and cathedrals" of the human race and a necessary influence on poets and painters. His overstatement resembles whistling in the dark or, perhaps, the gloom.[23]

Ruskin's doubts are cumulative. In volume five of *Modern Painters,* he questions whether he can "continue to labour in any cause of Art." He has been unable to come to "demonstrable conclusions" regarding the "right and worthy effect" of art or nature upon the human mind. "I am . . . in doubt respecting the real use to mankind of that [Turner's art] or any other transcendent art; incomprehensible as it must always be to the mass of men." What is more, a nation's success in art appears often to have precipitated its decline. As early as 1846, Ruskin had this to say of the Venetians: "I think their art can only have done them mischief—and I want their history before I venture any more assertions." *The Stones of Venice* is the result. Ruskin's studies have convinced him that the city's religious art had no positive effect on the life of the people. Even its architecture, the most "direct and substantial" of arts, had no power to preserve the state of national "purity" from which it sprang. Ruskin can no longer pursue his vocation of saving souls by interpreting nature and art. His conclusion that art has no obvious utility and that a nation's appreciation and creation of art depend upon its moral vitality leaves him free to move in one direction—social criticism. The circle of his views on the relationship of art and society has been broken.[24]

Ruskin is well aware that he has reached a turning point. In a letter to Elizabeth Barrett Browning, dated November 5, 1860, he describes the "lassitude" and "disappointment of discovered uselessness" which has come over him. He has reached the painful conclusion

that great Art is of no real use to anybody but the next great Artist; that it is wholly invisible to people—for the present—and that to get anybody to see it, one must begin at the other end, with moral education of the people, and physical. . . . (36.348)

Ruskin recognizes the difficult position of art in the nineteenth century. His reaction is not defensive, but aggressive. He does not join later "aesthetes" in making art a sacred precinct, independent of social and economic considerations. Instead, he attempts to change industrial society and make it hospitable to artistic values. He sees no

other choice but to "turn myself quite upside down" and become a social critic. "I'm half broken-backed," he complains, "and can't manage it." Ruskin had been practicing the feat for many years and accomplishes it with remarkable success.[25]

In its broad outlines, Ruskin's development in the fifties resembles that of Coleridge and Wordsworth after the French Revolution. There is the same ability to exult in nature and the same loss of this ability. With this loss goes a loss of early talent. In Ruskin's case, it takes the form of an aesthetic rigidity and an inability to appreciate new movements like French Impressionism. In the case of Wordsworth and Coleridge, it is a loss of poetic creativity and a decline from "imaginative" to "fanciful" poetry. The result for them, as for Ruskin, is a new interest in "more important" matters, matters which have direct relevance to the human condition. The similar experiences of Ruskin and the poets suggest that the worm in the rose of Romanticism is the suspicion that art is an escape from reality. Here the similarity ends. The poets' loss of the landscape feeling is not accompanied, as is Ruskin's, by a rediscovery of man's goodness. It is accompanied by a social conservatism and a growing conviction of the power of human sin. This difference has important ramifications. The "more important" matters to which the poets turn their attention are orthodox religion or metaphysics, Coleridge's "darling studies," and, only to a lesser extent, society and politics. Ruskin feels no resurgence of orthodox faith and devotes his energy to social and economic criticism. With him, this development in both its loss and gain is more frankly recognized. If Ruskin is one of "the last Romantics," he is also one of the most self-conscious.[26]

IV Streams of Abundance

The vocation of social criticism which Ruskin adopts publicly in 1860 is not unfamiliar. Throughout the fifties, he prepares for it by digressions in *Modern Painters* and by lectures ostensibly on art but really on social and economic problems. In these digressions and lectures, often overlooked by students of Ruskin, he introduces many of the basic principles of his social criticism. The most important is his pioneering perception of the possibility of an abundance of good things for all men and his rejection of the usual Victorian belief that life is a struggle in which scarcity is the expected condition. The corollary of his perception of abundance is an intense horror at the waste caused by rampant competition, whether in art or economics. To prevent waste and secure a society of abundance, Ruskin suggests that a strong "paternal" government intervene in and manage economic affairs. Finally, in the writings of the fifties, Ruskin foreshadows his reconstruction of classical economics by examining the problem of consumption and the role of the consumer in providing employment. This chapter will survey the ground broken by Ruskin as he tests out his new vocation.

2

The surreptitious character of Ruskin's experiments in social criticism during the fifties owes much to his parent's opposition. Ruskin tries as early as 1852 to don the mantle of social prophet but is restrained by his father who disagrees with his son's ideas and fears that they will hurt his reputation as an art critic. In that year, John James Ruskin suppresses three letters which his son had written to the *Times* on taxation, election, and education. In the first, Ruskin advocates abolition of import and export duties, higher excise taxes on luxuries, a steeply graduated income tax, and a property tax on the wealthy. In the second, he proposes limiting the vote to those qualified by age, wealth, position, and education. The third, existing only in fragments, is the most interesting. In it, he demands a more practical education than the learning of Latin verses—an education which would help a man discover "what kind of faculties he

possesses; what are the present state and wants of mankind; what is his place in society; and what are the readiest means in his power of attaining happiness and diffusing it."[1] Such an education would include natural history, a reasonable religion, and politics. Under politics, Ruskin would teach the following:

The impossibility of equality among men; the good which arises from their inequality; . . . the honourableness of every man who is worthily filling his appointed place in society, however humble; the proper relations of poor and rich, governor and governed; the nature of wealth, and mode of its circulation; the difference between productive and unproductive labour; the relation of the products of the mind and hand; the true value of works of the higher arts, and the possible amount of their production; the meaning of "Civilization," its advantages and dangers; . . . and, above all, the significance of almost every act of a man's daily life, in its ultimate operation upon himself and others. (11.260)

Here, in 1852, Ruskin enumerates what he himself will attempt to teach his countrymen.

Ruskin's father refuses to forward these letters to the *Times*. He describes them as "Slum Buildings liable to be knocked down." Ruskin acquiesces and returns to *Modern Painters*. Still, the parental prohibition rankles, and he vows in the future to write a "great essay on man's work." It is from this time that he begins to read Carlyle and to think seriously about political economy. In 1855, he tells Mrs. Carlyle that his studies of political economy have "induced" him to think that no one knows "anything" about it. He claims that he is "engaged in an investigation, on independent principles, of the Natures of Money, Rent, and Taxes, in an abstract form, which sometimes keeps me awake all night." The groundwork for *Unto This Last* and *Munera Pulveris* is laid in this decade.[2]

The conflict with his parents over the letters to the *Times* is symptomatic of the tension which had developed in Ruskin's relationship with the oversolicitous deities of Denmark Hill. Ruskin is brutally frank about his feelings toward his parents. Of his father he writes to Lady Trevelyan, "If he loved me less and believed in me more, we should get on, but his whole life is bound up in me, and yet he thinks me a fool. . . ." Three months before the elder Ruskin's death in 1864, he accuses his parents of having deprived him of "all the earnest fire and passion of life." In spite of his ambivalence, Ruskin never leaves home. After the failure of his marriage in 1854, he returns to "the place which ought to be home," where he suffers a feeling of "unendurable solitude." It is tempting to see the changes in Ruskin's outlook which occurred during the fifties only as super-

ficial variations on the theme of his tortured relationship with his parents. His new view of man as "nobly animal, nobly spiritual," his rejection of his mother's Evangelicalism, and his turn to a frequently vitriolic social criticism can, once again, be viewed as strategies in his rebellion against his parents and their values. The importance of this view to an understanding of Ruskin's ideas will become evident. Now, it is sufficient to note the strong impetus which his frustrated rebellion gives to the venture in social criticism.[3]

3

Ruskin soon discovers that the best way to avoid parental censorship is to lecture. In lectures, he can digress onto social problems or talk about society under the guise of art. *The Political Economy of Art* is a significant title. Many of his lectures focus on art, but, even in these, Ruskin speaks as a social critic. One of his major themes is the contemporary application of lessons from "The Nature of Gothic." Victorian architects must encourage the creativity of their workers. A spirit of "socialism" or "social help" is needed if the talents of the men are to find expression.[4]

Speaking to the builders of the Oxford Museum in 1856, Ruskin emphasizes the social character of their project. All good architecture rests on a "fraternity of toil." The Oxford Museum, constructed in the Gothic style, will serve as an example of cooperation and a symbol of the organic society. It will stand as an alternative to the "cold, inhuman" style of the Renaissance, "full of insult to the poor in every line." Architectural models play an important role in Ruskin's critique of competition and exploitation. Already he urges the workers at Oxford to carry their sense of fellowship and harmony into a broader sphere. They should join with other workers to bring pressure on the upper classes.[5]

There is a second theme in Ruskin's lectures of the fifties which points to the future. It is the theme of waste. This theme is not entirely new to Ruskin. The "happiness of the worker" criterion in *The Seven Lamps* can be studied in terms of it, for mechanical labor wastes the worker's originality. Ruskin deplores the "enormous mass of intellectual power" lost in the nineteenth century by not allowing workmen to express themselves grotesquely in Gothic architecture. He touches on the theme of waste several times in the last three volumes of *Modern Painters.* He condemns the destruction of nature by railroads and cities and the waste of human lives in factories and

on battlefields. But it is only in the lectures that the theme of waste comes to dominate his vision.[6]

At the most obvious level, Ruskin is disturbed by the waste of venerable paintings and architecture. The damp, tattered Tintorettos on the walls of a chapel in Venice fill him with bitterness. So does the destruction of ancient buildings by railroads and other "improvements." They are leading to a barren "Americanness." Ruskin doubts the sanity of a society which will build the Crystal Palace and ignore the destruction of historic monuments. He reserves some of his sharpest barbs for the restorer. Ancient buildings should be "preserved," not restored. In 1854, he calls for the formation of an association to preserve and, if necessary, purchase ancient architecture. William Morris heeded Ruskin's call and, in 1877, founded "The Society for the Protection of Ancient Buildings" or "The Anti-Scrape." Today, the National Trust stands as a reminder of Ruskin's efforts.[7]

The lectures of the fifties also condemn the social waste of artistic talent. An artist cannot be manufactured, but society is responsible for preparing the ground in which artistic talent is sown. In a lecture at Bradford in 1859, Ruskin doubts whether the ground in England is suitable for growing artists. "How many mills do we want? or do we indeed want no end of mills?" he asks. No doubt, if we want, we could turn "the whole of the south of England into a brickfield, as we have already turned nearly the whole of the north into a coal-pit." The result will be

that from shore to shore the whole of the island is to be set as thick with chimneys as the masts stand in the docks of Liverpool; that there shall be no meadows in it; no trees; no gardens; . . . that, the smoke having rendered the light of the sun unserviceable, you work always by the light of your own gas. . . . (16.336-338)

The result will also be that "no development of beautiful art will be possible." Design is an inborn gift, but observation of an unspoiled environment—of "beautiful things"—is important. Ruskin wonders what there is for a modern designer to contemplate in the polluted streams and sulphurous air, the "sooty slime" and "curdling scum," of an English manufacturing town. Here he returns to his suggestion in the second volume of *Modern Painters* that genius depends for its nurture on the social environment.[8]

4

The waste of artistic talent and its remedy are the themes of Ruskin's first lectures of direct social import—*The Political Economy of Art,* later republished as *A Joy for Ever.* In these lectures (1857), Ruskin advises society how to manage its "art-wealth." He traces the "commercial and political interests" involved in such a task. Before turning to "art-wealth," he follows his inclination to identify art and work and makes several important remarks on political economy in general. Ruskin's most original insight, implicit in his "happiness of the worker" theory, his emphasis on consumption in "The Nature of Gothic," and his concern with social waste, becomes explicit in these introductory pages. He believes that a society of abundance is possible *now.* The necessities of life can be provided. Already, the quality of consumption or "happiness" above the level of subsistence is a plausible topic of discussion. Ruskin's own words are as follows:

The world is so regulated . . . that a man's labour, well applied, is amply sufficient to provide him during his life with all things needful to him, and not only with those, but with many pleasant objects of luxury; and yet farther, to procure him large intervals of healthful rest and serviceable leisure. And a nation's labour, well-applied, is, in like manner, amply sufficient to provide its whole population with good food and comfortable habitation; and not with those only, but with good education besides, and objects of luxury, art treasures such as these. . . . (16.18)

Ruskin rejects the common Victorian premise that the world is a place of material scarcity where men must compete and work hard just to keep from falling into the strata of the unfit. In a very literal sense, Ruskin's world displays the "generous" abundance or "redundancy" which finds expression in the decorations of Gothic architecture.[9]

To complement his perception of abundance, Ruskin urges a change in the use of the word "economy." For once, his interest in philology is not a playful symptom of his inability to concentrate but a serious diagnosis of cultural change. Ruskin points out that, in his contemporaries' use of the word "economy," it has the meaning of "saving" or "sparing." In Ruskin's view, "economy no more means saving money than it means spending money." "It means the administration of a house; its stewardship; spending or saving, to the best possible advantage. In the simplest and clearest definition of it, economy, whether public or private, means the wise management of labour." This shift from "saving" to "managing" is not a small one.

Its importance lies, not in the realm of philology where the distinction Ruskin draws may be inaccurate, but in the more significant realm of those slow and often subconscious cultural changes which shape a people's entire outlook. Ruskin is casting a beam of light into the future to glimpse the emergence of "affluent societies" and "*managed* economies."[10]

Ruskin's assumption of abundance inspires his demand that the management of labor be directed to "splendour" as well as "utility." He criticizes nations which ignore the arts of beauty and "delight" for wasting energies intended for those arts. More important, he believes that "a mean lust of accumulation merely for the sake of accumulation, or even of labour merely for the sake of labour, will banish at last the serenity and morality of life as completely, and perhaps more ignobly, than even the lavishness of pride, and the likeness of pleasure." In this passage, Ruskin begins his caricature of the scarcity-oriented Protestant ethic.[11]

A necessary adjunct of an economy managed for utility and pleasure is full employment. This is another of Ruskin's principles. He compares the economy of a state to that of a household or farm where the problem is to find men for the work, not work for the men. In a nation "in which political economy is rightly understood," there will never be difficulty in finding work. Public works can be inititated on a vast scale to make life more abundant. Here Ruskin's beam of light flashes briefly on the "economics of full employment."[12]

Ruskin sets down a major requirement of a national economy managed for abundance—authority. The state must resemble a farm "in which the master is a father, and in which all the servants are sons." Citing Wordsworth and Carlyle, he advocates a "paternal government" under which law would do more than define and punish crime. It would be positive or "paternal," based on "social knowledge." A true government would educate its citizens, direct their labor, provide jobs for the unemployed in government workshops, and relieve the sick or aged. Undeserving poor would no longer exist. Parish relief would be received, not as a disgrace, but as a reward for service to the community. Obviously, *laissez faire,* the "let-alone" principle, is the great enemy, the "principle of death," while "the notion of Interference and Discipline lies at the very root of all human progress." One is reminded of the "government and co-operation" dictum in "The Law of Help" in volume five of *Modern*

Painters. One is also reminded of Ruskin's belief that a Gothic cathedral, "ordered, disciplined, and variously ranked," is expressive of the "type of divine, and therefore of all good human government."[13]

5

In the remaining sections of *The Political Economy of Art,* Ruskin turns to the branch of the economy concerned with artistic "delight." He is convinced that his principles apply to all labor but limits himself, with occasional lapses, to "art-labor." He gives his ideas a trial run in a field with which he is thoroughly familiar. Recalling his definition of economy as management, he divides the subject into four parts: the "discovery," "application," "preservation," and "distribution" of art-labor and its "results."[14]

There is no surfeit of artistic talent. It is limited and cannot be transferred to mechanical occupations. Ruskin denies the complacent view that all real genius overcomes its obstacles. It is an open-ended situation: much talent is lost, and even those great artists who have survived could have done better work under more favorable conditions. Still, with proper management, there will be an abundance of art just as, with proper management, there will be an abundance of more prosaic commodities. To maximize "art-wealth," Ruskin suggests that the government establish "trial schools" to discover talent. Once discovered, artists would be given a liberal education and secure employment on public projects, a proposal first made by William Blake.[15]

In its "application," art-labor should resemble that of the Gothic workmen in *The Stones of Venice.* It should be various and "easy" in the sense that it should be employed on amenable materials. It is a waste of energy to cut diamonds when the same men might be cutting sandstone into shapes which express "ideas" or feelings. Above all, art-labor should be applied to "lasting" work. Ruskin doubts the value of "wholesome evanescence," a more felicitous phrase, perhaps, than our "planned obsolescence." Work of lasting quality should be done on lasting materials. He proposes government-owned and operated manufactories of high quality paper and color pigments. They are the aesthetic prototype of his later public enterprises. Ruskin doubts whether craftsmen will put much quality of thought into things easily destroyed or ruled by yearly fashion changes and urges the consumer to see that talent is not wastefully employed in this way.[16]

Ruskin's recognition of the consumer's role in the application of artistic talent leads him to break the bonds of his lecture. It launches him briefly into a more general discussion of the consumer, reminiscent of paragraphs in "The Lamp of Obedience" and "The Nature of Gothic." Since money represents power over the workingman, the spender or consumer is one of the most important managers of labor. The quality of his demand determines the quality of the worker's employment. Ruskin criticizes apologists for the rich who argue that every expenditure and every invention of a new want are beneficial to the community since they put people to work. Looking ahead to his critique of the law of supply and demand, he denies that the economy is a self-correcting system in which all things turn out for the best as in Mandeville's *Fable of the Bees.* It is not enough to put people to work. The real question is what sort of work. Is it useful to society or is it merely accumulating useless luxuries in the hands of the rich? He condemns people who spend vast sums on ball gowns while children are starving in the streets. They are literally in a "partnership with Death." At the conclusion of the lecture, Ruskin strives to return to his subject by comparing the money wasted in this fashion with that paid by the nation for works of art.[17]

In an addendum entitled "Invention of New Wants," Ruskin reaffirms his belief in the possibility of abundance. He is not opposed to luxuries even if they take labor away from more useful projects. The invention of "imaginary wants" may be a sign of healthy activity and may "lead, indirectly, to useful discoveries or to noble arts." Although Ruskin would postpone the enjoyment of luxuries to a time when the poor have been housed and fed, he sees no reason why this time should be very distant.[18]

The second lecture of *The Political Economy of Art* begins with a discussion of the accumulation of art-wealth. In his role as manager of abundance, Ruskin remarks that good art should be neither too cheap nor too common since much of the enjoyment of art depends on the attention brought to bear on it. The real problem is to prevent the destruction of existing art. After describing the effects of war on Verona, he urges his readers to forgo their conspicuous consumption at home and form a "National Society" for the purchase of valuable paintings. They should wave "blank cheques" in the eyes of foreign nations. Better still, the English should abandon their parochial outlook and consider themselves members of one "great Christian community of Europe," Burke's "commonwealth of Europe." Imagina-

tive sympathy or "travel in soul" would lead them to appreciate and protect Continental art without transporting it to England. This, to be sure, would involve political intervention to secure stability and relieve distress. It foreshadows Ruskin's idealistic imperialism.[19]

Ruskin next considers the distribution of art. He advocates both public galleries and private possession as means of "refining the habits and touching the hearts" of ordinary men. He has not given up all hope of making art an instrument of soul culture. To encourage painters to produce more, he suggests a professionalization of painting on the basis of lower prices and steady employment. Turning once more to the consumer, Ruskin urges him to purchase works of living artists, especially younger artists. He condemns those who buy famous paintings for ostentatious reasons. They are investing their money in a "cargo of mental quick-lime or guano" capable only of nurturing competitive display. It would be much better to employ young artists at public expense on government buildings, hospitals, and schools, where decorative art might "animate" the ideals and events of history. Ruskin hopes to make something resembling the art workshops of the American New Deal a permanent feature of mid-nineteenth-century English government.[20]

Trade-guild centers would also provide an opportunity for the display of art. Again, Ruskin escapes from art to work. Competition is his target in this digression. Jealous rivalry, secrecy, and opposition are socially wasteful, especially when justified by a political economy which conceals their true effects—a glimpse of *Unto This Last* and *Munera Pulveris.* Work must be cast into "social and communicative systems," or guilds, with the emphasis on that honesty and fellowship which characterized the builders of Gothic cathedrals. Ruskin describes his revived guild system as follows:

There will be a great council or government house for the members of every trade . . . with minor council-halls in other cities; and to each council-hall, officers attached, whose first business may be to examine into the circumstances of every operative, in that trade, who chooses to report himself to them when out of work, and to set him to work . . . at a fixed rate of wages, determined at regular periods in the council-meetings; and whose next duty may be to bring reports before the council of all improvements made in the business, and means of its extension: not allowing private patents of any kind, but making all improvements available to every member of the guild, only allotting, after successful trial of them, a certain reward to the inventors. (16.96-97)

In concluding *The Political Economy of Art*, Ruskin makes no attempt to return to his subject, although, in a sense, he has never

left it. He continues to attack competition. He notes that society frowns on physical competition but not on mental:

When a man . . . instead of being long-armed only, has the much greater gift of being long-headed—you think it perfectly just that he should use his intellect to take the bread out of the mouths of all the other men in the town who are of the same trade with him; or gather some branch of the commerce of the country into one great cobweb, of which he is himself to be the central spider. . . . (16.100)

Ruskin admits that some men are necessarily superior to others in capacity and wealth. These men should not crush the poor but guide and help them. The rich are the directors of labor, "the pilots of the power and effort of the State." Under their responsible guidance, an age of abundance will dawn: "A time will come—I do not think even now it is far from us—when this golden net of the world's wealth will be spread abroad as the flaming meshes of morning cloud are over the sky; bearing with them the joy of light and the dew of the morning, as well as the summons to honourable and peaceful toil."[21]

6

Competition as the cause of waste in artistic and, indeed, all forms of work is an important theme in the writings of the fifties. Ruskin closes *Modern Painters* with a passage in which he relates social waste and competition. He notes how little "help" Turner and other great Englishmen receive from their society. England surrounds them with an environment of jealous competition and scorns their best endeavors until it is too late. Ruskin wonders what Turner might have accomplished if he had lived in Venice or the society outlined in *The Political Economy of Art.* And not just Turner, but all men, for he believes that the quality of everyone's work suffers from England's substitution of the "cross bones" for the "cross" as the national shop sign. Through her competitive methods, England manages to get the least possible product from her abundant supplies of power and talent.[22]

In a lecture on "Modern Manufacture and Design" (1859), Ruskin strikes a democratic note in his demand for a cooperative environment. He returns to his model of the Gothic. A "wholesome" society should "bring the power and charm of art within the reach of the humble." It should encourage the expression of every man's peculiar talent. Ruskin believes that, until now, great art has had no influence because it served the "pride of life" of superior classes—a pride sup-

ported by competition and robbery. With Wordsworth, he insists that art cannot be the exclusive luxury of an elite. It must have a broad base in the sympathy and delight of common men: "The magnificence of past ages failed by its narrowness and its pride, ours may prevail and continue, by its universality and its lowliness."[23]

Ruskin considers competition the major factor destroying the quality of life in England's potentially abundant society. He deplores the tendency of the lower classes to emulate the ostentatious habits of the upper. More severely, he condemns manufacturers who concentrate their energies on successful competition and ignore the effect of their actions on the public:

You must remember always that your business, as manufacturers, is to form the market, as much as to supply it. If, in short-sighted and reckless eagerness for wealth, you catch at every humour of the populace . . . if, in jealous rivalry with neighbouring States, or with other producers, you try to attract attention by singularities, novelties, and gaudinesses—to make every design an advertisement . . . no good design will ever be possible to you, or perceived by you. You may, by accident, snatch the market . . . and cause the ruin of opponent houses; or you may, with equal justice of fortune, be ruined by them. But whatever happens to you, this, at least, is certain, that the whole of your life will have been spent in corrupting public taste and encouraging public extravagance. (16.344)

Advertising contributes to social waste. If manufacturers would act in the spirit of great artists and resist the temptations of competition, they would "literally become more influential for all kinds of good than . . . many treatises on morality." Their products would become "educational instruments." An abundance of high quality would be realized. But, first, businessmen must use their "imaginations" to shape or "form" the market creatively. They must not follow it passively and exploit it through the calculations of the "understanding." Fortunately for his peace of mind, Ruskin overlooks the possibility that businessmen of the future might "form" the market for less than altruistic purposes.[24]

Ruskin's hostility to competition is deeply rooted in his aesthetic themes and in his organic approach. It is, in fact, one of the major fruits of his social application of Romanticism. Competition is symptomatic of an "impure," disorganized state—a state of "death" or "decomposition." It destroys that "unity of membership" which is the perfection of all creatures, whose strength and delight are in their "inseparable dependency on each others' being." Competition also

violates the "Law of Help" in nature, in Gothic architecture, in artistic composition, and in the composition of human lives in society. Its existence reflects a diseased condition of the imaginative powers, whether of the artist or the social leadership. The imagination's task is to weld discordant, competitive elements into an organic whole, just as nature, by the "political economy of co-operation," creates a sapphire out of the slime produced by the "political economy of competition."[25]

Ruskin's critique of competition follows from his attack on mechanism. When elements are related externally, they do not "interpenetrate" one another. Whether men or things, they tend to clash competitively. Competition, like mechanism, destroys vital beauty. It marks the corruption of the "pure" energy which is a necessary factor both objectively in the fabric of wholes and subjectively in the act of love or contemplation. In volume five of *Modern Painters,* Ruskin urges man to sympathize with other creatures and uses the term energy to describe this relation. Man should no more separate himself from other beings than he should separate body from soul: "Every healthy state of nations and of individual minds consists in the unselfish presence of the human spirit everywhere, energizing over all things; speaking and living through all things." Competition perverts this "energy of Love." It leads to the impure social relationships symbolized by the pointed iron fences in London. The fact that competition brings forth more and more machinery and more and more useless products like iron fences only sharpens the physical edge of an already painful metaphysical reality.[26]

Stripped of its rhetoric, Ruskin's critique of competition is, perhaps, the least original aspect of his social criticism. It is difficult to find a critic of the status quo in nineteenth-century England who does not oppose competition or wish to restrict its sphere of action. Thinkers as diverse as Robert Owen and Thomas Arnold, Blake and Mrs. Gaskell, Coleridge and William Thompson see in competition one of the chief forces tending to the dissolution of English society. To determine where in the spectrum of opposition Ruskin stands, one must use external, not internal, criteria: one must study the direction in which a thinker's argument expands rather than the content of the argument per se. Ruskin's criticism of competition moves in two directions. In one, it touches on the theme of waste and, in the other, on the theme of mechanism.

Of the critics of competition who attack its wastefulness, the

Owenites are the most prominent. Well aware of the new productive powers of industry, they are disturbed by the waste of a potential abundance through faulty social organization. Abram Combe (1785-1827), the leader of the Orbiston community, treats the theme of waste in the most striking fashion. He puts his argument in the form of a parable or "metaphorical sketch." England's wealth is contained in a great cistern supplied from three streams—agriculture, mining, and commerce. When these streams have been purified at special stations and have been directed into the cistern, they provide all that is necessary for the supply of human wants. At the stopcock of the cistern stands a guardian by the name of Competition. His duty is to manage and distribute the reservoir of wealth. The problem is that Competition is incompetent and allows the cistern to overflow wastefully. For once, at least, Ruskin's imagery is outdone in colorfulness, if not in grandeur, and by an Owenite at that![27]

Those who relate competition to mechanism can also be isolated. They are drawn chiefly from the Romantic camp and seem closer in tone to Ruskin. Coleridge and Southey both condemn competition not so much for its wastefulness as for its corrosive effect on social unity. The policy of *laissez faire* is a symptom of mechanistic modes of perception and atomistic modes of social relationship. It is in the writings of Carlyle that such ideas find their most flamboyant expression. This is one of the few areas in which Ruskin can truly be said to have added little to his "master's" teaching. Carlyle identifies competition with mechanism and the dissolution of social bonds. It signifies general "Chaos" and "Social Gangrene." The "Cant" of *laissez faire* or "Devil take the hindmost" is more than a "Gospel of Despair" or "Paralytic Radicalism" bent on proving things to be impossible. It is a virulent disease destroying the "Life-essence" of society and encasing every individual in a "transparent 'ice palace' " of isolation and alienation. The root of the problem is that "we figure Society as a 'Machine' " in which cash-payment is "the sole relation of human beings." Carlyle anticipates Ruskin in pointing to London's spiked iron fences as evidence of the warfare euphemistically called competition.[28]

The ideal society which Ruskin would substitute for the present nonsociety is an organic one. In this, too, *The Political Economy of Art* reveals the direction of his thought. His persistent use of the analogy of a family and of the adjective "paternal" leaves little doubt about his preferred mode of conceiving social organization. Ruskin's

vision of wholesome social relationships is no more original than his attack on competition. Earlier critics hold up the ideal of a closely knit society existing in the past, the future, or, in a disguised or damaged form, in the present. The terms they use to describe their ideal are many: "vital" union, "mysterious brotherhood," "organic whole," "soul-politic," or "spirit of the nation."[29] In the case of Coleridge, Southey, the Young Englanders, and the Tory agitators William Cobbett (1763-1835) and Richard Oastler (1789-1861), appeals for social renewal need no elaboration. Southey, Cobbett, and Oastler resemble Ruskin in their use of paternalistic models. In England, one obvious source of a nostalgic emphasis on the unity and continuity of the social whole is the writings of Edmund Burke. Burke's society is not an "individual momentary aggregation" but a "variegated unity"—a "partnership" bound together by an intricate web of moral relations, social sentiments, and "prejudices." Like Ruskin many years later, Burke compares civil society to the family, "from kin to kind," and views both as links in "the great mysterious incorporation of the human race."[30]

The ideal of an organic society does not spring full-blown from Burke's *Reflections.* A similar view of social interdependence can be found in the writings of the eighteenth-century Scottish thinkers David Hume, Adam Ferguson, Adam Smith, and John Millar. The intention of these pioneers in sociology is not to fashion an ideal organic society but to analyze the complicated configuration of relationships, customs, and institutions which bind together existing society. In the process, they create a language and style of discourse which Burke and the Romantics adapt to their less detached purposes and color with tones of enthusiasm and mystery. Hume and Smith, for example, place the origin of society in the family and recognize the social character of every individual motive. The most systematic studies are Adam Ferguson's *Essay on the History of Civil Society* (1766) and *Principles of Moral and Political Science* (1792). "Send man to the desert alone," Ferguson writes in a passage indistinguishable from many in Burke, Coleridge, or Carlyle, "he is a plant torn from its roots . . . every faculty droops and withers. . . ." John Millar agrees. The fact that Ferguson and his fellow Scots accept the present society and are more concerned with scientific analysis than with propounding ideals does not prevent them from expressing concern over the tendency of specialization and contractual relationships to weaken social bonds. While accepting their society's propensity to take on the characteristics of a *Gesellschaft,* or "corporation" they

feel that something of the spontaneous solidarity of a *Gemeinschaft* or "community" is being lost. With Ruskin, this feeling has become so sharp as to make him wish to restore an already departed *Gemeinschaft*.[31]

The difference between the Scottish philosophers and the Romantics lies not so much in the content of their ideals as in the location of these ideals in time. While the Scottish philosophers and even Burke look to the present society for evidence of the "astonishing fabric" of the social whole, the Romantics, living in a later period, can find their ideal only in the past, frequently a medieval past. They are tempted to construct the future with materials drawn from history. William Godwin and Robert Owen, on the other hand, hope to create a "New Moral World" out of new materials. Ruskin stands closer to the Romantics. With Carlyle, Cobbett, and Southey, he has a great respect for the Middle Ages, "to me the only ages," and much prefers their intensity of experience to the mechanical dullness of the nineteenth century. Ruskin, however, is no uncritical worshipper of the Middle Ages in the fashion of the Young Englanders. He can point with equal admiration to other periods of history. References to ancient Greece, to the Greek political thinkers Plato and Xenophon, and to the Christian philosophers Sir Thomas More and Richard Hooker abound in his writings.[32]

This discussion of Ruskin's critique of competition has so far carefully avoided the crowning ambiguity of his thinking and, perhaps, of Romanticism in general on the subject. If one pursued the implications of "The Nature of Gothic" without knowing the direction of Ruskin's social criticism, one might conclude that he prefers a liberal, even competitive society in which each person will express himself freely as did the Gothic workman. His belief that the freedom of the worker was realized in the Middle Ages and his suggestion that the orderly subordination of parts in a cathedral typifies the ideal society might give one pause, but these bits of contrary evidence could be dismissed as unimportant. There is more than a grain of truth in this interpretation. Ruskin's preference for the roughness, variety, and redundancy of Gothic and for the formlessness of Turner does, indeed, seem to have a closer "elective affinity," to use Max Weber's phrase, with the exuberant disorder of *laissez faire* than with the harmony of a well-organized, noncompetitive community. To broaden the question, one might suggest that the preference of Romantics generally for whatever bursts the controlling channels of human technique, whether it be the conceptions of genius or the landscape of the Alps,

finds its distorted reflection in the chaos of nineteenth-century cities and economic processes. Of course, neither Romantics nor advocates of *laissez faire* choose disorder as an ultimate condition. Both those who wish to leave nature alone and those who wish to leave economic processes alone believe that free development and apparent chaos will lead, if not to ultimate harmony, then to the least painful disorder.

The problem is that not all Romantics are willing to transfer their liberal ideal from nature to the social sphere. Coleridge, Carlyle, and Ruskin criticize society from an essentially conservative point of view. They reject the fiery liberalism of Byron and Hazlitt and restrict the "let-alone" principle to nature, poetry, or Gothic ruins. They urge government intervention to maintain order and meet the problems of society. In nature or the Gothic, chaotic vitality or decay may lead to the most satisfying result, and, in the history of nations, an unplanned course of development may coincide with God's plan, but, within the society of the nineteenth century, man must take action to bring order out of chaos.[33] The Romantic critics are far from convinced that such action will succeed. They are haunted by the feeling that an organic society can develop only in an unconscious, natural manner without the aid of "machinery." They fear, one suspects, that any attempt to organize an organic society or to cultivate a culture will result in the repellent artificiality of the eighteenth century. Thomas Carlyle is torn between admiring the growth of "organic filaments" within the present society and demanding forceful action by a "Hero" to defeat chaos. The fact that Carlyle finally adopts desperate tactics to impose order suggests that his faith in the power of spontaneous growth yields to an organicism of the surface and a fear of decay resembling Ruskin's. Ruskin never gives full credence to spontaneous growth in nature or society. He has few qualms about urging immediate action to bring order out of the chaos of an excessively liberal society. Nonetheless, his vision of the Gothic builder stands as a testament to the unresolved conflict within his thought and within the Romantic movement between a dynamic organicism of free energy and a static organicism of surface form and order.[34]

7

Although a pervasive theme in his later writing, Ruskin's attack on competition is not the most important of the principles set forth in his lectures of the fifties. More important and far more original is his

awareness of the possibility of social abundance. Abundance plays
the role in Ruskin's thought of the hero who is sabotaged by the
villain competition. The belief that there is, or soon will be, enough
material wealth to enable every individual to lead a healthy life is one
of those assumptions by which men order their thinking concerning
social and economic processes. The adoption of an abundance
"frame of reference" is a recent occurrence in the Western world and
reflects the increase in wages, goods, and services which has charac-
terized life in Europe and the United States since 1800. Indeed, it is
only within the last fifteen years that economists, sociologists, and a
large segment of the general public have adopted the assumption of a
potential or actual abundance. The opposite frame of reference,
which has dominated Western thinking for centuries, is that of
scarcity—the belief that man's urgent need to obtain what he can
from a scarce or "niggardly" environment is the chief factor in eco-
nomic behavior. The change from an assumption of scarcity to that
of abundance has not been easy. Many men prefer to keep their
traditional assumptions and ignore facts which they no longer ex-
plain comfortably. The full implications of the new outlook remain
to be seen. What is certain is that a growing number of men are
finding useful the assumption that man has discovered the means to
produce an abundance of material goods and that he is now free to im-
prove the quality of life. Ruskin plays an important role in this
historic change in man's assumptions concerning social and economic
activity.[35]

The history of the discovery of abundance has yet to be written.
Although many books have been published in which the concept of
abundance and its implications are discussed, very few approach the
subject with the tools of the intellectual historian. Most writers as-
sume that the history of abundance as a viable concept begins with
John Maynard Keynes or even John Kenneth Galbraith. Keynes, of
course, would be an important figure in such a history. In 1919, he
spoke regretfully of the damage done by the peace arrangements to
the hope that "perhaps a day might come when there would be
enough to go around . . . and men, secure of the comforts and neces-
sities of the body, could proceed to the nobler exercise of their
faculties." Several years later, he expressed the belief that the "eco-
nomic transition amidst the early stages of which we are now living"
is a transition from an "Era of Scarcity" to an "Era of Abun-
dance."[36]

The only scholarly study to face the problem of the "discovery of

abundance" is Daniel M. Fox's book by that name. Fox credits the American economist Simon N. Patten (1852-1922) with discovering and publicizing the concept of abundance. His study is an intellectual biography of Patten. Fox is correct in asserting that Patten is the first professional economist to make the assumption of abundance the explicit basis of his economic analysis. Patten devotes the larger part of his life's work to a study of the economic, moral, and aesthetic implications of the transition from an age of scarcity to one of "affluence." Fox, however, too blithely rejects as dreamers or men of simple ideas those who, although not professional economists or sociologists, must rank as precursors of Patten. It is logical that a new frame of reference should reach the light of day slowly, first among social visionaries and later among professional scholars and systematic thinkers. Fox is correct in asserting that "the vision of abundance, of enough to go around, has been part of the spiritual heritage of Western man for thousands of years." This is no reason to reject out of hand the visionaries of the nineteenth century as simple dreamers. In several respects, they differ markedly from their counterparts in earlier centuries. First, they are more numerous. Second, their visions of abundance are not placed at such a distance from existing society and are consistently connected with specific proposals for social reconstruction. Throughout the nineteenth century, a common refrain of social critics is the comparison of society's productive power and potential abundance with its present poverty. Later, Keynes will write of the "paradox of poverty in the midst of plenty."[37]

Ruskin repeats this refrain many times in his social criticism. He differs from his predecessors in carrying its implications into the center of his thought. Ruskin stands as the most important nineteenth-century precursor of Simon Patten and twentieth-century abundance thinking. His awareness of the assumption of abundance is much less conscious than Patten's. He repeats the insight of *The Political Economy of Art* frequently enough for readers to be certain he has not forgotten it but pursues the economic, moral, and aesthetic implications of this perception, not as consciously elaborated deductions, but as unconscious, almost organic outgrowths of his original assumption. The difference between Patten and Ruskin is that, reading Patten, one cannot miss the fact that he is discussing the implications of abundance. Reading Ruskin, one reaches this conclusion only if one is previously familiar with the concept and its ramifications. In a sense, this makes Ruskin more interesting. He is,

as it were, a test case of the effects which the assumption of abundance works on a traditional moral and social outlook. The fact that the implications which Ruskin deduces are very similar to those suggested by later abundance theorists says something for the power and inevitability of the change from a scarcity to an abundance frame of reference.

As it appears in *The Political Economy of Art,* Ruskin's statement of his perception of abundance is indistinguishable from that of many English thinkers writing after 1780. Two very different groups are noteworthy. The first might be called the Enlightenment or radical group, having its source in Thomas Paine and William Godwin and including Charles Hall, William Thompson, and Robert Owen. Each writer asserts the possibility of an abundance for all men if the productive resources of society are managed properly. Each deplores the simultaneous existence of great poverty and potential abundance and asks, "Why the misery in the midst of all the means of happiness?" Robert Owen is the most forceful of these. In a series of *Memorials* to the chiefs of state assembled at Aix-la-Chapelle in 1818, he declares that an "age of plenty" is dawning as a result of new techniques in industry and agriculture. Already "wealth can be created in such abundance as to satisfy the desire of all." What is needed to secure this abundance is a society where cooperation has replaced competition. Unlike many earlier visionaries, Owen and his followers relate their vision of abundance closely to the existing productive powers of society—"the inventions and discoveries which have been matured and which are now in full practice." In this respect, they are more consistent than Ruskin who assumes the results of the industrial revolution while disliking its techniques.[38]

Closer to Ruskin are the Romantic critics Coleridge, Southey, Hazlitt, and Carlyle. Their tone, even when conservative, is indistinguishable from a caustic radicalism. In terms identical to those of the Owenites, they make the contrast of existing poverty and potential abundance one of the focal points of their social criticism. In his *Lay Sermon* (1817), Coleridge remarks, "I have, at least, met with no proof that there is or has been any scarcity, either in the materials of all necessary comforts, or any lack of strength, skill, and industry to prepare them." He compares the English economy to "a man in health pining at a full table." The existing scarcity is not natural but the result of the insatiable greed of men infected with the "Spirit of Commerce." Carlyle does most to publicize this theme. He marvels

that, in the midst of the "plethoric plenty" produced by England's industrial power, people are starving. In the opening paragraph of *Past and Present* (1843), he puts it this way:

England is full of wealth, of multifarious produce, supply for human want in every kind; yet England is dying of inanition. With unabated bounty the land of England blooms and grows; waving with yellow harvests; thick-studded with workshops, industrial implements, with fifteen millions of workers; . . . the work they have done, the fruit they have realized is here, abundant, exuberant on every hand of us: and behold, some baleful fiat as of Enchantment has gone forth, saying, "Touch it not. . . ." (p. 2)

The cause of this remarkable condition is "the increase of social resources, which the old social institutions will no longer sufficiently administer," a phrase which has unwittingly been echoed by many abundance theorists of the last decade.[39]

The interpenetration of Romanticism and radicalism is confirmed by other writers who anticipate Ruskin. William Blake stands near the source of both traditions. One of the bitter notes struck by his later poetry is the recognition of man-made poverty "in the day of full-feeding prosperity." He sees an "Age of Plenty" or "Affluence" when the blight of poverty will be removed. Man will be freed from the rigors of the search for the "necessaries of animal life." Much later and much less prophetic are the Christian Socialists, with whom Ruskin was associated at the Working Men's College in the fifties and who owed much to both Owenites and Coleridgeans. The most articulate on economic matters is John M. Ludlow. He asserts the immediate possibility of providing everyone with a "physical abundance" if production and distribution are managed in a cooperative fashion. The agreement of Romantics and radicals on the paradox of abundance is an example of how scholarly barriers crumble in the face of new perspectives.[40]

One cause which cuts across the traditional divisions within Victorian intellectual history is opposition to Malthus' population doctrines. The rigorous pessimism of Malthus forced many thinkers, who might not otherwise have done so, to examine their assumptions concerning scarcity and abundance. Each of the writers mentioned opposes Malthus on the grounds, among others, that man's environment is more abundant than Malthus had thought. Many less well-known figures refute the theory of population. Their most valuable argument is that the greatest stimulus to population restriction is not war or famine but a rising standard of living and the creation of new wants above the subsistence level. The success of the anti-Malthusian

movement by 1850 suggests that, well before Ruskin, a belief in the possibility of abundance, at least in the form of an opposition to the dire prophecies of Malthus, had become fairly widespread.[41]

If Ruskin's perception of abundance is not original, the degree to which it shapes his thinking certainly is. In this respect, he resembles the French visionaries Condorcet, Saint-Simon, the Saint-Simonians, and Charles Fourier more than his English predecessors. Freed from the trammels of traditional social thought, the "prophets of Paris" allow themselves to speculate in detail concerning the future society of abundance and its effect on the lives of individuals. Although, compared to Patten, the French writers are definitely dreamers, they are not "mere" dreamers. Their vision of abundance is based on a shrewd awareness of the new power of industry and the new possibility of a scientific management of social processes. Their outlines of the future society bear as much resemblance to the present as do the predictions of the "tough-minded" professional economists Malthus, Ricardo, and John Stuart Mill.[42]

Ruskin is more bound by traditional values than are the French utopians. He can draw out the implications of abundance only with difficulty and without full awareness of the direction of his thinking. His perceptions do not work their way through the traditional matrix of his thought unscarred. Still, in their scope, Ruskin's insights resemble the speculations of the French writers, not the limited suggestions which his English predecessors find useful in the propaganda of social criticism. In the reform of economic doctrine, he carries the implications of abundance even further than do the French utopians. The tendency of Ruskin's assumption to color all of his thinking distinguishes him sharply from Carlyle. Carlyle's vision of abundance occupies a minor place in his work. Many of his attitudes, such as his scorn of the "pretension of everyone to be happy" and his call for a perpetual struggle against "Necessity," "Barrenness," and "Scarcity," cannot be understood in terms of an abundance frame of reference. It is in this sphere of the moral, aesthetic, and economic implications of abundance that Ruskin's originality lies. It is his grasp of these implications that reveals the extent to which the concept of abundance shapes his social criticism.[43]

<div align="center">8</div>

Once again, the personal dimension of Ruskin's thought demands attention. His vision of a social abundance wasted by chaotic competition and mismanagement reflects in a remarkable way his own con-

dition. Ruskin never doubted his ability. Nevertheless, he felt that his abundant genius was being wasted by chaotic, *unmanageable* emotions. These emotions sprang from his relationship with his parents and from a bitter sense of failure in his own tasks. By 1860, he had lost much of his delight in nature and become convinced of the failure of his mission to make the English appreciate the "gigantic moral power" of art. His books had not sold well, and the public still thought of him as an artistic dilettante, not a professional art critic. Turner died under heavy criticism for his later style, which Ruskin had defended. The Pre-Raphaelites, too, seemed to be slipping away from him after the painter Millais married Effie. Even Ruskin's architectural teachings had come to nought. Ancient buildings of value were being destroyed at a faster rate than ever, and, of the neo-Gothic buildings constructed on Ruskin's principles, there was hardly one on which he could look with pleasure. "I felt answerable to the schools I loved," he writes, "only for their injury. I perceived that this new portion of my strength had also been spent in vain." A more personal failure, the unconsummated marriage with Effie, ending in 1854, must have sharpened Ruskin's sense of frustration and wasted potential.[44]

The feeling of abundance running to waste gave rise to two obsessions which appear in Ruskin's writing. They are, first, his fear of encroaching death, sapping his strength and preventing him from finishing his work, and, second, his extraordinary interest in controlling the Alpine torrents by innumerable dykes, ditches, and reservoirs to prevent flooding and make the valleys "one Paradise of safe plenty." The unreality of both is apparent. Ruskin was scarcely forty and had good health in spite of his many complaints. As for the Alpine torrents, an overflow, perhaps, of that waterspout in Hunter Street which fascinated Ruskin as a child, they still flow to waste. Although his advice is being taken, they are hardly to be harnessed by the slender means and hand labor which he thought adequate.[45] The Alpine streams, in desperate need of management, symbolize Ruskin's own abundant but chaotic power. They suggest a very personal taproot for his vision of a social "plenty" wasted by mismanagement and the "pure" energy of a social "whole" corrupted by competition and conflicting purposes. If one doubts the symbolic significance which Alpine streams hold for Ruskin in terms of his own personality and his concept of social abundance, one need only scan his diaries and notice the frequency with which streams appear in his sexually troubled dreams.[46] One might also peruse the *General*

Index of the Library Edition under such headings as streams, rivers, inundations, torrents, and water, which Ruskin describes aptly as a "good thing, though unstable." Again, one might examine the intensity which he brings to his interpretations of water imagery in paintings and the tendency of his scientific studies to focus upon erosion, glacier movement, and the formation of clouds. Finally, and most important, one should notice the frequency with which Ruskin uses stream imagery to clarify aspects of his economic analysis and to describe the "flow of wealth" in an abundant society.[47]

The importance of streams for Ruskin should not astonish one familiar with English Romanticism. The poetry of Coleridge and Wordsworth is saturated with flowing streams, literal, metaphoric, and symbolic. It makes one less reluctant to give a radically personal interpretation to Ruskin's water imagery. Ruskin was familiar with the work of both poets and occasionally refers to their "streamy" passages. The poets' use of streams to describe the life or energy pervading nature and the human mind has been mentioned. Streams, wells, or fountains also represent the imagination of the poet, the creative process, and the unconscious sources of poetic genius. Water is a vehicle for the current of emotion and for the flow of life and time. In Wordsworth's autobiographical poems, *The Prelude* and "The River Duddon," both among Ruskin's favorites, stream imagery plays a central role. It relates the poet's life, the stream of consciousness in the mind, and the movement of the poem itself. In *The Ancient Mariner*, Coleridge surrounds the theme of the loss and recovery of creativity with aquatic imagery.[48]

Most relevant to our interpretation of Ruskin is the poets' use of streams and springs to represent the flow of emotion and of life. At times, this flow becomes turbulent and unmanageable. It "overflows" the channels guiding it. Wordsworth urges the Duddon and by implication himself "to soothe and cleanse, to lead and restore / not madden and pollute." He compares his own life to a "turbulent Stream" which nature must guide and educate just as Ruskin wished to "educate" the Alpine torrents. Carlyle uses stream imagery in this sense. In *Sartor Resartus* (1833), the Editor compares the life of Teufelsdröckh to the little *Kuhbach* (cow brook), which is "a vein or veinlet of the grand World-circulation of Waters." At one point, he describes this stream in terms similar to Ruskin's fear of the Alpine torrents:

The river of his History, which we have traced from its tiniest fountains, and hoped to see flow onward, with increasing current, into the ocean, here dashes

itself over that terrific Lover's Leap; and, as a mad-foaming cataract, flies wholly into tumultuous clouds of spray! (Bk. II, ch. vi, 121)

A recurrent theme in Ruskin's own autobiography *Praeterita* is the stream flowing by his aunt's house in Scotland. Ruskin describes this stream as "an infinite thing for a child to look down into." One is reminded of the poets' suggestion, repeated by Carlyle and Matthew Arnold, that the source of the river of imagination and emotion lies in the depths of man, the "blind cavern, where is faintly heard the sound of waters." Even the most naive reader of "Kubla Khan" will grasp the symbolic significance of that

> . . . deep romantic chasm which slanted
> Down the green hill athwart a cedarn cover!
> A savage place! . . .
>
> And from this chasm, with ceaseless turmoil seething,
> As if this earth in fast thick pants were breathing,
> A mighty fountain momently was forced: (ll.12-14, 17-19)

Clearly, the stream as it comes to Ruskin from the Romantic poets is permeated with associations congenial to his fantasies. It becomes the bearer of those drives and fears to which he cannot give a more conscious expression.[49]

If the Romantic poets provide the inspiration for Ruskin's very personal use of the stream image, so early economists and social critics precede him in applying the image to the economic sphere. Economists of all shades speak of the "streams" or "flow" of wealth. They differ over the degree to which these streams should be channeled and controlled. The mercantilists were the first to use stream imagery to describe the course of foreign trade. They were followed, in turn, by the physiocrats in France and by Adam Smith, Ricardo, and the English classical economists, who apply the image to domestic as well as foreign trade. At the same time, radical critics like Godwin, Owen, Abram Combe, and the Ricardian socialists write in more Ruskinian terms of the "streams of prosperity," which should be "fructifying and gladdening" society but which have been diverted by mismanagement. Much later, Karl Marx, in his *Critique of the Gotha Program* (1875), describes the highest phase of communism as a time when "all the springs of cooperative wealth flow more abundantly." Even Coleridge, in his infrequent but perceptive specu-

lations on economics, proposes a government policy of taxation to stimulate the "circulation" of the streams of wealth. Coleridge is the only writer before Ruskin to bring together the personal and social connotations of streams. This conjunction strikes Ruskin with a force and intensity of which not even he is fully conscious.[50]

In conclusion, it is with a sharp personal thrust that Ruskin baits the members of the Public Institutions Committee in 1860. When asked about the advantages which might accrue to workingmen by opening art galleries at night, Ruskin remarks that, until labor is made less competitive and its hours closely regulated, workers will have no time for such amenities. Again, when asked whether he intended to cast a slur upon the idea of competition, Ruskin declares: "Yes, very distinctly; I intended not only to cast a slur, but to express my excessive horror of the principle of competition, in every way." Ruskin is now ready to override his parents' objections and undertake the "great essay on man's work" which he had threatened to write much earlier.[51]

V Bastard Science

The year 1860 is an important one in Ruskin's life. It marks, in his own words, "the beginning of the days of reprobation"—of a "new epoch of life and death." Although he has long been moving toward social criticism, there is a real change. No longer does he conceal his critique behind a façade of artistic studies. He has pleased his father by finishing *Modern Painters* and feels free to embark openly onto the rough waters of social and economic thinking. Ruskin does not consider his earlier art studies wasted. In the preface to *Munera Pulveris*, he writes, "No exhaustive examination of the subject [economics] is possible to any person unacquainted with the value of the products of the highest industries, commonly called the 'Fine Arts.' " Ruskin begins this "exhaustive examination" at Chamonix in the shadow of Mont Blanc, where he had begun *Modern Painters* and received his original inspiration concerning typical beauty in nature. Here in the summer of 1860, he writes *Unto This Last*, "the only book, properly to be called a book, that I have yet written."[1]

Unto This Last and its sequel *Munera Pulveris* must be considered together, for they contain the theoretical core of Ruskin's social criticism. In them, he exposes what he believes to be the ideological root of competition and social waste, orthodox political economy, and attempts to construct a true economic theory which will provide accurate guidance in the managing of social abundance. *Unto This Last* is the better organized and more readable of the two works. It is chiefly concerned with the task of destructive analysis. *Munera Pulveris*, written in the years 1862 and 1863, when Ruskin's relations with his parents have worsened, is discursive and only an introduction to the great constructive work which he hoped to write. This chapter will treat the broad outlines of Ruskin's attack on classical economics—his criticism of its method and scope and, most important, its neglect of ethical considerations. It will also weigh the justice of Ruskin's attack and trace its antecedents. One thing is certain. Ruskin makes no attempt to conceal his position. "The Science of Political Economy *is* a Lie," he writes,

wholly and to the very root (as hitherto taught). It is also the Damned-
est ... that the Devil, or Betrayer of Men, has yet invented. To this "science,"
and to this alone ... is owing *All* the evil of modern days. I say All. ... It is *the*
Death incarnate of Modernism ... the most cretinous, speechless, paralysing
plague that has yet touched the brains of mankind. (17.1xxxii)

Ruskin is not alone in his opinion of the "bastard science" of politi-
cal economy. Wordsworth speaks of the doctrine "false as mons-
trous," Southey of the "foul philosophy" or "pseudo-science of poli-
tical economy," Thomas Arnold of the "one-eyed" race of econ-
omists, and Carlyle of the "Pig Philosophy." Beside Ruskin's
thorough criticism of political economy, these outbursts seem the
purest slander. Nowhere is Ruskin's attempt to draw out the implica-
tions of Romanticism more evident than in his study of economics.[2]

2

In Ruskin's critique of classical economics, the "drive to human-
ity" which has impelled him from art to the Gothic and finally to
society finds its full expression. The first error of orthodox theory is
that it bears no relation to living men. Its assumption of an economic
man is false—just as false as the postulate of an aesthetic man in art
or of a Utilitarian man in moral philosophy. At the end of *Modern
Painters,* Ruskin strikes the central note of his economic criticism.
He deplores the "imbecility" of economists who believe that man is
moved only by "brutish, covetous, contentious instincts." Ruskin
repeats this theme many times in the course of his career. In *Unto
This Last,* he accuses the classical economists of viewing honesty as a
"disturbing force which deranges the orbits of political economy"
and, in *Fors Clavigera,* of founding economic science on "what you
have stated to be the constant instinct of man—his desire to defraud
his neighbor." These comments reveal the ethical concern behind
Ruskin's discussion of the method of political economy.[3]

Without its ethical edge, Ruskin's first criticism of classical eco-
nomics is thoroughly empirical. His purpose is to refute the notion
that "an advantageous code of social action may be determined irre-
spectively of the influence of social affection." Economic behavior,
like artistic behavior, is an expression of the whole man. It cannot be
isolated from emotions and affections. He condemns the abstract
method which leads political economists to set up the fiction of a
rational, selfish man, preoccupied with material wealth. He recog-
nizes that the economists are deliberately abstracting from human

conditions and intend to modify their deductions before applying them in practice:

"The social affections," says the economist, "are accidental and disturbing elements in human nature; but avarice and the desire of progress are constant elements. Let us eliminate the inconstants, and, considering the human being merely as a covetous machine, examine by what laws of labour, purchase, and sale, the greatest accumulative result in wealth is obtainable. Those laws once determined, it will be for each individual afterwards to introduce as much of the disturbing affectionate element as he chooses, and to determine for himself the result on the new conditions supposed." (17.25)

Ruskin admits that this would be a logical method "if the accidentals afterwards to be introduced were of the same nature as the powers first examined." But they are not: "They alter the essence of the creature under examination the moment they are added; they operate, not mathematically, but chemically, introducing conditions which render all our previous knowledge unavailable." "Observe," he continues, "I am here considering the affections wholly as a motive power; not at all as things in themselves desirable or noble. . . . I look at them simply as an anomalous force, rendering every one of the ordinary political economist's calculations nugatory. . . ."[4]

In Ruskin's view, a political economy which does not perceive, "if not the moral, at least the passionate element to be an inextricable quality in every calculation" has no claim to be a science of human relations. Its deductions are valid for cloud-cuckoo land. The only realistic view of man is an organic or "chemical" one which places as much emphasis on his social affections and aesthetic needs as on his avarice. The *soi-disant* science of political economy resembles "a science of gymnastics which assumed that man had no skeleton"— logically reasoned but totally inapplicable to human conditions. Or, better, "Assuming, not that the human being has no skeleton, but that it is all skeleton, it founds an ossifiant theory of progress on this negation of a soul. . . ."[5]

Ruskin demonstrates the irrelevance of political economy to human conditions by considering the relationship of master and domestic servant. Classical economics fails in its obvious purpose of teaching men how to make money. If the master followed the precepts of "ordinary" economists, the limits of his harsh treatment would be set only by the practice of other masters in the neighborhood. Since the servant is not a rat or a steam engine but an engine with a soul, "the force of this very peculiar agent enters into all the political economist's equations, without his knowledge, and falsifies every one

of their results." The greatest quantity of work will be gotten from the servant only when his will is "brought to its greatest strength by its own proper fuel: namely, by the affections." Orthodox political economy cannot instruct one how to make money because it ignores the wholeness or, as Dickens puts it, the "unfathomable mystery" of human nature.[6]

Ruskin's first criticism of orthodox theory is a criticism of method. He claims that classical economics, even within its narrowly defined scope, is unrealistic, a "pseudo-science." Its abstract, deductive approach prohibits contact with the facts of human nature. This empirical mode of criticism has a long tradition in the history of economic thought. The Abbé Galiani (1728-1787) criticizes François Quesnay and the French physiocrats for making economics an abstract science. With the rise of the classical school in England, such criticism gathers strength until the "historical" economists play an important role in the reconstruction of classical theory after 1860. The "historists" Wilhelm Roscher, Karl Knies, and Gustav von Schmoller in Germany and T. E. Cliffe-Leslie, John Kells Ingram, and Arnold Toynbee in England substitute an inductive, empirical approach for the abstract, deductive one of the classical school. On the Continent, this leads to the famous *Methodenstreit.* There is little to distinguish the historical economists' criticism of the method of classical economics from that of Ruskin. Knies in Germany and Cliffe-Leslie in England attack the orthodox school's assumption that man is motivated by selfish interests. Bruno Hildebrand suggests that the classicists "transform political economy into a mere natural history of egoism." Ruskin, though no professional economist, takes his place in one of the nineteenth century's major reform movements in economic thought.[7]

This place is a tenuous one. Ruskin shows no interest in the writings of the historical economists. He never mentions the German economists, and the English "historists" were too young to influence him. Indeed, Cliffe-Leslie and Arnold Toynbee acknowledge Ruskin's influence on their own development. That Ruskin should not have been closely associated with the historical economists is not surprising. He differs from them in his ethical absolutism and his refusal to contemplate the relativism implicit in the study of historical development. Ruskin's criticism of the abstract, deductive method of orthodox political economy is negative. He proposes no program of inductive, empirical analysis. For him, the attack on abstraction is a means of opening the door to ethical considerations. Although Ruskin in-

sists that kindness and justice are empirically as essential to human nature as is avarice, this is not the real point of his argument. He is not interested in empirically examining human nature and refuses to use the tools of psychology to delve beneath the framework of traditional virtues and vices. His view of the awful unity and complexity of human nature serves to thwart any ethically neutral approach, abstract or inductive. It gives full license to the "dictates of paramount and infallible conscience."[8]

Ruskin's discussion of disputes between employers and workmen illustrates his use of complexity. In "the first vital problem" of political economy, Ruskin writes, economists are "practically mute." "Disputant after disputant vainly strives to show that the interests of the masters are, or are not, antagonistic to those of the men; none of the pleaders ever seeming to remember that it does not absolutely follow that the persons must be antagonistic because their interests are." Even if this were so, the circumstances which influence the interests of men are infinite. "All endeavour to deduce rules of action from balances of expediency is in vain." Man can know only the "balances of justice" and follow these, certain that the "consequences will be the best possible." Ruskin's argument is identical to that of the eighteenth-century theologian Joseph Butler (1692-1752). Butler makes the infinite complexity of human relations the basis of his case for following the dictates of conscience instead of utilitarian calculation. In Ruskin's hands, Butler's argument becomes a way of applying to economics the Romantic distinction between the imagination which intuits ultimate principles and the "calculating understanding" which judges from expediency.[9]

Ruskin's ethical and Romantic bias places him closer to Simonde de Sismondi (1773-1842) than to any other economist critical of the abstractions of the classical school. Sismondi is best known today for his vast histories of Italy and France. Nonetheless, his *Nouveaux principes d'économie politique* (1819) is a landmark in radical economic criticism. With Sir James Steuart in Scotland, Richard Jones in England, and Friedrich List in Germany, Sismondi ranks as a precursor of the historical school of economics. He warns against the economists' tendency to simplify and generalize. As early as 1803, he declares that economics

is not founded on dry calculations, nor on a mathematical chain of theorems. . . . Political economy is founded on the study of man and of men; human nature must be known, and also the condition of life and societies in different times and in different places.

He criticizes classical economists for ignoring the "complexity of things" and for "supposing a hypothetical world entirely different from the real world." Sismondi rejects the assumption of economic man and urges the study of real producers and consumers. He differs from other advocates of an empirical approach in the extent of his ethical concern. For him as for Ruskin, the attack on method is a way of injecting ethics into economic analysis. Unlike Ruskin, Sismondi retains a strong interest in making economics more accurate as a science. Ruskin's debt to the Swiss scholar is unknown. Although he was familiar with Sismondi's history of the Italian republics, it is difficult to determine whether he had read the *Nouveaux principes.* Two years before the publication of *Unto This Last,* Ruskin could have found his criticism of economic man in a book published by the American economist Henry C. Carey.[10]

To discover the antecedents of Ruskin's critique, one would do well to turn from the history of economics to more Romantic fields. Robert Southey condemns political economy for defining man as a "manufacturing" animal. It estimates his importance "by the gain which can be extracted from him." To Wordsworth, Coleridge, and Southey, economic man resembles the rational, atomistic man of the Enlightenment—the man of their own revolutionary or "pantisocratic" phases.[11] Coleridge criticizes the "solemn humbug" of political economy for ignoring the "true and unerring impulses of our better nature." Economists assume man's selfish desire for material goods to be universal and constant to the neglect of sentiment, imagination, and force of habit. It is this empirical study of real men which John Stuart Mill finds appealing in Coleridge's thought and lacking in the abstractions of his father and Jeremy Bentham. For Coleridge, there is little difference between economic and Utilitarian man. Both rely on the calculating understanding and neglect the "enlarged systems of action" suggested by imaginative intuition. Hazlitt, Carlyle, and Dickens agree. They see in political economy the sort of Utilitarian "motive-grinding" which reduces man's soul to a "patent engine." Ruskin follows the Romantics. He hails economic man as the latest manifestation of a long and undesirable historical development including neoclassicism, Jacobinism, and mechanism. He is the final product of the "foul torrent" of the Renaissance.[12]

Ruskin's adoption of the Romantic tradition is so eclectic that he can incorporate into his criticism of economic man elements from a very different tradition, that of Robert Owen and the Ricardian

socialists. Ruskin's "engine with a soul" resembles Owen's "living machines." Ruskin agrees with Owen that the businessman can turn benevolence to his own profit since the "machines" perform most efficiently when treated with justice. In an essay on the "Social System" (1821), Owen expands his awkwardly phrased perception into a criticism of economic man. He complains that economists reason as if men were "mere machines" without understanding or sentiment. William Thompson takes a similar position. He accuses the economists of being "mechanical speculators" who view man as a self-interested "mechanical agent" without intelligence or emotions. For Thompson as for Ruskin, man is a "complicated being," and the economist's deductions must be based on that assumption.[13]

Ruskin is not the first Victorian whose social criticism spans Owen-ite and Romantic concerns. The Christian Socialists Frederick Denison Maurice, Charles Kingsley, and John M. Ludlow combine both elements more fully and more consciously than does Ruskin. Ruskin became acquainted with the Christian Socialists through his friend F. J. Furnivall and taught a drawing class at the Working Men's College from 1854 to 1860. The Christian Socialists criticize the abstractions of classical economics in terms similar to Ruskin's. In his lecture on *Christian Socialism and its Opponents* (1851), Ludlow accuses the economists of studying the mechanical processes of exchange and ignoring the men behind them, men with emotions and social affections. Ruskin may have learned much from his association with the Working Men's College.[14]

The eclecticism of Ruskin and the Christian Socialists should surprise no student of nineteenth-century England. Coleridge and Southey praise Robert Owen. What is surprising is that, while Coleridge and Southey show by their reservations their essential disagreement with Owen's view of human nature, the Christian Socialists seem unaware of the conflict between Owenite and Romantic assumptions. Ruskin scarcely mentions the Owenites. By 1850, the Victorian mixture has gone far toward settling. Even now, the scholar can hear Ruskin asserting that any discussion of the nineteenth-century sources of his thought is irrelevant and that his ideas on economic method are those of the Greeks. Xenophon believes that the subject of economics is the whole man and notes the advantages of treating servants with kindness. Very well, but perhaps there was something "in the air" of his own age which encouraged Ruskin to find what he did in the ancients.[15]

3

Ruskin is not content to attack the abstract method of orthodox political economy. He also criticizes its scope. Having demonstrated that political economy is empirically false on its own ground as the science of making money, he now denies that this is its proper ground. His second criticism of classical economics is that its scope is too narrow. It treats society, not as an organic whole, but as an aggregate of discrete individuals motivated by private gain. It is a political economy of "dust" (*pulveris*) instead of diamonds. It is not truly "political" and resembles an aestheticism which ignores the artist's relation to society. Classical economics generalizes from the profitable actions of individuals and confuses private gain with social wealth. A true political economy, "the economy of a State, or of citizens," would not rely on the "partial views" of the "meddling intellect."[16]

Ruskin's concept of a social whole in which economic behavior is social behavior owes much to the Romantic tradition of organicism. Coleridge, Southey, and Carlyle warn of the dangers of a mechanical approach. They refuse to isolate the economic aspect of social processes. Ruskin is chary of recognizing his immediate forebears. Instead, he claims that his task in economics is simply to call attention to the wisdom of the ancient Greeks. Ruskin's vision of the scope of economics does bear a remarkable similarity to that of the Greeks. Plato, Aristotle, and Xenophon consider economics a subordinate branch of politics, the study of society. They never contemplate writing separate treatises on economic phenomena. Though lacking the moral incentive of Greek philosophy, the English mercantilists and German cameralists also view economic problems as social and political problems. It will soon be evident how close Ruskin's mode of handling economic phenomena is to that of the mercantilists. In a sense, Ruskin's welfare economics is a domesticized and moralized mercantilism.[17]

The study of economics follows the path of Adam Smith and Ricardo, not that of the "last" mercantilist Sir James Steuart (1712-1780). Although it attempts to free itself from social considerations, it retains a number of critics who adopt a social or national point of view. Among these, Sismondi foreshadows Ruskin. He takes a broad view of the scope of economics, defining it as a "moral science where all the facts are interwoven." He admits a debt to Xenophon and the

Greeks. The German "national" economists Adam Müller (1779-1829) and Friedrich List (1789-1846) also assert the unreality of an economic science which denies the "mysterious reciprocity of all the relationships of life." Many years before Ruskin, List refuses to give the name political economy to a science vitiated by "a disorganizing particularism and individualism." The German and English historical economists repeat these sentiments. They urge their colleagues to study the facts of social as well as individual existence. Ruskin lacks the emphasis on historical development and relativity which characterizes the national and historical critics. Although he uses the argument familiar to Müller, List, and the historical economists that the laws of classical economics are applicable only to England and only to a certain stage of her development, he does not consider its implications relevant to his own work. Ruskin's organicism of the surface does not prevent him from seeking universal laws of his own, laws more comprehensive than those of the classical school. To formulate theories able to grasp the complexity of social reality, he calls for the removal of barriers between economics and the social sciences. Ruskin, Saint-Simon, August Comte, Herbert Spencer, and the historical economist become improbable, methodological bedfellows.[18]

Ruskin's criticism of the scope of classical economics takes a more specific shape in his distinction between individual and social wealth. He believes that orthodox economists ignore the latter. They teach the art of making the individual monetarily rich and of "keeping his neighbour poor." Money, for Ruskin, is a legal document of debt. It signifies a claim upon the labor of others. Classical economics is not "political," but "mercantile," the economics of *merces* or "pay"— the science of "the accumulation, in the hands of individuals, of legal or moral claim upon the labour of others." Since every claim implies "precisely as much poverty or debt on one side, as it implies riches or right on the other," economics becomes "the art of establishing the maximum inequality in our own favour."[19]

Ruskin's point is that "the establishment of such inequality cannot be shown in the abstract to be either advantageous or disadvantageous to the body of the nation." He believes that most economic fallacies have their root in the "absurd assumption that inequalities are necessarily advantageous." Political economists suffer from a failure of imagination—a failure to see things in their true scope and organic connection. They fail to see that the "beneficialness of the inequality depends, first, on the methods by which it was accom-

plished; and, secondly, on the purposes to which it is applied." Here Ruskin gives a theoretical edge to his demand for social responsibility on the part of the wealthy. To prove that "the establishment of mercantile wealth" may signify "a political diminution of real wealth," Ruskin takes the case of a Robinson Crusoe island economy in which the forestalling of a middleman diminishes the abundant wealth "in substantial possessions." He compares the circulation of wealth in any society to that of blood in the body. The circulation should be "soft, warm, steady," not clotted by the attempts of individuals to gain private advantage by establishing an artificial scarcity.[20]

The distinction between public and private or national and individual wealth is a common one among unorthodox economists. The eccentric Lord Lauderdale (1759-1838) is the first to emphasize it. Lauderdale rejects Smith's assumption that the "sum-total of individual riches forms an accurate statement of public wealth." He anticipates Ruskin in his use of the words "riches" and "wealth." Behind Lauderdale's distinction lies a more important one between real and exchange value. A commodity possesses real value and constitutes "wealth" when it is "useful or delightful to man"; it possesses exchange value and constitutes "private riches" when it is scarce as well. The idea that scarcity is a prerequisite of exchange value or private riches provides the clue to Lauderdale's criticism of Smith. He concludes his argument by noting that "the common sense of mankind would revolt at a proposal for augmenting the wealth of a nation, by creating a scarcity of any commodity generally useful and necessary to man." As early as 1804, Lauderdale states one of Ruskin's premises.[21]

Lauderdale and his followers strike one as at best partial precursors of Ruskin. The idea of a conflict between private riches and public wealth is there, but in the wrong setting. When one comes to Sismondi, one finds not only the idea but also a similar motivation—an intense concern for the welfare of the lower classes. Even the style of Sismondi's argument resembles Ruskin's. While Ruskin describes political economy as a "mercantile science" or, from the Greek, a science of "catallactics," Sismondi turns to Aristotle and declares it to be mere "chrematistics." "Chrematistics" increases monetary value at the expense of national well-being. Sismondi accuses the classical economists of ignoring the health of the population. They encourage the entrepreneur to maximize net profit at the expense of gross

production. This is a less felicitous version of Lauderdale's theory of the role of scarcity in increasing "riches." Similar complaints are voiced by J. P. de Villeneuve-Bargemont (1784-1850), François Droz (1773-1850), and Eugene Buret (1810-1842) who were influenced by Sismondi and who were much interested in Catholic Socialism. They resemble Ruskin in the ethical intent of their theoretical criticisms.[22]

Mention of the French economists suggests that Ruskin may owe something to the Christian Socialists in England on the scope of political economy. J. M. Ludlow was familiar with French socialist and cooperative thinking. In *The Christian Socialist* (1851), he refuses to grant the orthodox school the name political economy. What "mercantile science" is to Ruskin and "chrematistics" to Sismondi, "plutonomy" is to Ludlow. The orthodox economists are mere "plutonomists" because they confuse private "riches" with public "weal" or "welfare" and concern themselves with commercial gain. A true political economy would penetrate beneath the dead machinery of economic processes and become "a science of the relations of men." It would be "Socialism." The combination of economic criticism, demand for an improved sociology, and ethical exhortation in Ludlow's thought reminds one of Ruskin and, to keep a proper perspective, Comte.[23]

Again, the Ruskin scholar hears the "master" discounting the need for perspective and urging a return to the Greeks. Sismondi and Ruskin freely admit the Greek source of their distrust of a science of making money. Aristotle distinguishes between economics proper, or household management, and "chrematistics," the art of wealth-getting or acquisition. "Chrematistics" may be natural or unnatural—natural if wealth is sought to fill basic needs and unnatural if sought for unlimited gain. The natural procuring of wealth is a necessary, though subordinate, part of economics. Neither Ruskin nor Sismondi accepts Aristotle's restriction of economics to the household. They enlarge his definition to include the management of society, a field reserved by Greeks for "politics." At the same time, Aristotle's distinction between natural and unnatural acquisition lingers on in their low opinion of a science devoted to increasing private riches. To what extent Ruskin, in his tribute to the Greeks, is pointing to the real source of his criticism of the scope of political economy is debatable. The Greeks, like Sismondi or the Christian Socialists, may have sharpened ideas concerning the public-private

dichotomy found originally in the social criticism of Coleridge and Carlyle or in the propaganda of the Owenites and Ricardian socialists. Indeed, the idea of a conflict between public and private interests is a part of almost every English thinker's conceptual framework since the time of Hobbes. It lies behind Ruskin's attempts to prevent the waste of a social abundance.[24]

<div align="center">4</div>

Ruskin's third criticism of orthodox political economy is implicit in his criticism of its method and scope. It neglects moral considerations. In Ruskin's mind, this is the most important point. Earlier, he had brought ethics into aesthetics by enlarging the sphere of art and by destroying the fiction of an aesthetic man. Now, he frames his criticism of the scope and method of political economy with the intention of injecting ethics into economics. How he does this in his criticism of economic man and the abstract method of political economy has been noted. Ruskin follows the same tack in the matter of scope. By enlarging the scope of political economy to include the study of man as a "social being," he moves economics into a field of such complexity that, to Ruskin's way of thinking, ethical rules and the dictates of conscience are the only valid guides. Ruskin's way of thinking is not the only one. One might criticize the method and scope of classical economics without considering ethics. One might call upon economists to study more carefully the facts of historical development or the results of sociological and psychological investigation. The historical economists do attempt to fashion an ethically neutral criticism of the classical school and to view the ethical concerns of a society as one more historical datum. Ruskin cannot accept this relativity. To him ethical values are absolute and universal. They are unavoidable aspects of the nature of man and society.

Ruskin's style of argument appears in one of his many sallies against John Stuart Mill. In *Unto This Last*, he takes Mill's statement that wealth "consists of all useful and agreeable objects which possess exchangeable value." He proceeds to show that, since "usefulness" and "agreeableness" have a human reference, "political economy, being a science of wealth, must be a science respecting human capacities and dispositions." "But," he adds sarcastically, paraphrasing and distorting Mill, "moral considerations have nothing to do with political economy. Therefore, moral considerations have nothing to do with human capacities and dispositions." Ruskin believes

that, once economists grasp the true nature of man and society, they will be forced to adopt ethical values. All Ruskin has to do to inject ethics into economics is to demonstrate that the science is narrow and unrealistic, just as earlier he had demonstrated that the neoclassical conception of art was superficial. A criticism of the scope and method of classical economics is per se a criticism of its neglect of ethical factors. Both prongs of Ruskin's attack are implicit in his definition of political economy as a "system of conduct and legislature, founded on the sciences, directing the arts, and impossible, except under certain conditions of moral culture."[25]

Convinced that his position is obvious, Ruskin asserts the ethical implications of his economic critique. "The whole question," he declares,

respecting not only the advantage, but even the quantity, of national wealth, resolves itself finally into one of abstract justice. It is impossible to conclude, of any given mass of acquired wealth, merely by the fact of its existence, whether it signifies good or evil to the nation in the midst of which it exists. Its real value depends on the moral sign attached to it, just as sternly as that of a mathematical quantity depends on the algebraical sign attached to it. . . . That which seems to be wealth may in verity be only the gilded index of far-reaching ruin. . . . The idea that directions can be given for the gaining of wealth, irrespectively of the consideration of its moral sources, . . . is perhaps the most insolently futile of all that ever beguiled men through their vices. (17.52-53)

Social dogmatism grows on Ruskin as Evangelical fades. It conceals the vitality or "purity" of his thought under a weight of "purism."

Ruskin's ethical approach lends an important quality to his economic criticism—a strong practical bias. The devotion to action, which he shares with many Victorian intellectuals and, indeed, with many Victorian businessmen, colors his criticism of economics in the same way that his desire to improve the souls of his countrymen colored *Modern Painters*. He assumes that the purpose of economics is to give directions to gain and manage wealth in a socially useful way. Science serves art and suggests "an advantageous code of social action." Since classical economics is a practical discipline, he condemns it for selecting the wrong means to attain its end and for pursuing the wrong end, riches instead of wealth. He never contemplates the possibility of an economic science concerned only with things as they are. It is this emphasis on practice and "doing" which leads Ruskin to reject *laissez faire* both as a hypothetical model to facilitate the study of economic forces and as a practical imperative to do nothing. Ruskin's practical zeal makes him uninterested in how

things work by themselves. He fails to recognize the value of hypothetical studies when used cautiously. As for the policy of *laissez faire*, his belief that it encourages rampant competition and social waste is, in part, but the capping stone on his profound distaste for doing nothing.

Most writers on economics before the rise of the classical school evince an ethical and practical concern similar to Ruskin's. Ruskin dissects the present with the tools of the past. For the ancient Greeks, the early Church Fathers, and the medieval Scholastics, economic behavior is governed by moral and religious prescription. It is subject to strict regulation by the community. In the writings of Plato, Aristotle, and Xenophon, wealth-getting serves the "good life" and the dictates of justice. It is a subordinate aspect of politics and ethics. The Greeks' practical emphasis colors their definition of economics as the art of managing the household. Although, for Ruskin, economics is the study of society, he gives the same importance to management and makes the household his favorite model for explicating economic relationships: "As domestic economy regulates the acts and habits of a household, political economy regulates those of a society or State, with reference to the means of its maintenance."[26]

One would not readily associate the English mercantilists or German cameralists with Ruskin and Aristotle on the relation of economics and ethics. Yet, apart from its amoral purpose of increasing state-power, the form of mercantilist thinking is very similar to Ruskin's. There is the same subordination of economics to a larger purpose, the same practical imperative, and the same treatment of economics as an art which guides the statesman in the control of economic processes. The model of domestic management appears frequently in the writings of mercantilists and cameralists.[27] That the mercantilist approach could, on occasion, accept a Ruskinian or "welfare" content is seen in the work of Sir James Steuart and Bishop Berkeley, whose *Querist* (1735-37) Ruskin cites. Steuart and Berkeley reveal an intense ethical purpose and shift the focus of mercantilism from foreign to domestic matters. They, too, praise Xenophon.[28]

With the rise of "scientific" economics in the form of physiocracy and the classical school, thinkers who assert a close connection between economics and ethics are forced into heterodoxy. They tend to be the same thinkers who criticize the scope and method of classical economics. Two groups can be distinguished. The first includes

those for whom ethical considerations take precedence over and in-
spire technical criticisms: Sismondi, the English Christian Socialists,
the Owenites, most Continental socialists, and the Romantics Cole-
ridge, Southey, and Carlyle, who, in a cursory fashion, criticize the
classical school for ignoring ethical values. The list is crude and
chaotic, but these are the thinkers with whom Ruskin finds a place as
one who comes to economic criticism by the path of ethics. Sis-
mondi seems closest in tone to Ruskin. Not as radical as the socialists
but deeply concerned for the well-being of the lower classes, he
defines political economy as, at its widest, "the theory of charity"
(*la théorie de bienfaisance*). Its purpose is to "increase the happiness
of mankind."[29]

The second group of ethical critics attack the classical school for
reasons which are not in the first place ethical. They note a lack of
national awareness or historical perspective. Later, they are drawn to
assert the importance of ethical factors by the complexity of the
issues involved. In this group, one finds the national economists
Müller and List and the historical economists in Germany and Eng-
land. Both "nationalists" and "historists" turn to ethics in the course
of relating economics to a broader social sphere. Müller and List, for
example, discover a "spiritual capital" or "productive power" which
a true political economy must preserve and nourish. The "spiritual
capital" of the nation depends on the moral condition of its inhabi-
tants. The historical economists are torn between asserting the neu-
trality of the inductive, historical approach and judging the results of
their inductive studies in terms of the "high moral issues to which
the economic movement is subservient." The ethical concern of most
historical economists suggests the inevitability of turning to ethics in
a period when sociology is not a verifiable science. Auguste Comte,
who exercised great influence over the English historical economists,
combines ethics and sociology in equal parts. Ruskin's step from
criticizing the scope of economics to asserting moral values is not an
unusual one. But Ruskin does not wait for the tools of economic and
social investigation to fail. With him as with Sismondi and the social-
ists, the ethical impetus is present from the start.[30]

Both groups of ethical critics display a strong practical urge. Many
use the model of domestic management which Ruskin and the
Greeks find so attractive. This is not the place to compare the modes
of practical action or "management" which the heterodox econ-
omists of the nineteenth century advocate. The purpose of this and

the preceding sections has been served if the reader grasps that Ruskin, far from being a dangerously original critic of the scope and method of political economy, stands in a main tradition of economic thought. Even in the nineteenth century, he has many predecessors.

5

That Ruskin is not alone in his criticism of orthodox political economy by no means proves his possession of the truth. It may only demonstrate the longevity of error. In discussing the accuracy of Ruskin's attack, one can treat his three major criticisms of orthodoxy as one. For Ruskin and for many of his nineteenth-century predecessors, they stand or fall together. The scope of political economy is to be enlarged to include ethical considerations by the use of a more empirical method which will force economists to examine the real nature of man and society. Insofar as the classical economists deal with these criticisms, they consider them to be directed at a single target, the abstract quality of their science. One can distinguish two levels of Ruskin's attack. At the beginning of *Unto This Last,* he admits that the professional economists intend to modify their abstract model in practice. He concentrates his attack on the impossibility of making the necessary changes without transforming the character of the science. In less charitable moods, he accuses the economists of not understanding the abstract and hypothetical nature of their science or, worse, of deliberately concealing it in an attempt to defend the position of the wealthy.

On the second count, Ruskin is wrong. As John T. Fain has shown, the leading economists of Ruskin's day are aware of the abstract, limited view of man and wealth taken by their science. Even earlier economists defend their abstract approach and reveal an awareness of "disturbing factors." Within the classical school, there are intensely argued differences on scope and method.[31]

The Malthus-Ricardo exchange of letters is the earliest and most famous of these. Malthus, with his interest in short-term phenomena and practical application, criticizes Ricardo for basing his theoretical models on unrealistic assumptions. In the preface to his *Principles of Political Economy* (1820), Malthus warns agains the "precipitate attempt to simplify and generalize." It results in an "unwillingness to acknowledge the operation of more causes than one in the production of particular effects" and "an unwillingness to bring theories to the test of experience." Because the practical consequences of eco-

nomic theory "depend upon the agency of so variable a being as man," economics "bears a nearer resemblance to the science of morals and politics than to the science of mathematics." Malthus' criticisms of Ricardo closely resemble Sismondi's. The two writers acknowledge the similarity and point to Adam Smith as a true practitioner of economic method.[32]

Adam Smith is the source of several conflicting strands in classical theory. Writing at an early stage in economic analysis and influenced by the empiricism of Hume and the deductive approach of the French physiocrats, he is neither methodologically self-conscious nor completely decided concerning the scope of his subject. Smith combines induction and deduction in a haphazard fashion and supports his conclusions with examples drawn from history, not from his imagination as does Ricardo. Economic man, though certainly present in *The Wealth of Nations* (1776), is not the rigorously calculating, totally self-interested sort he later becomes. Smith had written *The Theory of Moral Sentiments* (1759) with its discussion of sympathy and desire for approbation. He knows that man is ruled by "passions" as well as self-interest. Although the relation between *The Wealth of Nations* and *Moral Sentiments* is a point of controversy, Smith recognizes the need to place economics in a setting of social philosophy. More important, he studies economics from a national point of view. On the question of agriculture or the home trade, he is capable of distinguishing between "private profit" and "public advantage," Lauderdale and Ruskin notwithstanding. Smith suggests that, while the mass of the people live on gross production, it is the aim of monopolists to maximize net profit. Even Ricardo distinguishes between exchange value and "riches." By increasing the abundance of goods, a nation decreases values but adds to the "national riches." Finally, Smith and Malthus emphasize the practical end of economic science. Smith defines economics in mercantilist terms as the art of increasing national wealth. It provides recipes for the "statesman." Both he and James Mill use the analogy of a domestic economy. Ruskin's own use of the analogy derives as much from Smith or Mrs. Marcet as from the ancient Greeks.[33]

The older classical economists, Smith, Ricardo, and Malthus, are in some respects far less "classical" than their critics portray. This is not to say that their method is inductive or empirical. Malthus' criticisms are aimed at making the abstract premises of deductions more realistic. It is to say that, implicitly or explicitly, they reveal an aware-

ness of the problems of method and scope which, according to Ruskin, they neglect. They are not just concerned to teach the art of getting rich by whatever means.

The leading political economists of Ruskin's day, Nassau Senior (1790-1864), John Stuart Mill (1806-1873), and John E. Cairnes (1823-1875), are more conscious of method and scope. They readily admit the abstract nature of their science and the narrow definition of wealth and man on which it is based. For Senior, political economy is the science which treats only of "wealth." Wealth, in turn, is defined as

those things, and those things only, which are transferable, are limited in supply, and are directly or indirectly productive of pleasure or preventive of pain; or, to use an equivalent expression, which are susceptible of *exchange. . . .*

Senior assumes that "every person is desirous to obtain, with as little sacrifice as possible, as much as possible of the articles of wealth." He defends his assumption of economic man:

We must not be supposed to mean that everybody, or indeed anybody, wishes for an indefinite quantity of everything; still less as stating that wealth, though the universal, either is, or ought to be, the principal object of human desire. What we mean to state is . . . that every person has some unsatisfied desires which he believes that additional wealth would gratify. The nature and urgency of each individual's wants are as various as the differences in individual character. Some may wish for power, others for leisure; some require bodily, and others mental amusement . . . and there are few . . . who, if it could be done by a wish, would not benefit their acquaintances and friends. Money seems to be the only object for which the desire is universal; and it is so because money is abstract wealth. (*Political Economy,* p. 27)

Senior cannot be accused of confusing his abstractions with actual conditions.[34]

John Stuart Mill also recognizes the abstract, deductive nature of economic science. In his astute essay "On the Definition of Political Economy" (1836), he distinguishes between natural and moral sciences. Moral sciences cannot employ the method of empirical experiment. Political economy is a moral science and one which treats man not as an individual but as a member of society.[35] It does not, however, study "every part of man's nature, insofar as influencing the conduct or condition of man in society":

It is concerned with him solely as a being who desires to possess wealth. . . . It makes entire abstraction of every other human passion or motive; except those which may be regarded as perpetually antagonizing principles to the desire of

wealth, namely, aversion to labour, and desire of the present enjoyment of costly indulgences. . . . Political Economy considers mankind as occupied solely in acquiring and consuming wealth; and aims at showing what is the course of action into which mankind, living in a state of society, would be impelled, if that motive, except in the degree in which it is checked by the two perpetual counter-motives above adverted to, were absolute ruler of all their actions. . . . Not that any political economist was ever so absurd as to suppose that mankind are really thus constituted, but because this is the mode in which science must necessarily proceed. . . . There is, perhaps, no action of a man's life in which he is neither under the immediate nor under the remote influence of any impulse but the mere desire of wealth. . . . But there are certain departments of human affairs, in which the acqusition of wealth is the main and acknowledged end. It is only of these that Political Economy takes notice. (*Col. Works,* IV, 319-323)

It would seem that Ruskin's entire vision of economics lies beyond Mill's definition.

Later in the essay, Mill stresses the hypothetical character of his science and its assumptions. Mill must be allowed to speak at length, for it is this that neither Ruskin nor most Ruskin scholars have allowed him to do:

In the definition which we have attempted to frame of the science of Political Economy, we have characterized it as essentially an abstract science, and its method as the method *à priori.* . . . It reasons, and, as we contend, must necessarily reason, from assumptions, not from facts. It is built upon hypotheses. . . . Geometry presupposes an arbitrary definition of a line. . . . Just in the same manner does Political Economy presuppose an arbitrary definition of man. . . . The conclusions of Political Economy, consequently, like those of geometry, are only true, as the common phrase is, *in the abstract.* (*Col. Works,* IV, 325-327)

Senior disagrees with Mill on the hypothetical nature of the premises of political economy. Like Smith, Malthus, and Ricardo, he believes that its premises are abstract but not deliberately hypothetical. They are based on general observation. This seems a conflict of words. If anything, it suggests that Ruskin's criticism of the economists for being unaware of their limited premises applies less to Mill, against whom it was directed, than to Senior.

Although John E. Cairnes does not take sides in the debate between Senior and Mill, he goes far toward meeting Ruskin's complaints on one point. After describing the limited goals of economic science and noting the "insuperable" objections to an economist's wandering into a broader social or moral inquiry, he declares himself willing to relinquish the name political economy:

Even if it should be thought desirable to give the *name* of Political Economy to the larger inquiry, it would still be necessary to reserve for separate and distinct

investigation the laws of the production and distribution of wealth. (*Character and Logical Method*, p. 33)

Here, in 1857, Ruskin's argument that orthodox economics wrongly usurps the name political economy is granted. Mill comes close to making a similar concession much earlier in his essay on method. After describing the broad field of "speculative politics," of which political economy is a narrow part, he writes,

It is to *this* important division of the field of science that ... M. Say has chosen to give the name Political Economy. And, indeed, this large extension of the signification of that term is countenanced by its etymology. But the words "political economy" have long ceased to have so large a meaning. (*Col. Works,* IV, 321)

Richard Whately, a somewhat unorthodox member of the classical school, in lectures given at Oxford in 1830 and 1831, goes further than Mill or Cairnes. He declares that, if it were not too late, he would abandon the name political economy with its connotation of state or household management as unsuited to the narrow science of exchange value. He urges the adoption of Aristotle's term "catallactics" for the narrow science. There is evidence that Ruskin read Whately and borrowed the term "catallactics" from him for his own negative purposes.[36]

At its more superficial, vituperative level, Ruskin's criticism of the political economists is misguided. They admit the abstract, even hypothetical character of their science and take no pains to conceal it. Ruskin's basic charge holds. It is that the abstractions of the economists cannot be applied to actual conditions without undergoing modifications which would change the nature of the science. In other words, the "disturbing factors" of morality and affection are organically, not mechanically, related to the original premises. They cannot be considered separately without vitiating the entire chain of deduction. Senior, Mill, and Cairnes are aware of this problem. To them the crucial point is the relation of theory to practice, of science to art. It is here that the abstractions of their science must face the test of reality and be modified by other considerations.

The economists maintain that the science itself is deductive and does not give practical advice. Cairnes puts this most simply. Political economy is a science like astronomy or physics. It pursues its investigations without regard for problems of application. Cairnes does not ignore practical questions. He insists that, although purely eco-

nomic considerations "may indeed go far to determine our judgment," they should not always do so:

For there are few practical problems which do not present other aspects than the purely economical—political, moral, educational, artistic aspects—and these may involve consequences so weighty as to turn the scale against purely economic solutions. (*Character and Logical Method*, p. 37)

Senior denies that there is an art of economics and that the economist can give practical advice. It is beyond human capacity to study all the branches of knowledge necessary to apply economic conclusions:

We believe that by confining our own and the readers' attention to the Nature, Production, and Distribution of Wealth, we shall produce a more . . . instructive work, than if we allowed ourselves to wander into the more interesting and more important, but far less definite fields by which the comparatively narrow path of Political Economy is surrounded. . . . The business of a Political Economist is neither to recommend nor to dissuade, but to state general principles, which it is fatal to neglect, but neither advisable, nor perhaps practicable, to use as the sole, or even the principal, guides in the actual conduct of affairs. (pp. 2-3)

This passage is found in Senior's *Political Economy* of 1836. His recent experience on the Poor Law Commission had impressed upon him the difficulty of applying economic principles. Elsewhere, Senior admits the possibility of an art of economics. It must consider the "anomalies produced by particular disturbing causes" and can be given a "qualified assent."[37]

John Stuart Mill agrees. At the beginning of his essay "On the Definition of Political Economy," he warns against the common notion, which Ruskin shares, that political economy teaches the art by which an individual or nation becomes rich. He rejects his father's and Adam Smith's use of the domestic model. Political economy is an abstract, a priori science. It can be applied to actual circumstances only "with proper allowances" for the noneconomic factors present. To discover these factors, he urges careful observation or "Verification by Specific Experience." The assumption most affected by "disturbing causes" is that of perfect competition. Competition has become "in any considerable degree the governing principle of contracts at a comparatively modern period" and within a circumscribed geographical area. The disturbing forces which impair free competition are referred by Mill to the sphere of "custom." Practical application depends on "the customs, institutions, and opinions of society." It requires a knowledge of other social sciences. In *A System of*

Logic (1843), Mill declares with Comte that economics is a subordinate branch of sociology. It is "so intertwined with all the other branches, that its conclusions, even in its own peculiar province, are only true conditionally." Mill reveals his interest in practice and in the relationship of economics to a broader study by entitling his treatise *The Principles of Political Economy with Some of their Applications to Social Philosophy* (1848).[38]

The best example of the classical economists' awareness of the difficulty of "application" is their position on *laissez faire*. It is, after all, their supposed advocacy of a rigid policy of *laissez faire* which Ruskin cites as evidence of their lack of social and empirical perspective. *Laissez faire*, the policy of "letting alone," is the form which the economists' assumption of perfect competition takes when applied to actual conditions. The "laws" of political economy describe the course which economic processes would follow under perfect competition. The relevance of these "laws" to actual conditions depends much on the validity of the original assumption. The economists' willingness to modify the policy of *laissez faire* in practice is an excellent indication of their more general willingness to modify the abstract deductions of their science in the face of "disturbing forces." That the leading economists do not support a rigid policy of *laissez faire* has been demonstrated by several recent studies. The most valuable is Lionel Robbins' *The Theory of Economic Policy*.[39]

Although less explicit on the subject than John Stuart Mill, the founders of classical economics show a remarkable flexibility in applying the principle of *laissez faire*. Adam Smith allows many exceptions. Tariffs are justifiable to make a nation self-sufficient in materials for defense and to protect infant industries. He admits the need for restrictions on banking and interest rates. Smith's state is something more than a "night watchman," for it has "the duty of erecting and maintaining certain public works and certain public institutions, which it can never be for the interest of any individual, or small number of individuals, to erect and maintain." Smith has no illusions concerning the harmony which free competition brings as his remarks on the opposed interests of masters and workmen, on the growth of rents and profits at the expense of wages, and on the tendency of merchants to "conspire against the public" indicate. Malthus' vision of free competition is even more bleak. He sees a conflict between agricultural and manufacturing interests and the threat of overpopulation and poverty. Malthus is far from a strict exponent of *laissez faire*. He urges government intervention to pro-

vide education, restrict child labor, supply medical relief, and protect agriculture.[40]

One could argue that the *laissez faire* bias of the classical school has its source in Jeremy Bentham (1748-1832) and the Utilitarians, not in Smith or Malthus. Bentham does insist that the "general rule" for government is "Be Quiet," but this is not a question of natural law. His utilitarian approach and his goal of "the greatest happiness of the greatest number" lead him to admit "agenda" as well as "non-agenda." "Agenda" include those things "which are not to be expected to be performed by the spontaneous exertions of individuals." Many industrial reforms were carried out under Benthamite auspices. Even today a large portion of Bentham's "agenda" remains to be enacted.[41]

The later economists Senior and John Stuart Mill recognize the problem of *laissez faire*. Senior's position is more complicated than those familiar only with his opposition to the Ten Hours Bill realize. In his role as "statesman or moralist," if not as pure economist, he advocates government action in housing, education, public health, and recreation. He couches his view of government authority in terms of expediency. In 1847, Senior notes that many writers "have declared that the business of government is simply to afford protection . . . and that to do more is usurpation." "This proposition I cannot admit. . . . It is the duty of a Government to do whatever is conducive to the welfare of the governed." In 1870, Cairnes denies any attempt to associate political economy with a dogmatic policy of *laissez faire*. As if in reply to Ruskin's criticism, he describes *laissez faire* as "at best a mere handy rule of practice, useful, perhaps, . . . but totally destitute of all scientific authority."[42]

John Stuart Mill's uncertainties on the subject are well known. They are so apparent that one marvels at Ruskin's blindness in attributing to Mill a particularly rigid adherence to the policy. Mill never abandons a belief in the value of free competition and warns that every departure from *laissez faire*, "unless required by some great good, is a certain evil." But his position is the opposite of dogmatic. He maintains, for example, that "the functions of government embrace a much wider field than can easily be included within the ring-fence of any restrictive definition. . . . It is hardly possible to find any ground of justification common to them all except . . . general expediency. . . ." Mill's distrust of government intervention owes little to abstract principle. His reasons include the greater efficiency

of private enterprise, the value of individual variety, and the opportunity which an overgrown bureaucracy offers to corruption. Mill insists that "there is scarcely anything really important to the general interest which it may not be desirable or even necessary that the government should take upon itself, not because private individuals cannot effectually perform it, but because they will not." Among the "large exceptions" to the rule of *laissez faire* are education, colonization, hours of labor, support of the poor, and inheritance. Mill suggests other areas of government intervention so broad that they are best discussed in conjunction with Ruskin's outline of the welfare state in a later chapter. Not only is Mill willing to make "exceptions" to the policy of *laissez faire*. With the assumption of perfect competition, he views the policy itself to be historically conditioned and liable to "expire" shortly: "Peace be with its ashes when it does expire, for I doubt much if it will reach the resurrection."[43]

Clearly the leading classical economists are aware of the distinction between science and art in economics and the danger of applying abstract principles to actual conditions. Their discussions of method and their flexible approach to *laissez faire* place them beyond the pale of many of Ruskin's criticisms. Still, from the latter's point of view, the most important question remains. Beneath the bluster of his attacks, Ruskin makes it plain that the real point of his criticism is not the economists' lack of caution in considering actual conditions or "disturbing forces" but their fallacious view of the relationship between "disturbing forces" and original premises. If these "forces" are organically, not mechanically, related to the original premises, the method of postponing their consideration until the train of deduction has been completed will fail. In other words, economic laws formulated under the assumption of a perfectly competitive, rational, even atomistic society cannot be applied with minor modifications to a society which is an organic whole. To determine the nature of the relationship between original and disturbing forces in the writings of the leading economists, one must study their metaphors and analogies. They are invariably mechanical. After describing the difficulty of the "practical branch" of economic science, Senior declares: "The machinery of civilized society is worked by so many antagonistic springs . . . that we are liable to the greatest mistakes when we endeavour to assign motives to past conduct, or to predict the conduct which a new motive will produce."[44]

John Stuart Mill gives more attention to this problem than does

Senior. He uses a variety of mechanical metaphors and analogies. When examining the actual, as opposed to the hypothetical, behavior of man in economic matters, Mill speaks of a "concurrence of causes" and of the need to investigate them separately: "The law of centripetal and that of tangential force must have been known before the motions of the earth and planets could be explained, or many of them predicted. The same is the case with the conduct of man in society." After studying the trains of causation separately, the student can relate them to one another to attain accuracy of prediction. In his essay on method, Mill describes the process as follows:

When the disturbing causes are known, the allowance necessary to be made for them detracts in no way from scientific precision, nor constitutes any deviation from the *à priori* method. The disturbing causes are not handed over to be dealt with by mere conjecture. Like *friction* in mechanics, they . . . are brought within the pale of the abstract science itself. . . . The disturbing causes have their laws, as the causes which are thereby disturbed have theirs; and from the laws of the disturbing causes, the nature and amount of the disturbance may be predicted *à priori*. . . . The effect of the special causes is then to be added to, or subtracted from, the effect of the general ones. (*Col. Works*, IV, 330)

Note the use of friction as an example, a favorite one with Mill, and also the concept of adding and subtracting causes or forces. Mill differs little from the more dogmatic Ricardian John R. McCulloch (1789-1864), who urges the economist to make allowance for various disturbing forces just as "in mechanics the engineer must allow for the friction and resistance of matter." When Mill speaks of a "synthesis" or "concurrence" of disturbing causes and original ones, he is thinking in mechanical terms. Even when the disturbing factor destroys the basis of the argument, a possibility Mill admits, it does so by its sheer force, not by its integral, organic relationship with the original premises.[45]

One does not have to rely on metaphor and analogy to grasp the mechanical quality of Mill's conception of social forces. Mill discusses the point in his *Autobiography*. He describes his deep interest in the controversy between his father and Thomas Babington Macaulay over the use of the empirical or deductive method in political thought. In order to solve the problem of how one arrives at conclusions in the social sciences, he studies the process of reaching conclusions in the more highly developed sciences. He focuses on the notion of the composition of forces:

On examining, accordingly, what the mind does when it applies the principle of the Composition of Forces, I found that it performs a simple act of addition. It

adds the separate effect of the one force to the separate effect of the other, and puts down the sum of those separate effects as the joint effect. But is this a legitimate process? In dynamics, and in all the mathematical branches of physics, it is; but in some other cases, as in chemistry, it is not; and I then recollected that something not unlike this was pointed out as one of the distinctions between chemical and mechanical phenomena in the introduction of that favorite of my boyhood, Thomson's *A System of Chemistry*. This distinction at once made my mind clear as to what was perplexing me in respect to the philosophy of politics. I now saw that a science is either deductive or experimental, according as, in the province it deals with, the effects of causes when conjoined are or are not the sums of the effects which the causes produce when separate. (pp. 112-113)

One might expect Mill to conclude that problems of social relations resemble those of chemistry: the effect of combining two forces is something more than their sum. Instead, he chooses the method of physics. He insists that social forces can be treated in the same fashion as physical forces—by addition or subtraction. This is the crux of the difference between Mill and Ruskin on the relationship between original premises and "disturbing forces." The two men hold very different views of the nature of society and of what happens to individuals in society. For Ruskin, social forces interact organically or "chemically." The social whole is more than the sum of its parts. The character of the individual is changed mysteriously and unpredictably by life in society. For Mill, this is not the case. In *A System of Logic*, he writes:

The laws of the phenomena of society are, and can be, nothing but the laws of the actions and passions of human beings united together in the social state. Men, however, in a state of society are still men. . . . Men are not, when brought together, converted into another kind of substance, with different properties; as hydrogen and oxygen are different from water. . . . Human beings in society have no properties but those which are derived from, and may be resolved into, the laws of the nature of individual man. In social phenomena the Composition of Causes is the universal law. (Bk. VI, ch. vii, sec. 1, 573)

Mill's view of society reflects his view of human nature. Man is not an organic whole as he is for Ruskin and the Romantics. Mill never abandons an associationist psychology. He considers human nature capable of being split up into smaller elements or "properties." These can be abstracted from one another and examined separately for purposes of deduction or prediction. Human nature for Mill is not really a "tree," shaped by "the inward forces which make it a living thing."[46]

The discussion is inconclusive. The differences between Ruskin and

Mill on method stem from their antithetical views of society and human nature. The differences stand. One agrees either with Mill or with Ruskin. Today, a majority of intellectuals would side with Ruskin and reject the mechanical, associationist assumptions of Mill's position. On the other hand, many social scientists follow a vastly more complicated and cautiously circumscribed version of Mill's method. Science cannot rest with an imaginative intuition of wholes but must, if it is to say anything, isolate, add, and subtract. This controversy is fading before the use of experiment in social science. Experimentation encourages "chemical" modes of analysis. It permits the consideration of forces which interact organically, not mechanically. Mill's chief criticism of the chemical method in social science is the impossibility of experimenting. It is too early to decide concerning the value of experiment. In the future, perhaps, Mill will be proven right and the debate will return to the rigid lines drawn by Romantics and Utilitarians.

A final, more general observation may help explain the inconclusiveness of Ruskin's debate with the economists on scope and method. The conflict is not between an ethically inspired approach on the one hand and an immoral or amoral one on the other. Ruskin is wrong. It is between two different systems of moral preference, for, in spite of the economists' professions of neutrality, they never succeed in abstracting ethical considerations. The ideals are the Judaeo-Christian softened by Romanticism and the Utilitarian modified by a strong attachment to individual liberty.

On the surface, these ideals are remarkably similar in the ends they posit for human action. For Bentham, James Mill, and especially John Stuart Mill, the useful resembles the Christian. The "greatest happiness of the greatest number" resembles Ruskin's more richly textured concept of social wealth or welfare. The difference between Ruskin and the Utilitarians or their allies the economists lies less in ethical end than in choice of means to attain the end, or, better, the difference in end becomes apparent only through the choice of means. The economists and Utilitarians believe that men will maximize the general welfare if left free to pursue their separate interests. By a simple and mechanical process of addition, individual happiness becomes social happiness. Ruskin, on the other hand, believes that society as a *whole* must actively seek and order the welfare of its *lesser* members. A belief in the system of natural liberty as the best means to attain the "greatest happiness" is, of course, no necessary

part of a utilitarian ethic. Witness Fabianism and the merging of the traditions of Ruskin and John Stuart Mill in the founding of the welfare state. Even for the classical economists and the early Utilitarians, the system of liberty is carefully conditioned or nurtured by laws and institutions. It is an end in itself. Indeed, Malthus, Ricardo, and John Stuart Mill value liberty more as an end than as a means, for they are well aware that the system of liberty leads to conflict between landlords, manufacturers, and workers. The economists' devotion to liberty is an ethical assumption imbedded in their analyses and transcending both their professions of ethical neutrality and the dictates of Utilitarianism. Ruskin cannot share a belief in liberty. He is unwilling to accept its divisive effects. Now, he values justice, unity, or even love more than liberty. This difference in ethical preference lies behind his conflict with the leading economists over the relationship of social forces and chains of causation. Questions of value often determine the nature of sociological models.

6

Whether right or wrong in his dispute with the economists, Ruskin must be given credit for cutting through the surface of the debate and relating it to crucial differences in the combatants' views of man and society. He deserves little credit for the pervasive unfairness of his treatment of the political economists. As Fain has shown, Ruskin uses all the cheap tricks of propaganda in his assault on orthodoxy. He invariably quotes out of context and neglects qualifying phrases. He deliberately exaggerates his differences with the economists by refusing to acknowledge points of agreement. When he does mention such a point, he still refuses credit and attempts to show that the writer in question does not understand the meaning of his own statements or has fallen into an accidental inconsistency.[47]

More important, Ruskin fashions his indictment of the classical school with ammunition taken directly and without acknowledgment from writers like John Stuart Mill and Adam Smith. Mill's admirable tolerance of opposing points of view and the care with which he qualifies his propositions provide Ruskin with much material for his ill-intentioned criticisms of scope and method. The case of Adam Smith is more complicated and more interesting. Ruskin deplores the great economist's "entirely damned state of soul," and yet there is a remarkable parallel between Ruskin's criticism of the classical school and Smith's earlier criticism of the "mercantile system." In words

similar to those Ruskin employs against the classical economists, Smith condemns the mercantilists for confusing real wealth with money. He suggests that the mercantile system was framed by merchants to gain profit at the expense of national advantage. Smith is less than fair to the mercantilists in the same way that Ruskin is less than fair to the classical economists. He ignores the diversity to be found among them, exaggerates their bias, and misstates their confusion of wealth and money. The crowning indignity, from Smith's point of view, is Ruskin's adoption of the term "mercantile" to describe orthodox political economy. The arts of propaganda frequently bite the hand that feeds them.[48]

In the final analysis, how one judges Ruskin's criticisms of classical economics depends on whom one takes to be his target. If his criticisms are directed at the leading economists, they are frequently misguided and even malicious. If they are directed at the lesser members of the classical school, at popularizers like Mrs. Marcet, or, indeed, at the ordinary businessman's or politician's understanding of political economy, they are more valid. In the hands of James Mill, J. R. McCulloch, and any number of lesser writers, political economy lacks the methodological sophistication so evident in John Stuart Mill's work. These economists, for whom Ruskin's epithets "common" or "vulgar" might be accurate, tend to apply their abstract deductions directly to the real world. Businessmen and politicians show a similar tendency, partly from failure to understand the position of the leading economists and partly from a sense of their own interests. The economists' assumption of perfect competition and the deductions which follow from this appealed to the interests of the business classes in England. Once economic theory was drawn into the political sphere and triumphed with the adoption of free trade, it became rigid and immune to criticism.[49]

To an extent, the leading exponents of political economy, Ricardo, Senior, and John Stuart Mill, are responsible for the hardening of the science into orthodoxy or "classicism." They fail to make the reader thoroughly and continuously aware of the limitations of their abstract approach. Ricardo assumes that the reader understands his method of fashioning abstract "suppositious cases" but never explains what he is doing. Mill confines his methodological musing to his essay "On the Definition of Political Economy" and his *System of Logic.* One could read the first part of the *Principles* and not understand that his propositions are intended to undergo strict limi-

tation before being applied in practice. Senior also makes statements in which he seems to throw all caution to the winds. In Ruskin's most vituperative moments, his criticisms are not irrelevant. If he occasionally misinterprets the leading economists, he is not alone in doing so. It is an easy mistake to make. Moreover, from his point of view, it is more important to attack the common notion of political economy than its most thoughtful expositions. The common notion confuses *laissez faire* with natural law and provides the ideological justification for the waste of a potential abundance.[50]

VI Shattered Majesty

One turns with relief from the wilderness of methodological discussion to Ruskin's more specific criticisms of orthodoxy. Ruskin's belief that economics must relate its abstractions to living men colors every aspect of his critical and constructive endeavors. It leads him to redefine value, cost, and wealth in "vital" terms and to attempt a reconstruction of economics on the basis of these definitions. The shape of his "vital" economics is rough and awkward. Ruskin cuts through the surface of economic behavior and studies economic realities from an ethical and practical point of view. His political economy deals with the difficult questions which classical economists try to avoid while, at the same time, it slights the questions of exchange value and market behavior which the orthodox school isolates.

Strangely enough, Ruskin's awkward, "vital" approach yields valuable insights into the surface of economic phenomena, insights comparable to those of the most farsighted economists of his own day. Indeed, many of these insights have been incorporated into the fabric of professional economics. They include his emphasis on demand as a determinant of price; his awareness of psychological factors in changing currency values; his rejection of the gold standard; and his view of currency as an instrument to be "managed" for prosperity. More important is Ruskin's interest in consumption and his critique of the orthodox economists' obsession with production. From this follows his rejection of the doctrines of classical economics which lend a deterministic, mechanical quality to the discipline. They are Say's theory of markets, the belief in the social utility of unlimited saving, the wages-fund theory, the iron law of wages, and the law of supply and demand. Taken together, Ruskin's criticisms suggest a more flexible view of economic processes—a view which recognizes the human element in economics and encourages human control of economics. The fact that Ruskin's revisions, however crudely phrased, point to the transformation of economic science in the twentieth century confirms his conviction that the "disturbing" human factors would prove more disturbing than classical economists suspected.

Ruskin's achievement stems from his "drive to humanity." Just as earlier he had broken through the superficial laws of neoclassicism, so now he pierces through commodity relationships in the market, what Marx calls the "fetishism of commodities," to the human realities beneath. Ruskin's ability to do this is the privilege or luxury of his belief in abundance. The classical economists' scarcity frame of reference impels them to stress the production of commodities and neglect consumption. In an environment of scarcity, the demand for commodities seems endless. They assume that an increase in production will redound to the benefit of the consumer without a careful adjustment between demand and supply. The rigid, mechanical character of their economic "laws" testifies to the belief that demand will take care of itself and to its corollary that production and capital accumulation are the main thing and must be maximized. Moreover, for the economists, production is a matter of quantity, not quality. In a famine, one does not worry about the quality of supply. Ruskin's vision of abundance allows him to shift attention from production to consumption and to criticize the rigidities of classical theory. Unlike the economists, he can afford to think about the quality of goods and services. He can redefine value and wealth in terms which focus attention on the qualitative aspect of economic phenomena and on the quality of the consumer's life.[1]

That Ruskin maintains his vision of abundance is evident. On the final page of *Unto This Last,* he writes, "Luxury is indeed possible in the future—innocent and exquisite; luxury for all, and by the help of all. . . ." Again, in *Munera Pulveris,* he defines the object of political economy to be "the continuance not only of life, but of healthy and happy life." Ruskin's theoretical endeavors as well as his specific proposals for reform are directed toward realizing this abundant life. They are directed to answering the "radical" question asked in the fifth volume of *Modern Painters*: "What is the noblest tone and reach of life for men; and how can the possibility of it be extended to the greatest numbers?"[2]

<p style="text-align:center">2</p>

Ruskin's concern for quality shapes his critique of the orthodox economists' misuse of common words: value, utility, cost, and wealth. Ruskin reminds one of Bentham and Adam Smith in his pleas for a closer definition of economic terms. His purpose, however, is to include, not exclude, ethical considerations. Ruskin denies that the value of a commodity is its exchange value in goods or money, no

matter what the character of the commodity. He opposes "the idea that anything which is an object of desire to numbers, and is limited in quantity, so as to have rated worth in exchange, may be called, or virtually become, wealth." Wealth and money are not interchangeable. Ruskin redefines these terms in a way which encourages the discussion of qualitative as well as quantitative, immaterial as well as marketable, "goods" in a national economy. With the arrival of abundance, quality is the most important consideration.[3]

After demonstrating that Mill and Ricardo know nothing about value and confuse it with exchange value, Ruskin proposes a new definition. The title of the fourth essay in *Unto This Last,* "Ad Valorem," suggests his approach. He returns to the Latin derivation of the word: *"Valor,* from *valere,* to be well or strong (ὑγιαίνω);—strong *in* life (if a man), or valiant; strong, *for* life (if a thing), or valuable. To be 'valuable,' therefore, is to 'avail towards life.' " A valuable or useful thing is a "wholesome, healthful, helpful, or holy" thing. It supports life or "leads to life with its whole strength." Obeying the Law of Help, it contributes its own energy to the vital energy or purity of the person using it. It will make him whole. An "unvaluable or malignant" thing serves the Lord of Waste. It will corrupt, "break in pieces," or kill. The *"life-giving power of anything,"* Ruskin declares, is absolute—independent of the opinion of mankind and of the quantity supplied. Since life has intellectual, spiritual, and aesthetic as well as physical components, vital value is qualitative as well as quantitative. Its quantitative aspect is measurable. Its qualitative aspect is more difficult to determine, although Ruskin believes himself to be as good a judge of economic value as of artistic value.[4] "A sheaf of wheat of given quality and weight," he writes,

has in it a measurable power of sustaining the substance of the body; a cubic foot of pure air, a fixed power of sustaining its warmth; and a cluster of flowers of given beauty a fixed power of enlivening or animating the senses and heart. (17.153)

Ruskin is wrong, of course, in asserting that economists fail to distinguish between exchange value and real value. Classical economists make this distinction one of their premises and deliberately limit themselves to exchange value. Aristotle is the first to draw the distinction. By focusing on vital value or value in use, Ruskin puts himself beyond the pale of orthodox economics and renders dialogue with the economists futile. His position is made more difficult by the

claim that value in use is intrinsic and independent of man's desires. Although scholarly opinion is divided on the question, value in use for Aristotle, St. Thomas Aquinas, and later thinkers is as much subjective as objective; it is dependent on man's wants and needs. This is especially true of nineteenth-century economists who pioneer in the subjective mode of analysis adopted by the marginal utility school after 1870. Although Ruskin shares in this movement, he does so at the expense of a slight confusion in his theory of value, for there can be no doubt that vital value, as he defines it in *Unto This Last* and *Munera Pulveris,* is objective and intrinsic. "Think what you will of it, gain how much you may of it, the value of the thing itself is neither greater nor less. For ever it avails, or avails not. . . ."[5]

That Ruskin's concept of vital value is perversely unempirical does not disturb him. The realm of empiricism is a lower realm, the realm of the "calculating understanding." Like Plato and most idealists, Ruskin is concerned with a higher realm, a realm of absolute or intrinsic values intuited by the imagination—a realm of permanence. His concept of vital value bears the same relation to economic appearances and apparent wealth as does Coleridge's "Idea" of the constitution to England's apparent political realities. Ruskin's approach, however, is fraught with difficulty, for, like Marx, he frequently uses the method of idealism, the piercing through of appearances to the "reality" beneath, without explicitly transcending the material realm. His idealism is often a higher empiricism. Ruskin plays the role of a scientist using empirical methods of superior objectivity to determine the *real* value of a commodity and negate the pseudoscientific views of the economists, who waste their time "weighing clouds" and "portioning out shadows" in the market place. Ruskin would refute this interpretation by declaring that the most important aspects of vital value are those spiritual qualities of an object, such as its typical beauty, which can be grasped only by a "genial" man like himself. Ruskin's position is not inconsistent. Still, he fails to examine problems of epistemology. His ambiguous use of the word "vital," an ambiguity rooted in the Romantic tradition's unwillingness to accept a material organicism, makes the reader's confusion understandable and encourages perceptive scholars like Patrick Geddes to give Ruskin's thought a materialistic or biological interpretation.[6]

When Ruskin turns from vital or intrinsic value to "effectual" value and "acceptant capacity," his concern for spiritual qualities becomes obvious. Intrinsic value is only one side of the problem since value

must have reference to living men. A dead body cannot possess wealth. If value is to become "effectual," it must be in the hands of someone who can realize the intrinsic value—someone who has "acceptant capacity." In Ruskin's words,

The production of effectual value, therefore, always involves two needs: first, the production of a thing essentially useful; then the production of the capacity to use it. . . . A horse is no wealth to us if we cannot ride, nor a picture if we cannot see, *nor can any noble thing be wealth, except to a noble person. . . .* As the aptness of the user increases, the effectual value of the thing used increases. . . . (17.154)

Possession is "not an absolute, but a gradated power." It "consists, not only in the quantity or nature of the thing possessed, but also (and in a greater degree) in its suitableness to the person possessing it and in his vital power to use it." Wealth is *"the possession of the valuable by the valiant,"* or, since value and utility are synonomous for Ruskin, "the possession of useful articles, *which we can use."* Property which we cannot use is a form of money, not wealth. Many people commonly considered wealthy are in reality no more wealthy than the locks of their strong boxes. Wealth depends on a "can" as well as on a "have." Political economy must be a science of the accumulation of physical and spiritual capacity as well as of material goods and of the distribution, "not of every thing to every man, but of the right thing to the right man"—a difficult science, Ruskin adds, dependent on more than arithmetic.[7]

Ruskin derives the concept of "acceptant capacity" from Xenophon, whose *Economist* he cites in an appendix to *Munera Pulveris.* The important passage is the following:

You, then, it seems, count as property only what is useful to a man, but do not include under the term anything that hurts him?
Just so.
Then the very same things are property to a man who knows how to use them, and not property to one who does not. For instance, a flute is property to a man who can play on it fairly; but to one who is wholly unskilled in its use it is no more property than mere useless stones would be. (p.4)

Similar suggestions are found in Aristotle. Many years later, the German economist Adam Müller insists that wealth cannot be estimated by weight and number, for its real existence "lies in use as well as in property." Müller is thinking primarily of use to society. If the state intends to realize its wealth, it must concern itself with persons and social relations as well as with things. In a similar vein, Coleridge

believes that the material riches of England are outstripping the capacity of the people to use or "actualize" them. Unlike his predecessors, Ruskin makes the concept of "acceptant capacity" an integral part of his thought. It is the economic expression of his "drive to humanity" and becomes an incisive weapon against the forces of orthodoxy. Its consideration renders impossible any attempt to isolate economic processes from living men. Its suggestion of the "felicitous fulfilment of function" of vital beauty gives to Ruskin's interest in consumption and his vision of the welfare state a qualitative edge.[8]

Ruskin's relation of value to living men allows him to unify three counters of economics—production, product, and consumption. Since value or utility "depends on the person, much more than on the article," Ruskin can speak of utility in consumption and in production as well as in the product itself. The development of acceptant capacity or "valiant men" depends on useful consumption. Useful consumption, in turn, is dependent on useful production since the quality of the productive process determines, on the one hand, the value of the product and, on the other, the quality of the worker's life, his habits of consumption, and the quality of the products he demands—in short, his acceptant capacity. Ruskin points to the large consumption of gin among English laborers as evidence of how degrading production lowers the quality of consumption. While useful consumption depends on useful production, the converse is also true, for the quality of consumption determines the type of product demanded, the quality of the consumer's life, and, hence, his "valiant" power as a worker. Production, product, and consumption in Ruskin's vital economics form a triangle of interdependent elements. Man is the center, and the whole structure is potentially infused with utility or value, the life-giving power. Ruskin would take exception to the choice of geometric metaphor. Comparison of a well-ordered economy to a well-composed painting or a living body would better suit his tastes.[9]

Ruskin's vision of the interdependence of economic processes resembles in a crude way and at a very different level the "circular flow" of goods which Quesnay and the physiocrats chart in the *Tableau économique* (1758). With Ruskin, the physiocrats prefer organic metaphors—the circulation of blood and streams. The classical economists grasp the interdependence of economic elements but prefer mechanical metaphors. Smith's "wheels of circulation" remind

one of Blake's "Satanic Wheels." The advantage of the organic metaphor is that it encourages the economist to recognize the possibility of sickness in the economy and the need for a doctor. The mechanical metaphor suggests automatic and perpetual motion. In the history of economics, there is a close connection between a tendency to think in physiocratic or organic modes and a willingness to recognize the danger of crises due to a disproportion between production and consumption. R. L. Meek has confirmed this in the case of Malthus, William Spence (1783-1860), Sismondi, and Thomas Chalmers (1780-1847). Ruskin can be added to the list. In *Unto This Last*, he writes: "The circulation of wealth in a nation resembles that of the blood in the natural body. . . . There is a flush of the body which is full of warmth and life; and another which will pass into putrefaction."[10]

Utility or value is the positive side of Ruskin's vital economics. It is balanced by a negative, life-destroying factor which also enters the structure of the triangle—cost. Ruskin defines the cost of anything as "the quantity of labour necessary to obtain it." Labor is "the contest of the life of man with an opposite;—the term 'life' including his intellect, soul, and physical power. . . ."

Literally, it is the quantity of "Lapse," loss, or failure of human life, caused by any effort. It is usually confused with effort itself, or the application of power (*opera*); but there is much effort which is merely a mode of recreation, or of pleasure. The most beautiful actions of the human body, and the highest results of the human intelligence, are . . . achievements, of quite unlaborious,—nay, of recreative,—effort. (17.183)

Ruskin stresses the distinction between *opera*, work which "recreates," and *labor*, work which corrupts or destroys. *Labor*, he continues, is the suffering in effort. "It is the negative quantity, or quantity of de-feat, which has to be counted against every Feat. . . . It is 'that quantity of our toil which we die in.' " *Opera* is happy, creative work. It includes "as much intellect and feeling as will fully and harmoniously regulate the physical force." Whether or not the productive process involves vital cost depends on the nature of the work, its quantity, and its distribution among the workers, just as the vital value of a product depends on its nature and its distribution in proper quantity among consumers who can use it.[11]

Ruskin's distinction between *labor* and *opera* is basic to his thinking. It has its source in his vision of the Gothic builder and his own creative experience in art and authorship. Ruskin's belief in positive work separates him sharply from the classical economists and from

many of his Victorian contemporaries. To them, work is a negative thing, the "toil and trouble," "sacrifice," "pain," or "inconvenience" necessary to draw a living from a nature where scarcity and the law of diminishing returns rule. Although Adam Smith and his followers emphasize labor and base their theory of value upon it, their "labor" is identical with Ruskin's "cost." Positive, cost-free effort as an end in itself does not enter into their speculations. Certainly it does not contribute to economic value. Ruskin is aware of his differences with the classical economists. To John Stuart Mill's description of labor as "all feelings of a disagreeable kind, all bodily inconvenience and mental annoyance," he replies:

True; but why not also "feelings of an agreeable kind"? It can hardly be supposed that the feelings which retard labour are more essentially a part of the labour than those which accelerate it. The first are paid for as pain, the second as power. (17.67)

Later, Ruskin rejects the labor theory of value and bases exchange value on consumer demand in the hope of bringing immaterial goods and services, the products of creative work, within the scope of value theory.[12]

More important is the close relation between Ruskin's vision of positive labor and his assumption of abundance. Only in a society of abundance will cost-free labor, in Ruskin's sense, be sufficiently common to warrant consideration by the economist. For classical economists and for most Victorians, the world is a place of scarcity. Labor is undertaken out of a sense of duty or necessity. Its opposite is not positive, creative work (*opera*), but leisure or no work. Progress is measured by a diminution in the quantity of labor expended, a fact which a thinker with the Ruskinian vision of Lewis Mumford might relate to the growth of the suburb. Ruskin's society of the future is not a society of leisure but a society in which happy work is maximized and degrading labor minimized. Significantly, other thinkers who consider work a positive, creative experience—William Godwin, Saint-Simon, Charles Fourier, Karl Marx—also accept the possibility of an abundant society.

In theory, Ruskin confines vital cost or life-destroying labor to the productive process. He makes it clear, however, that production in which vital cost is heavy results in a product low in vital value and destructive of the life of the consumer. The consumer, in turn, will make a poor worker and perpetuate the process. Ruskin refuses to separate consumption, product, and production. A negative or posi-

tive charge in one element immediately communicates itself to the other two. To determine the real wealth of a nation, one must subtract vital cost from vital utility in all economic processes. The result is a balance of vital value, similar to the mercantilists' "balance of trade" only in the crudeness with which both conceptions are formulated.[13]

The balance of vital cost and vital utility forms the theoretical foundation of Ruskin's famous dictum, "There is no Wealth but Life. Life including all its powers of love, of joy, and of admiration." Early in *Unto This Last*, Ruskin defines wealth as power over men and asks, "Will it not follow that the nobler and the more in number the persons are over whom it has power, the greater the wealth?" "Perhaps it may even appear, after some consideration," he writes,

that the persons themselves *are* the wealth. . . . In fact, it may be discovered that the true veins of wealth are purple—and not in Rock, but in Flesh—perhaps even that the final outcome and consummation of all wealth is in the producing as many as possible full-breathed, bright-eyed, and happy-hearted human creatures. (17.55-56)

After redefining value, utility, and cost, Ruskin confirms this suggestion: "That country is the richest which nourishes the greatest number of noble and happy human beings; that man is richest who . . . has the widest helpful influence, both personal, and by means of his possessions, over the lives of others." The aim of political economy is not the accumulation of money, not the "building of a pyramid of gold," but "the extension of life"—"the multiplication of human life at the highest standard." Ruskin brings to bear on economics the force of the Romantic concern for healthy, creative living. He describes life as "the happiness and power of the entire human nature, body and soul." "No physical error can be more profound, no moral error more dangerous, than that involved in the monkish doctrine of the opposition of body to soul." Ruskin's rejection of his mother's puritanism takes on real significance in his redefinition of economic terms.[14]

The power and intricacy of Ruskin's vital economics result more from diligence of application than originality of perception. His insight and style of argument are not new. His definition of wealth as life is the culmination of a long tradition of rhetoric on the subject of true versus false wealth. The false conception most often criticized is that identifying wealth with money. From here, the critic delves to one of two levels—that of goods and services or that of the people

who consume or produce goods and services. The first level is the most common resting place. It involves few radical implications. The thinkers who penetrate to the second level are the more interesting. They form a tradition in which Ruskin's distinction between true and false wealth is quite commonplace. Of these, Bishop Berkeley, Adam Müller, Sismondi, and J. M. Ludlow most resemble Ruskin. The central theme of Berkeley's *Querist,* which Ruskin admired, is the elaboration of the distinction between true and false wealth until the former becomes the "well-being of the whole" and the latter money. Sismondi asks, "Are riches then everything and men absolutely nothing?" Ludlow fashions a reply. He condemns "plutonomists" for ignoring the living men who make up the real wealth of the "commonwealth." "We should learn," he writes, "to look upon man himself as a treasure. . . ." Coleridge, Southey, Thomas Arnold, and Robert Owen agree. The distinction between "things" and "persons," "artificial wealth" and "solid welfare," appears frequently in their pages. Yet, none of these critics approaches Ruskin's diligence in drawing out the implications of a remark in "The Nature of Gothic": "We manufacture everything . . . except men."[15]

The device of attacking "shams" is not limited to the question of wealth in the nineteenth century. It is a favorite device of many thinkers. In a time of rapidly expanding knowledge and great uncertainty, the sensation of cutting through superficialities, Bentham's "fictitious entities," and reaching a firmer ground of reality or value must have been especially satisfying. Carlyle makes striking use of this approach. He speaks of cutting through the "clothes" of social, political, and religious institutions. The search for roots can also be seen in Marx's attempt to puncture the "fetishism of commodities." Bentham, Carlyle, Ruskin, and Marx! One is tempted to speak, however cautiously, of a spirit of the age.[16]

3

In two chapters of *Munera Pulveris,* "Store-keeping" and "Coinkeeping," Ruskin outlines the substance of a political economy based on his vital definitions. The premise of his constructive effort is the existence of a "national store" capable of being improved or wasted by its holders—the government or private persons. Ruskin's concept of a national store, drawn, perhaps, from Aristotle or Berkeley, reveals his interest in problems of vital, not exchange, value. His cavalier attitude to the question of ownership foreshadows his pro-

posals for expanding the sphere of public enterprise. In both chapters, Ruskin asks and only partially answers a number of questions about the store and its relation to holders or "claimants." His treatment is fragmentary, to say the least. He finds logical analysis boring and soon returns to the more congenial task of social exhortation. At the end of his chapter on "Coin-keeping," Ruskin disappears into a mysterious haze of quotations from Homer, Plato, Dante, Chaucer, Shakespeare, and Goethe on the use and misuse of money.[17]

Ruskin's first question concerns the nature of the national store: "Has the nation hitherto worked for and gathered the right thing or the wrong?" On the answer to this rest "the possibilities of its life." Ruskin deplores the resources wasted in the production of munitions of war and gives the example of a country where "the supply of rockets is unlimited, but that of food, limited, in a quite final manner. . . ." In a passage reminiscent of *The Political Economy of Art,* he deplores the labor wasted in the production of unnecessary luxuries. Examples of "helpful" or "life-giving" articles in a national store are houses, food, fuel, books, and works of art. Ruskin's view of man as an organic whole colors his conception of goods in the national store. In each case, he discusses the mental and emotional as well as the physical components of the article's value. Refinement and delight are as important as sustenance. His belief that a nation's goods should stimulate man's higher qualities testifies to his assumption that life need no longer be a matter of scarcity and animal struggle.[18]

In his concern for the "immediate and actual utility" of products in the national store, Ruskin overlooks the processes of production and consumption. Although he intends to examine the national store in terms of "the past national character which it signifies by its production, and future character which it must develop by its use," he does not emphasize this aspect of his theoretical structure. His attempt to relate "wealth" to "life" or "things" to "persons" appears more clearly in the second question he raises.[19]

This concerns the relation of the store to the real needs of the population—in short, its mode of distribution or administration. Since wealth is life, Ruskin maintains that a nation is not necessarily most wealthy which has the largest *per capita* income. For him, as for Sismondi, "the life is more than the meat; and existence itself more wealth than the means of existence." The question is not how much property a nation has but whether it is in a form that can be used and in the possession of persons who can use it. "Whence, of two nations who have equal store," he declares, "the more numerous

is to be considered the richer, provided the type of the inhabitant be as high. . . ." To determine whether "the nation in its total" may be judged rich, Ruskin suggests a variation on the balance of vital cost and vital utility. He urges a comparison of the number of rich people with the number of poor. He wonders whether "the quantity and intensity of the poverty is indeed so overbalanced by the quantity and intensity of wealth, that we may . . . call ourselves, complacently, a rich country." Unfortunately, Ruskin lacks the data and perseverence to provide a full answer. It is an important question and one which believers in England's progress, like Macaulay, would have done well to consider.[20]

<div align="center">4</div>

Ruskin's vital definitions and his concept of a national store prevent his study of the more usual topics of economic discussion, price and currency, from overlooking "real" men and commodities. Of these topics, Ruskin is more interested in the theory of currency. Price as determined by exchange would have no place in a just society where prices would be based on vital value and goods would be allocated to secure their most effective use. Nonetheless, in his brief discussions of price or exchange value, Ruskin adopts a position sufficiently advanced to mark him as a precursor of the marginal utility school. In the early sixties, Ruskin is the only leading Victorian to stand up, however awkwardly, against the dominant and sterile labor theory of exchange value.

From its suggestion by Richard Cantillon (1680-1734) and Adam Smith, through its rigid statement at the hands of Ricardo, to its modification by Senior and Mill to include other costs of production besides labor, the labor theory of value is a striking symbol of the classical school's assumption of a scarce environment where the painful labor or sacrifice of the producer is the most important consideration. Ruskin criticizes the weak points of the labor theory as found in Ricardo. They are its inability to measure different kinds of labor, its assumption of perfect competition, its neglect of monopoly, and, most important, its failure to consider the demand or utility side of price phenomena.[21] In his own treatment of price, Ruskin puts aside his definition of "intrinsic" value and stresses the role of demand based on subjective evaluations of utility. In a footnote to his criticism of Ricardo, he writes the following:

Perhaps it may be said, in farther support of Mr. Ricardo, that he meant, "when the utility is constant or given, the price varies as the quantity of labour." If he

meant this, he should have said it; but, had he meant it, he could have hardly missed the necessary result, that utility would be one measure of price (which he expressly denies it to be). . . . The fact is, he did not know what he meant himself. The general idea which he had derived from commercial experience, without being able to analyze it, was that when the demand is constant, the price varies as the quantity of labour required for production; or, using the formula I gave in last paper—when y is constant, xy varies as x. But demand never is nor can be ultimately constant, if x varies distinctly; for, as price rises, consumers fall away; and as soon as there is a monopoly (and all scarcity is a form of monopoly, so that every commodity is affected occasionally by some colour of monopoly), y becomes the most influential condition of price. Thus the price of a painting depends less on its merit than on the interest taken in it by the public . . . and the price of gold less on the scarcity which affects it in common with cerium or iridium, than on the sunlight colour and unalterable purity by which it attracts the admiration . . . of mankind. (17.83-84)

Ruskin goes on to declare that his view of demand differs from that of the classical economists:

I use the word "demand" in a somewhat different sense from economists usually. They mean by it "the quantity of a thing sold." I mean by it "the force of the buyer's capable intention to buy." In good English, a person's "demand" signifies, not what he gets, but what he asks for. (17.84)

Ruskin's distinction is a valid and important one. Ricardo and his more dogmatic followers do, in fact, equate demand with "quantity demanded" in the *ex post* sense of the quantity actually sold. This allows them to argue that demand and supply must change in the same proportion since the quantity sold varies from the quantity produced only temporarily. Labor cost and not demand is the best explanation of exchange value. A general overproduction or glut due to failure of demand is impossible. Ruskin takes issue with this argument. For him, demand is not a quantity fixed and determined by price in an *ex post* sense but a subjective variable or "force" determining price in an *ex ante* sense through its dynamic relationship with supply. Ruskin views demand as a psychological phenomenon— an "estimate" of utility or desirableness. "Three-fourths of the demands existing in the world," he writes, "are romantic . . . and the regulation of the purse is, in its essence, regulation of the imagination and the heart. Hence, the right discussion of the nature of price is a very high metaphysical and psychical problem. . . ." Ruskin explores this "psychical" problem in an unpublished footnote on the price of hats which reveals a shrewd awareness of the influence of fashion on demand, an awareness gained, perhaps, from hard experience with the art dealers of London.[22]

Although Ruskin does not formulate a schedule of the intensity of demand or grasp the concept of marginal utility, several of his statements point in the direction of these ideas. He believes, for example, that price results from the action of the following variables:

A. The quantity of wish the purchaser has for the thing; opposed to *a*, the quantity of wish the seller has to keep it. *B.* The quantity of labour the purchaser can afford, to obtain the thing; opposed to *b*, the quantity of labour the seller can afford, to keep it. These quantities are operative only in excess: *i.e.*, the quantity of wish (*A*) means the quantity of wish for this thing, above wish for other things; and the quantity of work (*B*) means the quantity which can be spared to get this thing from the quantity needed to get other things. (17.94)

Price, in other words, is dependent on human will and choice. "This choice," Ruskin continues,

is always a relative one. It is a choice to give a price for this, rather than for that. . . . Price depends . . . not only on the cost of the commodity itself, but on its relation to the cost of every other attainable thing.

Farther. The *power* of choice is also a relative one. It depends not merely on our own estimate of the thing, but on everybody else's estimate; therefore on the number and force of the will of the concurrent buyers, and on the existing quantity of the thing in proportion to that number and force. (17.186)

Ruskin's suggestion of quantities or forces operating in "excess" might, with a slight stretch of the imagination, be translated into marginal terms and form the basis for a general equilibrium analysis. Ruskin admits that his treatment of price is incomplete and describes the problem as "intensely complex, curious, and interesting—too complex to be examined yet." Unfortunately, he never does find time for further examination. He never elaborates on the relationship between exchange value and intrinsic or vital value. He dismisses it with one sentence. An object's true value, he writes, only affects its price so far as it is "contemplated" in the subjective estimate of the potential buyers, "perhaps, therefore, not at all." Ruskin also fails to distinguish between long-term and short-term market phenomena. This distinction lies behind many of the historical disagreements on value theory. Still, his rejection of the labor theory of value lays the groundwork for his emphasis on consumption and his belief in the possibility of crises. His interpretation of demand, not as fact or thing sold, but as desire or potential sale gives him a more flexible view of economic processes. It permits the diagnosis of disarray in the functioning of the economy and encourages the hope of adjusting economic processes and educating consumers. It is an important

step toward his rejection of the determinism of the classical law of supply and demand.[23]

Although Ruskin anticipates the subjective marginal utility school of the seventies and eighties, his views are hardly original. The tradition of discussing price in terms of a dynamic relationship between demand and supply is a long one. It stretches back to Aristotle and the Scholastics. Indeed, the labor theory of value, although dominant in the first half of the nineteenth century among both classical economists and socialists, is the exception, not the rule, in the history of economic analysis. It has its origins as late as the natural law theories of Locke and Hobbes and the writings of the mercantilist William Petty. From the Middle Ages to the rise of the classical school, historians of economic doctrine point to many exponents of a utility theory of price, especially on the Continent. The Abbé Galiani, secretary to the Neapolitan embassy in Paris, is the most important figure in this tradition. He influenced Étienne B. de Condillac, Robert J. Turgot, and, slightly later, J. B. Say (1767-1832). Say's theory of exchange value, stressing utility and demand and fashioned in conscious opposition to Smith's derivation of value from costs, forms the backbone of French economics, including Sismondi's, in the first half of the nineteenth century. In Britain, Adam Smith's teacher Francis Hutcheson (1694-1746) is one of the first to recognize the importance of utility. His theory of price in its clear connection of utility, scarcity, and effective demand is far more perceptive than Smith's chaotic suggestions on the subject.

In nineteenth-century England, in spite of the dominance of the classical school's labor theory, there is a countertradition of utility and demand analysis. From it are derived concepts of the intensity and elasticity of demand and of diminishing utility which lay the foundation for the marginalist approach of William Stanley Jevons (1835-1882) and the Austrians. This tradition comprises Lauderdale, Richard Whateley, Mountifort Longfield, William F. Lloyd, Senior, and the lesser figures William Spence, Samuel Bailey, and Richard Jennings. Whether Ruskin was familiar with any of these writers except Whateley is unknown. He could have obtained the germ of his ideas from Smith or John Stuart Mill. Both mention supply and demand as determining market prices but place the emphasis on cost or supply. Ruskin had also studied the economic writings of Thomas De Quincey, who adopts Ricardo's labor theory but, in the *Logic of Political Economy* (1844), suggests that more attention be given to utility. Ruskin's remarkable balance of utility

and scarcity, demand and supply, may owe something to the fact that his reading in economics was largely confined to Smith and Mill. While emphasizing demand because it had been neglected, he also admits the importance of cost and supply. Note his concluding statement on price: "Hence the price of anything depends on . . . (1) Its cost. (2) Its attainable quantity at that cost. (3) The number and power of the persons who want it. (4) The estimate they have formed of its desirableness." This sense of balance, which many advocates of utility analysis do not share, reminds one of the equilibrium theory of Alfred Marshall (1842-1924) or the earlier work of Senior.[24]

Ruskin is not an original thinker in the history of utility analysis. His ideas are not as advanced as those of earlier English precursors of the marginal school like Longfield. Ruskin is important for several reasons. First, he writes at a time when creative thinking on value is at a low ebb. In the fifties and sixties, there is no leading economist to fill the gap between Senior and Jevons and study the demand or utility aspect of exchange value. Mill's cost of production theory dominates. Ruskin's muffled voice is the only one to be heard on the other side.

More important is Ruskin's significance as a barometer of some of the deeper implications of the change in value theory which occurred after 1870. The chaotic, unprofessional, even "mixed-media" character of Ruskin's economic writings reveals underlying assumptions in a way which no professional economic treatise could. Ruskin's interest in demand, for example, is closely related to his vision of abundance and his rejection of the classical economists' assumption of scarcity. The economists are intent upon increasing the quantity of material goods in a scarce environment. They understandably take demand for granted and view supply and the labor which produces it as the determinants of value. Ruskin, on the other hand, can afford to focus on the consumers instead of on the goods produced and make their desires an important determinant of value. If it is no longer a question of supplying necessities, consumers might logically have a say in the kind and quantity of goods produced by sharing in the process of determining value and allocating resources. In a society of abundance, the problem of assuring a demand for goods would come to the fore and make obvious the importance of demand to the realization of value. Conditions of scarcity encourage the classical economists to assume that increases in output will be easily absorbed. The connection between Ruskin's modification of the classi-

cal theory of value and his perception of abundance suggests that a similar connection may be at work in the rise to dominance of the marginal utility school with its emphasis on the pleasure side of Bentham's pleasure-pain calculus—its emphasis on the "utilities" of consumption, not the "disutilities" or costs of production. From a different point of view, one might claim that this change in value theory serves the upper and middle classes who possess abundance by securing them from the radical implications of the labor theory as interpreted by those still living in a world of scarcity.[25]

<div style="text-align:center">5</div>

In the chapter on "Coin-keeping" in *Munera Pulveris,* Ruskin leaves his theory of price in its unfinished state and immerses himself in the problem of currency. He relates it to his concept of a national store by asking three questions: "What is the quantity of the store in relation to the Currency?" "Who are the Holders of the store, and in what proportions?" "Who are the Claimants of the store (that is to say, the holders of the currency), and in what proportions?" The tone of these questions suggests the major theme in Ruskin's currency speculations, his view of currency as a means to the better management of an abundant national store. Much of Ruskin's discussion of money is a rephrasing of generally accepted ideas and needs no analysis. His view of currency as a means to the end of human life does lead him to several cryptic but shrewd insights. For a Victorian, he adopts a nonchalant attitude toward the gold standard and strikes at the root of the competitive market economy by suggesting government management of currency to maintain prosperity. Ruskin undermines the Victorian belief in a fixed gold standard just as, earlier, he has undermined neoclassical formalism in aesthetic theory. Even the style of his argument is similar. The crucial levers of his attack on gold are, first, his broad definition of money as "every document acknowledging debt, which is transferable," and, second, his awareness of human or psychological factors in the changing value of currency.[26]

Ruskin's definition of currency as the "transferable acknowledgment of debt" is advanced for his time and, in its essentials, is the one currently accepted by professional economists. It goes beyond the common definition of money as a medium of exchange or measure of value and stresses the power of money, its role as a store of value or claim against property. Ruskin relates this view of currency

to his "vital" economics. Since property is the result of labor, currency is a claim upon labor. "The chief value and virtue of money," he writes, "consists in its having power over human beings." Similar statements can be found in the writings of mercantilists who view monetary policy as a means of stimulating industry and socialists who wish to relate currency to a vision of exploitation. Ruskin, in his own fashion, falls under both heads. Here, it is sufficient to note that his definition casts the burden on the function of money as a means to an end and on its beneficial or harmful effect on living men. Currency, for Ruskin, is not an end in itself. It is unlikely that he will be found among the votaries of any standard of value which, like gold, demands absolute obeisance. The breadth of his definition of currency as a "documentary" claim implies that, for him, the chief thing is not a particular standard but the purposes served by the currency.[27]

The second lever of Ruskin's attack on the gold standard is his perception of the psychological determinants of currency value. His theory of currency resembles his more general theory of exchange value. He insists that "the real working power or worth of currency is founded on the entire sum of the relative estimates formed by the population of its possessions." Every change in the people's estimate of their possessions and every change in the national character "instantly alters the value of money in its great function of commanding labour"—a change as inevitable as "the change in volume of the outflowing river from some vast lake, caused by change in the volume of the inflowing streams." Here Ruskin connects price and currency and makes both, to a degree, psychologically determined.[28]

Ruskin's attempt to relate currency to the "estimates" of the consumer appears in his interesting and farsighted view of inflation. In a dialogue with Cairnes, conducted through periodicals (1863), Ruskin denies that the influx of gold from Australia and California had an immediate inflational effect on the British pound. The presently visible phenomena of price increase are "equally regulated by thousands of other conditions." Chief among them are the nation's attitudes and its habits of spending and saving: "These agencies of daily economy have so much more power over the market than the supply from the mine that no statistics of which we are yet in possession are . . . sufficient to prove the dependence of any given phenomena of the market on the rate of metallic supply." Ruskin cites the inflationary effect of "our European amusements in the manufacture

of monster guns." By attributing inflation not to a simple influx of gold bullion but to a complicated configuration of factors, Ruskin is on more solid ground than Cairnes. In *Munera Pulveris,* he relates inflation to the quality of consumption and the need for consumer education. He suggests that inflation is a sign of that overcivilization which Coleridge describes as the "hectic of disease":

In proportion as the habits of the nation become complex and fantastic (and they may be both, without therefore being civilized), its circulating medium must increase in proportion to its store. If every one wants a little of every-thing . . . if multitudes live by work which, ministering to fancy, has its pay measured by fancy . . . and, finally, and worst of all, if the currency itself, from its largeness, and from the power which the possession of it implies, becomes the sole object of desire with large numbers of the nation . . . the currency neces-sarily enlarges in proportion to the store . . . and has a more and more important and malignant power over the nation's dealings, character, and life. (17.192)

To the modern reader, accustomed to mathematical studies, this moral approach seems strange. Nonetheless, it is Ruskin's view of currency as a means to the end of human life, a means closely related to human wants and desires, which inspires his attack on gold.[29]

When Ruskin turns to the gold standard, the tone of his argument is one of expediency. He does not defer to this standard as the major linchpin of a self-adjusting competitive economy. On the contrary, he notes the inconveniences attaching to gold as a document or as a standard for documents, first, because of its liability to sale as a commodity and, second, because of its tendency to vary sharply in value with "the popular estimate of its desirableness." Ruskin com-plains that, under the gold standard, "the stream of currency itself becomes opaque with gold—half-currency and half-commodity." His awareness of psychological factors does yeoman service in alerting him to the disadvantages of gold. He suggests abandoning the gold standard and basing currency on a substance of "truer intrinsic value" or, better, on several substances like bread, iron, and silk. In *Unto This Last,* he suggests using the wages of labor or labor-time, an idea more frequently associated with the Owenite or socialist tradi-tion. Ruskin is not the first to criticize the gold standard. Plato and Sir Thomas More attack the fetishism of gold and silver. They ad-vocate a currency based on the state's authority. In nineteenth-century England, there are several currency reformers with whom Ruskin might have been familiar—Thomas P. Thompson, Charles and Thomas Attwood, John Wheatley, Joseph Lowe, and John Rooke. Wheatley, Lowe, and Rooke would relate currency to the value of

basic commodities. Unlike most reformers, Ruskin declares modestly that he can come to no conclusion on the subject and urges further analysis.[30] He insists only that the use of gold

is a barbarism;—a remnant of the conditions of barter, which alone render commerce possible among savage nations. . . . In proportion to the extension of civilization, and increase of trustworthiness in governments, it will cease. (17.159)

Ruskin's criticism of the gold standard and his awareness of psychological factors lead him to grasp briefly the possibility of a currency managed to assure prosperity. A managed currency is one of the tools of today's economics of abundance. Ruskin admits that, as a general rule, currencies of forced acceptance or unlimited issue are "modes of disguising taxation." On occasion, however, "arbitrary control and issues of currency" are wise. They can "affect the production of wealth by acting on the hopes and fears of men." More specifically, when new money is brought into the market, "the desire to obtain the money will, under certain circumstances, stimulate industry: an additional quantity of wealth is immediately produced and . . . the value of the existing currency is undepreciated." In his dialogue with Cairnes, Ruskin argues that an influx of bullion will stimulate the economy and not result in long-term inflation. He admits the need for further study but never returns to follow out his original insight. Nowhere is the "shattered majesty" or Gothic quality of Ruskin's work more evident.[31]

Ruskin's vision of a managed currency and his suggestion of raising the level of production and employment through controlled inflation are not original. His ideas bear an affinity to those of certain mercantilist thinkers who consider an injection of currency the best way to stimulate industry. Their goal is not to maximize public welfare but to better the nation's trading position by increasing exports. Bishop Berkeley and Sir James Steuart are exceptions. Berkeley anticipates Ruskin in his insistence that currency is a means to a larger, human end. Steuart, on the other hand, resembles John Maynard Keynes in proposing a well-regulated and somewhat inflationary currency policy to bolster employment. Earlier writers who suggest that an increase in currency will stimulate trade are Edward Misselden (fl. 1608-1654), William Potter (fl. 1625-1656), and the eighteenth-century advocates of paper money, John Law and Jacob Vanderlint. In the nineteenth century, Henry Thornton and Thomas Attwood make the stimulation of the economy one of their purposes

as do the more radical critics Robert Owen and John Gray. Abram Combe's fantastic cistern parable concludes with the replacement of Competition by a guardian of the stopcock who will issue paper money. It reminds one of Ruskin's use of stream imagery. Many of these writers give more considered attention to the problem of currency than does Ruskin. Ruskin excels again in the wholeness of his approach and in his ability to relate his theory of currency to the other perceptions which spring from his vision of abundance.[32]

The assumption of abundance underlying Ruskin's discussion of currency appears in his criticism of parsimony and hoarding. He desires to keep money in circulation by spending. Since economy is "management," the important thing, Ruskin insists, is not to save money but to arrange the relations of the holders of the store and the holders of the currency so that real wealth is produced, distributed, and consumed in the most effective way. In *Munera Pulveris,* he is particularly disturbed by the increase of money in the hands of currency-holders: "The currency-holders always increase in number and influence in proportion to the clumsiness of the store-holders; for the less use people can make of things, the more they want . . . to change them for something else; and all frequency of change increases the quantity and power of currency." Here Ruskin relates his concept of acceptant capacity and his psychological analysis of inflation to his critique of hoarding. The hoarder of money is a "curator" rather than a "possessor" of wealth. Lacking acceptant capacity, he does not know what he really wants or needs but proceeds compulsively in "vague collection and aggregation." He is enticed by the "seclusion" and imaginary value of money and by the power of arithmetical comparison. His pleasure is, first, in his money and in his possessions only as representing it. His money is a "deluge, with the wealth floating, and for the most part perishing in it," when it should be an "atmosphere surrounding the wealth, rising from it and raining back upon it." The danger is that accumulations of money seldom end in beneficial distribution and use:

The circulation of wealth, which ought to be soft, steady, strong, far-sweeping, and full of warmth, like the Gulf stream, being narrowed into an eddy, and concentrated on a point, changes into the alternate suction and surrender of Charybdis. (17.208)

With this image of a flowing stream, Ruskin concludes his effort at constructive theorizing. The choice of metaphor reminds one of the unmanageable Alpine torrents. It reveals the close relation between

his analysis of currency, his assumption of abundance, and his personal obsessions.[33]

<center>6</center>

At this point, the reader might object that an emphasis on spending, while opposed to the ascetic tradition of puritanism and the classical economists' view of saving, does not in itself imply a belief in the imminent arrival of abundance. It is easy to find writers of the seventeenth and eighteenth centuries who value spending. Among these are Nicholas Barbon (c. 1640-1698), Mandeville (1670-1733), Hume, Steuart, and Quesnay. In the early nineteenth century, Malthus, Müller, Lauderdale, and Sismondi condemn the orthodox economists' "passion for accumulation." There is, however, an important difference between these thinkers and Ruskin. For them, spending is a means to the circulation of currency and trade, a means closely circumscribed by the particular economic goal to be achieved, whether it be the mercantilist goal of a favorable balance of exports over imports, the physiocratic goal of a prosperous agriculture, or the Malthusian goal of preventing "gluts." For Ruskin, spending is an end in itself, or a means to consumption, and only secondarily a means to the smooth functioning of the economic machine. Although Hume, Steuart, and Malthus insist that the ultimate beneficiaries of an increased circulation of wealth are the lower classes, spending for them is the spending of the rich. It redounds to the poor through its effect on the level of employment. For Ruskin, spending is an immediate thing, identical with consumption or "life." His interest in it applies to the poor, or, better, to those who soon will be poor no longer, as well as to the rich. There is an evangelical fervor in Ruskin's view of consumption, a fervor which explains the casualness, if not carelessness, of his attempts to relate spending and consumption to other aspects of the economy. It is consumption, not the dynamic relationship of consumption and production, which concerns him. "The wealth of a nation," he writes, "is only to be estimated by what it consumes."[34]

Analytic carelessness aside, Ruskin's insistence on spending and consumption is the central theme of his economic criticism and his most important contribution to economic thought. It is implicit in his concept of acceptant capacity, in his dictum, "There is no wealth but life," and in his redefinition of demand. Earlier, one is reminded of his discussion of the role of the consumer in directing employment in *The Stones of Venice* and *The Political Economy of Art.* It

is this pervasive emphasis on consumption which makes the idea that Ruskin is one of the first to study social problems from the viewpoint of abundance so convincing. In an abundant society, where necessities are far from scarce, the desires and demands of consumers will hold first attention. Production per se will no longer be infinitely useful.

Ruskin's emphasis on consumption colors every page of his economic writings. In *Unto This Last,* he declares:

The final object of political economy . . . is to get good method of consumption, and great quantity of consumption. . . . It is the manner and issue of consumption which are the real tests of production . . . and the question for the nation is not how much labour it employs, but how much life it produces. For as consumption is the end and aim of production, so life is the end and aim of consumption. (17.102-104)

Ruskin accuses classical economists of omitting "the most important branch of the business—the study of *spending.*" They speak "as if there were no good in consumption absolute." "So far from this being so," he writes, "consumption absolute is the end, crown, and perfection of production; and wise consumption is a far more difficult art than wise production." Ruskin condemns John Stuart Mill for distinguishing between productive consumption, which increases "the productive powers of the community," and unproductive consumption, which involves "pleasures and all higher uses." Mill confines his study to the former. In Ruskin's view, this is an absurd reversal of priorities.[35]

Ruskin devotes much space to unmasking the orthodox economists' fixation with capital accumulation and production. His interest in etymology serves him well:

Capital signifies "head, or source, or root material"—it is material by which some derivative or secondary good is produced. . . . It is a root, which does not enter into vital function till it produces something else than a root: namely, fruit. That fruit will in time again produce roots; and so all living capital issues in reproduction of capital; but capital which produces nothing but capital is only root producing root; bulb issuing in bulb, never in tulip; seed issuing in seed, never in bread. (17.98)

Orthodox political economy aims at "the multiplication, or (less even) the aggregation, of bulbs" without concern for the fruit. Its capital is like a well-made ploughshare begetting other ploughshares which glitter in the sun but never see a furrow. True capital is like the ploughshare which "grows bright in the furrow; rather with diminution of its substance, than addition, by the noble friction." In

Ruskin's view, "the true home question, to every capitalist and to every nation, is not, 'how many ploughs have you?' but, 'where are your furrows?' " Economists confuse production of seed with that of food or production for the "Ground" with that for the "Mouth." They fail to see that the granary is not the goal of production but only an intermediary in the greater goal of distribution and consumption. They confuse "money-gain" with "true gain, which is humanity."[36]

Ruskin's use of organic metaphors suggests an important connection between his economic and aesthetic attitudes. His emphasis on fruit and food over root and seed, for example, suggests an unconscious parallel between his organicism of the surface in nature and art and his emphasis on consumption in economics. In both cases, it is the wholeness or health of the final product, not the process of growth and germination, which interests Ruskin. In economics, the final product or "fruit" is man or, rather, vital beauty in man. This fact is often overlooked by orthodox economists who lack Ruskin's "drive to humanity." In a time of economic expansion, they are more interested in the growth of capital and production than in the final goal. With an annoying hauteur, Ruskin assumes the process of growth and the abundance it has created and concentrates on the quality of the result. So far is he from stressing growth and accumulation that he considers the value of capital to be realized in its "destruction" or "diminution." The ploughshare "growing bright in the furrow . . . with diminution of its substance" recalls his psychological attachment to decay instead of positive growth. Here, however, he makes decay a phenomenon of fertility. Could it be that Ruskin is closer to the late nineteenth-century "decadents" than he would have admitted?

Whatever its source, Ruskin's criticism of political economy for emphasizing production at the expense of consumption is justified. At first glance, he seems to be totally wrong and even to have plagiarized from earlier economists. "Consumption," writes Adam Smith, "is the sole end and purpose of all production; and the interest of the producer ought to be attended to, only so far as it is necessary for promoting that of the consumer." James Mill is no less emphatic:

Of the four sets of operations, Production, Distribution, Exchange, and Consumption, which constitute the subject of Political Economy, the first three are means. No man produces for the sake of producing and nothing further. . . . The end is consumption.[37]

These statements are truisms, borrowed from the physiocrats and directed at the mercantilists whose regulations were supposed to have favored individual producers. A more accurate description of the direction of classical economics is to be found in John Stuart Mill's remark: "Political Economy has nothing to do with the consumption of wealth, further than as the consideration of it is inseparable from that of production, or from that of distribution." The chief concern of the classical economists is to maximize physical production. Their labor theory of value, especially the "labor-embodied" version which Ricardo adopts, their distinction between productive and unproductive labor, their belief in free competition, and, above all, their emphasis on capital accumulation, saving, and "abstinence" form a body of doctrines unified by the goal of expanding production. Unlike the marginal utility economists after 1870, the classical economists focus, not on the problem of "allocating" present resources to satisfy consumers' wants, but on the problem of increasing the productivity of labor and the total volume of economic activity. Adam Smith is aware that the mechanism of exchange and the division of labor serve the satisfaction of consumers' wants, "the necessities and conveniences of life." But his interest in the subjective level of analysis and the problem of allocating resources is neither clearcut nor long maintained. On the whole, Smith and his followers agree that consumer satisfaction is roughly proportioned to the quantity of things produced. Wealth can be maximized more effectively by increasing the volume of output than by making careful adjustments in the distribution of resources among consumers' goods industries. Even free competition is valued more for its contribution to economic expansion by widening the market, promoting the division of labor, and encouraging thrift than for its service in allocating resources within a given market. The "allocative" interpretation of competition gains favor only after 1870.[38]

The demands of expanding production inspire the classical school's obsession with saving and investment. When one reads the following statements from *The Wealth of Nations,* one can sympathize with Ruskin's description of the tumblebug "gathering its treasures (such as they are) into little round balls; and pushing them home with the strong wrong end of it . . . like a modern political economist with his ball of capital" or Marx's exclamation, " 'Accumulate, accumulate.' That is Moses and the prophets!'":

The industry of the society can augment only in proportion as its capital augments, and its capital can augment only in proportion to what can be gradually

saved out of its revenue. . . . Parsimony, and not industry, is the immediate cause of the increase of capital. . . . Every prodigal appears to be a public enemy and every frugal man a public benefactor.

Fortunately, economic man is assumed to be frugal. "The principle which prompts to save is the desire of bettering one's condition, a desire which . . . never leaves us till we go into the grave. . . ."[39]

Ruskin and the marginal economists attach less importance to production and accumulation. For them, the problem is not so much one of "laboring" against a scarce nature to produce a sufficiency of goods as one of serving consumers' desires by making efficient use of resources present. From similar assumptions, Ruskin and the marginalists take very different routes. The marginalists examine the "allocative efficiency" of the exchange mechanism—its technical ability to satisfy consumers' wants expressed as demands in the market and accepted as "given." Ruskin shows little interest in the technical problems of exchange. Although he admits that prices are determined by the subjective demands of consumers, he refuses to accept these as the final standard. His concept of vital value prevents him from recognizing the sovereignty of the consumer. For Ruskin, as for Simon Patten and John A. Hobson in later years, the assumption of abundance is a license not only to view consumption as the end of the economic process but also to stress the qualitative and ethical aspects of consumption. "There is a swine's pleasure, and dove's; villain's pleasure and gentleman's," he declares.[40]

Ruskin is not the first to give a central place to consumption. The French economist Frédéric Bastiat (1801-1850) believes that "consumption is the great end of Political Economy." He anticipates Ruskin's calls for a consumer ethic: "If humanity is to be perfected, it must be by the conversion of consumers, and not by the moralising of producers." He holds consumers responsible for the production of worthless commodities. Ruskin mentions Bastiat several times but only to criticize him as being at one with the classical economists. Bastiat does, in fact, believe that the competition of producers for profit redounds automatically to the benefit of consumers. His interest in the role of the consumer does not undermine his faith in the natural "harmonies" of economic law. The thinkers who most resemble Ruskin in their emphasis on consumption are the radical critics Sismondi, Proudhon, William Thompson, and the Ricardian socialists. Unlike Bastiat, they deny the validity of the laws of classical economics. But these writers lack Ruskin's concern for the quality of consumption. It is as though they have a vision of an

abundant society but do not feel its reality. The most they can hope is that the lower classes will be given a larger quantity of the goods produced. They speak more frequently of improving "distribution" than of improving "consumption." Their world, unlike Ruskin's, has not emerged sufficiently from the chains of scarcity to encourage a concern for happiness as well as for justice. Happiness is found in Utopia.[41]

<div align="center">7</div>

Ruskin's belief that consumption limits the usefulness of capital accumulation and production inspires his opposition to the doctrines of political economy which lend a deterministic or mechanical quality to the discipline. The most important of these is Say's Law. Say's Law states that, since products are given in exchange for products, supply creates its own demand. "The total supply of products and the total demand for them," Say writes, "must of necessity be equal, for the total demand is nothing but the whole mass of commodities which have been produced." Already the ways in which Say's assumptions differ from Ruskin's are evident. First, Say views money as a "veil" or means of "carriage" and not as a store of power; second, he views demand not as a subjective variable but as a fact determined by supply; third, and most important, he has succumbed to what Marx calls the "fetishism of commodities" and ignores the relationship of commodities to the living men behind them. Long before Ruskin, Malthus makes these points the basis of his rejection of Say's Law.[42]

The purpose of Say's Law is to prove that a general glut or overproduction is impossible. James Mill sums up this aspect of the theory in his *Commerce Defended* (1808):

Whatever be the additional quantity of goods therefore which is at any time created in any country, an additional power of purchasing, exactly equivalent, is at the same instant created; so that a nation can never be naturally overstocked either with capital or with commodities.

A localized disproportion between supply and demand may occur in a particular commodity, but there can be no "general congestion." A glut in one market will be balanced by a shortage in others. Since saving and investment are assumed to be identical in classical theory, there can be no limit to socially useful saving. In a famous passage, written well before Say's time, Smith asserts that "what is annually

saved is as regularly consumed as what is annually spent and nearly in the same time too; but it is consumed by a different set of people." Ricardo puts it more briefly: "To save is to spend."[43]

The importance of Say's law of markets should not be underestimated. Its validity is crucial to the assumption of Ricardo and his followers that there can be no hitch in the transformation of physical production into economic welfare, an assumption which lies behind the labor theory of value. The effect of the law is to throw all the emphasis onto production, capital, and saving and to encourage statements like J. S. Mill's, "the capital cannot be dispensed with, the purchasers can," which Ruskin condemns in a footnote. Say's Law also justifies the policy of *laissez faire.* It makes the relationship between production, distribution, and consumption a matter of mechanical or automatic adjustment and denies the necessity of social management to stimulate consumption and prevent waste. Say makes explicit the mechanical bias implicit in Smith. He differs from the physiocrats and other writers who admit the possibility of sickness in the economic "organism" and hence the usefulness of a doctor. Say is, in fact, the first to adopt Newtonian physics as the proper model for the science of economics. The scarcity frame of reference to which the mechanical theory of markets owes its credibility is evident in Say's parenthetical comment, "Wealth is none too plentiful among nations, any more than it is among individuals."[44]

Ruskin nowhere mentions Say's Law. Nonetheless, all of his economic theorizing may be taken as in indictment of it: his denial that private accumulations of wealth are necessarily beneficial to society, his belief that social waste occurs through uncontrolled competition, his redefinition of wealth in terms which emphasize the "capacity for use" of the possessor, his questioning of the social utility of unlimited saving and production, and, finally, his belief that "gluts of the market" are a "disease of clumsy and wanton commerce."[45] Ruskin's position finds its best expression in the following, significantly fluvial metaphor. He declares that the wealthy operate

for the nation, in an economical point of view, either as pools of dead water, and eddies in a stream (which, so long as the stream flows, are useless, or serve only to drown people, but may become of importance in a state of stagnation should the stream dry); or else, as dams in a river, of which the ultimate service depends not on the dam, but the miller; or else, as mere accidental stays and impediments, acting not as wealth, but . . . as "illth," causing various devastation and trouble around them in all directions; or lastly, act not at all, but are merely animated conditions of delay. . . . (17.89)

Ruskin's lapse into metaphor is typical of his approach. He is, as it were, a prophet of abundance, content to propound his vision and to suggest briefly its implications for economic theory. He seems to believe that the renovation of economic theory can be worked out later or, better, that the materials for such a renovation already exist and need only to be welded together by his power of imagination. As in the study of landscape, Ruskin stops short after delineating an organic wholeness of surface. It is this tentative, mysteriously suggestive quality of his writing which makes it influential. He propounds no theory so specific and rigid that it can be definitely rejected. At the same time, he provides a large, faintly sketched canvas on which other men can impress their theoretical constructions.

The materials for a reconstruction of economic theory are, indeed, present when Ruskin writes. His disagreement with Say's theory of markets places him in the company of economic critics whose rejection of the social utility of unlimited saving and whose belief in the possibility of crises due to insufficient demand or "underconsumption" point to the Keynesian economics of the twentieth century. Even a partial list would be awkward. Long before Say had formulated his theory, thinkers in the eighteenth century had rejected its central idea. These include Berkeley, Hume, Steuart, and the French physiocrats. In the first half of the nineteenth century, the list is much longer: in France, Sismondi, Charles Fourier, and Louis Blanc; in Germany, the nationalist Müller and the radicals Rodbertus and Lassalle; in England, Robert Owen, most of the Ricardian socialists, the journalists William Cobbett and William Benbow, the Christian Socialist J. M. Ludlow, and writers like John Craig, William Spence, Lauderdale, Malthus, and Thomas Chalmers who are concerned primarily with the spending of landowners. Karl Marx also should be mentioned. Although lack of consumption forms but a part and not the most significant part of his theory of crises, he condemns Say's Law as a "childish dogma":

The last cause of all real crises always remains the poverty and restricted consumption of the masses as compared to the tendency of capitalist production to develop the productive forces in such a way, that only the absolute power of consumption of the entire society would be their limit. (*Capital*, III, ch. xxx, 568)

The frequency with which many of these writers have been mentioned as precursors of Ruskin on scope, price, and currency suggests that the organic wholeness of Ruskin's thought is original only in its

intensity. Or, perhaps, the unified quality of classical economics forces a unity of rejection upon its critics.[46] This unity is one of surface or form, not of detail or content. On any particular point, there will be as many theories as there are thinkers and no more so than on Say's Law. Here the theories are so diverse as to defy brief summary. The critics agree only in asserting the possibility or, frequently, the inevitability of disarray in the functioning of the economy due to a disproportion between consumption and production, demand and supply. Several principles of organization might isolate those with whom Ruskin has a special affinity.

The first concerns the location of the failure of demand. Is it located in the lower classes or elsewhere, and is the remedy better distribution of income or more spending by the rich? Using this approach, one would have Sismondi, the Ricardian socialists, J. M. Ludlow, and Rodbertus opposing Craig, Lauderdale, Malthus, Chalmers, and most of those who wrote before the nineteenth century. This distinction does not really help place Ruskin. He resembles Sismondi and the socialists in his demand for a better distribution of income and his vision of an economy of high wages. He can even declare in tones reminiscent of William Godwin or Charles Hall that the usefulness of expenditure by the rich depends entirely on how they obtained their riches and what sort of work they employ men to do. At the same time, Ruskin would find the agrarian and traditional preferences of writers like Lauderdale and Malthus appealing. He spends much time stressing the importance of proper spending by the landed. Ruskin's rare blend of radicalism and conservatism makes classification difficult. Occasionally, he takes a third position and proposes government spending on public projects to clear the flow of wealth. Malthus, too, recognizes the value of public works in stimulating demand, but an interest in government spending is more typical of the mercantilists *manqué* Berkeley and Steuart or the Romantics Coleridge and Southey, who take their economics from Steuart. In the face of such diversity, the first principle of organization must rank as a failure.[47]

A second principle, which might be more useful, centers on ethical considerations. Ruskin's denial of the utility of unlimited accumulation and production has its roots in his ethical idea of value or use. Although he insists that "vital" value includes goods which serve man's happiness and creativity as well as his physical needs, there is an idea of necessity and objective limit about it. Man needs such and such for his well-being, which is viewed in the relatively simple terms

of a healthy, creative life with ample repose. Beyond this, production of luxuries is unnecessary. Ruskin hopes to include in the living standard of all men items which are now only the luxuries of the rich, but these items would then be considered necessities. His perception of abundance does not negate a lingering prejudice against luxuries. He cannot accept the view of the classical economists that man's wants are infinite, a view which had its origins in Hobbes and Locke and received support from Helvetius and Bentham. Ruskin goes back to the thinking of Shaftesbury, Hume, Hutcheson, and the Smith of *The Theory of Moral Sentiments,* who recognize benevolence and a desire for the happiness of others to be incentives as well as selfishness. They describe the man of virtue as one who, in Hume's words, "governs his appetites, subdues his passion, and has learned, from reason, to set a just value on every pursuit and enjoyment." They see a definite limit to the amount of wealth which is useful to man. "What can be added," Smith asks, "to the happiness of the man who is in health, who is out of debt, and has a clear conscience?" Smith marks the break in this tradition. In *The Wealth of Nations,* he assumes that man will seek endlessly to accumulate wealth and posits this as the end of his behavior with no questions asked.[48]

Although Ruskin was familiar with the work of the Scottish "moral sentiment" school, his own attitude springs as much from Plato, Aristotle, and the Stoics. For the Greek philosophers, wealth is neither an end in itself nor a means to the insatiable pursuit of pleasure. It is a means to the "good life" or "living in accordance with the virtues," the chief of which is temperance. The ancients refuse to separate their ideal of human nature from their view of what man is when they approach economic matters. Sharing this ideal and this approach to economics, Ruskin is predisposed to regard production or accumulation beyond man's limited needs as useless and wasteful: "Possession is in use only, which for each man is sternly limited. . . ." Since the legitimate wants which man has are absolutely "vital," Ruskin is also predisposed to discover conditions of "underconsumption" among the poorer members of society. The step from this moral or "real" plane of analysis to an economic plane, in which overproduction and underconsumption are viewed as technical problems hindering the efficient operation of the economy, is not a long one for those seeking to discredit Say's Law. Thinkers who make the transition from the ethical to the technical level often lack the knowledge to fashion economically sound arguments. Rus-

kin's criticism of Say's Law is a case in point. It is haphazard, unfinished, and worked out only so far as will serve his larger purposes of ethical propaganda.[49]

Returning to the "underconsumptionists," one can distinguish between those like Ruskin who adopt a moral approach and those whose criticisms stem from technical concerns or from special interests of an economic nature. The first group view man as a creature with limited but important wants. They value the simple life and place their ideal societies in a rural environment. Their attitude is a common one: the rich have too much and the poor too little. They proceed to argue in technical terms that this condition underlies economic dislocations. Their concern is not first with maintaining the level of productivity or employment, as it is for Lauderdale, Malthus, or Chalmers. They are interested in obtaining justice for an underpriviledged class. They are concerned more with what ought to be than with what is, a fact which helps explain the lower quality of their economic analysis. These thinkers include, among others, Robert Owen, William Cobbett, the Ricardian socialists, J. M. Ludlow, Sismondi, and Rodbertus. Ruskin's ethical concern, if not his natural inclinations and prejudices, places him on this side of the spectrum. The second principle of organization reinforces the more tentative results of the first.

The reader who has followed this argument is undoubtedly infuriated by the cavalier manner in which the attempt to "place" Ruskin has been pursued and is demanding more specific information. He is no more frustrated than the student of Ruskin who tries to determine Ruskin's view of the function of consumption and his position on such a technical matter as the cause of crises. For the fact is that Ruskin has no detailed theory of crises and no view of the relation of consumption to production which an economist could understand or discuss. At moments like this, one will agree with critics of Ruskin who maintain, as De Quincey did of Coleridge, that his attempt to broaden the scope of political economy leads to a vitiating vagueness and that the only way to understand the complexity of modern economics is to confine oneself to very small, detailed problems. One wishes that Ruskin had been more of a fox and less of a hedgehog. Since he does not understand what it means to analyze at a purely economic level, it is impossible to compare his technical views with those of the writers mentioned above and futile to describe their views in an essay on Ruskin. This task should be left to the future

historian of underconsumption, who will find that many under-consumptionists suffer from an ethical distortion similar to Ruskin's.[50]

<div style="text-align: center">8</div>

Say's Law is a basic element in the mechanical, production-oriented character of orthodox political economy. A second element is the wages-fund theory. Since this has a direct effect upon employers' attitudes, Ruskin leaves less to implication in his criticism of it. The wages-fund theory has a long, if confusing, history in classical economics. It is difficult to determine who adheres to it and who does not, for it is not a separate theory of wages in the sense that it explains the sources of wage income. Rather, it is a very simple description of what happens in the final sequence of wage payment by employers. It states that the level of wages is determined by dividing the funds available for wage payment by the number of laborers. The significance of this truism depends not on the process of division but on the definition of the divisor and dividend. As its name suggests, the wages-fund theory gains notoriety in proportion as the dividend is supposed to be fixed and determined. Under these conditions, the only way to raise wages is to reduce the number of workers. If their number increases, each will receive less. If one group gains an increase, it will be at the expense of another group. Such a theory, if generally accepted, could do valuable service for employers who wished to focus their energies on capital accumulation and resist demands for higher wages.

Suggestions of a limited fund "destined for the maintenance of labour" can be found in Smith, Malthus, and Ricardo. In Ricardo, it takes the form of an assertion that "if wages should rise . . . profits would necessarily fall," a remark loaded with explosive significance for prophets of class war. The wages-fund theory receives its most rigid expression in the hands of James Mill and John R. McCulloch. "The price of labour," writes McCulloch, "depends on the number of labourers seeking employment, compared with the capital or fund which is to pay their wages, and is independent alike of the schemes and combinations of the buyers and those of the sellers."[51]

John Stuart Mill is the economist commonly associated with the wages-fund, perhaps because of his celebrated "recantation" of the doctrine in 1869. Mill's cautious version runs as follows:

Wages, then, depend mainly upon the demand and supply of labour; or as it is often expressed, on the proportion between population and capital. By popula-

tion is here meant the number only of the labouring class, or rather of those who work for hire; and by capital only circulating capital, and not even the whole of that, but the part which is expended in the direct purchase of labour. . . . With these limitations of the terms, wages . . . cannot rise, but by an increase of the aggregate funds employed in hiring labourers, or a diminution in the number of the competitors for hire. (*Principles*, Bk. II, ch. xi, 207-208)

In this guise, the wages-fund theory is harmless and seems hardly worth "recanting." One suspects that it was not the attacks of William T. Thornton and other critics of the wages-fund that made Mill recant but the usefulness of the doctrine in its more rigid form to opponents of the labor movement. They could declare that the fixed nature of the fund made wage increases "scientifically" impossible. After reading Mill's version, one can agree with him that the wages-fund is a "shadow which will vanish if we go boldly up to it."[52]

The best way to exorcise the shadow is to move back in the sequence of analysis to the employer's decision and emphasize the flexibility of the decision and the variability of the fund. This approach shows the wages-fund theory to be irrelevant. Each of the major English critics of the wages-fund in the sixties, Francis D. Longe, T. E. Cliffe-Leslie, W. T. Thornton, and Fleeming Jenkin, adopts this approach. Thornton puts it clearly in *On Labour* (1869):

If there really were a national fund the whole of which must necessarily be applied to the payment of wages, that fund could be no other than an aggregate of smaller similar funds possessed by the several individuals who composed the employing part of the nation. Does, then, any individual employer possess any such fund? Is there any specific portion of any individual's capital which the owner must necessarily expend upon labour? (pp. 84-85)

The year before, Jenkin had made the same point by identifying the determination of wages with the determination of prices generally and noting the subjective factors in both. He uses a phrase very similar to one used by Ruskin on price: "Wages, like the price of all the limited commodities, depend on a conflict between the desire for the commodity and the reluctance to sell it. Anything affecting either feeling as to labour will alter wages." The rejection of the wages-fund theory is a part of that shift from the fixed and determined to the subjective and flexible at work in the decline of the labor theory of value. It is a part of the movement from a scarce world where things can be done only in fixed, determined ways and where the employer, faced with a declining rate of profit, has only limited funds at his disposal to an abundant world where there is

leeway, flexibility, and freedom of choice. As if to demonstrate the connection between this movement and Ruskin's "drive to humanity," J. M. Ludlow declares in 1851 that "there is a human element in the determination of the demand of capital for labour." This demand is "no arbitrary, fatal quantity . . . it is subject to human wills, varies with human affections, is responsible to human duties."[53]

The assertion that employers have a flexibility of choice in the payment of wages does not make it so. The next step in the critique of the wages-fund theory consists in pointing out factors which make for latitude in wage payment. The most important is the productivity of labor itself. This argument reaches its complete form in the work of the American economist Francis A. Walker, writing in the 1870's. According to Walker, wages are paid out of the product of labor, not out of capital. Even when advanced out of capital, they are ultimately paid from what labor produces, for it is the expectation of a profit resulting from production which encourages the employment of labor. Walker did not originate the productivity theory of wages. There are suggestions of it in Smith, Lauderdale, Senior, and the less well-known economists John Craig, Richard Jones, and Longfield. Samuel Bailey (1791-1870) and Thomas Hodgskin (1787-1869) are the first to criticize the wages-fund theory itself from the standpoint of "the productiveness of labour." They anticipate by several decades the more thorough analyses of Longe, Jenkin, and Thornton. The term "productivity" is misleading. These theories actually make wages depend on the level of consumer demand. Only through consumer purchases can the value of the product of labor be realized. The critics of the wages-fund, like those of Say's Law, reject the classical school's emphasis on capital as expressed in Mill's dictums, "industry is limited by capital" and "demand for commodities is not demand for labour." They share in the tendency to shift the focus of political economy to consumption which marks the decline of the classical school. Their criticisms are to a large extent justified, for the wages-fund theory and Say's Law conspire to ignore demand and make capital the prime mover of the economic process.[54]

Ruskin's attack on the wages-fund theory is not as fully developed as Thornton's or Walker's. Nevertheless, before their criticisms appear, Ruskin grasps the essential point. His treatment demonstrates how an unprofessional harping on the "vital" realities behind economic terms can merge imperceptibly into professional insights of a

high order. Ruskin condemns the "frequently uttered aphorism of mercantile economy—'Labour is limited by capital.' " He continues:

> Out of a given quantity of funds for wages, more or less labour is to be had, according to the quantity of will with which we can inspire the workman; and the true limit of labour is only in the limit of this moral stimulus of the will, and of the bodily power. In an ultimate, but entirely unpractical sense, labour is limited by capital, as it is by matter . . . but in the practical sense, labour is limited only by the great original capital of head, heart, and hand. (17.177)

The relation of labor to capital is that of fire to fuel: "out of so much fuel, you *can* have only so much fire—but out of so much fuel, you *shall* have so much fire," depending on the air and wind.[55]

In a metaphorical way, Ruskin is foreshadowing Walker's theory. Even if the fund of capital were limited, the productivity of labor itself would remove the rigidity from the situation. Ruskin, however, denies that the original fund is limited. He cuts through the whole problem by identifying the wages-fund with the amount of consumers' "purchase-money": "It can never be said positively that the purchase-money, or wages fund, of any trade is withdrawn from some other trade. The object itself may be the stimulus of the production of the money which buys it. . . ." Ruskin condemns J. S. Mill's remark that "the consumer does not, with his own funds, pay the weaver for his day's work." "Pardon me," he writes, "the consumer of the

> velvet pays the weaver with his own funds as much as he pays the gardener. He pays, probably, an intermediate ship-owner, velvet merchant, and shopman . . . but the velvet is as much produced by the consumer's capital, though he does not pay for it till six months after production, as the grass is produced by his capital, though he does not pay the man who rolled and mowed it on Monday, till Saturday afternoon. (17.102-103)

Ruskin suggests that the "purchasing public" is "a great capitalist" employing and paying both the workmen and their masters. Although his comments ignore the technicalities of wage theory, he sees the fallacy of the wages-fund. It promotes an overly rigid view of economic phenomena. It places the focus on capital and fails to relate wage payment to consumption or demand. Ruskin refuses to accept the vision of a tight, scarce economy where things must be done in a certain way as determined by the requirements of capital accumulation. His vision is of an abundant economy more open and responsive to the desires and management of men.[56]

9

The management of an economy of abundance would aim first for higher wages. Ruskin denies the validity of the "iron law of wages," which states that wages must remain at the level of subsistence. Indeed, he considers acceptance of this "natural" law to be final proof of the economists' bad intentions. The subsistence theory of wages is not peculiar to classical economics. Mercantilists and physiocrats believe that wages stay at a subsistence level and that this is a valuable stimulus to productive labor and a favorable balance of trade. In the hands of Ricardo, Malthus, and Richard Torrens (1780-1864), the theory takes a more elaborate form. It is reinforced by the wages-fund doctrine with its postulate of a limited supply of funds for the payment of labor and by the Malthusian theory of population. The "law of wages" is the wages-fund theory considered in terms of its long-run effects on the laborer.[57]

In its essentials, the law is a version of the law of supply and demand in which the laborer is viewed as a commodity on the market. With the supply of wages fixed, laborers compete for work and drive down wages to the level which the cheapest worker will accept. If this is above the subsistence level, the laborers will multiply, according to Malthus' theory of population, until the slack is taken up and wages return to a subsistence level. So crudely stated, the subsistence theory can be found only in popularized versions of political economy such as Mrs. Marcet's *Conversations* (1816). In the work of Ricardo and Malthus, the theory is more cautiously put. Both writers recognize that the market price of labor may rise above its natural or subsistence rate for long periods and that subsistence itself is not a purely physical minimum but a matter of custom and habit, rising as society progresses. Ruskin either ignores or has not read carefully the work of the leading economists. He directs his fire at the popular version, which served as an excellent defense against wage increases and outdoor relief. Unfortunately, he implies that the leading economists propound the popular version.[58]

Ruskin rejects both legs of the "iron law of wages"—the wages-fund doctrine and Malthus' theory of population. The latter may apply to animals but not to man. His increase is limited only by "the limits of his courage and his love." "Both of these *have* their bounds," Ruskin adds, "and ought to have; the race has its bounds also; but these have not yet been reached. . . ." He admits that, if the wages of the laborer are raised now, he will drink the increase away

and "people down to the point of misery at which you found him." But this is due to lack of education, not physical inheritance. Ruskin condemns the rich for refusing to the poor wisdom as well as food. Ruskin's criticism of Malthus is twofold. First, with proper management, an abundant society will be able to provide for a considerable increase of population. Second, improved living conditions and education will encourage the worker not to waste the abundance in his own life by drink or too large a family. Ruskin shows greater faith in education than Malthus does even in the revised edition of the *Essay on Population* (1803). His casual approach to the problem of overpopulation indicates the success of the anti-Malthusian movement by mid-century.[59]

If wages are not bound to a subsistence level, what is their proper level? Although he does not use the phrase, Ruskin formulates the concept of a "living wage." Laborers should be paid at a level which will enable them to live *well*. After noting Ricardo's definition of the "natural rate of wages" as that which will "maintain" the laborer, he exclaims:

Maintain him! yes; but how? . . . As, first, to what length of life? Out of a given number of fed persons, how many are to be old—how many young? that is to say, will you arrange their maintenance so as to kill them early . . . or so as to enable them to live out a natural life? You will feed a greater number, in the first case, by rapidity of succession; probably a happier number in the second: which does Mr. Ricardo mean to be their natural state and to which state belongs the natural rate of wages? (17.108-109)

Ruskin asks several questions without answering them. He does insist that the population should be as numerous as possible and as healthy and happy as possible. Quantity should not take precedence over quality. "The presence of a wise population implies the search for felicity as well as for food." In the ideal state, none would merely subsist. All would live abundantly and, in their happiness and creativity, augment the real wealth of the nation. Ruskin's vision of a population both as numerous as possible and of as high a quality as possible points to later theories of "optimum population."[60]

If Ruskin is vague about the proper level of wages, he is certain that they should be fixed and vary only with the cost of living, not the demand for labor. "Perhaps one of the most curious facts in the history of human error," he writes, paraphrasing J. M. Ludlow, "is the denial by the common political economist of the possibility of thus regulating wages; while, for all the important, and much of the

unimportant, labour, on the earth, wages are already so regulated."
Ruskin cites prime ministers, bishops, doctors, and lawyers. He be-
lieves that "the best labour always has been, and is, as *all* labour
ought to be, paid by an invariable standard." Good and bad work-
men should be paid the same so that the bad worker will not force
down the wages of the good by offering his product at half price. It
is the duty of the consumer to employ the good and not the bad
worker just as it is his duty to purchase good, not bad paintings. With
adequate education and with standards set by guilds or governments,
bad work will disappear.[61]

A corollary of Ruskin's pleas for fixed wages is his call for secure
employment—the employment of "constant numbers of work-
men . . . whatever may be the accidental demand for the article they
produce." This would give workers a permanent interest in their
place of work or an *esprit de corps* like that of soliders in a crack
regiment. With Carlyle, he regrets the tendency of modern commerce
to "throw both wages and trade into the form of a lottery" and
suggests that much of the cyclical nature of employment "results
merely from love of gambling on the part of the masters." Ruskin
urges the factory owner to pursue his operations with restraint. Once
the mechanical, autonomous characteristics of the economy are re-
moved both theoretically and practically, wages and security can
adhere to a standard of welfare.[62]

Ruskin's call for higher wages and secure employment is hardly
original. It would take great research to draw up a list of thinkers in
the nineteenth century who desire lower wages and cyclical unem-
ployment. As Lionel Robbins has noted, quotations can be mar-
shalled from each of the leading economists to show that he opposes
low wages. What is significant about Ruskin's demands is not their
originality but, first, their extent and, second, their relation to the
rest of his thinking. Ruskin's vision of a proper standard of living for
the worker has never been surpassed. Although, in his economic
writings, he examines the quantitative problem of higher wages, he
realizes that padding and physical comforts will not make men
happy. Security and leisure are needed and creative use of leisure.
Work, too, must be made creative, for the ideal of the Gothic builder
guides Ruskin even in his theoretical studies. Ruskin's vision of the
good life for workers places him in the camp, not of middle- or
upper-class liberals who advocate "improved conditions," nor of radi-
cal socialists determined to increase the worker's physical share of

distribution, but of visionaries like Sir Thomas More, Robert Owen, the Saint-Simonians, and Charles Fourier who are concerned with the quality of life and work in the total environment.[63]

Ruskin also differs from the usual advocate of high wages in the degree to which his proposals are related to the rest of his thought. High wages are essential to maintaining consumer demand and, hence, to creating economic value and preventing crises. Capital or saving is not the only key to the economy. For investment to be realized, there must be demand for the work which capital sets in motion. Otherwise, a glut or crisis of overproduction will result. Nowhere is this theoretical framework stated so explicitly by Ruskin, but its outlines are visible close beneath the surface of his writing. Earlier thinkers who recognize the importance of high wages to the efficient functioning of the economy are, in the eighteenth century, Berkeley, Hume, and Steuart, and, in the nineteenth century, Owen, Sismondi, Rodbertus, and, to a limited extent, Karl Marx. Ruskin takes his place as one of the most widely read of those whose vision of an economy of high wages points to the Keynesian economics of the twentieth century.

10

So far Ruskin has argued in terms of scientific accuracy and empirical possibility in his criticism of political economy. To leave Ruskin's critique here would be to ignore his appeal to Christian ethics. Ruskin himself regards his early religious training as the "most precious, and, on the whole, the one *essential* part" of all his education. Very early in his life, his mother instituted a strenuous program of Bible reading in which she and her son went through the Bible from beginning to end, "hard names, numbers, Levitical law, and all." Upon finishing the last verse, they would begin with Genesis the next day. As John Rosenberg remarks, the cadence of Ruskin's literary style shows the influence of his religious training. So does his sense of mission and social conscience. Ruskin's social criticism is an attempt to infuse the ethics of the Gospels into capitalist society. The line between his ethical and empirical criticism of economics is a fine one. The two approaches interpenetrate, with the empirical critique serving goals of welfare set by Ruskin's ethical concern and Romantic imagination.[64]

The belief that economics is "the science of getting rich by just means" guides Ruskin's discussion of wages and commercial ex-

change. Payment of wages should be based upon "absolute equity," which means "giving time for time, strength for strength, and skill for skill." Ruskin admits the difficulty of determining equity, first, because the labor given in payment is general and more valuable than the specific labor received and, second, because it is difficult to determine the monetary value of skill. By skill, he means, as in *The Stones of Venice,* "the united force of experience, intellect, and passion in their operation on manual labour." Even so, Ruskin is convinced that work "*has* a worth, just as fixed and real as the specific gravity of a substance," and that "it is easier to determine scientifically what a man ought to have for his work, than what his necessities will compel him to take for it." If wages are not bound by the "iron law" of subsistence, Ruskin sees no reason why they should not be bound by the absolute law of justice.[65]

Ruskin's ideal of a just wage, like his concept of artistic symmetry, has its roots in the ancient Greek and medieval notion of "commutative" justice. "Commutative" justice concerns the relationship of one individual to another individual. It differs from "distributive" or relative justice in that it seeks to establish an exact arithmetical equality of "thing and thing," an objective relationship dependent on the value of the things exchanged and unaffected by the social position of the persons. According to Ruskin, the standard by which wage payment is to be measured is the amount of labor involved in the production of the commodity. He does not discuss the relationship of commutative and distributive justice. Nor does he relate just wage to just price or show how equal amounts of work are equal in value, whether defined in vital terms as "availing for life" or in market terms as a function of demand and supply. Ruskin's description of wage justice makes sense only if he accepts the labor theory of value, which, elsewhere, he rejects. His statements are identical to those of Charles Hall, William Thompson, John Bray, and other radical interpreters of the labor theory. Ruskin's concern for equal justice also blinds him to the possibility of workers' sharing in the final productivity of their labor and receiving back in wages a value more than sufficient to replace their energy and skill. This, after he has criticized the wages-fund theory for ignoring the elements of productivity and consumer demand. On the question of wage justice, Ruskin's ethical convictions distort the wholeness of his vision and lead to impressively high-minded confusion.[66]

The payment of just wages is a subordinate aspect of just commer-

cial exchange. Ruskin's ethical approach in the larger field takes the form of a paradoxical assertion that there can be no "profit" in exchange, only equal "advantage." All "acquisition" in exchange is unjust. Ruskin defines profit, from the latin *proficio,* "making in favour of," as material gain "attainable only by construction or discovery, not by exchange," as when one man, by sowing and reaping, turns one measure of corn into two measures. Advantage, a "bringing of vantage or power to the exchanging persons," occurs when the product is given to the person who can use it, the person with acceptant capacity. If labor is necessary to effect the exchange, "that labour is in reality involved in the production, and . . . bears profit." Acquisition in exchange is possible but unjust. When one man is able to give what cost him little for what has cost the other much, he acquires a certain quantity of the other's labor. He "makes a profit" in the common mercantile sense of the word. Actually he does not because, what he acquires, the other loses. Examining economic processes from a national point of view, Ruskin can see no *real* profit, no "addition to the actual property or well-being of the State," in such exchange. "For every *plus* there is a precisely equal *minus.*" Political economists overlook the minuses, which have a tendency "to retire into back streets . . . or even to get themselves wholly and finally put out of sight in graves." The Science of Exchange, considered a science of profit, is simply "nugatory." Considered a science of acquisition, it is founded on the ignorance or weakness of the opposite person. It is "a science founded on nescience, and an art founded on artlessness." A true science of exchange would teach that there must be advantage on both sides and just payment to any person effecting the transaction.[67]

Ruskin's ideal of just exchange echoes earlier traditions. Aristotle formulates the rather opaque concept of a "just price." The Church Fathers and medieval Scholastics follow suit, and, in the hands of Aquinas, the concept becomes an elaborate aspect of commutative justice. Later, the ideas of just exchange and just price enter the socialist tradition in England and on the Continent. For thinkers like Owen, Proudhon, and the Ricardian socialists, just price is based on labor values. Scholarly opinion is much at variance over the basis of just price for the Greeks and Scholastics: is it based on labor costs, subjective utility, or the inherent quality of the commodity, and does it bear any relation to short-run or long-run market prices? Ruskin does not pause to clarify this muddy problem. He assumes

that justice in exchange can be easily determined by a man of honest intention like himself.[68]

More interesting than the determinants of just price is Ruskin's belief that there can be no "profit" in exchange. Surprisingly enough, this is not a quirk of his imagination. Aristotle himself believes that exchange is essentially barren. This and the belief that trading encourages unlimited acquisition lead the Greek philosophers to look down on commerce. A similar prejudice against trade and a similar belief in the unproductiveness of commercial exchange are to be found in the writings of the physiocrats. Indeed, there is a remarkable similarity between Ruskin's definition of true "profit" and the physiocrats' description of the productivity of agriculture. The physiocrats' negative opinion of trade is directed at the mercantilists. Even for the mercantilists, trade is not truly productive. A vision of the world as containing only a limited amount of wealth lies behind their emphasis on foreign trade. Trade for them is a matter of what Ruskin calls "acquisition"—a matter of pluses equalling minuses with no advance in the world's wealth. A nation can grow rich only by "acquiring" the wealth of others, not by creating its own. Their view of trade is no different from that of the physiocrats, but, while the physiocrats have a vision of agricultural productivity, the mercantilists, lacking this, must focus on "acquisitiveness." Adam Smith and the classical economists broaden the concept of productivity to include industry as well as agriculture. For them, as for the physiocrats, trade can be left free since it is not the chief thing. Unlike the physiocrats, the classical economists do not view trade as useless. It brings "advantage" to the exchanging persons, who can make this "advantage" contribute in a roundabout fashion to true productivity. Adam Smith speaks of trade in Ruskinian terms as bringing equal "advantage" to the exchanging parties. He describes the mercantilist attempt to maximize gain from foreign trade as futile.[69]

What is really at issue is a changing vision of the universe. The mercantilists view the world's wealth as definitely limited. Trade is the means by which the nation corners some of this scarce wealth for itself. The physiocrats and classical economists view the world more optimistically as a place where wealth will increase if man exerts himself. While the mercantilists view the struggle for existence as a struggle against other societies for a strictly limited amount of wealth, the classical economists view it as a difficult, competitive, yet potentially successful struggle against a niggardly nature to increase

the sum total of wealth. Ruskin, on the other hand, views nature as less niggardly and the struggle against her as successfully providing abundance for all. His belief that commercial exchange, domestic and foreign, is "profitless" is not so quixotic as it seems. He is accusing Victorian businessmen and "vulgar economists" of the same error of which the physiocrats and classical economists accuse the mercantilists—the error of viewing trade itself as productive. By levelling this accusation, not at the makers of national policy in the sphere of foreign trade, but at the behavior of individuals in the domestic economy, he is able to fashion a critique of competition and exploitation: the minuses become real people, not trade statistics. Ruskin's vision of abundance convinces him that competitive acquisitiveness is unnecessary even in the domestic sphere. It encourages his ethical approach to commercial exchange.[70]

Ruskin's call for justice in exchange finds a simpler and more striking expression in the chapter on "Commerce" in *Munera Pulveris.* He regrets that the "mischiefs of commerce" are so pervasive that the word "trader" has become synonymous with "traditor" or "traitor." He denies the existence of a separate international morality. "The farther your neighbor lives from you, and the less he understands you, *the more you are bound to be true in your dealings with him."* The chapter concludes with the kind of philological playfulness common in Ruskin's later writings. The play is partly serious. With the aid of quotations from Shakespeare and Xenophon, Ruskin urges the substitution of mercy ("Gratia"), love ("Charis"), and joy ("Chara") for "merces." Commerce, "presiding over the circulation and communication of things, is symbolized by the heart; and if that hardens, all is lost." A joyful commerce of the heart would be possible only in an economy of abundance. Ruskin's use of the heart as a symbol for commerce is a striking application of Christian ethics and Romantic imagery to economics. It points up his demand for love, sympathy, and social imagination in all economic transactions.[71]

What is one to make of Ruskin's infusion of Christian morals into economic analysis? His ethical approach and Biblical rhetoric are, perhaps, the proper medium for an audience inculcated so thoroughly with Christian attitudes as the Victorian. On the other hand, Ruskin's perceptive imagination becomes the captive of the very phrases which inspire him and many of his readers. He stretches the paradoxical nature of his opinions to the breaking point and certainly to the point where "sensible" readers are alienated. His moral

absolutism does not diminish with the passing years. Although, in
Munera Pulveris, he recognizes that an object's value depends on the
development of acceptant capacity in the user, Ruskin cannot admit
that man varies so greatly from society to society or from period to
period as to make any concept of absolute value irrelevant. When it
comes to right and wrong, his tolerance of human variety, frailty, or
Gothicness vanishes. This position may be admirable, although
Blake's ideal of "forgiveness" seems more appealing. It becomes dan-
gerous when the desire to preach the law of absolute justice or value
supersedes the desire to examine the problems of wage and exchange
in their complicated, "organic" relationship to other social factors.
Ruskin's ethical concern limits the full realization or "purity" of his
organic approach. It contributes to the stiffening or calcifying of his
opinions.

11

In conclusion, whether Ruskin uses arguments of empirical expedi-
ency or quotations from the Bible, his opposition to *laissez faire* and
his call for interference with the law of supply and demand remain
the focal points of his critique. They illustrate his vision of an econ-
omy managed for abundance.

"Vulgar economists," Ruskin believes, are not certain what they
mean by the law of supply and demand:

Some mean only that prices are regulated by the relation between demand and
supply, which is partly true; and others mean that the relation itself is one with
the process of which it is unwise to interfere; a statement which is not
only . . . untrue; but accurately the reverse of the truth: for all wise economy,
political or domestic, consists in the resolved maintenance of a given relation
between supply and demand, other than the instinctive, or (directly) natural,
one. (17.136-137)

The relation of supply and demand is not a relation of "heavenly
balance." To say that labor or any commodity depends for its ex-
change value on this relation is to beg the real question: "What does
demand depend upon, and what does supply depend upon?" Econ-
omists should look beyond the superficial phenomena of wages and
prices to intrinsic value. They should ask what is being supplied and
what is being demanded or, better, what *can* be supplied and what
ought to be demanded. At the intrinsic level, Ruskin denies the
existence of a law of supply and demand. Demand and supply are
completely separate entities. The only bond between them is the one
man creates by foresight. "It is the privilege of the fishes, as it is of

rats and wolves, to live by the laws of demand and supply; but the distinction of humanity, to live by those of right." Ruskin agrees with Carlyle that there are obligations deeper than those defined by the "fixed and unalterable" laws of political economy.[72]

Ruskin's criticism of the law of supply and demand is well taken. It is difficult to determine what this "law" of classical economics means. If it means that supply always adjusts itself to demand, it is a truism when demand is defined as the "quantity taken." If demand is defined as the "quantity desired," it is only "effective" demand or demand expressed in terms of money to which supply adapts itself and not real or social demand, a point made by Sismondi and Ludlow. At other times, the law states that the price of commodities is determined by the relation of supply and demand. Then, it is circular. As John Stuart Mill notes, if changes in demand and supply cause variations in price, it is equally true that changes in price cause variations in demand and supply. Mill attempts to define the law with more precision. Ruskin insists that whether or not price is determined by supply and demand is unimportant. The real question is whether these factors ought to be left free to work themselves out regardless of justice, expediency, or need. His call for intervention in the relationship of supply and demand epitomizes his rejection of the determinism of classical economics. It is the logical consequence of his belief that the human element cannot be considered a separate "disturbing force" in the mechanical functioning of the economy. The human element is an integral, organic part of economic processes. It must guide the economist in his theoretical studies and the politician in his work of practical management.[73]

Ruskin summarizes his view of economics:

The popular economist thinks himself wise in having discovered that wealth . . . must go where it is required; that where demand is, supply must follow. . . . Precisely in the same sense, and with the same certainty, the waters of the world go where they are required. Where the land falls, the water flows. The course neither of clouds nor rivers can be forbidden by human will. But the disposition and administration of them can be altered by human forethought. Whether the stream shall be a curse or a blessing, depends upon man's labour, and administering intelligence. . . . In like manner this wealth "goes where it is required." No human laws can withstand its flow. They can only guide it: but this, the leading trench and limiting mound can do so thoroughly, that it shall become water of life—the riches of the hand of wisdom; or, on the contrary, by leaving it to its own lawless flow, they may make it, what it has been too often, the last and deadliest of national plagues: water of Marah—the water which feeds the roots of all evil. (17.60-61)

Ruskin's use of water and stream imagery is not in itself remarkable. In the eighteenth and nineteenth centuries, mercantilists, physiocrats, classical economists, and socialists find such imagery congenial. They differ on the extent to which the flow of economic processes is to be controlled. For Hume, Smith, and most members of the classical school, the streams of wealth find their level without the assistance of Ruskin's "leading trench and limiting mound." For the conservatives Steuart and Coleridge or the radicals Owen and Marx, the "springs of social wealth" must be managed and channeled if they are to "flow more freely" and bring benefit to all. John Stuart Mill approaches Ruskin's view. "Man cannot turn back the rivers to their source," he writes, "but it rests with himself whether they shall fertilize or lay waste his fields."[74] What is significant in Ruskin's case is the pervasive way in which streams flow through his thought. Much of Ruskin's writing after *Unto This Last* and *Munera Pulveris* concerns methods of managing the flow of social abundance to ensure that its "purity" will not be wasted by the troubled currents he cannot control in his own life:

The stream which, rightly directed, would have flowed in soft irrigation from field to field—would have purified the air, given food to man and beast, and carried their burdens for them on its bosom—now overwhelms the plain and poisons the wind; its breath pestilence, and its work famine. (17.61)

VII System of Iniquity

The organic quality of Ruskin's work makes it difficult to divide his career into neat categories. He seems to have seen it all from the beginning, illuminating now this and now that portion of his vision with the random brilliance of lightning. As Ruskin ages, the flashes become more and more random and finally fade into the darkness of insanity. Many of his later flashes are repetitive, especially in the fields of art and political economy and in the criticism of waste and competition. Even so Ruskin often expands or restates his ideas in a way which demands attention. The important insights of his work in the twenty years after 1865 concern exploitation, modern war, imperialism, and the nature of the welfare state. Ruskin's surprisingly radical analysis of exploitation forms the chief subject of this chapter. Discussion of the "system of iniquity" will not suffer by yielding precedence to a brief look at Ruskin's more repetitive artistic and economic insights and at his criticisms of the quality of English life. In an age when exploitation is not so obviously crude or simple as Ruskin portrays it, it is his criticism of the quality of life and environment which retains a depressing relevance.

2

Although Ruskin threatens to give up art criticism and concentrate, as in a besieged city, on "seeking bread and water for its multitudes," he never does. In the 1860's, he continues to lecture and write on art and, in 1870, assumes the first Slade Professorship of Art at Oxford. Basically, Ruskin remains fixed at the position reached in the last volume of *Modern Painters,* with his doubts about the value of art and art teaching painfully apparent. In his Inaugural Lecture at Oxford, he notes how "the attaining of perfection in art power has been hitherto, in every nation, the accurate signal of the beginning of its ruin." He refuses to hold art responsible, but the doubts become no less acute as he grows older. Ruskin neither suppresses his doubts nor abandons his artistic beliefs. He holds the two in a state of dynamic tension. Until his working days are over, he propounds all aspects of his aesthetic theories, from the moral utility of art to the source of

art in the moral character of the artist and his society. Although he continues to stress the latter at the expense of the former, he never gives up hope that art has some useful or moral influence.[1]

Ruskin's emphasis on the utility of art undergoes a significant change in his later writings and lectures. Earlier, the usefulness of art sprang from its quality as great art. Now he believes that, if art is to have utility, it must be sought in qualities extrinsic to itself or, better, extrinsic to the highest forms of art. He comes close to defining utility in terms so prosaic as to make his concept of it indistinguishable from that of the "common" Utilitarians whom he roundly condemns. For example, he bases the utility of art on its ability to convey practical information or adorn useful implements. Art never exists for itself alone: "it gives Form to knowledge, and Grace to utility." Its vitality depends on its "stating a true thing" or "adorning a serviceable one." The graphic arts aim at the first; the architectural arts aim at the second, beginning in the shape of a cup and ending in the fountain or aqueduct. In his lectures at Oxford, Ruskin places special emphasis on the role of art in refining the "actual uses" of life. This is its main business since "the giving brightness to picture is much, but the giving brightness to life more."[2]

This very literal view of the utility of art leads Ruskin to insist upon the industrial sources of all art. He believes that art arises from common industrial activities like pottery making and domestic building. "A true artist is only a beautiful development of tailor or carpenter." He demands that art be considered a broad unity including the practical arts as well as painting and sculpture. Every art is fine, he maintains, which is founded on skill of hand, not mechanism, and gives evidence of "soul" or imagination. Art forms a continuum from the lowest manual craft to the highest painting. It is best defined simply as joy in work. Nowhere is Ruskin so explicit in his application of standards drawn from art to the condition of the ordinary worker as in the lectures of the sixties and seventies. His critique of degrading labor sharpens: "The laws which regulate the finest industries must regulate *all* industries." "Life without industry is guilt, and industry without art is brutality." The brutality of most work is suggested by the fact that workers are called "hands" not "heads," a play on words borrowed, perhaps, from Thomas Arnold or Arthur Helps. Ruskin admires the craft-guilds of thirteenth-century Florence where "the best artist is assuredly also the best artisan; and the simplest workman uses his invention and emotion as well as his fingers." If art is to flourish in the industrial environment of Vic-

torian England, it cannot retreat into itself. Like Gothic, it must become "a common and diffused delight." Every man must become, to some degree, an artist.[3]

Just as the utility of art leads Ruskin into social criticism, so does his belief that art expresses the "purity" of the artist and his society. Again and again, after 1860, Ruskin affirms the central theme of his early studies. Since art is the "formative and directing Action of a Spirit," whatever character the spirit has will be manifest in the product as in a mirror. The art of a nation is *the exponent of its social and political virtues* . . . its ethical life." More eloquently, the theme reads: "Let a nation be healthful, happy, pure in its enjoyments, brave, broad in its affections, and its art will spring round and within it as freely as foam from a fountain." Very concisely it runs: "A man cannot hide himself in his work," or "Taste is morality," or, again, "Great art is the expression, by an art-gift, of a pure soul." At times, Ruskin follows his insight onto insecure ground. In *The Queen of the Air* (1869), he declares that sweetness of voice is the result of the moral training of generations, even if the singer himself lacks moral character, since "every impulse, of virtue and vice, affects in any creature, face, voice, nervous power, and vigour and harmony of invention." Ruskin's organic view of human nature provides the key. An artist's powers of observation, design, and execution cannot be isolated from the "conditons of his being." The poetic "energies" depend on the healthy development of "the whole living creature" and on the quality of the society of which he is a part. From here the path to a broader social critique is marked.[4]

Ruskin treads this path frequently in later years. In public lectures, he makes the paradoxical assertion that there is no point in his talking about art in the present condition of English life. At Manchester, he declares that good art is out of the question in such a city. If the English insist on digging the coal and carrying the goods of the rest of the world, they should forget about art. In a selfish, mercenary environment, no artist can love his work for its own sake. As Blake put it many years before, "Where any view of Money exists, Art cannot be carried on." At a purely physical level, the artist must have beautiful cities, unspoiled landscapes, noble action, and happy people around him for subjects. "The beginning of art," Ruskin writes, *"is in getting our country clean. . . ."* How can the artist paint a blue sky, if he cannot see the sky because of the smoke, or how can he paint the harbor at Folkestone, if the harbor is polluted? With utter seriousness, Ruskin declares that the question of art at Oxford

cannot be solved until the more important question of why a little girl has no shoes is answered.[5]

If Ruskin is right in his view of the social sources of artistic creativity, he need take no responsibility for the failure of the Gothic Revival. Ruskin is not entirely right. Even when his love of paradox and exaggeration is considered, his view of the relationship of artist to environment is simplistic. He ignores the many perplexing psychological factors involved in artistic creativity. Contrary to his lofty hopes for the growth of art in a reformed English society, hopes similar to those of later radicals for a "socialist art," it may be that genius grows best in alienation from its environment or under the stimulus of unpleasant necessity as Mandeville suggested. The problem, at any rate, is more complicated than Ruskin, unwilling to enter the uncharted territory of psychology, believes it to be.

3

Ruskin's later social criticism extends beyond the need to provide a favorable environment for the artist. Much of it consists of general imprecations against the nineteenth century, the middle class, and the "mad-dog's creed of modernism." Reason, science, machinery, printing, and gunpowder are all anathematized. Ruskin would gladly see Manchester, New York City, and the new section of Edinburgh wiped off the map. Morally, the age has reached a low ebb. Through selfish competition and domestic vice, it has contracted a case of "moral syphilis." Modern systems of education and morality are the "mere whirr and dust-cloud of a dissolutely reforming and vulgarly manufacturing age." And yet there is Macaulay telling the middle class that England, "enlightened by Liberal newspapers, and cleansed by Pear's soap," has attained the highest state of humanity. In reality, England resembles ancient Egypt, sunk in fleshpots. The ideals of her middle class are vacuous, if not cruel, and their style of consumption materialistic and imitative. They are incapable of any manual art and take no interest in good literature, nature, or physical exercise. They are "monkeys that have lost the use of their legs." The members of the upper class, Carlyle's "Dilettantes," are no better. They spend their time in vain show or wasteful hunting of foxes.[6]

To call the nineteenth century an age of "progress" and "improvement" is to lie or else to be ignorant of the true meaning of wealth. One of Ruskin's favorite rhetorical devices is the comparison of newspaper clippings. After citing a euphoric description of England's

"seeming prosperity," he will quote a less euphoric account of abject poverty or crime. He fails to comprehend how anyone can speak of England's wealth while children are dying of starvation and overdoses of narcotics. Ruskin urges Macaulay to stop prattling about the prosperity of England until he has taken the balance of vital cost and vital utility. In a discursive fashion, Ruskin devotes much of *Fors Clavigera* (1871-1884) to weighing this balance. The result he finds to be so negative that he must invent a new word to describe it: *illth,* the opposite of *wealth.* England's abundance is vitiated by the "cancer" of waste, waste of nature and human lives through useless production and rampant competition.[7]

The destruction of nature and the environment inspires in Ruskin a passionate rage. He knows how Blake felt as he saw the smoke of the "dark Satanic Mills" blight the countryside and the "running Kennels" choke the "bright rivers." *Fors Clavigera* is, in part, a series of monthly reports on the "Diabolic work" of air and water pollution. Industrialism has turned "every river of England into a common sewer, so that you cannot so much as baptize an English baby but with filth. . . ." Ruskin's rhetoric becomes manic indeed when he witnesses the pollution of a stream like the Wandel or the presence of oil slicks in Sir Walter Scott's country. As for the air: even if good architectural ornament were possible in the nineteenth century, it would be rendered invisible by the "foul chemical exhalations" and distillations of "the horrible nests which you call towns." Steps must be taken to purify air by forbidding noxious manufactures and planting trees. Already the atmosphere over England has succumbed to the "sulphurous chimney-pot vomit" of the "United Grand Steam Percussion and Corrosion Company, Ltd." In his famous essay *The Storm-Cloud of the Nineteenth Century* (1884), he notes the persistence of a "plague-wind" and "vile" leaden sky. He warns of a time when the earth will be poisoned and made uninhabitable. One should not attribute Ruskin's vision of a "devil cloud" composed of dead men's souls entirely to encroaching madness. As early as "The Nature of Gothic," he regrets that the "animation" of England's multitudes "is sent like fuel to feed the factory smoke." Moreover, recent studies confirm his vision. In the nineteenth century, the use of coal for both heating and industrial purposes increased twentyfold. The greatest increase occurred in the seventies and eighties, the years when Ruskin's fear of the storm-cloud of "poisonous smoke" was most marked. Today, when it is perhaps too late, his pioneering obsession has become a common one.[8]

If England's "green & pleasant" countryside suffers from in-
dustrialism—if her sky has become a "dome of ashes"—what must the
centers of this blight, the cities themselves, be like? Ruskin would
answer in one word, filth. He devotes many pages to sensuous des-
criptions of the filth encountered in walks around "that great foul
city of London there,—rattling, growling, smoking, stinking,—a
ghastly heap of fermenting brickwork, pouring out poison at every
pore." On one of these walks, Ruskin discovers the Victoria Embank-
ment. He describes the flight of steps which are "the descent from
the very midst of the metropolis of England to the banks of the chief
river of England":

They are covered with filthy dust, shaken off from infinitude of filthy feet;
mixed up with shreds of paper, orange-peel, foul straw, rags, and cigar-ends, and
ashes; the whole agglutinated, more or less, by dry saliva into slippery blotches
and patches; or, when not so fastened, blown dismally by the sooty wind hither
and thither, or into the faces of those who ascend and descend. (20.256-257)

Can man live in this environment? Perhaps, it would be wise to shoot
babies instead of rabbits.[9]

Ruskin's reaction to the filth and noise of cities is that of a Roman-
tic. Wordsworth, Southey, Scott, and Cobbett save their sharpest
barbs for the quality of nineteenth-century urban living. They antici-
pate Ruskin in focusing their attention on the great "wen" or "can-
ker" of London and avoiding other, less attractive areas of England.
London was the least obnoxious, because the least industrialized, of
large English cities. Like Ruskin, the early Romantics do not work
for practical sanitary reform. They leave this to Lord Shaftesbury,
Charles Kingsley, or Dr. Southwood Smith.[10]

Ruskin's attack on air and water pollution also has Romantic
antecedents. Southey and Wordsworth complain of the smoke in
English cities. Carlyle fears the dangers of pollution. He describes the
"ink-sea of vapour, black, thick, and multifarious as Spartan broth,"
which hovers over "that monstrous tuberosity of Civilized Life, the
Capital of England."[11] In *Shooting Niagara* (1867), Carlyle poses
questions which remain unanswered:

Most certain it is, an immense Body of Laws upon these new Industrial, Com-
mercial, Railway, etc. Phenomena of ours are pressingly wanted; and none of
mortals knows where to get them. For example, the Rivers and running Streams
of England; primordial elements of this our poor Birthland, face-features of it,
created by Heaven itself: Is Industry free to tumble out whatever horror of
refuse it may have arrived at into the nearest crystal brook? Regardless of gods
and men and little fishes. Is Free Industry free to convert all our rivers into

Acherontic sewers; England generally into a roaring sooty smith's forge? Are we all doomed to eat dust, as the old Serpent was, and to breathe solutions of soot? (p. 390)

Arthur Helps (1813-1875), a much neglected social critic and older friend of Ruskin's, takes these suggestions seriously. He proposes legal restrictions to deal with water and air pollution. He is especially interested in preventing the "smoke nuisance." It destroys health and drives a wedge between the upper and lower classes by encouraging the rich to live outside the urban centers. He discusses inventions to make the burning of coal more efficient. Writing in the early 1840's, Helps shows a shrewder understanding of the problems involved in preventing pollution than does Ruskin. He has much to say about the conflict between private and public interests which is relevant today. Unlike Ruskin, Helps is familiar with the Parliamentary reports on sanitation and quotes from them at length. One of Ruskin's weaknesses as a social reformer is his tendency to ignore steps taken by the Government to explore problems. He might have written with more authority if he had been willing to bury himself from time to time in the reports and statistics from which Helps, Carlyle, and even Southey do not shrink.[12]

Ruskin's assaults on the nineteenth century and the shibboleths of progress are launched with weapons of no striking originality. Carlyle mocks men like James Mill or Macaulay who consider the extension of railways, steam engines, and cheap literature a sign that things are getting better. In *Latter-Day Pamphlets* (1850), his disgust with the present issues in a river of ooze, sewerage, abortions, kennels, and dung. His fellow men resemble stupid horses, dead dogs, pigs, bloated asses, and slimy snakes. Many years before Carlyle, Cobbett denounced the "Corruptions" of the modern age with its parasites and "tax-eaters." *Rural Rides* (1830) shatters the illusions of those who mistake the growth of the "wen" and the extension of enclosures for "vast improvements" or "proofs of prosperity." Benjamin Disraeli shows a similar detachment from his age, remarkable in a politician. He declares, "Progress to what and from where? . . . The European talks of progress, because by an ingenious application of some scientific acquirements he has established a society which has mistaken comfort for civilization." Ruskin's true predecessor is the satirist Dean Swift. Swift's efforts to deflate the belief in progress and his Biblically spiced predictions of a lapse into barbarism are familiar to every reader of *The Tale of a Tub* and *The Drapier's Letters.* Ruskin placed Swift among the three literary figures in his-

tory with whom he felt most sympathy: "Putting the delight in dirt, which is a mere disease, aside, Swift is very like me, in most things, in opinions exactly the same." Ruskin's long, salacious descriptions of filth suggest that he, too, subconsciously shared a delight in dirt. They suggest that such a delight is helpful to one who would grasp the extent of environmental decay even in Ruskin's day.[13]

4

Although *Time and Tide* (1867) and *Fors Clavigera* are devoted to the quality of English life, Ruskin does not lose sight of his economic analysis. His attacks on the classical economists become more vituperative. They provide the ideological justification for the destruction of the English environment. He speaks of the "Monuments of Brutification" of Adam Smith and Ricardo and considers J. S. Mill to be "the root of nearly all immediate evil" in England. Jevons and Henry Fawcett (1833-1884) are added to his list of public enemies for their failure to see the qualitative aspect of economics. To Ruskin, orthodox political economy is the "Devil's Economy," and the economists themselves "a strange spawn begotten of misused money." The failure of his friend Charles Eliot Norton to recognize this puts a serious strain on their relationship. Ruskin believes that he is right and that no one else knows anything about the principles of a "Human Economy." The errors of orthodoxy remain its assumption that man is a beast of prey, its confusion of wealth and money, and its neglect of acceptant capacity. Economists should aim at "creating together the means of life, and the living persons who are to use them; and of both, the best and the most."[14]

More specifically, Ruskin continues his critique of the production-saving bias of classical economics. Say's Law, the wages-fund theory, and the iron law of wages are again rejected. In Letter Two of *Fors* (1871), Ruskin focuses more clearly on what he feels to be the basis of these fallacies—the proposition, in Mill's words, that "a demand for commodities is not a demand for labour." According to Mill, "the demand for labour depends upon the amount of capital: the demand for commodities simply determines in what direction labour shall be employed." Ruskin denies this proposition. It implies that capital has unlimited social utility. In his view, capital or savings are next to worthless unless there is sufficient demand to warrant their investment. A cloth manufacturer, no matter how much capital he has, cannot profitably employ workers unless there is a demand for his product. The wages he pays depend not on his fund of capital but

on the level of consumer demand. Since demand depends in part on
the level of wages, it is unsound economics to allow wages to be
driven down by competition.[15]

Whether Ruskin or Mill is right regarding the specific proposition,
"a demand for commodities is not a demand for labour," is an un-
profitable question. It depends for its answer on one's definition of
the terms used and on the point in the economic process at which
one begins his analysis. Their disagreement, however, is symptomatic
of a crucial difference in vision. While Mill's formula allows him to
focus on production and neglect consumption in the belief that it
will take care of itself, Ruskin's places consumption at the center of
the economy. This difference, too, is possibly a semantic one, but it is
very significant. It leads to the distinction between a quantitative and
qualitative view of economics. Ruskin's approach brings home to
each consumer that he is responsible for *what* he consumes and the
type of labor he instigates. Mill's emphasis on production could lead
to a concern for quality. Historically, it has not. Production has
imaginative overtones of infinite utility—the piling up of valuable
quantities, the addition of ciphers. It is frequently controlled by a
small segment of the community with little knowledge of the needs
and wants of other men. Consumption, on the other hand, is an
individualizing concept. Each person can consume only so much and
has only so much to spend. The question of *what* inevitably arises
and suggests the need to interfere in the mechanical operation of the
economy. Ruskin's approach suggests more directly than Mill's that
the real question is what *can* be supplied and *ought* to be demanded.
Ruskin's crude refashioning of economic doctrines in terms which
encourage a concern for quality is his great achievement, an achieve-
ment evident in the chaos of his later work where the question of
how the consumer shall spend his money is the unifying theme. This
achievement is due partly to the success of a production-oriented
economy in creating an abundance which makes plausible a concern
for quality. It is due mostly to Ruskin's social imagination.

Ruskin admits that his insights spring, not from the possession of
more data or knowledge, in the narrow sense, than other people, but
from the way he looks at this data. John Stuart Mill may have more
knowledge about the economic system than Ruskin, but he fails to
"organize" or "see" it in a way which brings out its full meaning. In
Modern Painters, Ruskin describes true vision as intuitive, an imagi-
native grasping of wholes or "relations of truth." His turn from art to
social criticism is itself so "organic" that the imagination retains its

epistemological primacy. In later writings, Ruskin recognizes that modes of perception, not logic, lie behind his differences with the orthodox economists. He stresses the need for imaginative sympathy, the "touch-faculty" of the soul, if one is to see social and economic problems in the proper perspective. True vision involves a "general habit of just comparison and estimate." It means, Ruskin writes, "that I cannot be consoled by a bit of Venetian glass for the destruction of Venice, nor for the destitution of a London Suburb by the softness of my own armchair." Most men neglect injustice because they lack the "tragic power" of "comprehending, balancing, and comparing" which would allow them to conceive the distress. What one sees and how one sees it are vitally related.[16]

The question of trade depressions, which Ruskin examines in Letter Sixty-eight of *Fors* (1876), provides an excellent example of perspective in economics. The *Monetary Gazette* and professional economists like Henry Fawcett declare that "overproduction" is the cause of depressions and the suffering of the working class. To Ruskin, as to Carlyle, this is "the negative acme of mortal stupidity." How can one speak of overproduction of clothing while men are freezing in the streets? The truth is that England is suffering from "over-*destruction*" through unwanted production and faulty distribution—from what is now called "underconsumption." If one studies statistical charts without any attempt at imaginative comprehension, "overproduction" and "underconsumption" look very similar. It makes a difference, however, to the starving worker whether the remedy taken is a cutback in production or a redistribution of wealth. It also makes a difference to the capitalist. While a cutback in production may right the economy and forestall a redistribution of wealth, in the long run, as Ruskin suggests, the economy will function successfully only when there is consumer demand. The meaning one gives to trade statistics depends on whether one's imaginative grasp of social processes is partial, focused narrowly on the interests of the wealthy, or "organic," comprehending society as a whole. Ruskin is the first Victorian to apply the concept of Romantic imagination to the hard realities of industrial society. He puts Romanticism into action.[17]

5

In *Unto This Last* and *Munera Pulveris*, Ruskin directs his imagination to economic theory and considers what ought to be. In later

contemporaries. Orthodox economists and most middle- and upper-class Englishmen believed that, if each man pursued his interests as effectively as possible, the well-being of society would be realized. Ruskin denies this. English society is a "system of iniquity" based on the exploitation of the lower classes by the upper and of consumers by producers. The result is the wasting of abundance. Although Marx and the early Ricardian socialists Thompson, Hodgskin, and Bray would agree, Ruskin's relation of exploitation to an aesthetic vision of deterioration in the quality of work, consumption, and environment is unique. His ideas have been little examined by scholars and seldom included in anthologies. Four categories—exploitation of laborer and consumer, speculation, interest, and rent—will make for clarity.

Ruskin's theory of exploitation is not confined to the writings after *Munera Pulveris*. As early as 1858, in a lecture on "The Work of Iron in Nature, Art, and Policy," he describes the exploitation of labor in its simplest form. While the "sober, industrious, intelligent" workman will command a fair price for his work, there will always be a majority "somewhat unintelligent, a little inclined to be idle, and occasionally, on Saturday night, drunk." He continues:

These are the kind of people whom you *can* oppress, and whom you do oppress. . . . For, to take one instance only, remember this is literally and simply what we do, whenever we buy, or try to buy, cheap goods—goods offered at a price which we know cannot be remunerative for the labour involved in them. Whenever we buy such goods, remember we are stealing somebody's labour. Don't let us mince the matter. I say, in plain Saxon, STEALING. . . . The old barons of the Middle Ages used the thumbscrew to extort property; we moderns use, in preference, hunger, or domestic affliction. . . . We steal habitually from the poor. We buy our liveries, and gild our prayer-books, with pilfered pence out of children's and sick men's wages. . . . (16.401-402)

England's vaunted "cheapness" of production rests on extortion. It is a measure of national distress, not of industrial efficiency. What permits extortion is the "power held over those who are earning wealth by those who already possess it." Money is power over human beings and over the "means of life" which they produce. In the Middle Ages, the soldier and clergy used their strength or sanctity to gain riches. Now, idle capitalists and landowners increase their wealth by underpaying laborers, degrading them, and "reaping the poor fruits of their degradation." Capitalist exploitation is one of many historical forms of "pillage." Competitive markets, local overpopulation, and machine industry, an "accidental condition of national

In the final chapter of *Munera Pulveris,* Ruskin creates a model of exploitation out of the relations of provident and improvident persons:

Accident interrupts the daily work, or renders it less productive; the idle person must then starve or be supported by the provident one, who, having him thus at his mercy, may . . . say to him, "I will maintain you, indeed, but you shall now work hard, instead of indolently, and . . . I will take all the surplus. . . ." (17.262)

Since the power of the provident person to do this is checked only by the similar power of neighbors who can offer the laborer a little more, it is to the interest of the rich that *"the poor should be as numerous as they can employ and restrain."* The rich are not always so selfish. But Ruskin has reached the following conclusion:

Success (while society is guided by laws of competition) *signifies always so much victory over your neighbour* as to obtain the direction of his work, and to take the profits of it. *This is the real source of all great riches.* No man can become largely rich by his personal toil. . . . *It is only by the discovery of some method of taxing the labour of others that he can become opulent.* Every increase of his capital enables him to extend this taxation more widely; that is, to invest larger funds in the maintenance of labourers,—to direct, accordingly, vaster and yet vaster masses of labour, and to appropriate its profits. (17.264-265)

The use of the words "appropriate" and "surplus" gives an unexpected Marxian flavor to this passage.

Unlike Marx, Ruskin does not believe that capitalists are necessarily exploiters. He suspects, however, that large fortunes can be made only by "dishonest acquisition"—by "sacrifice of surrounding lives, or possibilities of life."[19] Writing to the editor of the *Daily Telegraph* in 1868, he draws the line between proper and improper employment of capital:

All capital is justly and rationally invested . . . so long as it renders . . . only such gain as shall justly remunerate the superintendence and labour given to the business. . . . But all rates of interest or modes of profit on capital, which render possible the rapid accumulation of fortunes, are simply forms of taxation, by individuals, on labour, purchase, or transport; and are highly detrimental to the national interests, being, indeed, no means of national gain, but only the abstraction of small gains from many to form the large gain of one. (17.533)

In the introduction to *The Crown of Wild Olive* (1866), Ruskin relates exploitation to the quality of English work and life. Walking on High Street in Croydon, he comes upon a new pub with an "imposing iron railing, having four or five spear-heads to the yard of

it, and six feet high," which, by this stately arrangement, became a "protective receptacle of refuse." The iron bars are aesthetically and vitally useless. They represent a "quantity of work which would have cleansed the Carshalton pools three times over: of work, partly cramped and perilous, in the mine; partly grievous and horrible, at the furnace . . . work from the beginning to the last fruits of it, and in all the branches of it, venomous, deathful, and miserable." Why is the English worker made to produce "an entirely (in that place) valueless, piece of metal, which can neither be eaten nor breathed, instead of medicinal fresh air and pure water?" Why is he made to produce the means of death, instead of the means of life? "There is but one reason for it," he declares, "that the capitalist can charge percentage on the work in the one case, and cannot in the other." Ruskin sees in the iron railing a symbol of exploitation and its effect on both the worker and his environment.[20]

The consumer, too, suffers since exploitation leads to the production of shoddy or adulterated goods. He suffers literally: his nature is *"altered by"* the destructive product which he consumes. Ruskin deplores John Bright's statement in Parliament (1869) that adulteration "arises from the very great, and perhaps inevitable, competition in business; and that to a great extent it is promoted by the ignorance of customers." He agrees with Southey and Carlyle that adulteration is a form of cheating by the producer. It is part of the "universal shoddy" and "sham" pervading all aspects of nineteenth-century commerce, morality, and religion. So is the practice of concealing discoveries and patenting inventions. To Ruskin, the "selling of knowledge" valuable to the community is unjustified. So is advertising or "puffery." Like false art, advertising distorts the truth, exploits popular taste, and creates useless wants. Even worse, it destroys the landscape. Ruskin's view of the role of advertising in the creation of wants and the misleading of consumers is remarkably farsighted.[21]

"Want creation" suggests speculation. Speculators create transitory booms by "exciting imaginary necessities and popular desires." Ruskin's criticism of speculation begins in the lecture on "Iron" of 1858. Wage exploitation is the economical way to cheat, "getting the product of other people's work by cheapening their labour in times of distress." Speculation is the bold way, the "grand one of watching the chances of the market." It is made possible by the "system of mercantile credit, invented simply to . . . enable rogues to live upon

the wreck of honest men." Ruskin's social imagination allows him to see the consequences of "the fury of modern trade":

Have you ever deliberately set yourselves to imagine and measure the suffering, the guilt, and the mortality caused necessarily by the failure of any large-dealing merchant, or largely-branched bank? . . . Let us use that imagination which we waste so often on fictitious sorrow, to measure the stern facts of that multitudinous distress. (16.403-404)

Ruskin launches into a long passage in the genre of social horror and concludes, "Consider whether the hand which has poured this poison into all the springs of life be one whit less guiltily red with human blood than that which . . . guides the dagger to the heart?" Of earlier thinkers, Coleridge has a sense of the evil effects of speculation most like Ruskin's. To Coleridge, speculative fluctuations are the result of the unchecked spirit of commerce condemned in *A Lay Sermon.* His famous comment that "things" may find their proper level after a depression but that "people" are not "things" refers to this problem.[22]

 In Ruskin's view, "the rage in speculation" has no redeeming utility. Those who fail drag down many innocent persons. Those who succeed only gain what others lose. They do not make a true profit. The net result to society is zero, less than zero when the loss of time, ingenuity, and moral worth in the transaction is considered. Work done from a speculative motive is "illth." Ruskin cites with special venom the "ornamental arrangements of zigzag bricks, black and blue tiles, cast-iron foliage, and the like" which decorate railway stations throughout England. This "bad" architecture is constructed only so that "the builders may put the percentage upon it into their own pockets." Once again, Ruskin moves from the ethical to the aesthetic level and relates his vision of exploitation to the quality of English life.[23]

 The final two methods of exploitation described by Ruskin are interest and rent. He denounces both as "usury." Ruskin's opposition to *all* interest and *all* rent over the original investment is cited by those who wish to ignore him as mad or impractical. Ruskin comes to deny the justice of all interest and all rent only in the seventies and eighties. His position is summarized in Letter Sixty-eight of *Fors Clavigera*:

Usury is properly the taking of money for the loan or use of anything (over and above what pays for wear and tear), such use involving no care or labour on the part of the lender. It includes all investments of capital whatsoever, returning

"dividends," as distinguished from labour wages, or profits. Thus anybody who works on a railroad as platelayer, or stoker, has a right to wages for his work ... but idle persons who have only paid a hundred pounds toward the road-making, have a right to the return of the hundred pounds,–and no more.... Again, when we build a house, and let it, we have a right to as much rent as will return us the wages of our labour, and the sum of our outlay.... But if, sooner or later, we take a pound more, we are usurers. (28.669-670)

All increase in capital gained by loaning or leasing is "stealing." It is not even a real increase since "money cannot grow out of money," a position first adopted by Aristotle. Ruskin might have doubted its validity if he had kept in mind his broad definition of money as a documentary claim upon labor.[24]

Much of Ruskin's writing on interest and rent consists of Biblically spiced diatribes against usury and against the failure of English bishops to denounce it. However, in Letter Eighteen of *Fors* (1872), he recognizes and rejects the arguments in favor of rent and interest given in Fawcett's *Manual of Political Economy* (1863). He denies that they are "wages for the labour of superintendence." Capitalists or landlords should receive *wages* for the *work* of superintendence, but most investors do absolutely nothing. Nor can interest and rent be defended as "compensation for the risk of loss." A lender should cover his own risks and not expect to make a profit on them. He should not receive compensation for anxiety or extra payment for *im*prudence. As for interest being a "reward for abstinence," it strikes Ruskin that "if I had not my £15,000 of Bank Stock I should be a good deal more abstinent than I am, and that nobody would then talk of rewarding me for it." He agrees with Marx and Rodbertus that "it might be possible to find even cases of very prolonged and painful abstinence, for which no reward has yet been adjudged by less abstinent England." Interest is neither payment for labor, compensation for risk, nor reward for abstinence. It is a "tax on industry" and ultimately on the consumer. Exorbitant rent is less justifiable since the land was possessed by force or fraud.[25]

Ruskin does not intend to forbid all lending. On the contrary, everyone would lend as they do now, but with conscious justice and charity and no taking of interest. This would have several beneficial effects. First, it would end much of the lending to "fools" who waste money or use it to produce illth instead of wealth. Second, the ending of interest payments would allow the money which accumulates in "the chests of the rich to fructify in the hands of the honest and active poor." It would redirect the flow of wealth toward those

who spend money and do not hoard it uselessly. Restriction of in-
terest and rent is a means of bolstering consumption and bears
directly upon Ruskin's economic analysis in *Munera Pulveris* and his
view of depressions in *Fors*. Ruskin has no illusions concerning the
practicality of abolishing interest and rent. His strictures are "coun-
sels of perfection." Each person should try to demand less interest
and lower rents and view his loaning or leasing as a socially benefi-
cent act.[26]

Ruskin's discussion of interest and rent is an instance of his ethical
concern leading him into needless paradox. His opposition to ex-
orbitant interest and rent is justifiable, and his belief that lower rents
and interest rates will redirect the flow of wealth and stimulate con-
sumption is cogent. His opposition to *all* interest and rent above the
original investment, however, seems an almost calculated provocation
to critics. Ruskin was converted to this view by William C. Sillar and
his brother Robert G. Sillar, who, in numerous pamphlets between
1867 and 1885, waged a single-minded and futile war on usury from
a Biblical point of view. That Ruskin yielded to their arguments
indicates several things, first, the continuing hold which Biblical
literalism had over his mind, second, the tendency of his opinions to
become more rigid with age, and, finally, his gullible attitude to the
typically Victorian breed of well-intentioned crank. Once convinced,
Ruskin could draw upon a long tradition of thinkers opposed to
usury. He cites Solon, Plato, Bacon, Dante, Shakespeare, and several
historical statutes against usury. Unfortunately, Ruskin fails to study
the tradition of usury theorizing. He has no idea how unique a con-
demnation of all rent and interest is in the history of Western
thought.[27]

At the same time, Ruskin shows little desire to understand the
political economists' view of rent and interest. If he had, he might
have been surprised to find Adam Smith urging a legal limitation of
interest rates and John Stuart Mill urging a high rate of taxation on
rents to gain the unearned increment for public use. Practically all
classical economists, except Malthus, take a dim view of rents and
suggest that the major burden of taxation be placed upon landlords
who "love to reap where they never sowed." Smith and Ricardo
suggest that both rent and interest are deductions from the full
produce of labor. The Ricardian socialists fashion this suggestion into
a theory of exploitation which had a significant influence upon Marx
and Rodbertus. Ruskin's incorporation of rent and interest into a

broader vision of exploitation places him closer to these thinkers and to the early radicals William Ogilvie (1736-1819), Thomas Spence (1750-1814), and Charles Hall than to more "respectable" critics of rack-renting.[28]

6

Ruskin's scattered analysis of exploitation is accompanied by a rhetoric of condemnation which, according to George Bernard Shaw, makes Marx's criticism read like the "platitudes of a rural dean." In tones of the Old Testament, he denounces his society's pervasive "atmosphere of Calculation." Self-interest never produces any "living change," only deadly dissolution and disorganization. Responsibility for this lies with the upper classes. Robber, blackleg, liar, murderer, and "bag-baron" are Ruskin's favorite epithets. Much of the robbery and murder is occult, that is, apparently legal and respectable. It is more cowardly than rapine by a confessed enemy. Even those who do not intend evil are caught up in the "vast system of iniquity"—a "river of blood which can but sweep me down in the midst of its black clots, helpless." The upper classes are one "Picnic Party," playing at the game of making money and, in the process, taxing the labor and necessities of the poor.[29]

The result is a "separation" of the classes. In his testimony before the Select Committee on Public Institutions (1860), Ruskin insists that relations between upper and lower classes are worse in England than on the Continent. He notes how rich and poor avoid meeting and how the poor would rather starve than accept charity. Ruskin makes Disraeli's theme of the two nations his own. He calls them the beggars and the bagmen, "not merely bearing the bag—but nothing else *but* bags;—sloppy, star-fishy, seven-suckered stomachs of indiscriminate covetousness." In "Traffic," a lecture delivered in 1864 to Bradford citizens planning a new Exchange, he claims that the only fit decoration for their building is a statue of the "Goddess of Getting-on." There are two ways of life in England:

Your ideal of human life then is, I think, that it should be passed in a pleasant undulating world, with iron and coal everywhere underneath it. On each pleasant bank of this world is to be a beautiful mansion. . . . In this mansion are to live the favoured votaries of the Goddess; the English gentleman, with his gracious wife, and his beautiful family. . . . At the bottom of the bank, is to be the mill. . . . In this mill are to be in constant employment from eight hundred to a thousand workers, who never drink, never strike, always go to church on Sunday, and always express themselves in respectful language.

Is not that, broadly, and in the main features, the kind of thing you propose to yourselves? It is very pretty indeed, seen from above; not at all so pretty, seen from below. For, observe, while to one family this deity is indeed the Goddess of Getting-on, to a thousand families she is the Goddess of *not* Getting-on. (18.453)

Less delicately, Ruskin declares the Paris Revolution of 1870-71 to be the inauguration of "the *Real* war in Europe" between capitalists "who live by percentages on the labour of others" and workmen. That this is not evident to his readers he ascribes to their lack of social imagination. They should "see" the organic relations among groups in society and grasp the impure corruption of these relations.[30]

This failure of imagination is encouraged by the misleading pronouncements of segments of society which have a vested interest in exploitation. In *Sesame and Lilies* (1865), long before the twentieth century's concern with propaganda, Ruskin describes the phenomenon acutely:

There are masked words droning and skulking about us in Europe just now . . . which nobody understands, but which everybody uses, and most people will also fight for, live for, or even die for, fancying they mean this or that, or the other, of things dear to them: for such words wear chameleon cloaks—"ground-lion" cloaks, of the colour of the ground of any man's fancy: on that ground they lie in wait, and rend them with a spring from it. There never were creatures of prey so mischievous, never diplomatists so cunning, never poisoners so deadly, as these masked words; they are the unjust stewards of all men's ideas: whatever fancy or favourite instinct a man most cherishes, he gives to his favourite masked word to take care of for him; the word at last comes to have an infinite power over him,—you cannot get at him but by its ministry. (18.66)

Chief among these unjust stewards is the conviction that pursuit of self-interest, "a scientific selfishness," will secure the well-being of society. From this spring such chameleon cloaks as "benevolent avarice," "pious egotism," and "interest-bearing charity." Ruskin points to political economists as a major source of propaganda supporting the system. They use many subterfuges to "accommodate their pseudo-science to the existing abuses of wealth." He accuses John Stuart Mill and, with more justice, the vulgar economists of deliberately concealing the nature of rent and interest and "abetting the commission of the cruellest possible form of murder on many thousands of persons yearly." A more subtle misrepresentation removes all responsibility from the consumer for the quality of life of the worker he employs: "the blasphemous blockheadism that you

can swill salvation into other people's bodies out of your own champagne bottles." Ruskin notes a discrepancy in the economists' attitudes toward the spending habits of rich and poor. While it is beneficial for the rich to indulge in luxurious consumption, the poor must be abstinent. A double standard cuts through English economics.[31]

Politicians cannot grasp the truth of present social arrangements. They serve landlords and capitalists to such an extent that the House of Commons has become the House of "Uncommons." Journalists and authors also defend the system either directly or through their desire for money. Ruskin cites Bishop Berkeley's complaint in the *Querist* that the press is under the control of the money men. It corrupts the public by selling faulty opinions. Ruskin takes pride in the fact that he has never written for money.[32]

Of all the minions of the system of exploitation, Ruskin reserves his sharpest barbs for the clergy. Not only do they resist the advance of science, but they connive at the public and private abuse of wealth. Not only do they conceal "God's demise" because "Mr. Bishop was always so agreeably and inoffensively pungent an element of London Society, and Mrs. Bishop and Miss Bishop so extremely proper and pleasant to behold, and the grass of the lawn so smooth shaven," but they refuse to preach against usury and Mammon-worship in order to "keep smooth with Manchester." Ruskin rejects the distinctions drawn between avarice and prudence, "greed and modest expectation," as much too fine. He accuses the clergy itself of participating in commercial gain. The Church, reduced to a means of entertainment, has substituted "the service of the clergyman and his rich" for "the service of God and His poor." It has failed to concern itself with the neglected areas of the cities.[33]

Ruskin's critique of exploitation and the separation of classes has many precedents. Coleridge and Godwin, Hazlitt and Charles Hall, Lord Shaftesbury and John Bray, Disraeli and Feargus O'Connor are a few of the unexpected parallels one can draw in the history of early nineteenth-century protest against exploitation. Ruskin differs from other critics in his facility at vituperative invention or name-calling. He has close rivals, however, in Southey and Carlyle. Southey accuses the "manufacturing system," that "fungous excrescence from the body politic," of treating man as a "brute, denuded, pitiable animal." He compares capitalists to "pikes in a fish pond, who devour the weaker fish." Carlyle, too, uses animal imagery to describe the

condition of the worker in a society divided between "Dandies" and "Drudges." Not even cattle, he remarks, are set free to find their level in the "grand corn-mill of Economic Society." In a Swiftian and, indeed, Ruskinian vein, he suggests that a government which can find no better way to exploit able-bodied paupers might shoot them: "The expense were trifling: nay, the very carcasses would pay it. Have them salted and barrelled. . . ." Only members of society who are not themselves exploited can employ such sarcasm. One does not find this suggestion in the pages of the *Poor Man's Guardian* or *The Black Dwarf*, in appeals written by builders or journeymen cotton spinners, or in the writings of Tom Paine, William Cobbett, Ernest Jones, and others who spoke in the tones and captured the allegiance of the working class.[34]

Questions of tone aside, what distinguishes Ruskin's attack is the unity of his vision of an oppressive system, extending its control over the law, the press, the political organization, and the church. Even here, Ruskin's distinctiveness lies more in application than in original perception. Witness William Blake. To Blake, economic, sexual, religious, and political oppression form one system having its roots in rationalistic or Lockeian modes of perception. The "mind-forged manacles" of the great Work-master Urizen reduce the earth and its inhabitants to possessions. Blake sees in the "cogs Tyrannic" of mill and furnace the symbol of all oppression. He is painfully aware of the "sinewy deceptions," the "nets & gins & traps" of propaganda, used by merchant and priest to catch "many a Spirit" in the toils of the system.[35]

Blake was acquainted with the work of Paine and Godwin. They have a similar, although less richly textured, vision of an exploiting system defended by organs of propaganda, "the *lo here!* and the *lo there!*" of governments. Godwin deplores the "generalizations" fostered by the institutions of a class society. The prejudices of nation and class act as "distorting spectacles" and encourage a dull uniformity of opinion. Charles Hall, Robert Owen, and Thomas Hodgskin evince glimmerings of a unified view in their disparagement of politicians, churchmen, and lawyers as minions of an exploiting class. So does Cobbett on the rare occasions when he identifies the "Thing," the "vermin-breeding System," or "Old Corruption" with the industrial system or "Millocracy." Although Southey, Coleridge, and Carlyle write less of a unified *system* of iniquity, they are not loath to attack the "cant" and "quackery" spouted by clergymen and economists in defense of an unjust social order. The substance, if

not the rhetoric, of Ruskin's critique places him closer to Godwin and Hall than to the Romantic critics. It demonstrates the remarkable centripetal tendency of Victorian and pre-Victorian social criticism.[36]

Once again one feels compelled to right the balance in favor of the political economists. Ruskin and many of his predecessors describe them as defenders of a system of exploitation. Whether they were or not seems a question to which no clear-cut answer can be given. The answer lies somewhere between the view of Joseph Schumpeter or Lionel Robbins, for example, that the classical economists were responsible thinkers, whose logical faculties and scientific detachment guarantee the theoretical purity of their work, and the view of Ruskin and Marx that the economists' appeal to scientific criteria is a blind to conceal their class bias. Classical economics is one of those difficult subjects which call for the use of both of the approaches to intellectual history suggested by Karl Mannheim. On the one hand, it is a problem-solving science with a logic and inner dynamic of its own. On the other hand, it is an ideology or "style of thought" whose changes are to be understood, not in terms of a cumulative development of solutions to problems, but in terms of the "changing social background . . . of the social groups or classes which are the 'carriers' of these styles of thought." Whatever the final verdict on the economists, it is certain that Ruskin and his predecessors are wrong in assuming that thinkers of the caliber of Adam Smith or John Stuart Mill fully support the capitalist system.[37]

Smith's grave doubts concerning the moral quality of the new commercial society lend their tone to *The Wealth of Nations.* He fears that a society based on self-interest, competition, and the division of labor will gain freedom at the expense of virtue. He distrusts the motives of businessmen and, in terms very similar to Ruskin's, condemns their "mean rapacity," "monopolizing spirit," and "infamous covetousness." While "vulgar" businessmen conspire with impunity, workers are prevented by law from uniting to protect their interests. He warns against the influence of businessmen upon legislation:

The proposal of any new law or regulation of commerce which comes from this order ought never to be adopted till after having been long and carefully examined . . . with the most suspicious attention. It comes from an order of men . . . who have generally an interest to deceive and even to oppress the public, and who accordingly have, upon many occasions, both deceived and oppressed it. (Bk. I, ch. xi, 215)

The radical view of government as a committee of the exploiting class owes much to Smith's suggestion that "for one very rich man

there must be at least five hundred poor." "Civil government, so far as it is instituted for security of property, is in reality instituted for the defense of the rich against the poor. . . ." Many years later, John Stuart Mill declares that the attempt of capitalists "to retain the working classes in avowed slavery has ceased to be practicable." The "division of the human race into two hereditary classes, employers and employed," can no longer continue. Mill gives serious attention to ways of modifying the capitalist system. He would reorganize it on a cooperative basis in which the "distribution of the means of life and enjoyment" are no longer "capricious" and "obviously unjust." Ruskin could not have found two less lackey-like political economists to attack than Smith and Mill.[38]

Behind this discussion of Ruskin's critique of exploitation, there lurks, finally, the figure of Ruskin's contemporary Karl Marx. Ruskin, who never read a word of Marx, understands how an exploiting class can turn the institutions of society to its own advantage. Ruskin's vision of capitalism as a system of robbery depriving the worker of the produce of his labor closely resembles Marx's. Their differences lie not in diagnosis of the disease but in analysis of the causes. Ruskin points to the constant elements of human selfishness and lack of "imagination" as taking a virulent form in the industrialized nineteenth century. Marx, on the other hand, points to the organization of the means of production under capitalism as the source of exploitation. This difference is important. Ruskin's position leads him to place his faith in moral exhortation, while Marx believes that only radical, even violent, institutional change will succeed. The contrast, however, is not absolute. Ruskin proposes institutional reform, and Marx is far from loath to assign moral responsibility to capitalists. Whether Ruskin's or Marx's approach is the correct one is a difficult question. Exploitation results from a complicated configuration of factors. Both Marx and Ruskin are right: Ruskin for emphasizing the role of human choice and modes of perception; Marx for pointing out the apparent inevitability of capitalism and for suggesting the effect of material conditions on human behavior. Of the two, Ruskin, with his emphasis on perception, on how one looks at things, and his interest in the use and meaning of words, anticipates an important area of present-day research.

One is tempted to apply this approach to Ruskin himself and examine his writing in terms of modes of perception and use of

words. His rhetoric is distinctive, more so than Marx's. It is so distinctive and so exuberantly indulged that one wonders whether it is not a style of verbal aggression which leads him to his insights and not the insights to the rhetoric. Ruskin seems to move inward from the verbal surface to the idea behind it rather than outward from the concept to its verbal sign. The difference is one of "feel," for the two approaches are theoretically indistinguishable. Nevertheless, this suggestion might explain Ruskin's great interest in word associations, an interest which forms the verbal counterpart to his visual organicism of the surface. It might also explain his unwillingness to think in terms of historical change or development. Marx prefers to move outward, developing new words or adapting old ones to suit his ideas. He does not become entangled by the values of an intricate and inherited verbal surface. He can fashion a critique of exploitation based on a dynamic view of social processes. Ruskin pays a significant price for his verbal pyrotechnics.

7

One question remains: were Ruskin's own hands clean? This would, perhaps, be an irrelevant question if Ruskin himself had not raised it. With a frankness unusual in one convinced of his rightness, he admits that the money his father made in the sherry business came ultimately from the pockets of vineyard workers in Spain. He is aware that his privileged style of life depends on the work of many people. In Letter Fifty-six of *Fors* (1875), he describes his childhood tours through the English countryside: "Let us consider, then, how many conditions must meet; and how much labour must have been gone through, both by servile and noble persons, before this little jaunty figure, seated on its box of clothes, can trot through its peaceful day of mental development." He lists vineyard workers, cask-makers, sailors, clerks, carriage-makers, smiths, and so forth. As for his present wealth, Ruskin wonders how real it is since much of it is in the form of stocks and government bonds. It is based on "taxation" or "pillage" of the working populace. "Nearly every problem of State policy and economy," he writes, "consists in some device for persuading you labourers to go and dig up dinner for us reflective and aesthetical persons. . . ."[39]

Ruskin admits that he lives almost entirely upon interest. Several of his correspondents remark that, if he is not to be thought a hypocrite, he should give up his dividends. Ruskin's defense of his

interest-taking is as skillful an attempt at rationalization as one could expect under impossible circumstances. His first line is that usury, like murder, is wrong but that there are open and relatively wholesome forms of it. A soldier is a more wholesome murderer than a "hired bravo." So Ruskin is a wholesome usurer since he makes no attempt to conceal the fact or proclaim the virtue of taking interest. Ruskin's second line of defense is that he takes interest "because, though taking interest is, in the abstract, as wrong as war, the entire fabric of society is at present so connected with both usury and war that it is not possible violently to withdraw, nor wisely to set example of withdrawing, from either evil." His third line is, perhaps, more reasonable. He believes that, since he makes good use of his money in charity and support of painters, it is better for the money to come into his hands than into the hands of someone with less acceptant capacity. Ruskin is not satisfied with this reasoning. He reproaches himself for being "a man clothed in soft raiment," unwilling to live in a garret or make shoes like Tolstoi. "Here I am trying to reform the world," he confides to a friend, "and I suppose I ought to begin with myself. I am trying to do St. Benedict's work, and I ought to be a saint. And yet I am living between a Turkey carpet and a Titian, and drinking as much tea as I can *swig!*" The trials of personal abundance![40]

In projects under his control, Ruskin does try to follow his precepts. After his father's death in 1864, he purchased several run-down tenement buildings in Marylebone and placed Miss Octavia Hill (1838-1912), later famous in philanthropic housing reform, in charge of their management. To demonstrate the validity of "enlightened landlordism," Ruskin kept only five percent on the leasehold and three percent on the freehold for himself. The rest of the rent he devoted to repairs or to a fund of compulsory savings for the tenants. In the land which he leased as master of the Guild of St. George, Ruskin charged no rent at all or a low, fixed rent which went toward the improvement of St. George's properties.[41]

Ruskin's pioneering efforts in the publishing and bookselling business are less well known. With *Fors Clavigera* in 1871, Ruskin took complete charge of the publication of his books. This involved a break with George Smith, his previous publisher, and the appointment of George Allen. In the publishing trade of the time, there was the "published price" of a book, and then there were numerous and uncertain "trade discounts" to booksellers. Booksellers either de-

manded the published price or granted varying discounts to undersell competitors. The system encouraged dishonesty and was inconsistent with Ruskin's demand for fixed prices and confessed profits. He adopted a new plan for the sale of *Fors* and eventually his other books. The published price was the price paid both by booksellers and by private customers who bought directly from the author-publisher. He gave no credit, discount, or abatement: "The trade may charge a proper acknowledged profit for their effort in retailing the book. Then the public will know what they are about, and so will tradesmen." Ruskin also ceased to advertise. Although the book-sellers opposed this experiment and, for a time, refused to handle his books, George Allen attracted a good number of customers. In 1882, Ruskin modified his plan. He fixed the retail price and gave the trade a uniform discount, large enough to leave booksellers a livelihood and small enough to prevent their underselling each other by cutting the public price. In this form, Ruskin's experiment was widely adopted as the "Net Book System." This was his greatest, indeed only, practical success. A tea shop which he opened in Paddington to sell pure tea to the poor without advertising and at "honest prices" was a failure. Success or failure, Ruskin cannot be accused of idle preaching.[42]

VIII War and Empire

One of the most important themes of Ruskin's writing after 1860 is his critique of modern warfare and imperialism. It sets the stage for later liberal and socialist endeavors. While propounding an exalted vision of England's imperial status, Ruskin is the first Victorian to become fully aware of the wastefulness of modern war with its conscripted armies and spiraling armaments. He is also one of the few Victorians to suggest an economic motive for military aggression and imperialism. The munitions manufacturer and international financier make an early appearance as instigators of war in his pages. Finally, Ruskin relates his critique of war and empire to his economic analysis by suggesting a direct connection between imperial expansion abroad and capitalist exploitation at home. He arrives at this insight at least thirty years before John A. Hobson and V. I. Lenin.

2

Ruskin moves slowly to his final position on war. Only in the sixties and seventies does he relate his criticism of it to his theory of exploitation. Ruskin's development on this question is a tribute to the honesty of his genius. For much of his career, he takes a conventional view of war. He delights in its aspects of colorful pageantry and sees in it the aristocratic ideal of harmony between disciplined ranks. He uses a military metaphor to describe social discipline and leadership. Ruskin is proud of Britain's traditional bravery and succumbs to the myths which cluster around Napoleon and Wellington. He thinks of war as a form of art or play, a game of chess, as Wilenski puts it, and is intensely interested in strategy and tactics. In the course of the game, men are strengthened in body and mind. This is the root of his exorbitant claim that the fine arts of peace are founded on the "great art of war" because a warrior nation will concentrate on its men instead of its material possessions. Ruskin's romantic view of war reveals itself in his pronouncements on actual wars. He opposes the Italian stirrings of 1848 and sympathizes with the Austrian occupation during his stay in Venice. He makes a hero of Napoleon III and urges vigorous prosecution of the Crimean War.[1]

In 1872, Ruskin admits to a confused inconsistency: "I entirely, in the abstract, disapprove of war; yet have the profoundest sympathy with Colonel Yea and his fusiliers at Alma, and only wish I could have been there with them." On the whole, Ruskin's view of war changes drastically after 1860. It parallels the development of his social criticism. The immediate cause is his realization of what war with modern weapons is really like. Ruskin was the contemporary of Alfred Krupp (1812-1887) and Sir William Armstrong (1810-1900). He saw the rise of the conscript army, first used successfully by Prussia. These two factors, the "misuse of modern discoveries" and the large numbers of ordinary citizens involved, lie behind his growing opposition to war. Ruskin now believes that war "determines *who is the best man*" only when it requires the "*full personal power of the human creature*" in the management of primitive weapons. He confesses to great sympathy for this "game of war, rightly played," but none when it means using a "multitude of human pawns" as fodder for weapons which "will kill anybody who happens to be in the way." War tests nothing when it is waged by money and machinery. The willingness of the upper classes to use the masses as puppets in a mechanized "game of death" is evidence of the separation between "the two races."[2]

What disturbs Ruskin most about modern war is not such discrimination but the waste in lives and wealth. In a lecture to the cadets of the Royal Military Academy at Woolwich in 1865, Ruskin surprised the authorities of the school:

If you have to take away masses of men from all industrial employment . . . to provide them with destructive machines, varied daily in national rivalship of inventive cost; if you have to ravage the country which you attack,—to destroy, for a score of future years, its roads, its woods, its cities and its harbours;—and if, finally, having brought masses of men, counted by hundreds of thousands, face to face, you tear those masses to pieces with jagged shot, and leave the living creatures, countlessly beyond all help of surgery, to starve and parch, through days of torture, down into clots of clay—what book of accounts shall record the cost of your work;—What book of judgment sentence the guilt of it?

That, I say, is *modern* war,—scientific war,—chemical and mechanic war. . . . And yet you will tell me, perhaps, that any other war than this is impossible now. It may be so; the progress of science cannot, perhaps, be otherwise registered than by new facilities of destruction; and the brotherly love of our enlarging Christianity be only proved by multiplication of murder. (18.472)

Modern war weighs heavily on the cost side of Ruskin's balance of vital cost and vital utility.

Destruction of lives and property is one aspect of the cost of war. Ruskin also deplores the resources wasted in the creation of vast armaments. These resources could have gone to the realization of England's abundance. The central teaching of *Unto This Last* and *Munera Pulveris* is that nations cannot live on iron and nitroglycerin. Sardonically, Ruskin imagines a conversation between himself and a private gentleman who has employed him as interior decorator:

I begin looking about me, and find the walls rather bare; I think such and such a paper might be desirable—perhaps a little fresco here and there on the ceiling—a damask curtain or so at the windows. "Ah," says my employer, "damask curtains, indeed! That's all very fine, but you know I can't afford that kind of thing just now!" "Yet the world credits you with a splendid income!" "Ah, yes," says my friend, "but do you know, at present I am obliged to spend it nearly all in steel-traps!" "Steel-traps! for whom?" "Why, for that fellow on the other side the wall, you know: we're very good friends, capital friends; but we are obliged to keep our traps set on both sides of the wall; we could not possibly keep on friendly terms without them, and our spring guns. The worst of it is, we are both clever fellows enough; and there's never a day passes that we don't find out a new trap, or a new gun-barrel, or something; we spend about fifteen millions a year each in our traps, take it altogether; and I don't see how we're to do with less." A highly comic state of life for two private gentlemen! but for two nations, it seems to me, not wholly comic. (18.438-439)

Far less comic if weapons are so "advanced" that defense against them is futile. The aim of generals, Ruskin suggests, soon will be "rather to take care of their weapons than to use them." One hundred years later, in a remarkable age when missiles guard missiles, his question remains: why waste money feeding the "Woolwich Infant," a huge gun, when real Yorkshire infants are dying of starvation?[3]

3

Ruskin's critique of war sharpens when he considers who pays for armaments and who profits by them. In Letter Sixty-seven of *Fors* (1876), he describes the creation of a "National Debt"—something very different from a "National Store":

A "civilized nation" in modern Europe consists, in broad terms, of (A) a mass of half-taught, discontented, and mostly penniless populace, calling itself the people; of (B) a thing which it calls a government—meaning an apparatus for collecting and spending money; and (C) a small number of capitalists, many of them rogues. . . .

Now when the civilized mob wants to spend money for any profitless or mischievous purposes, . . . being itself penniless, it sets its money-collecting machine to borrow the sum needful for these amusements from the civilized capitalist.

The civilized capitalist lends the money, on condition that, through the money-collecting machine, he may tax the civilized mob thenceforward for ever. The civilized mob spends the money forthwith, in gunpowder . . . and appoints its money-collecting machine to collect a daily tax from its children and children's children, to be paid to the capitalists. . . . (28.639-640)

Wars are financed by taxation which bears heavily on the poorer members of society. The taxes benefit capitalists, government contractors, and financiers, who "take the peasants by the throat." Although Ruskin does not explain the details of this transaction, he is certain that the financing of wars is a part of competitive capitalism and that the manufacture of munitions is a way of giving "remunerative employment."[4]

The next step in Ruskin's argument is a logical one and one which he takes frequently after the Franco-Prussian War of 1870. If capitalists and financiers profit most from modern war, they are, perhaps, the prime movers behind war and the tensions leading to armaments. Ruskin concludes a letter to the editor of *Fraser's Magazine* (1876) with this warning:

That the money-lenders whose pockets are filled, while everybody else's are emptied, by recent military finance, should occultly exercise irresistible influence . . . on the deliberation of Cabinets, and passions of the populace, is inevitable under present circumstances; and the exercise of such influence, however advantageous to contractors and projectors, can scarcely be held consistent either with the honour of a Senate or the safety of a state. (34.525)

Through their control of the press, money-lenders "improve contention of arms with contention of tongues." They lie in universal and permanent print.[5]

At this point, Ruskin becomes less temperate in assigning responsibility. "All unjust war" is supported by loans from capitalists. The people "appear to have no will in the matter, the capitalists' will being the primary root of the war." In a preface to *Munera Pulveris* (1871), he accuses capitalists of persuading the lower classes in various countries that they want to shoot each other. By manufacturing guns and lending money, capitalists profitably invest funds "they do not know what to do with." The last phrase is important. Ruskin comes close to connecting his critique of war with his critique of hoarding and his demand for a better flow of wealth within the community. He foreshadows the views of later writers who cite maldistribution of income as the cause of imperial aggression. Whether or not Ruskin makes this connection, he does emphasize the dangerous role of international finance in persuading England and

France to purchase "ten millions sterling worth of consternation annually." Financiers are the "source of all deadly war." And behind them stands the science of political economy.[6]

Even in cynical moods, Ruskin does not oppose all wars. Wars for defense are justified, as are aggressive wars if waged for "protective" or "helpful" purposes. He considers the principle of nonintervention to be as shortsighted as the worst frenzy of conquest and sanctions intervention "to save any oppressed multitude, or even individual, from manifest violence." He is careful to distinguish between justifiable action which refuses territory or political influence and "acquisitive wars" which capitalists and financiers instigate. Ruskin believes that wars for dominion stem from a failure of imagination. Men fail to distinguish between quantity and quality. They fail to see, as Plato and Sir Thomas More put it, that the strength of a nation depends not on its land, numbers, or machinery for defense but on the quality of its people. "Only that nation gains true territory, which gains itself." True power does not consist in authority to interfere, regardless of the good or evil done. It is "life-giving," the power of "help." It is more interested in raising harvests than in burning them.[7]

Ruskin's theory of just and unjust war colors his criticism of particular wars. The American Civil War stirred Ruskin deeply. He opposed the war and, at the risk of damaging his friendship with Charles Eliot Norton, viewed the North as aggressor. He notes the devastated condition of the South: "Is not *this* a beautiful result of an *Evangelical* war proclaimed pathetically by sundry ministers and benevolent ladies—in favour of their black friends? I think they will find they have emancipated quite another sort of black friends out of a much warmer climate than that of Carolina." The "idiocy" of the North is its "mixing up" a fight for liberty with that for dominion and money, a "mixing" of motives which American historians began to take seriously in the twentieth century. As for England, Ruskin believes that "we have fought where we should not have fought, for gain; and we have been passive, where we should not have been, for fear." England should have assisted the Poles in their insurrection against Russia in 1863 and prevented Prussia from taking Schleswig-Holstein. While England failed to act in cases of justifiable intervention, she was going with armed steamers up and down the China Seas, burning the Summer Palace, and bombarding Kogashima. Ruskin's sense of outrage finds expression in *Sesame and Lilies* and *The Crown of Wild Olive.*[8]

4

Ruskin's importance as a critic of modern war should not be under-estimated. To be sure, there are many writers before Ruskin who condemn war. Wordsworth, Coleridge, and Southey, in their early years, manifest a pacifist dislike of war. They see in the ideals of the French Revolution the hope of lasting peace. So do Byron, Shelley, and Hazlitt. Ruskin praises Byron as a true "seer" for his imaginative grasp of the horrors of war. He also cites Carlyle and Arthur Helps. Carlyle's demands for what William James calls a "moral equivalent of war," a substitution of the fight against natural "Chaos" for the fight against an enemy and soldiers of the ploughshare or even a teachers' corps for soldiers of the sword, find their echo in Ruskin's writing.[9]

Ruskin surpasses Carlyle and the Romantic critics in his view of war as part of a broader system of exploitation. In this, he resembles Paine, Godwin, Joseph Fawcett (1758-1804), and, later, Ernest Jones (1819-1868). Paine and Godwin see war as the inevitable result of exploitation, class division, and expensive government. It is Blake, however, whose vision is most intense. In his poetry, images of mills and barracks, of death in the factory and death on the battlefield, are never far apart. The "ravening, eating cancer of war" is the first result of the political, sexual, and industrial oppression depicted in the poem "London." Many years before Carlyle and Ruskin, Blake hopes for a time when "iron engines of destruction" will be beaten down to forge the spade, the mattock, and the ax.[10]

Blake also anticipates Ruskin's suspicion that commercial or financial motives generate wars for dominion. Behind the "dismal cries and clarion calls," he writes, "across Europe & Asia to China & Japan" lurk the "Fiends of Commerce" and the labor of Albion's sons at the furnace. The motive behind war and empire is "Money (the life's blood of Poor Families)." In a less opaque fashion, Coleridge and Cobbett repeat Swift's view that foreign wars spring from the influence of "Usurers and Stockjobbers." More consistent and, in some ways, closer to Ruskin are Godwin, Charles Hall, and William Thompson. They attribute war to the acquisitive scramble for over-seas markets, a scramble necessitated by domestic inequalities and the contraction of consumer demand. Peace will arrive when co-operation has replaced competition, for, then, the home market will absorb all goods produced. There will be few capitalists who "do not know what to do with their money." Sismondi and Rodbertus give

these views a more precise expression. Ruskin differs from his predecessors, if not in clarity, at least in the amount of space he devotes to unmasking the economic roots of international conflict.[11]

Surprisingly, the radical critique of war owes much to Adam Smith and the classical economists. They believe that the tendency of the rate of profit to decline can be checked temporarily by the flow of investment overseas and the opening up of foreign markets. Smith, Ricardo, and John Stuart Mill do not fashion a theory of capitalist war and imperial exploitation, but their thinking points in that direction. Take the case of Richard Cobden (1804-1865) and John Bright (1811-1889). Renowned free traders and believers in the benefits of foreign investment, Cobden and Bright were the nineteenth century's most influential critics of military intervention. In their opposition to wasteful armaments and military loans and in their belief that commercial interests lie behind most wars, they are indistinguishable from radicals who reject competitive capitalism altogether. Ruskin, a "passionate" free trader, may have owed more to Cobden and Bright than he admitted. But Ruskin goes beyond them. He describes capitalism as a "system of iniquity" and suggests that it leads to foreign aggression through its inner dynamism and not merely through the conniving of special interests. In this, he resembles Hall and Godwin, whose ideas have been much neglected, and the later and more famous critics of imperialism, John A. Hobson, Rudolph Hilferding, Rosa Luxemburg, and V. I. Lenin. Ruskin's position is important. He stands, unwittingly, as the Victorian link between the earlier and later critics and as the first Victorian to comprehend the true dimensions of mechanized war. Those who point to Hobson as the source of Lenin's theory of imperialism and capitalist aggression would do well to consider the possibility that Ruskin's fragmented suggestions had an influence on Hobson as great in this as in other respects.[12]

5

The distinction between Ruskin's vision of what is and his vision of what ought to be appears clearly in his position on England's imperial activities. In 1870, he concludes his Inaugural Lecture at Oxford, a lecture to which Cecil Rhodes owed some of his inspiration, with this plea:

We are still undegenerate in race.... We have been taught a religion of pure mercy.... And we are rich in an inheritance of honor.... Within the last few

years we have had the laws of natural science opened to us. . . . Will you, youths of England, make your country again a royal throne of kings; a sceptered isle, for all the world a source of light, a centre of peace; mistress of Learning and of the Arts. . . . There is indeed a course of beneficent glory open to England, such as never was yet offered to any poor group of mortal souls. . . . And this is what she must either do, or perish: she must found colonies as fast and as far as she is able, formed of her most energetic and worthiest men;—seizing every piece of fruitful waste ground she can set her foot on, and there teaching these her colonists that . . . their first aim is to be to advance the power of England by land and sea. (20.41-42)

Ruskin criticizes the upper classes for wasting time and energy fox hunting while they could be extending England's dominion. In a lecture on "The Future of England" (1869), he describes their role:

We may organise emigration into an infinite power. We may assemble troops of the more adventurous and ambitious of our youth; we may send them on truest foreign service, founding new seats of authority, and centres of thought, in uncultivated and unconquered lands; . . . aiding them with free hand in the prosecution of discovery, and the victory over adverse natural powers; establishing seats of every manufacture in the climates and places best fitted for it, and bringing ourselves into due alliance and harmony of skill with the dexterities of every race, and the wisdoms of every tradition and every tongue. (18.513)

Not content with this vision of England's destiny, Ruskin makes the connection between imperialism and domestic reform which becomes common in the 1890's. "The England who is to be mistress of half the earth," he writes in tones of Lord Milner and Robert Blatchford, "cannot remain herself a heap of cinders. . . ." "Where are men ever to be happy, if not in England?" Three years before Disraeli's Crystal Palace speech, Ruskin strikes the highest notes of British imperialism.[13]

If Ruskin's imperial vision is prophetic, it is hardly original. The "new" imperialism of the 1880's and 1890's is remarkably old-fashioned. Early in the century, proposals for emigration and "systematic colonization" are endorsed by Malthusians and anti-Malthusians, Utilitarians and Romantics.[14] Coleridge, Thomas Arnold, and James Anthony Froude stand out as opponents of Malthus for whom emigration opens the door to the vision of a Christian and British "Roman Empire." In the writings of Carlyle, the ambiguities of the white man's burden are obvious. Although the strident Carlyle, convinced that "Niggers" are natural slaves, is the one remembered, his early works call for well-organized, efficient emigration under leaders of ability. In 1838, he predicts the coming of a New Era. "Is it not as if this swelling, simmering, never-resting Europe of ours stood, once

more, on the verge of an expansion without parallel. . . ." Robert Owen holds a vision similar in scope to Carlyle's and Ruskin's of the extension of a "new moral order" or system of "sociality" to every part of the globe. With Robert Southey, he urges a reformed England to "cast her swarms." Ruskin has captured sentiments from several points of the ideological compass.[15]

Ruskin's imperialism is only one side of his vision of the future. As if to draw within his net all opinions, he declares in Letter Forty-two of *Fors* (1874) that, in a century, England "will be—where Venice is—among the dead of nations." Predictions of England's ruin are scattered through his writings:

And to the English people the choice of its fate is very near now. It may spasmodically defend its property with iron walls a fathom thick, a few years longer—a very few. No walls will defend either it, or its havings, against the multitude that is breeding and spreading, faster than the clouds, over the habitable earth. We shall be allowed to live by small pedlar's business, and ironmongery—since we have chosen those for our line of life—as long as we are found useful black servants to the Americans; and are content to dig coals and sit in the cinders; . . . they once exhausted, or got cheaper elsewhere, we shall be abolished. (19.398)

A decline in British exports will signal the rise of the United States and Germany to commercial pre-eminence.[16]

Ruskin's gloomy view of the future is not unique. Among Victorian intellectuals, pessimism is more pervasive than is usually believed. Often it concerns England's economic position. One of the staples of classical economics is the belief that a declining rate of profit will lead inevitably to some form of "stationary state." The law of diminishing returns from land and Malthus' theory of population growth serve to darken the picture. Among noneconomists, pessimism takes the form of a vague and not unreasonable fear that England's primacy in foreign trade will not last. Southey and Owen note that in neither men, capital, nor machines can England hope to keep ahead of the United States. In 1815, Owen states, a bit prematurely, that England's export trade has reached its peak. Not all fears for England's future are economically based. The advance of a liberal, democratic civilization lacking "culture" disturbs Newman and Matthew Arnold.[17]

Although Ruskin's pessimism has its economic overtones, his chief concern is neither economic nor "cultural" but moral. He lays the blame for England's decline on her dishonest trade practices and on her exploitation of the areas of the world under her control. He

blames British mismanagement for famines in Persia and India and notes with scorn the methods of "civilizing" China. He sympathizes with the demands of the Irish for land reform and opposes English oppression in Ireland. Even the American Indian receives his attention. Ruskin points to the fur trader's exploitation of the Indian as one of "the triumphs of the modern Evangel of Usury, Competition, and Private Enterprise." He also deplores the "blowing to pieces" of the "defenceless" Zulus in 1880. As for the Indian Empire: "Every mutiny, every danger, every terror, and every crime, occurring under, or paralyzing, our Indian legislation, arises directly out of our national desire to live on the loot of India." In *The Bible of Amiens* (1882), he urges his readers to consider "how long the nations over whom our freedom is imperious . . . may be satisfied in that arrangement of the globe. . . ."[18]

Ruskin's view of British imperialism is strangely perceptive. On the one hand, he grasps very early the appeal of imperialism and, in the short run, predicts the vast extension of Britain's dominion in the eighties and nineties. On the other hand, his later writings are a storehouse for the anti-imperialists of the twentieth century. In the long run, he predicts accurately Britain's fall from eminence although his moral approach ignores the many factors involved. Whatever one may think of his prescience, Ruskin seldom fails to attack imperial mismanagement or "acquisitive" aggression when it comes to his attention. Is Britannia a mother of nations, he asks in *Fors,* or is "her motherhood summed in saying that she makes all the world's ditches dirtier with her spawn?"[19]

Ruskin's criticism of the Empire places him closer to political Liberals or Radicals than to Romantics. Although Southey, Carlyle, and Lord Shaftesbury condemn imperial mismanagement, the tradition of Radicalism provides the most persistent critique of the Empire. From Paine and Godwin through Joseph Hume and James Mill to Cobden and Bright, there is sharp criticism of imperial corruption. There are suggestions, similar to Ruskin's, that the Empire benefits a small minority of aristocratic place-seekers, financiers, and fund-holders. Although Ruskin affirms a belief in free trade, it is difficult to associate him with such determined Little Englanders and supporters of *laissez faire* as Cobden, Bright, or James Mill. Ruskin never resolves the contradiction in his thought between support of free trade and criticism of competition as the "law of death." In answer to a correspondent, he declares that free trade will lead, not to competition, but to universal harmony since each nation will pro-

duce only those things for which it is "naturally" suited by climate and skill. This is a poor dodge. Even if a noncompetitive, international division of labor were possible, how would it provide the variety in work which Ruskin feels to be necessary? And how does he reconcile free trade with his belief in England's imperial destiny? It is, perhaps, this insoluble Cobdenite element which encourages the free trader John A. Hobson to make that conjunction with Ruskin's thinking which is crucial to the latter's influence on the Labour Party. One of Hobson's many books was a biography of Richard Cobden.[20]

6

Before leaving Ruskin's critique, it is important to emphasize his opposition to war. His truculent calls for intervention on the Continent, his vision of an expanded empire, and his nostalgic sympathy for the discipline of warrior nations are misleading. Ruskin is convinced that England can no longer afford the luxury of a game sustained by blood. In 1867, he warns of a future "insane war" which will make the sun redder still. He hopes for a time when war will be "extinct" and when the soldier's qualities of discipline and leadership will be exercised in useful projects instead of "the moral organization of massacre and the mechanical reduplication of ruin." Wars will end when men learn principles of justice. Wars occur because "the majority of persons, high and low, in all European nations, are Thieves" and live in systems of competition and exploitation which encourage enmity. Ruskin rejects Herbert Spencer's view that national rivalry is inevitable since patriotism is nationally what egoism is individually. Only the "leathern throat of modern death, choked inch-thick with putrid dust," could proclaim such a doctrine.[21]

The spirit of competition is one reason for the existence of war. A more basic reason is lack of imagination, perspective, or sympathy. It is this that makes Ruskin's generation "the most cruel and . . . the most unwise generation that ever troubled the earth:—the most cruel in proportion to our sensibility and the most unwise in proportion to our science." If people could cut through the sentiments of national pride, the lies of the press, and the vagueness which envelops all things distant—if they "could *imagine* others as well as themselves"—they would see that war is no more noble than individual murder. They would see that the making of war-machinery is a "physical crime . . . without parallel in its untempted guilt." They

would even see "what the real fact is" respecting foreign military loans:

If your little boy came to you to ask for money to spend in squibs and crackers, you would think twice before you gave it him. . . . But the Russian children, and Austrian children, come to you, borrowing money, not to spend in innocent squibs, but in cartridges and bayonets . . . and *that* you will give at once, because they pay you interest for it. (18.416)

Wars are fought because men are fools as well as thieves. They fail to see that all things are related and that the poverty of their neighbors becomes in the end their own. They fail to measure the "range" of their moral agency. Ruskin believes that every citizen is responsible for the suffering caused by a distant war, just as every consumer is responsible for the life of the worker he employs. The imagination, the "touch-faculty" of the soul, is no respecter of distance:

> Each outcry of the hunted hare
> A fibre from the brain does tear.[22]

In a remarkable blend of social criticism, Romantic imagination, and Victorian idealization of women, Ruskin claims that, since women have greater powers of sympathy than men, they are responsible for the "circus of slaughter" and can stop it whenever they wish. He turns to the girl friends and mothers of the cadets at the Woolwich Academy:

It is *your* fault. Wholly yours. Only by your command, or by your permission, can any contest take place among us. And the real, final reason for all the poverty, misery, and rage of battle throughout Europe, is simply that you women, however good, however religious, however self-sacrificing for those whom you love, are too selfish and too thoughtless to take pains for any creature out of your own immediate circles. . . . Now I just tell you this, that if the usual course of war, instead of unroofing peasants' houses, and ravaging peasants' fields, merely broke the china upon your own drawing-room tables, no war in civilized countries would last a week. I tell you more, that at whatever moment you chose to put a period to war, you could do it with less trouble than you take any day to go out to dinner. . . . Let every lady in the upper classes of civilized Europe simply vow that, while any cruel war proceeds, she will wear *black*;—a mute's black,—with no jewel, no ornament . . . I tell you again, no war would last a week. (18.491-492)

Who is to say that this Victorian variation on *Lysistrata* might not be a more effective means of protest than "confrontations" in the streets?[23]

It is difficult to take an impartial view of Ruskin's criticism of war

and empire. His courage in presenting an unpopular position and his influence on later thinkers cannot be doubted. Ruskin is the first to grasp in one vision many aspects of a form of criticism familiar to twentieth-century readers. Long before Hobson or Lenin, Ruskin draws a connection between competitive capitalism, military aggression, and imperialism. Whether this connection is valid is a question hotly debated by scholars and publicists. Ruskin's intuitive perception of it, without the aid of statistical research, suggests that the connection serves primarily to unify a larger vision of social evil. In other words, the connection has its origin not in fact so much as in a deeply felt need to see things organically or "in relation." Again, Ruskin and the iron railing:

How if, instead of flat rough spikes, you put triangular polished ones, commonly called bayonets; and instead of the perpendicular bars, put perpendicular men? What is the cost to you then, of your railing? . . . (27.37)

This is not to deny the validity of the connection. It is only to suggest that the heat generated by the debate has its source in the psychological investments of the participants. On the positive side, Ruskin is one of the first investors.

IX The Insolence of Reaction

The time has come to turn to the constructive side of Ruskin's social criticism and to study his proposals for reforming English society. There is no break in Ruskin's career. He continues his destructive critique in *The Crown of Wild Olive, Time and Tide,* and *Fors Clavigera.* He has already suggested many of his constructive themes in *The Political Economy of Art.* Still, there is a grain of truth in the traditional division of Ruskin's work. Only in his later years does he follow consistently the paths of social prophet, utopian, or, more practically, architect of the welfare state and general consultant on the quality of life in an abundant society. The purpose of this chapter is to examine Ruskin's style or method of reform. The following chapter will focus on his specific proposals in their varying proportions of shrewd perception and tragic fantasy. It is on method of reform that Ruskin seems most vulnerable to the modern reader, whose attitude is conditioned by the experiences of the twentieth century. The outspoken "illiberalism" of Ruskin's later writings has cast a pall over much of his social criticism. Before turning to his farsighted proposals for institutional reform, it will be well to face the problem of Ruskin's authoritarianism—to define its extent, to explain tentatively its sources, and to place it in the context of such countervailing themes as his radical sympathy for the workers' cause, his emphasis on moral reform, and his deep interest in education.

2

In his approach to social reform, Ruskin hesitates before three options: revolution by force, appeal to authority, and moral conversion or education. Although he relies on a combination of authoritarianism, moral suasion, and education, there are moments when he does, indeed, seem to be the "reddest also of the red." Ruskin's rhetoric of revolution is awkwardly divided between what will be and what ought to be. Frequently, he warns that the system of exploitation and the "separation" of classes are leading to social revolution. In this he resembles writers as diverse as Godwin, Thomas Arnold, Owen, and John Stuart Mill. The fear of a social upheaval like that

predicted by Engels was, as Walter Houghton notes, a remarkably pervasive constituent of the Victorian mind. Ruskin's own attitude to the "imminent transfer of power from the upper classes to the workers" varies between shock, sympathetic reproach, amazement at its continued delay, and forthright encouragement. A few examples of the last will place Ruskin in the strange company of the advocates of "physical force" J. R. Stephens, William Benbow, and George Julian Harney and will help modify the common opinion of him as a schoolmaster lecturing the worker on his duties.[1]

In Letter Eighty-nine of *Fors Clavigera,* dated September, 1880, and written especially for the working class, Ruskin encourages workers to unite internationally in defiance of capitalists. He excuses his failure to lead the revolution by pointing to his responsibilities at Oxford. Seven years later and not long before his pen was silenced by madness, Ruskin relates his call for revolution to his critique of war. In a letter for publication to Thomas Barclay, he writes: "The time is certainly drawing near for the workmen, who are conscious of their own power, to draw together into action. They ought first in all Christian countries to abolish, not yet WAR . . . but the Armaments for it, of which the real root cause is simply the gain of manufacturers of instruments of death." Earlier, in Letter Seven of *Fors* (1871), he tells the working class, *"You must simply rather die than make any destroying mechanism or compound."* Ruskin is staking out a position much debated forty years later by the socialist parties of Europe.[2]

Ruskin's ambiguous attitude to the coming revolution reflects his view of actual revolutions. He partly hails and partly condemns the Paris Commune of 1871 as the first engagement in the "war" between masters and workmen. Although Ruskin's reactions are more hesitant than Marx's, their perception of the facts in 1871 is identical. Ruskin's opinion of the first French Revolution is also equivocal. He can condemn it as inspired by demogogues proclaiming a false ideal of liberty. On the whole, he sees it as the inevitable working out of social forces. He goes beyond Carlyle's "phoenix" theory, however, to an interpretation of it in terms of a class struggle between peasants and landowners. Ruskin places the capstone on the long history of British reaction to the French Revolution by denying its "distance" and returning to the earlier, Burkean view of its dangerous relevance. The Constitution is breaking fast! In 1880, British squires will have to fight for their land in an upheaval like the French

Revolution. "Are you prepared," he asks them in 1874, "to clear the streets with the Woolwich Infant?" Ruskin urges historians to study the ambitions of the common people in order to understand the significance of the French Revolution and the Paris Commune.[3]

Whatever Ruskin's personal reactions, he believes that revolution is justified under the "system of iniquity." Although he does not fashion a concept of surplus value, the source of his moral outrage is very similar to that of Marx and the Ricardian socialists: the worker has the right to obtain by "honest force" the "means of life" which he alone produces but which have been taken from him by capitalists and landowners. Ruskin wonders whether the upper classes, who "dispense" the product of the poor man's labor "only in return for more labour," are necessary to society. Laborers are becoming aware of the unjust basis of the capitalist's and landowner's position. Soon they will rebel against the "rich dispenser" and take for themselves the produce of their labor. To do this, they must become "masters of their tools." They must appropriate the means of production. At present, the capitalist or landlord owns the tools and charges the laborer for the use of them. This is the source of his power over the worker. Ruskin even grasps the dynamics of the revolutionary process which, in Marx's analysis, will lead to the workers' possession of the means of production: "If the rich strive always to obtain more power over the poor . . . and if, on the other hand, the poor become continually more vicious and numerous, through neglect and oppression,—though the *range* of the power of the rich increases, its *tenure* becomes less secure; until, at last, revolution . . . closes the moral corruption, and industrial disease." Here is a description, in the Ruskinian manner (1863), of Marx's vision of the concentration of wealth in fewer hands and the corresponding growth of the proletariat before the revolution.[4]

<div align="center">3</div>

In spite of his incendiary rhetoric, violent revolution is never a solution for Ruskin. More often, he endorses forms of independent action which involve no agitation or violence. In *Time and Tide,* he urges workers to decide on what they desire concerning wages, hours, and the future of England. Until they have reached agreement, their voices will not be worth a "rat's squeak, either in Parliament or out of it." Once agreement has been reached, they should enforce their goals upon themselves without the aid of Parliament and without

agitation. Not long before the founding of the Trades Union Congress at Manchester in 1868, Ruskin proposes a workers' parliament to discuss "the possible modes of the regulation of industry."[5]

The quality of Ruskin's radicalism may be judged by the restrictions he places on this parliament:

If any of the laws thus determined appear to be inconsistent with the present circumstances or customs of trade, do not make a noise about them, nor try to enforce them suddenly on others, nor embroider them on flags, nor call meetings in parks about them, in spite of railings and police; but keep them in your thoughts and sight, as objects of patient purpose and future achievement by peaceful strength.

. . . Be assured that no great change for the better can ever be easily accomplished, or quickly; nor by impulsive, ill-regulated effort, nor by bad men; nor even by good men, without much suffering. (17.327-328)

Ruskin prefers gradual, voluntary action. He hopes that workers will pool their savings to obtain land and tools. He gives cautious approval to cooperative societies and to the trade-union movement, although he objects to the appellation "trade." Workers make and produce, not trade. They should change the name to "Labourers' Union" as a quiet reminder that they are the source of wealth. His suggestion may have influenced the Labour Party's choice of name.[6]

Even less radical is Ruskin's proposal that workers acquiesce in the present system but strive to become masters. From a position of power, they can initiate the reorganization of industry. He urges every industrial worker to become a "diminutive capitalist" and every agricultural worker to obtain his own plot of land. Ruskin's vision of a revived yeomanry of "diminutive squires" foreshadows the "return to the land" or "allotment" proposals of men like Joseph Chamberlain at the turn of the century. In the spectrum of reform, this appeal borders closely on the Victorian ideal of "getting-on," which Ruskin often criticizes. In *Unto This Last*, he notes that high wages, by diminishing "the power of wealth, in the hands of one individual, over masses of men," make social advancement easier.[7]

Ruskin could have borrowed his suggestions for voluntary, nonviolent action from almost any sector of nineteenth-century social criticism. Southey, for example, calls for savings banks and self-sufficient communities. So does Robert Owen. The cooperative movement, including Christian Socialism, is based on the premise that workers' self-help, whether as producers or consumers, is the best way to change society. The nostalgic theme of restoring a golden age of small farms also appears frequently. From Paine and Godwin

through Cobbett, Feargus O'Connor, and Charles Kingsley, the "small-holding" plays an important role in the vision of a new society. John Stuart Mill urges the value of small proprietorships, cooperative experiments, trade-unions, and profit-sharing schemes. Those who propose measures of self-help are, like Ruskin, trying to find a *via media* between violent revolution, however justifiable, and paternalistic reform from above or, as Cobbett puts it, "comforting." Ruskin does not hold consistently to this *via media*.[8]

<div align="center">4</div>

One of the stumbling blocks in Ruskin's support of revolution is the property question. In November, 1887, Ruskin was staying at Morley's Hotel in Trafalgar Square. He saw the noisy meetings of the unemployed, their dispersal by the Guards, and the arrest of John Burns. His reaction in a letter to the editor of the *Pall Mall Gazette* is this: "The shopkeepers have no business to ask the police to help them to swindle the public with cheap things or tempt them with showy ones. Let them shut their shops up . . . and . . . don't let the Life Guards interfere. . . ."[9] Twenty-five years earlier, in *Munera Pulveris*, Ruskin had written as follows:

The first necessity of all economical government is to secure the unquestioned and unquestionable working of the great law of Property. . . . Whatever evil, luxury, iniquity, may seem to result from it, this is nevertheless the first of all Equities; and to the enforcement of this, by law and police-truncheon, the nation must always primarily set its mind. . . . (17.192-193)

The difference in the tone of these passages is not a function of time. The dichotomy occurs often in Ruskin's writing. He is capable of expressing both attitudes in one passage, as in chapter three of *Unto This Last:*

And with respect to . . . the secure possession of property, so far am I from invalidating such security, that the whole gist of these papers will be found ultimately to aim at an extension in its range; and whereas it has long been known and declared that the poor have no right to the property of the rich, I wish it also to be known and declared that the rich have no right to the property of the poor. (17.75)

Ruskin never accepts communism. He quotes with approval communications from communists but refuses to adopt their specific proposals. Only on the question of land does he consider a system of complete public ownership. He states that land, air, and water should belong, not to private "hereditarily sacred persons," but to the whole

society. Landholders should pay a rent to the state. What he usually means is that private owners should submit to taxation and to public regulations concerning the use of land. Ruskin believes that property is a necessary incentive in the present state of human nature. Any attempt to abolish it will end "in ruin and shame." Possession of property is the sole exception he makes in the comparison of modern society to a storm-tossed ship in which all men are placed under conditions of equality. To the end, of course, Ruskin insists that he is a "Communist of the old school" whose "property belongs to everybody and everybody's property to him." Of these "old Reds," there are two divisions: a pink sect, who are more anxious for the possessions of other people than for their own, and a vermillion sect, who are not content with this "but cannot rest unless we are giving what we can spare of our own." A multicolored communism of the heart and imagination has little to do with the abolition of property. Ruskin's play on the word "red" reveals more about his lack of revolutionary fervor than the substance of his comments.[10]

Ruskin's preferred view of property is found in Letter Twenty-two of *Fors* (1872). He returns to his "vital" definitions of use and possession: "Land should belong to those who can use *it,* and tools to those who can use *them.*" This implies a redistribution of property. But Ruskin rejects the "common socialist idea of division of property" as tending towards chaos. He gives his dictum a "less revolutionary and instantly practicable" interpretation: those who have land and tools should use them. Both the original statement and Ruskin's interpretation can be found in Carlyle. John Stuart Mill takes a similar view of landed property. There is evidence that Mill and Carlyle were influenced by the Saint-Simonians, who make "the tools to those who can use them" the key to their hierarchy of industrial talent.[11]

Two passages from *Fors,* one on capital and one on land, confirm Ruskin's conservative posture. In Letter One of *Fors* (1871), Ruskin declares that, if all capital and machinery were destroyed, the laboring classes would be "very little worse off than they are at this instant" and that "their labour, instead of being 'limited' by the destruction, would be greatly stimulated." He continues:

It is only we who had the capital who would suffer; we should not be able to live idle, as we do now, and many of us—I, for instance—should starve at once: but you, though little the worse, would none of you be the better eventually, for our loss—or starvation. The removal of superfluous mouths would indeed benefit

you somewhat, for a time; but you would soon replace them with hungrier ones; and there are many of us who are quite worth our meat to you in different ways . . . also . . . our money is really likely to be useful to you in its accumulated form (besides that, in the instances it has been won by work, it justly belongs to us). . . . (27.24)

In Letter Twenty-two (1872), he hedges in a similar fashion concerning land:

You had better take care of your squires. Their land, indeed, only belongs to them, or is said to belong, because they seized it long since by force of hand . . . and you may think you have precisely the same right to seize it now, for yourselves, if you can. So you have,—precisely the same right,—that is to say, none. . . . In the meantime, by the law of England, the land is theirs; and your first duty as Englishmen is to obey the law of England, be it just or unjust, until it is by due and peaceful deliberation altered, if alteration of it be needful; and to be sure that you are able and willing to obey good laws before you seek to alter unjust ones. . . . Also, your race of squires, considered merely as an animal one, is very precious. . . . (27.379-380)

On the subject of property, Ruskin displays an unwonted rhetorical temperance.

His reluctance to declare with Bronterre O'Brien, "Property—property—this is the thing we must be at," is understandable. Very few social critics in nineteenth-century England wish to abolish private property, and many far more convinced radicals than Ruskin hesitate. O'Brien, himself, soon retreats. A good example of hesitation is provided by the Owenites. They make cooperation or "sociality" the key to the future but admit both private property and a reward for capital investment. The Christian Socialists follow suit. They are aware of the radical implications of Christian brotherhood and of the tradition of communism in the Early Church but plead expediency. Closer to Ruskin's own view is that of William Cobbett. Cobbett lashes out against the depradations of large property owners *and* demands that property rights be secured. Landowners should recognize that duties are correlative to rights.[12]

More interesting are the self-searchings of John Stuart Mill. Ruskin's fragmented opinions do not compare well with Mill's tolerant consideration of the socialist critique of property and his willingness to experiment with different forms of social organization. For the present, Mill holds to property. His reasons are the usual ones of incentive, individual liberty, and the impracticability of socialism. Mill's flexible approach reminds one of Hume's original arguments in favor of private property. If Mill cannot give up his attachment to

property and capital, it should be no surprise that Ruskin does not. Although a severe critic of his society and its values, he has little of the great Utilitarian's sense of the relativity of nineteenth-century social forms. The final positions of Mill and Ruskin are much the same. Both men criticize the abuse of property rights but refuse to abandon property itself. They call for public regulation to prevent the mismanagement of land. They adopt a nineteenth-century version of the Aristotelian or Thomistic concept of private property with public responsibility or "use."[13]

<div align="center">5</div>

The balance of Ruskin's hesitation weighs heavily on the side of authority. Against his most radical statements on behalf of violent revolution or even peaceful change from below must be weighed the following remark, which occupies a prominent position at the end of *Time and Tide:*

And this is the practical lesson I want to leave with you, and all other working men.

You are on the eve of a great political crisis; and every rascal with a tongue in his head will try to make his own stock out of you. . . . Those that say to you, "Stand up for your rights—get your division of living . . . don't let any man dictate to you—have not you all a right to your opinion?—are you not all as good as everybody else? . . . " Those, I say, who speak thus to you, take Nelson's rough order for—and hate them as you do the Devil, for they *are* his ambassadors. (17.461-462)

More concisely, he urges "you working men" to stop "crowing and peacocking" and "setting yourselves forth so confidently for the cream of society."[14]

Ruskin agrees with Carlyle that workers not only need but, if they knew their own desires, would cry out for leaders and governors. His conviction has its emotional counterpart. Ruskin describes the lower classes: "the yelping, carnivorous crowd, mad for money and lust, tearing each other to pieces . . . leaving heaps of their dung and ponds of their spittle on every palace floor and altar stone." At Verona, in 1869, he complains of the noisy, discontented mob. He would like to grind it down "in the valley of Chamouni for a mortar with Mt. Blanc, upside down, for a pestle." Ruskin's support of Governor Eyre in the Jamaica Case and his view of capital punishment further reflect his authoritarianism. To rid itself of "human vermin," society must maintain the principle of the gallows. His scornful references to the mob and criminals remind one of Carlyle's

unfortunate outbursts against "swarmery" in *Latter-Day Pamphlets* and Thomas Arnold's assertion that no convict or convict's child should ever be a free citizen. Swift's "vermin," Burke's "swinish multitude," Matthew Arnold's "populace," and Mill's "habitual liars" find their echo in Ruskin's comments.[15]

One of the least edifying aspects of Ruskin's later thought is his "illiberalism," his persistent demand for the kind of authority and subordination which he sees in Gothic architecture. He begins with a principle rooted in Plato's *Republic,* in the Romantic concept of genius, and in the Puritan doctrine of the elect. Men are not created equal. From here he proceeds in several, hardly original directions. First, society should discern and educate those who are superior. One recalls his discussion of artistic talent in *The Political Economy of Art.* Ruskin is much interested in conditions which encourage leadership. He views the Middle Ages as an instructive model. After leaders have been discovered and trained, they should be placed in positions of authority where they can "guide, lead, or on occasion even compel and subdue, their inferiors." Most men are inferior or "servile." They should stop demanding rights and, instead, seek out true "lords or law-wards." Aphorisms on mastership and loyal obedience crowd Ruskin's pages: "The fool, whatever his wit, is the man who doesn't know his master."[16]

Ruskin opposes democracy and universal suffrage. He admits that "all forms of government are good just so far as they attain this one vital necessity of policy—*that the wise and kind, few or many, shall govern the unwise and unkind."* He doubts that democracy with a universal, equal suffrage can meet this requirement. He proposes again the graduated system of voting, based on age, income, and education, which he had suggested in his unpublished letter to the *Times* and which resembles Mill's proposals in *Representative Government* (1861). Within the factory or the guild, he prefers benign "mastership" to cooperative profit-sharing or democracy. For the most part, Ruskin is implacably hostile to democratic processes. He calls himself a "violent Tory of the old school"—the school of Homer and Sir Walter Scott, the school of "kings." He "hates" republicans, feminists, and Americans with their ideas of equality and liberty. His belief that art springs from the happiness and creativity of a whole people does not imply democratic rule. The organic unity of society is like that of a painting or cathedral. It depends on the "helpful" cooperation of *unequal* parts in a hierarchy, not on the mechanical addition of *equal* parts in a democracy. The theory that democratic

processes create social unity by expressing and enforcing the general will finds no place in Ruskin's outlook. He would deny that "fulness of character absorbed in universal energy" describes the ideal democratic society as well as the society of the Middle Ages.[17]

Ruskin's opposition to democracy and equality is *de rigeur* for the Victorian period. It is difficult to find a convinced advocate of universal suffrage. Even spokesmen for the lower classes—Owen, Cobbett, the Christian Socialists—deny its viability. The most interesting Victorian critics, and certainly the most thoughtful, are John Stuart Mill and Matthew Arnold. Although Mill and Arnold are in sympathy with the "expansive" tendencies toward democracy and equality, they fear that the mass of the people are not ready for self-government. They suggest measures which will blunt the attainment of full democracy. Mill and Arnold differ in their motives. Mill hopes to protect individual liberty from the tyranny of public opinion. Arnold wishes to provide society with an effective government of the "best," the "saving remnant," who will preserve standards of culture. Both points can be found earlier in Coleridge's criticisms of democracy and later in the writings of Sir Henry Maine (1822-1888) and William Lecky (1838-1903). Ruskin's doubts resemble Arnold's more than Mill's. His chief and only criticism of democracy is that it cannot provide society with proper leadership. He evinces none of Arnold's or Mill's sympathy for the "modern movement."[18]

Ruskin's response to democracy resembles Carlyle's in its immediate, instinctive character. Ruskin and Carlyle spend more time heaping scorn on the ability of the ballot box to yield true leaders and equating universal "doghood" suffrage with *laissez faire* and "no-government" than carefully studying the new phenomenon. Many of Ruskin's strictures can be found verbatim in Carlyle. Neither writer is clear on whether his "true superiors" are to be an "aristocracy of talent" drawn from any class, as the Saint-Simonians and Comte urge, or whether they are identical to the existing aristocracy of land and money. Although their rhetoric implies the former, Ruskin and his "master" often urge the present upper classes to reform themselves and consider their wealth a trust. Occasionally, they fail to make this stipulation. In a letter to Lady Cowper-Temple (June 1869), Ruskin ignores his analysis of exploitation and declares that the granting of obedience to "a certain number of persons indiscriminately, and because they belong to a race," has a valuable effect both on those honored and those obeying. It is a short step to the

following comment on the aristocracy in *Time and Tide:* "Corrupt as it may be . . . I would at this moment, if I could, fasten every one of its institutions down with bands of iron, and trust for all progress and help against its tyranny simply to the patience and strength of private conduct."[19]

6

Ruskin's critique of liberty is one of the most controversial facets of his later writing. It is also one of the most pervasive. The liberty-restraint antithesis becomes an integral part of the opposition in his thought between mechanism and organism, competition and cooperation, anarchy and government. In a startling adumbration of Émile Durkheim's concept, Ruskin identifies liberty with "anomia." It leads to dissolution and disorganization. The consummate freedom is death—"permission for every particle in the rotting body to leave its neighbour particle, and shift for itself." Order and obedience, on the other hand, suggest purity, love, and life. "The Sun has no liberty—a dead leaf has much."[20]

It was not always so for Ruskin. Recall his emphasis on the worker's *life* and *liberty* in "The Nature of Gothic." Ruskin's growing conviction that liberty and organicism are mutually exclusive is not typically Romantic. Edward Young introduced the organic metaphor to liberate the genius from the rules of neoclassicism. In the hands of Blake, the early Coleridge, Shelley, and Byron, this strain of Romanticism inspired a vigorous demand for social freedom. It adapted itself easily to the ideals of the French Revolution. Even the later Coleridge follows Goethe in using the organic metaphor to describe the artist's spontaneous adherence to an inner lawfulness. Carlyle, too, turns the metaphor to a liberal purpose in his view of the free development of the hero. Ruskin's organicism of the surface and his distrust of spontaneous growth harden. In the end, they allow no compromise with liberty. His obsession with decay and death, with the flowing of the streams of life out of reach, gives a neurotic edge to his illiberalism. He places the "lamp of life" in permanent keeping of the "lamp of obedience."[21]

Earlier, Ruskin's hostility to liberty centered on the principle of *laissez faire.* Now he looks to a broader field. A discursive study on art, entitled *The Cestus of Aglaia* (1865-66), contains the most passionately argued attack on liberty penned in the nineteenth century. Ruskin begins with art. He asserts that all freedom in art is error:

"There is but one question ultimately to be asked respecting every line you draw, Is it right or wrong? If right, it most assuredly is not a 'free' line. . . ." In life, too, there is no value in liberty, only in right doing. What is important is not how free we are but what kind of creatures we are. Which is the nobler creature, Ruskin asks, the utterly free, egotistical housefly, "a black incarnation of caprice," or the chained watchdog with "wistful powers of wonder, sorrow, desire, and affection, which embitter his captivity?"[22]

Ruskin refutes three common arguments in favor of liberty. First, he denies that there is value in learning freely by trial and error since the poison in a wrong act deforms one's character permanently. "No one ever gets wiser by doing wrong, nor stronger. You will get wiser and stronger only by doing right, whether forced or not." Second, he denies that liberty is a necessary condition of individuality. "Your individuality was given you by God, and in your race; and if you have any to speak of, you will want no liberty." You will want "direction, instruction, reproof, and sympathy." Finally, Ruskin turns to those like John Stuart Mill who defend liberty of thought:

If you have not sufficient grounds for thought, you have no business to think; and if you have sufficient grounds, you have no business to think wrong. . . . The restriction of thought, or of its expression, by persecution, is merely a form of violence, justifiable or not, as other violence is, according to the character of the persons against whom it is exercised, and the divine and eternal laws which it vindicates or violates. (19.127)

He admits that there are "some important truths" in Mill's essay *On Liberty* (1859). But "many, quite vital, are omitted." To refute Ruskin's arguments, one would have only to disprove his assumption that there is "clearly discernible" right and wrong. James Fitzjames Stephen (1829-1894) refuses to rely on this assumption. His tendency to argue from utility or historical evidence makes his criticism of Mill more cogent than Ruskin's. The absolutism of Ruskin's later years does more than hinder the cogency of his critique of liberty. It blinds him to the lesson of "The Nature of Gothic": the value of permitting a free expression of man's thought and individuality regardless of "incapability," "roughness," or "failure."[23]

Ruskin's attack on liberty is accompanied by a defense of slavery so frank that he can hardly be accused of concealing the implications of his ideas. First, he compares the condition of the black slave in the tropics with that of the white worker in Britain's industrial cities. The tropical native, he believes, is much happier than the "free"

worker. To be fair, Ruskin never defends the slave trade, "the purchase of the body and soul of the creature itself for money," but he considers the zeal of emancipators misguided as long as white men are enslaved under more degrading conditions in the factory towns. Slavery is not neutralized by wage payment. Evangelicals fail to see this because they lack social imagination.[24]

Ruskin's claim that the white worker is worse off than the black slave is a well-worn and ambiguous forensic device. Carlyle's essay on "The Nigger Question" (1849) strikes one, but the comparison appears also in the writings of Dickens, Lord Shaftesbury, George Julian Harney, and William Maginn of *Fraser's Magazine.* Its origins demonstrate once again the remarkable interpenetration of Romantic and radical modes of social criticism. While the early critic of industrialism, Charles Hall, is the first to compare white worker with black slave, Cobbett, Southey, and Thomas Arnold bring the device into the mainstream of Victorian discourse. As early as 1822, Cobbett compares the sufferings of "free British labour" in "that bloodstained town" (Manchester) with the happy lot of the "fat and lazy and laughing and singing and dancing" Negro slave in the West Indies upon whom Evangelicals lavish attention. It is difficult to read such a passage without suspecting racial prejudice. In the case of Cobbett, Charles Kingsley, and Carlyle, this suspicion is justified. The attitudes of Ruskin and the other writers are more obscure. An exciting essay could be written on the device of comparing British worker and black slave and its significance for Victorian attitudes toward both.[25]

For the most part, Ruskin's defense of slavery focuses not on Negro slavery but on slavery in its pure sense of "compulsion." In this sense, it is an "*inherent, natural, and eternal inheritance* of a large portion of the human race." "The essential thing for all creatures," he writes, "is to be made to do right; how they are made to do it—by pleasant promises . . . or the whip—is comparatively immaterial." Ruskin returns often to the master-servant relationship as the model for social reconstruction. Most English laborers would be happier and healthier as servants under good masters, like the "most appealing" characters in Dickens and Scott, like Carlyle's Gurth, and like the servants of Denmark Hill, the Ruskin family seat after 1842. Ruskin also draws on the military metaphor. He responds to Carlyle's calls for industrial regimentation and proclaims himself a "violent Illiberal." These themes are not as prominent in Ruskin's writings as in Carlyle's; nor does Ruskin suggest that "mights" are more important than "rights" or launch into eulogies of Prussian militarism. A

concern for other, more interesting problems keeps him from following Carlyle to the brink.[26]

The strain of authoritarianism is not confined to Ruskin and Carlyle. Sir Walter Scott rides with the local militia to put down rioters and Southey calls for restrictions on the press. In a less impetuous way, Robert Owen adopts an authoritarian approach to social problems. In his experimental communities, the "wise bee" refuses to allow democratic control. He works to substitute habits of regularity and temperance for those of "distrust, disorder, dissension." One of the most common phrases in Owen's repetitive writings is "provided for them." A similar tone of paternalistic authority colors the writings of the Christian Socialists. Kingsley can plead the virtues of "drill" and coercion in terms worthy of Carlyle.[27]

Although Matthew Arnold rejects paternalism, he, too, sides with the forces of order. He derides the officer who failed to shoot down Hyde Park rioters at the time of the second Reform Bill and declares, "For my part, I do not object, whenever I see disorder, to see coercion applied to it." In *Culture and Anarchy* (1869), he lays down the proposition that "the framework . . . of the State, whoever may administer the State, is sacred." All anarchy must be suppressed. Arnold is not the most vigorous asserter of authority in the Victorian period. James Fitzjames Stephen, who makes the historical necessity of force one of the counters in his critique of Mill, comes immediately to mind. So do those from Tennyson to John Tyndall who support Carlyle and Ruskin in their defense of Governor Eyre. Indeed, the more one reads in the Victorians, the more one realizes that Mill's open-minded, apparently middle-of-the-road approach to problems is misleading when one tries to locate him in the spectrum of Victorian concerns. His unwavering insistence upon individual liberty places him at some remove from the center of Victorian attitudes. Even the classical economists, whose emphasis on liberty is the crux of their difference with Ruskin, should not be placed too near the center of Victorian opinion.[28]

<div style="text-align:center">7</div>

Denmark Hill and Ruskin's relationship with his parents play a major role in explaining his authoritarianism and also his organicism of the surface. As suggested, Ruskin's attack on English society is a way of relieving tensions in his relationship with his parents. It is a way of expressing long subdued rebellious or hostile feelings. Ruskin's social criticism is, among other things, a covert attack on his

parents and on that part of himself shaped in their pattern. His mother and father could be identified with the social order, for, in spite of the paternalism of their home and their romantic longing for the times described by Scott, they adhered to such Victorian principles as *laissez faire*. Ruskin's merchant father embodied symbolically many of the things Ruskin attacks. The failures of English society act as a lightning rod for a "subdued fury" which has its source in the "troubled currents" of Ruskin's relationship with his parents. Their "love . . . was cruelly hurtful without knowing it." Similarly, his endorsement of the worker's desire for a better life and his discovery of Veronese and Titian are partly an affirmation of the stirrings of his own spontaneous, instinctual, but irrevocably "lower" self against the authoritarianism of his home environment. The revolution of which Ruskin writes so wildly and ambiguously is his own.[29]

This is one side of the coin of Ruskin's ambivalence. While rebelling against his parents' authority, Ruskin clings to a paternalistic, authoritarian conception of the ideal society. He condemns English society because it does not mirror the organic, painfully symbiotic relationships to be found in his family. All of Ruskin's efforts at constructive suggestion end in some form of benevolent but unyielding paternalism. They end at Denmark Hill, the model "paternal government" in which each person has his assigned function. The "best" people, Ruskin's parents, give John and the servants "protection and education in childhood, help or punishment in middle life, reward or relief, if needed, in old age." This vain clinging to an organic but hopelessly damaged ideal of family relationships is crucial. It lies behind Ruskin's static organicism. He distrusts change and hesitates to admit positive growth because, in the relationship most important to him, change is decay. And so, in a broader sphere, Ruskin views social reform as a means of curing the cancer of waste and ugliness, of preventing further disintegration, and of *restoring* society to a condition of health or "purity," not unlike Denmark Hill in better days. Social reform is literally a regaining, recovering, or reclaiming. Ruskin thinks of the good society in static terms as a fully developed, perfected organism embodying absolute and immutable values, not as an organic *process* of growth and discovery in which men's ideals—their conception, for example, of what constitutes quality in life—are continually changing. This is the source of his belief that political authority must "enforce," not "represent" or express, the cooperation of men in society.[30]

An understanding of the importance which paternalistic and static-

ally organic modes of relationship have for Ruskin makes it easier to perceive the element of fantasy in his famous experiment, the Guild of St. George. "The object of the Society," Ruskin writes,

is to buy land in England; and thereon to train into the healthiest and most refined life possible, as many Englishmen, Englishwomen, and English children, as the land we possess can maintain in comfort; to establish, for them and their descendants, a national store of continually augmenting wealth; and to organize the government of the persons, and administration of the properties, under laws which shall be just to all. . . . (28.421)

This sounds fairly reasonable, but, as Ruskin's proposals for the Guild unfold in the 1870's, its neurotic edge becomes evident. It is to be organized on a medieval pattern with a "master," Ruskin himself, and "Companions" or "Retainers" of various sorts. Elaborate heraldry, a special coinage, and dress regulations for each class are featured. All authority is vested in the "Master," who will have under him "Marshals" to maintain discipline and care for the poor. The words obedience, order, and reverence form a constant refrain in Ruskin's descriptions of the project. His prose becomes ordered and mannered. The sentences are "marshalled" in even ranks like soldiers. The military metaphor becomes a reality when he proposes to select veteran soldiers as his commandants and to organize his laborers in well drilled companies as "soldiers of the ploughshare." The most prestigious of these companies will be called the "Company of Mont Rose" after "the central mountain of the range between north and south Europe, which keeps the gift of the rain of heaven." But really after Ruskin's child love Rose La Touche. Needless to say, its task will be the "guiding of pure streams and rain to the places where they are needed."[31]

Ruskin pretends to dislike being master of the Guild of St. George: "And what am I, myself then, infirm and old, who take, or claim, leadership even of these lords? God forbid that I should claim it; it is thrust and compelled on me . . . utterly, in many things, to my shame." He describes himself as "vacillating, foolish . . . and blown about by storms of passion." He hopes that a true nobleman will come forth to lead the Guild, but it is doubtful that Ruskin would have yielded to him. As long as he took an interest in the Guild, he never allowed anyone to brook his intermittent authority. In one of the few portions of land which the Guild did acquire, he quelled an attempt to establish majority rule. It is doubtful whether Ruskin would have supported the Guild if it had not been peculiarly his—a

conflict-free sphere, where he could play out his paternalistic fantasies and persevere in old habits under the guise of adding to the Guild's Museum at Sheffield. The Guild is the social equivalent of the fantasy house which Ruskin, in the early 1860's, hoped to build on an Alpine meadow, four thousand feet up the Brezon, in order to escape his parents while at the same time recreating the environment of Denmark Hill. Ironically, the location lacked a source of water.[32]

By rationalizing and idealizing the authoritarianism of his home life in experiments like St. George's Guild, Ruskin is expressing his fear of the spontaneous impulses which inspire his attacks on English society. His reluctance to give the worker any freedom or power and his blindness to the role of extended suffrage in realizing the reforms he advocates reflect, at a deeper level, a fear and distrust of himself. Part of Ruskin's greatness lies in his awareness of this fear and the reason for it. After noting, in *Fors,* that he "obeyed word, or lifted finger, of father or mother, simply as a ship her helm; not only without idea of resistance, but receiving the direction as a part of my own life and force," he goes on to remark upon the "chief evil" of his upbringing:

My judgment of right and wrong, and powers of independent action, were left entirely undeveloped; because the bridle and blinkers were never taken off me. Children should have their times of being off duty, like soldiers; and when once the obedience, if required, is certain, the little creature should be very early put for periods of practice in complete command of itself; set on the barebacked horse of its own will, and left to break it by its own strength. But the ceaseless authority exercised over my youth left me, when cast out at last into the world, unable for some time to do more than drift with its elements. My present courses of life are indeed not altogether of that compliant nature; but are, perhaps, more unaccommodating than they need be, in the insolence of reaction. . . . (28.351-352)

The metaphor of the horse is the one Freud uses to describe the "Id." Ruskin's distrust of the horse explains his unwillingness to accept freedom and the spontaneous growth it implies.[33]

Can this interpretation of Ruskin's authoritarianism bear wider application? Certainly, the vision of Ruskin as torn between "expansive," even rebellious urges and a strong fear of these urges provides a key to the ambiguities in Carlyle's thought. Like Ruskin, Carlyle supports the aspirations of the lower classes but refuses to give them any real power. Like Ruskin, he shifts dramatically between predictions of a justifiably violent revolution and shrill calls for the forces

of order to suppress chaos. That Carlyle identifies the stirrings of the "mob" with the eruption of his own instinctual energies is suggested by the similar adjectives he chooses for the "abyss" of the unconscious and the new social forces. It is easier to draw this connection in Carlyle than in Ruskin. He describes the "daemonic" unconscious and the lower orders of society as "giants" struggling to be free, the "devil" whom it is man's duty to keep bound, "anarchy" bursting up "from the infinite Deep," and, in aquatic terms, "black deluges" or "mud oceans" overwhelming the barriers of authority. In *The French Revolution* (1837), mobs are driven by primitive, almost personified human instincts—Hunger, Thirst, or Hatred. To discover an identification of "daemonic" urges and social revolution in Ruskin's writing, one must turn to the tortured pages of his *Diaries.* In 1873, he describes a dream in which he is running to escape an angry mob. He cannot run fast enough and is caught—by a torrent of water. Suddenly, a half-naked, disheveled woman puts in a mysterious appearance.[34]

One fails to find so explicit a linking of the forces of personal and social "expansion" in the writings of other Victorians. One suspects, however, that this connection lies behind Matthew Arnold's ambivalent view of the "modern movement." Earlier in the century, a similar tension marks the work of Coleridge, Wordsworth, and Southey, whose criticisms of society, on the one hand, and denunciations of "Jacobinism," on the other, suggest a level of meaning beneath the obvious. The validity of this interpretation remains to be tested by detailed studies of the writers mentioned and others like Charles Kingsley, whose cruder combination of revolutionary rhetoric and appeal to authority might provide an excellent way into the problem. If the way is not obstructed by individual variations, one might carry the search for parallels among Victorian critics into the realm of family relationships. Of course, a pattern of "revolutionary reaction" may spring as much from their position as members of a middle class trying to secure its power and, at the same time, watching warily the rise of the working class as from more personal conditions.

8

Torn between "the barebacked horse of his own will" and "the insolence of reaction," Ruskin realizes the futility of authoritarianism. He turns to the familiar task of moral reform. "Note, finally," he writes in *Unto This Last,* "that all effectual advance-

ment . . . must be by individual, not public effort." Ruskin has little faith in institutional reform. He paraphrases Pope's famous couplet: "No form of government is of any use among bad men; and any form will work in the hands of good." Like Marx, Ruskin holds political processes in "supreme contempt." Unlike Marx, he shows no interest in overthrowing the structure of society by other means. Although Ruskin admits that moral improvement will be possible only when economic relations have been transformed, he fears drastic changes in the social structure just as he fears the eruption of spontaneous impulses. His emphasis on personal reform inspires a cautious approach to social change: "The laws which at present regulate the possession of wealth are unjust . . . but no socialism can effect their abrogation, unless it can abrogate also covetousness and pride, which it is by no means yet in the way of doing."[35]

A return to the reassuring ground of moral reform is common with Victorians. They find it difficult to synthesize, as Blake does, institutional revolution and "mental warfare." They cannot envision both the new city of Jerusalem and the "New Spiritual birth" of those who will inhabit her. The theme stressed by Carlyle after the dust has settled from the rising of the Phoenix or the tread of the Hero is the futility of institutional change, Morrison's Pills. "Reform one man— reform thy own inner man; it is more than scheming for a nation." Carlyle's attitude leads to the kind of ineffectual appeal to sympathy and kindness evident in Dickens' or Lord Shaftesbury's solution to the social problem. The classic case is that of the Christian Socialists, who, like Dickens, were influenced by Carlyle. On April 11, 1848, Charles Kingsley posted a placard throughout London:

The Charter is not bad, if the men who use it are not bad. But will the Charter make you free? Will it free you from the slavery of ten-pound bribes? Slavery to gin and beer? Slavery to everyone who . . . stirs up bitterness and headlong rage in you? That, I guess, is real slavery: to be a slave to one's own stomach, one's own pocket, one's own temper. Will the Charter cure that? Friends, you want more than Acts of Parliament can give.

Twenty years later, one finds Ruskin persuading his "working-men friends" in *Time and Tide* that the important legislation a man enforces upon himself. "No political constitution can ennoble knaves; no privileges can assist them. . . ." Ruskin repeats the theme of a letter written in 1845: "It is not the love of *fresco* that we want . . . it is a total change of character."[36]

Matthew Arnold's doctrine of "culture" and his emphasis on the critic's "disinterestedness" provide a similar, though less blatant, escape from the problems of institutional change. "To act is easy," Arnold asserts, "to think is hard." To reform society, we do not need legislation or campaigns but culture, which works inwardly in the realm of the spirit. Arnold himself cannot be faulted for ignoring the demands of practical reform. His theoretical disparagement of action offered him, perhaps, a welcome relief from his ambivalence toward the "modern movement."[37]

Ruskin, Carlyle, and Arnold were encouraged to seek out the refuge of moral reform by the experience of the Romantic poets. Coleridge, Wordsworth, and Southey each find in appeals for moral regeneration or intellectual enlightenment a way to criticize social wrongs without threatening social order. They avoid the isolation of their previous radicalism. "Let us become a better people," Coleridge writes, and all constitutional questions will sink into the background. As if to confirm the relationship between moral reform and an acceptance of the structure of society, the poets address their appeals to the upper classes.[38]

It was the influence of Coleridge, Wordsworth, or even Carlyle which convinced John Stuart Mill that individual reform is the basis of social progress. Mill criticizes Bentham for stressing "outward good actions" and institutional manipulation at the expense of inner, personal reform. He believes that institutional changes are preceded by changes in "modes" of thought and feeling and that "it is possible to do mischief by striving for a larger measure of political reform than the national mind is ripe for. . . . " Emancipation from the evils of a competitive economy will come through "education, habit, and the cultivation of the sentiments." Mill's chief reservation concerning socialism is identical to Ruskin's, although phrased in more sympathetic terms. Man is not ready for socialism and can be made so only "by a system of culture prolonged through successive generations." The word "culture" reminds one of Matthew Arnold. Mill does resemble Carlyle, Arnold, and Ruskin in permitting a concern for individual reform to turn his attention from political or institutional action. He opposes the extension of government authority because it destroys the initiative necessary to the moral development of citizens. It renders them parasitic and dependent. Although Ruskin has little fear of "administrative machinery," his interest in moral reform places him closer to Mill than he would ever have acknowledged.[39]

One would be wrong to assume that an emphasis on moral reform is confined to Romantics or those obviously influenced by Romantic attitudes. Robert Owen and the majority of his followers eschew violent change. The millennium will arrive when both upper and lower classes have undergone a moral conversion. Owen's belief in rational or moral persuasion blunts the revolutionary thrust of his movement. In an "Address to the Working Classes" (1819), he urges workers not to be hostile to the rich, who should retain their wealth as long as they can hold it in estimation. The tone of his address is not much different from that of Kingsley's extraordinary placard. Behind Owen's insistence on rational persuasion and distrust of institutional change, one can detect the figure of William Godwin. Godwin's faith in the power of "opinion" is at work, in a disguised form, in the moral concern of Coleridge, Southey, and Wordsworth. Each of the poets passed through a Godwinian phase in the 1790's. As for John Stuart Mill, one might say that his contact with the Romantic movement led him to re-emphasize the Godwinian faith in rational and moral persuasion which had always been a part of Utilitarianism. The drawing of these connections is not as unreasonable as it might appear. Unlike his disciple Shelley and unlike Owen, Godwin insists on the need for slow, gradual change in a way which reminds one of the thinker often counted his opposite—Edmund Burke.[40]

It is, perhaps, unjust to imply that moral reform is a retreat from the demands of practical, institutional change. This judgment springs from hindsight, not from a reading of the authors' intentions. Southey and Kingsley are convinced that moral reform is "real and radical" reform and that the Bible is the true "*Radical Reformer's Guide.*" The same holds for Ruskin. In no way can he be considered a deliberate reactionary. Only seldom does he allow his emphasis on the moral *use* of wealth or power to obscure his diagnosis of the immoral basis of social arrangements. Although his call for a changed humanity is less threatening to the privileged and more palatable to comfortable reformers who wish to remain comfortable, it is, if taken seriously, a form of radicalism deeper than any call for the destruction of the "system." Ruskin had to reject his Evangelical heritage and adopt a Blakean view of human dignity before he could believe society capable of improvement. Who can say today that he was wrong—that a welfare state brought about by force, wartime accident, or bureaucratic expansion is superior to one created willingly by men whose natures have been changed?[41]

9

The best way to change human nature, Ruskin believes, is by education. With Coleridge and John Stuart Mill, he views education as the secure path to a better social order. Ruskin's ideas on the subject are not to be found in any one of his books. In a sense, all of his writing is concerned with education, whether of children, workingmen, capitalists, landlords, or consumers. Children are the most important. It is they he wishes to free from the competitive "system of iniquity" and prepare for a life of peace and abundance. Ruskin's criticisms of educational method and his constructive suggestions are framed with social goals in mind.

Ruskin's conviction that only moral reform can save England from the fate of Venice shapes his vision of education. "You do not educate a man by telling him what he knew not, but by making him what he was not." Education, like art and economics, is a moral endeavor dependent on the emotions. It is a question not of knowing but of being. Ruskin directs many aphorisms against the modern error of "mistaking erudition for education" and of depriving intelligent men of moral perspective. He opposes the common belief that the goal of education is success in life or "getting on." "You do not learn that you may live—you live that you may learn." True education is, itself, advancement in life. Writing from Verona in 1869, Ruskin compares education to his projects for harnessing the Alpine rivers and, by implication, to his plans for managing the flow of wealth. Human nature is a torrent: ". . . left to gain full strength in wantonness and rage, no power can any more redeem it; but watch the channels of every early impulse and fence *them,* and your torrent becomes the gentlest and most blessing of servants." The second task of the Company of Mont Rose is education.[42]

From the Platonic meaning of education as "leading human souls to what is best," Ruskin deduces four criticisms of contemporary practice. They reveal the close connection between his view of education and his hopes for moral and social reconstruction. First, he opposes competitive examination. Recalling the "deadly agony" of his examination days, he complains of "the mischief done to the best faculties of the brain" by the strain and anxiety of competition. Frequent examinations make children hate schooling. They should be few in number and graded on a "high pass standard in all skills or knowledge required." They should acquaint the student with his own

progress and "relative capacity," not provide an "arena" for victory.[43]

Examinations are one aspect of the competitive spirit in its academic guise. Ruskin also condemns prizes and awards for encouraging "envious or anxious effort." Since emulation is a false motive, teachers should never foster feelings of superiority and inferiority: "Every child should be measured by its own standard . . . by competition he may paralyze or pervert his faculties, but cannot stretch them a line." Ruskin especially criticizes Robert Lowe's system of payment by results. It rewards competitive cramming and places undue emphasis on the mechanical acquisition of knowledge at the expense of physical and intellectual health. The "madness of the modern cram and examination system" owes much to the "radical block-headism of supposing that all men are naturally equal, and can only make their way by elbowing. . . ." Competition in education is a reflection of competition in society. In both, it leads to waste. Instead of reinforcing competitive behavior, education should prepare men for life in an abundant society where competition for a limited supply of goods and services will no longer be necessary.[44]

Ruskin's criticism of competitive examination, rank, and prize places him among the innovators in education. Most reformers were too busy abolishing corporal punishment to concern themselves with the evils of less physical but still external forms of incentive. Many substituted complicated systems of reward and rank for the traditional methods of corporal punishment. Robert Raikes (1735-1811), the founder of Sunday Schools, and the Hills of Hazelwood School carried this to such an extreme as to make Mandeville's assertion that education is based on envy seem a gross understatement. Few English writers before Ruskin realize that appeals to emulation have as harmful an effect as corporal punishment. Most prominent are the Co-operators Robert Owen, William Thompson, and E. T. Craig. They wish to do away with praise or blame and rely on kindness and the "natural" rewards and punishments which follow from a course of action. Other less well-known opponents of competitive examination and the system of merits include Samuel Wilderspin (1792-1866), John Lalor (1814-1856), Arthur Helps, and Barbara Bodichon (1827-1891). Ruskin was familiar with the writings of Lalor and Helps. It is James Simpson, however, who anticipates the wholeness of Ruskin's vision. In evidence to the Select Committee on Education in 1835, the radical Scottish educationalist warns that merit

systems encourage a selfish "propensity to accumulate property." Ruskin draws the connection between academic competition and commercial accumulation in terms which reach a wider audience.[45]

Ruskin's second criticism of contemporary education concerns the teaching of the three *R*'s. In St. George's Guild, the imaginary testing ground of his educational ideas, scholars are to be educated "not at all, necessarily, in either arithmetic, writing, or reading." In 1872, this paradoxical assertion was justified. By the English Education Code of 1870 and the Scottish of 1872, the three *R*'s were all the education sanctioned and financed by the state. As his editors note, Ruskin does not object to children being taught reading, writing, and arithmetic if they desire to learn. But there are other things more important—manual skill, health, study of nature, appreciation of art and music, and, above all, moral development. The true "compulsory education," he writes in 1869, "is not teaching the youth of England the shapes of letters and the tricks of numbers; and then leaving them to turn their arithmetic to roguery, and their literature to lust. It is, on the contrary, training them into the perfect exercise . . . of their bodies and souls." The point of many of Ruskin's descriptions of idyllic peasant life is that illiteracy and lack of education are not synonymous.[46]

Ruskin's disparagement of the three *R*'s has greater significance than this appeal to morality and primitive simplicity might suggest. It reflects his belief that the usual education appeals to too few of the child's senses and fosters a precocious verbalism which destroys the imagination. Ruskin wishes the child to grasp the idea or "feel" of objects through direct experience of his environment and not memorize names, words, and numbers. He would abolish mechanical exercises in grammar and teach the "human" use of language. The distinctive characteristic of Ruskin's own teaching efforts, from the Coniston grammar school to Oxford University, is his use of numerous and varied visual aids to stimulate his students' interest in things "as they truly are." Ruskin hopes to raise a generation of citizens who, like Carlyle's hero, will "see" through the "masked words" of politics and economics and understand the nature of man and society.[47]

Ruskin's dislike of cramming and his desire to elicit the student's interest lie behind his third criticism of educational method, his criticism of the lecture system. Acquiring information by lecture, he writes in the second volume of *Deucalion* (1880), is comparable to

eating meat without tasting it in the fashion of a boa constrictor: "That's the exact way you expect your poor modern student to hitch himself on to *his* meat, catching and notching his teeth into it and dragging the skin of him tight over it. . . . " Ruskin deplores the passive, nonparticipatory character of learning by lectures:

I find the desire of audiences to be *audiences only* becoming an entirely pestilent character of the age. Everybody wants to hear—nobody to read—nobody to think; . . . to get the knowledge it has cost a man half of his life to gather, first sweetened up to make it palatable, and then kneaded into the smallest possible pills—and to swallow it homopathically and be wise—this is the passionate desire of the multitude of the day. (34.517)

From the teacher's point of view, lectures are an "abominable vanity," an extension of the invidious quality of commercial life into the classroom. Ruskin knew whereof he spoke. A great showman, he was susceptible to an audience's adulation and tended in his later years at Oxford to substitute the "fire-worky, smooth-downy-curry and strawberry-ice and milk-punch-altogether" lecture which he detested for the well-prepared one demanded by the situation. The personal dimension of Ruskin's criticism does not detract from its acuteness. His distrust of the passiveness of lecture learning and his relation of the lecture method to the competitive quality of commercial life seem farsighted today when the cracks in the lecture system are becoming evident.[48]

That perceptive follower of Rousseau, David Williams (1738-1816), is, perhaps, the first educationalist to launch an attack, if not on the lecture system, at least on the traditional dignity and authority of the teacher. In his most exciting experiment, Williams became a member of the student group, exercising subtle leadership by changing the group from within. In spite of his emphasis on authority, Ruskin tried this in small classes at the Working Men's College and in his unofficial association with the Winnington School for Girls and the Coniston grammar school. Ruskin goes beyond Williams. He criticizes university as well as elementary education and relates the assumed authority and prestige of the lecturer to the selfish tone of a competitive society.[49]

Ruskin's call for cooperation in the classroom between teacher and student finds a parallel in his view of the relationship between subjects in the curriculum. His fourth and final criticism of educational method concerns the organization of the curriculum. In *Unto This*

Last, he proposed that economics be studied in conjunction with other social sciences. Now, in the seventies and eighties, he refuses to abide by the traditional separation of subjects in the classroom and adopts what has come to be called the method of "correlation" or "integration." Ruskin's organic approach leads him to integrate art, natural science, history, geography, and economics. His ideas were drawn in part from his experience at the Working Men's College where an effort was made by the leaders Maurice and Ludlow to relate subjects on the basis of religion. Art forms the basis of Ruskin's correlations:

Geography . . . ought to introduce drawing maps and shapes of mountains. Botany, shapes of leaves. History, shapes of domestic utensils, etc. I think I could teach a boy to draw without setting *any* time *apart* for drawing, and I would make him at the same time learn everything else quicker by putting the graphic element into other studies. (36.160)

Ruskin's tendency as Slade Professor to ignore sharply defined disciplines and trespass upon other fields irritated his colleagues. Ruskin opposed the increasing specialization in universities. For him, as for Newman, the university is "a place where the character is to be formed which shall make Life graceful and honourable." Its object is general education in the "art of life," not vocational training.[50]

To concentrate on Ruskin's critique of educational method is to ignore a wealth of constructive detail. Still, it is in his general criticisms that one sees most clearly the social reference of his thinking on education. His rejection of competitive examination, cramming, the lecture system, and specialization are the educational reflection, so to speak, of his opposition to economic competition, accumulation, mechanism, and the division of labor. To remedy these evils, Ruskin turns increasingly to education, for it is here that men's values and modes of perception are shaped in a way which will lead them to perpetuate or to end social waste and exploitation.

Ruskin is aware of the prominent place occupied by education in his approach to social reform. "There is only one cure of public distress," he writes, "and that is a public education, directed to make men thoughtful, merciful, and just." Ruskin takes a more positive view of the role of education than his strictures on the formation of character and his criticisms of pedagogical practice suggest. Just as he criticizes the competitive "anomia" of present society and present education, so he would use a reformed education to "organize" society. The creation of a well-composed society, not the production of

prize individuals, is Ruskin's goal. "Moral education consists in making the creature practically serviceable to other creatures." It should encourage men "to mend themselves and the existing state of things, as far as either are marred or mendable." It should inspire "habits of gentleness and justice" by exercising youths in offices of "practical help" and acquainting them with distress. Ruskin's experiment in road building at Hincksey (1874) and his bizarre street sweeping efforts were intended to instill a social conscience. He urges his students to spend their spare time in useful, noncompetitive work so that they will understand the tragic division between hand-labor and mind-labor. To overcome this division, he hopes that all children, rich and poor, will be taught a manual skill. For Ruskin as for John Dewey, education is an instrument of social innovation.[51]

Ruskin's vision of a socially oriented education is not new. Robert Owen, Thomas Arnold, and the Christian Socialists encourage students to assist their fellows and reform society. Ruskin is more original than they when it comes to the content of an education which would make men "beneficent and effective in the world." It would include a "vital" political economy and not the orthodox political economy which Malthus and William Ellis of the Birkbeck Schools wished to teach the lower classes. It would also include politics in the Greek sense—"the science of the relations and duties of men to each other." In his letter to the *Times* (1852), Ruskin admits that this science is still in its infancy but defines its scope:

It implies, in its full sense, the knowledge of the operations of the virtues and vices of men upon themselves and society; the understanding of the ranks and offices of their intellectual and bodily powers in their various adaptations to art, science, and industry; the understanding of the proper offices of art, science, and labour themselves, as well as the foundations of jurisprudence, and broad principles of commerce; all this being coupled with practical knowledge of the present state and wants of mankind. (11.260)

Ruskin's "politics" reminds one of John Stuart Mill's "sociology."[52]

To understand "politics," one must have a knowledge of history. Ruskin's calls for historical study of the common people and "the influence of art on the human mind" are only one aspect of his interest in reforming historiography. Elsewhere, he deplores the emphasis on ancient history. He urges study of the medieval and modern periods as a way of understanding the problems of the nineteenth century. He would broaden the scope of history to include "all that influences the acts of mankind." Ruskin does not mean universal

history in the German sense, social history in the manner of Voltaire or Macaulay, or even national history in the fashion of Michelet. Instead, he urges detailed studies of small societies, villages, or families in the manner of Marc Bloch. Like Bloch, he considers archaeology a major tool in the study of local cultures. He believes it more important for a historian to have a knowledge of the manufactured products of a city than to be acquainted with the whims of the governing faction. After local research has been done, it is the task of the historian as "poet" to narrate the course of events in a way which will inspire the student to understand the "politics" of his own time and "reorganize" his own society.[53]

It is unfortunate that Ruskin never followed his perceptive advice to historians. He was, perhaps, too busy describing the kind of society which the product of a socially and historically oriented education would want to create. The next chapter will draw the outlines of this society.

X Public Thing

Of all the adjectives used to describe Ruskin, "sentimental" and "impractical" have stuck the longest. Ruskin's reaction to these epithets seemed to confirm their validity. After studying his proposals for institutional reform, one must conclude that, if Ruskin is sentimental and impractical, most forms of modern political and social organization are the same. For Ruskin outlines the shape of things to come more clearly than any other English thinker of the nineteenth century. It is difficult to convey the excitement of Ruskin's proposals. A description of them is bound to yield the scent of present reality. The reader is overly familiar with the bureaucratic and legal outlines of the welfare state. He must bear in mind that, as originally proposed, the formal extension of the "public thing" was to be accompanied by an "extension of life" and by the education of a new man of love and public spirit. The institutions without the spirit would be mere machinery—the shell of a dying organism. Ruskin believed there was a different path to the future. His concern for the quality or "art" of life guides his discussion of the institutional framework of the abundant society.[1]

2

The premise of Ruskin's proposals for institutional reform is a belief that the public sector of society must be given more emphasis than the private. Through the variety of his specific recommendations, this theme remains constant. In a quaint but crucial passage in Letter Seven of *Fors* (1871), he explains his purpose:

The second [law of "old Communism"] respects property, and it is that the public, or common, wealth, shall be more and statelier in all its substance than private or singular wealth; that is to say that . . . private dwellings . . . are to be very simple, and roughly put together . . . but the buildings for public or common service, more especially schools, almshouses, and workhouses, are to be externally of a majestic character, as being for noble purposes and charities; and in their interiors furnished with many luxuries for the poor and sick. And, finally and chiefly, it is an absolute law of old Communism that the fortunes of private persons should be small, and of little account in the State; but the common treasure of the whole nation should be of superb and precious things in

redundant quantity, as pictures, statues, precious books;... and vast spaces of land for culture, exercise, and garden, round the cities, full of flowers, which, being everybody's property, nobody could gather; and of birds which, being everybody's property, nobody could shoot. And, in a word, that instead of a common poverty, or national debt, which every poor person in the nation is taxed annually to fulfil his part of, there should be a common wealth, or national reverse of debt, consisting of pleasant things, which every poor person in the nation should be summoned to receive his dole of, annually; and of pretty things, which every person capable of admiration, foreigners as well as natives, should unfeignedly admire, in an aesthetic, and not a covetous manner.... Remembering, also, that the commonalty or publicity depends for its goodness on the nature of the *thing* that is common... and when you cry, "Live the Republic," the question is mainly, what thing it is you wish to be publicly alive, and whether you are striving for a Common-Wealth, and Public-Thing; or ... for a Common-Illth, and Public-Nothing, or even Public-Less-than-nothing and Common Deficit. (27.120-122)

How easily Ruskin moves from the surface of the word "common-wealth," with its suggestion of Plato, More, Milton, and Hooker, to a metaphorical description of the welfare state and to so advanced a proposal as that of green belts! And how remarkably close his concept of "Common Illth" or "Public-Nothing" is to John Kenneth Galbraith's concept of "public squalor!" Ruskin's "Common-Wealth" or "Public-Thing" is synonymous with the "national store" of *Munera Pulveris.* Even the Guild of St. George takes on new significance as an attempt to lay the foundation for an enlarged public sector and to combat the waste of private enterprise. Ruskin deplores the common opinion that the public realm "must be always of that form and force in which we have been accustomed to see it;—that its abuses can never be less, nor its wisdom greater, nor its powers more numerous." He urges Englishmen to adopt a positive attitude toward public authority. In this, he resembles Matthew Arnold. Although their visions of the role of the state differ widely, Ruskin and Arnold are at one in their relatively unqualified and most un-Victorian acceptance of an enlarged public sphere. They bring Burke's or Coleridge's view of the state as "the nation in its collective and corporate character" to bear on the expansion of state activity after 1860.[2]

3

Ruskin's purpose in enlarging the public sector is to improve the quality of the worker's life. He hopes to direct the benefits of modern society toward the worker. The title and central theme of *Unto*

This Last reflects his belief that, in the composition of society, "The Least" is as important as "The Greatest." Both must be governed by the Law of Help, not the "laws" of political economy. He repeats his call for higher wages and secure tenure. In a letter to the *Pall Mall Gazette* (1867), he proposes a legally enforced living wage:

> Let any half-dozen of recognized London physicians state in precise terms the quantity and kind of food, and space of lodging, they consider approximately necessary for the healthy life of a labourer in any given manufacture. . . . And let all masters be bound to give their men a choice between an order for that quantity of food and lodging, or such wages as the market may offer for that number of hours' work. (17.473-474)

High wages are not enough. Ruskin returns again and again to the theme of "The Nature of Gothic"–the need for healthy, creative work. He hopes to minimize mechanical employments by persuading consumers "*to live with as little aid from the lower trades, as they can possibly contrive.*" "Let us remember," he writes,

> that every farthing we spend . . . has influence over men's minds and spirits, far more than over their bodies. By the purchase . . . of every cup out of which you drink, and every table off which you eat your bread, you are educating a mass of men in one way or another. . . . You are making them lead happy or unhappy lives. . . . (12.68)

Ruskin hopes to restrict the use of machinery. He would draw out the element of craft or skill and encourage the expression of "every grade of practical intelligence and productive imagination." No trade should be "entirely unconnected" with the "fine arts" of working in wood, clay, stone, and metal. Every man should do much of his own domestic work "to the extinction of a great deal of vulgar upholstery and other mean handicraft." Here Ruskin's educational and social proposals touch closely. Ruskin is among the first to urge public support of manual and vocational training. In the 1862 preface to *Unto This Last,* where he describes his version of the welfare state, he gives first place to a national program of free and compulsory educaton. While Dickens, for example, sees in comprehensive education an alternative or counterweight to the destructive rhythms of the machine, Ruskin sees in it a way to change those rhythms.[3]

Ruskin admits that some forms of necessary labor will remain degrading in spite of education and in spite of attempts to elevate them in the public mind. He mentions the "mechanical works of mining, forging, and the like: the unclean, noisome, or paltry manufactures– the various kinds of transport" and "*simply* or *totally* manual work.*"

He proposes, not without irony, that these be undertaken by religious persons as an exhibition of humility or by men of the upper classes seeking variety and physical exercise. More seriously, he would rely on the forced labor of convicts, idlers, and servile types who are "fit for nothing better." Ruskin rejects Mandeville's suggestion that the education of the lower classes be limited to prepare them for degrading work and make them content in "the monotony of their vulgar occupation." "Mind, I do not say that this is *not* the right state of things," he continues.

Only, if it be, you need not be so over-particular about the slave-trade, it seems to me. What is the use of arguing so pertinaciously that a black's skull will hold as much as a white's, when you are declaring in the same breath that a white's skull must not hold as much as it can, or it will be the worse for him? (17.403)

Ruskin condemns capitalists for having kept the worker ignorant and blind so that they might "gather for themselves the produce of his toil"[4]

Ruskin's position is well taken. In the early stages of the industrial revolution, the fear that education would make workers restless inspired many writers to place a special emphasis on Christianizing and moralizing the lower classes. There is little to choose between the educational proposals of Southey and Wordsworth and those of Wilberforce, Hannah More, or Malthus. Even Coleridge, Thomas Arnold, and Carlyle wished to impress upon the lower classes the duties of peaceful existence. In one passage, Coleridge declares that the purpose of education is to assist every individual in "the development of those faculties essential to his humanity as a rational and moral being." In another passage, he speaks of instilling into the lower orders "legality" and "civility." Ruskin's thinking reveals a similar inconsistency. On the one hand, he expects society to give "every human being due aid in the development of his faculties" and to place him, by means of "trial schools," in the occupation for which he is best fitted. On the other hand, he believes that education should enforce habits of obedience and agrees with Plato that crucial distinctions of class and function will remain fixed. Every man ought to be "*equally well educated*"—for his circumstances. The conflict within Ruskin's mind between morality as Evangelical respectability and morality as vital energy has a relevance beyond his personal uncertainty.[5]

Ruskin realizes that, before one can worry about the quality of work and education, one must see to it that all men have work to do.

Charity is a temporary remedy. What is really needed is full employment. Ruskin hopes that this will result from a consumer-oriented economy of high wages. For those presently unemployed, he follows Coleridge, Southey, and Malthus in proposing public works of a useful, not make-work, character. Besides the ubiquitous harnessing of rivers and draining of wastelands, he suggests road-making, improvement of harbors, construction of houses, manufacture of clothing for the poor, and art or craft projects. The willfully idle should be compelled to work by "conscription" since employment is "the primal half of education" and the only remedy for crime. From the introductory pages of *The Political Economy of Art* to the final pages of *Fors Clavigera,* he notes the absurdity of permitting unemployment while men are starving in a world of potential abundance. Ruskin's position indicates the similarity of welfare economics to a moralized and domesticized mercantilism. Bishop Berkeley and Sir James Steuart support a policy of full employment and public works. Their goal is not simply a better balance of trade. Coleridge and Southey were familiar with the work of Steuart. They act as intellectual mediators between mercantilism and Ruskin's vision of an economy of full employment.[6]

The need for food, clothing, and lodging is more urgent than the need for employment. The first goal of St. George's Guild and indeed of all public enterprise is the production and distribution of necessities so that "no famine shall any more be possible among civilized beings." Ruskin cannot understand why the Government does not provide for sustenance as well as for defense—for the conveyance of food as well as for the passage of armies. In Letter Seventy-five of *Fors* (1877), he proposes a commissariat under a salaried "doge," whose task is "to know how many mouths you have to feed, get that quantity good, and distribute it without letting middlemen steal the half of it." Until the men, women, and children under the commissariat's jurisdiction are fed and clothed, every man must bring what he earns to the common stock. The housing problem is equally serious. Its solution will involve more than the adoption of a national architecture. It will involve "a great deal of vigorous legislation, and cutting down of vested interests that stand in the way." It will mean "thorough sanitary and remedial action in the houses that we have; and then the building of more, strongly, beautifully, and in groups of limited extent, kept in proportion to their streams. . . ."[7]

In the well-organized, abundant society of the future, there will be no lack of food, housing, or employment. Still, some men will fall

into distress. Medical care must be given to the sick and pensions to the disabled and the aged. In an addendum to *The Political Economy of Art,* Ruskin proclaims a universal "right to public support." He regrets the common disparagement of parish relief, since a laborer serves the public no less than a soldier. In 1852, he pens a tentative description of cradle to grave social security. Although his vision is that of Denmark Hill on a national scale, Ruskin stands in the tradition of Paine, Owen, Southey, and Carlyle. They reject Malthus' belief that not all men born have a place at nature's feast and demand, with varying qualifications, the recognition of a right to assistance. Even John Stuart Mill affirms as indisputable the "principle of securing, by a legal provision, the actual necessaries of life and health to all who cannot otherwise obtain them." The difference between Mill and Ruskin lies in interpretation. Mill believes that the economic system is relatively sound. He would give relief only in extreme cases and supports the New Poor Law's principle of "less eligibility," which has the effect of forcing individuals to participate in the economy. Ruskin doubts that the vast body of workers can secure a decent living under the system of competition. He urges a more comprehensive program of relief and a corresponding extension of public control over education and employment.[8]

The question of security is but one side of Ruskin's attempt to improve the life of the worker. He insists on the need for "play" and "amusement" as well as food and work. From his discussion of the grotesque in *The Stones of Venice* through his encounter with the Public Institutions' Committee to his own play in the Guild of St. George, Ruskin demands shorter hours and intelligent recreation for workers. "Museums are less important than leisure to muse." In *Munera Pulveris,* he proposes eight hours with more rest included if the labor is destructive of life. He agrees with Sir Thomas More that the shortening of labor will have no effect on a nation's "plenty" if all men are usefully employed. To encourage relaxation after work, land must be cleared in cities for open spaces, footpaths, and gardens. National parks and wildlife refuges must be set aside from the waste of industry. This distinguishes Ruskin from Carlyle who urges the "conquering" or "settling" of natural areas in the fashion of a twentieth-century land developer. Ruskin was one of the major inspirations behind the Commons Preservation Society and the National Trust. "As the art of life is learned," he writes, "it will be found at last that all lovely things are also necessary;—the wild flower by the wayside, as well as the tended corn. . . ."[9]

Ruskin's most original idea is that of preserving green belts. He would disperse manufactures through the country away from the urban centers. In 1870, he explains why art does not thrive in England:

You must have lovely cities, crystallized, not coagulated, into form; limited in size, and not casting out the scum and scurf of them into an encircling eruption of shame, but girded each with its sacred pomoerium, and with garlands of gardens full of blossoming trees and softly guided streams. (20.113)

He hopes to surround every urban area with a "belt" of greenery "so that from any part of the city perfectly fresh air and grass, and sight of far horizon, might be reachable in a few minutes' walk." These natural circles would help purify air and water, prevent pollution, and halt the "dreadful mildew" of suburban expansion. The vision of an interpenetration of city and country figures in the writings of a long line of utopians from More and Bacon through Owen, Thompson, and James Silk Buckingham (1786-1855). Ruskin popularizes the idea towards the end of the nineteenth century.[10]

Ruskin also has much to say about institutions especially created for the worker's enjoyment or edification. In 1867, he describes three institutions necessary for a healthy working population. First, in winter, there should be warm, in summer, shady places, "where hard-worked people may rest for a little time when they need." Second, there should be public places of amusement, not to be confused with museums or art schools. The Crystal Palace confuses the purposes of education and amusement. A true place of amusement should be beautifully decorated and include good theater and music. The third and most important are "public educational collections"— libraries, museums of natural history, and museums of art. Compare the funds presently devoted to such "goods" in the national store with those lavished on the Woolwich Infant or sunk in cast-iron foliage! Ruskin's own urge to collect and preserve things, like the Alpine torrents, led him to devote a disproportionate amount of energy to planning a museum at Sheffield. His efforts were not irrelevant. The success of the National Gallery and the extension of libraries and museums owe much to his inspiration.[11]

Ruskin's list of public services and amenities is best summarized under four heads: the right to support, the right to education, the right to work, and the right to a certain quality of life. Although Ruskin does not state his proposals in this way, he views the enlargement of the public sector in terms of rights on the part of citizens and duties on the part of the state. These rights are not the rights of

the natural law tradition but the kind of "right" which Edmund Burke identifies with "need." In the area of "welfare," there is little difference between the two. Radicals who think in terms of natural right and traditionalists who speak of the needs of the lower classes and duties of the upper agree on what must be done. So do utilitarians who reject both tradition and natural right. No writer before Ruskin synthesizes so completely all aspects, quantitative and qualitative, of what has come to be known as the welfare state. Not one of his proposals is in itself original. Taken together, they form an original whole. Ruskin's vision of the welfare state meets his requirements of a living architecture. It infuses new life into borrowed materials and fashions them into an imaginatively conceived unity. Ruskin is best viewed as the Victorian who keeps before the public proposals which were usually discounted as impractical or utopian but which the assumption of abundance was to make increasingly realistic and the population explosion and destruction of the environment increasingly mandatory.

<div align="center">4</div>

Ruskin's proposals for improving the quality of the worker's life— free and compulsory education, minimum wage laws, old age pensions, public works, and medical care—involve a large extension of the formal structure of the "public thing." In *Time and Tide,* he notes that "the precise extent of authorities must be different in every nation at different times, and ought to be so, according to their circumstances and character." But he asserts with confidence a need for the following authorities:

I. An *observant* one:—by which all men shall be looked after and taken note of.

II. A *helpful* one, from which those who need help may get it.

III. A *prudential* one, which shall not let people dig in wrong places for coal, nor make railroads where they are not wanted. . . .

IV. A *martial* one, which will punish knaves and make idle persons work.

V. An *instructive* one, which shall tell everybody what it is their duty to know. . . .

VI. A *deliberate* and *decisive* one, which shall judge by law, and amend or make law.

VII. An *exemplary* one, which shall show what is loveliest in the art of life. (17.446-447)

Ruskin foresees a large extension of the Government's bureaucracy. In *Time and Tide,* he gives a partial list of the officers of his ideal state. The most important are those "charged with the direction

of public agency in matters of public utility" and the "bishops." The former are bureaucrats, managing public services and state industries. The latter are not really religious officials but "overseers," the original meaning of the word bishop.[12] Ruskin describes their function:

> The thing actually needing to be done is this—that over every hundred (more or less) of the families composing a Christian State, there should be appointed an overseer, or bishop, to render account, to the State, of the life of every individual in those families; and to have care both of their interest and conduct to such an extent as they may be willing to admit, or as their faults may justify; so that it may be impossible for any person, however humble, to suffer from unknown want, or live in unrecognized crime. . . . (17.378-379)

Ruskin's "bishops" remind one of Coleridge's "clerisy." The similarity is more than incidental. While the members of the "clerisy" study and teach, they also watch over and help the poor. They supply every parish with a resident "guide, guardian, and instructor." On occasion, Ruskin takes his religious terminology seriously and, like Coleridge, hopes for a genuine merging or coordination of Church and State. This would require the reunification of the English Church. In a quixotic essay entitled *Notes on the Construction of Sheepfolds* (1851), Ruskin finds his place in the Broad Church movement by suggesting a number of moderate conditions for reunification. Thomas Arnold assigns to a National Church the task of teaching, guiding, and caring for the poorer members of society. Though not a Broad Churchman, Southey studies the social role of the Church before the Reformation. He urges the establishment of Protestant "Sisters of Charity" or "Beguines," who would visit and watch over the poor. It is a short step to J. M. Ludlow's parochial fraternity, Ruskin's overseers, Octavia Hill's housing visitors, and Arnold Toynbee's settlement workers. A thorough study of the religious background of the welfare state should not stop at the level of ethical impetus. It should descend to bureaucratic technique as well.[13]

However archaic Ruskin's language and conception appear, his vision of an expanded, efficient bureaucracy would meet Thomas Carlyle's demands for a "reformed executive." Carlyle admits that his proposals are in harmony with those of the Utilitarians Jeremy Bentham and Edwin Chadwick and praises the New Poor Law of 1834 as a small step toward a centralized inspectorate. Ruskin seems unaware of contemporary political movements. He would have been horrified if someone had suggested that his list of government officials is similar to the one Bentham published in his *Constitutional Code* (1827). Like Bentham, Ruskin shows little of Dickens' or John

Stuart Mill's concern for the dangers of administrative "Gradgrindery." His use of archaic language and his selection of a traditional setting for the model of the welfare state cushion for himself and his readers the shock of his proposals. They also blind him to the less appealing and more dangerous aspects of an expanded bureaucracy—the "grayness" of the welfare state as it has been experienced by the twentieth century.[14]

Ruskin's enlargement of the public sector entails a vast increase in the extent and flexibility of the legal system. Ruskin has no reservations about this. The need for laws is even greater in the ship of state than in a ship at sea due to the "impossibility of discerning the effects of individual error." In *Munera Pulveris,* as earlier in *The Political Economy of Art,* Ruskin criticizes the Victorian view that law should be limited to punishment of crime and protection of property. He foreshadows T. H. Green (1836-1882) in urging an extension of positive law—"archic law" or law of precept. "There is a highly curious feeling in the English mind," he writes, "against educational law: we think no man's liberty should be interfered with till he has done irrevocable wrong. . . ." Law should be formatory as well as *re*formatory. In the case of "critic law"—that of "discernment and award"—Ruskin would place more emphasis on reward than on punishment, on encouraging merit than on marking demerit. He has none of the Utilitarian distrust of the efficacy of legal rewards. Work or action is a positive, enjoyable experience for Ruskin, not a negative, painful one. He can readily conceive of a legal system which relies more on the promise of reward to *en*able than on the threat of pain to *dis*able. Ruskin is not bound by a presumption in favor of *laissez faire.* His positive, creative conception of law, like Green's, is derived from Plato and Aristotle. From the vantage point of Greek philosophy, he views with equanimity the burgeoning of law required by the welfare state. His awareness of the importance of modes of perception convinces him that a change in the public's attitude toward law is needed if the "public thing" is to become a reality.[15]

The most interesting of Ruskin's extensions of the legal system concern "meristic law," law regulating tenure of property. He describes it as follows:

Every article of human wealth has certain conditions attached to its merited possession; when these are unobserved, possession becomes rapine. And the object of meristic law is not only to secure to every man his rightful share . . . but to enforce the due conditions of possession, as far as law may conveniently

reach; for instance, that land shall not be wantonly allowed to run to waste, that streams shall not be poisoned by the persons through whose properties they pass, nor air be rendered unwholesome beyond given limits. (17.239-240)

Ruskin does not intend to abolish private property. He does, how-ever, intend to hedge it in by legal restrictions which seem plausible in an age of environmental concern. "The owner of land," he writes in *Fors*, "is entirely responsible to the State for the generally bene-ficial management of his territory." Large landholders should be sub-ject to unusual "meristic" regulations. In *Time and Tide*, Ruskin suggests that they be granted a fixed salary from the state provided they derive no income from rents and keep part of their land in "conditions of natural grace." Also under meristic law fall laws regu-lating wages and conditions of work in industry and laws fixing the prices and quality of marketable goods. So do the restrictions Ruskin proposes to set on interest, rents, and profits. Taxes, too, are a form of meristic statute. To support the fabric of the welfare state, he advocates steeply graduated income and property taxes in the man-ner of Paine. He agrees with Coleridge that taxation is a health-giving dew assisting the "flow" of wealth. Ruskin proposes as a matter of conscious policy meristic restrictions which were adopted only dur-ing the emergencies of two World Wars.[16]

Behind Ruskin's discussion of meristic law lies the assumption that property is the creature of society. The right to it is not absolute but conditional. The denial of an absolute right to property has its mod-ern origins in the radicalism of the French Revolution. Ruskin's posi-tion is closer to that of Coleridge, Carlyle, and Matthew Arnold: society is an organic whole in which individual rights are subordinate to the needs of the larger unit. "Every English Canal Bill," Coleridge writes, "proves that there is no species of property which the legisla-ture does not possess . . . the right of controlling . . . as soon as the right of the individuals is shown to be disproportionately injurious to the community." Arnold puts it more bluntly. He describes property as a "phantom of law." There is little to choose between Arnold's attitude and John Stuart Mill's. For Mill, as for the Saint-Simonians, the right to property is governed by expediencey. It depends "upon the estimate made of its conduciveness to the general welfare." Mill was one of the founders of the Land Tenure Reform Association (1871), which urged the restriction of property rights, heavy taxa-tion of unearned increment, and public control of wastelands. Ruskin differs from Mill and Arnold. He applies his irreverent atti-

tude to industrial as well as to landed property. He carries out the full implication of Coleridge's "no species of property" and includes under the heading of meristic law many industrial regulations.[17]

The enforcement of meristic law and the expansion of public authority will require information about the public. The information explosion is not an accidental concomitant of big government. It is foreseen and even desired by Ruskin. If the "overseer" is to watch over his flock and lay down meristic regulations, he must be able, with the help of deacons, to "get some account" of every one of his charges:

Overseers shall be not only the pastors, but the biographers, of their people; a written statement of the principal events in the life of each family being annually required to be rendered by them to a superior State Officer. These records, laid up in public offices, would soon furnish indications of the families whom it would be advantageous to the nation to advance in position, or distinguish with honour . . . while the mere fact of permanent record being kept of every event of importance . . . would of itself be a deterrent from crime, and a stimulant to well-deserving conduct, far beyond mere punishment or reward. (17.379)

Censuses of wealth—who has got it, how they got it, how they are spending it—would be part of this information. Ruskin has none of the salutary fear of statistics which inspires Godwin and Hodgskin to complain that censuses reduce men to the level of beasts. Open records or "glass pockets," he believes, would prevent chicanery in commerce, forestall bankruptcies, and encourage responsible expenditure. He considers the income tax a useful instrument in this respect. Commercial records and personal biographies would also aid the historian who will write not of a nation's wars but of its households. This may be good for the historian, but Ruskin's vision seems strange. It reminds one of his desire "to draw all St. Mark's, and all this Verona stone by stone, to eat it all up into my mind, touch by touch." Ruskin's strangeness is frighteningly close to present reality.[18]

In less extreme forms, a desire for information is not unusual in an era of great commercial development. Sir William Petty (1623-1687) first attempts the systematic gathering of information. He urges the establishment of a "Registry of Lands, Commodities, and Inhabitants" to continue and expand his own efforts at "political arithmetic." Bishop Berkeley, Sir James Steuart, and Dugald Stewart follow suit. Berkeley hopes that public authorities will use the information

to combat poverty. This is the motive behind Southey's call for wage statistics and Owen's "Labour Bureau." Carlyle joins hands with Utilitarians in demanding information about the condition of England although he admits that the mesh of statistics cannot catch matters of "quality." Unlike Ruskin, he takes careful note of the efforts made by Parliamentary committees and commissions to gather information. Ruskin is aware of the blue books but uses them as grist for his mill of moral indignation, not as material for careful study. The reason lies in his conception of the type of data needed. He is less interested in industrial statistics than in the kind of private information which would encourage one to make a moral judgment on the lives of individuals. Of this information, he would find little in the Parliamentary reports. Ruskin is less the descendant of William Petty than of the early predecessor of the Charity Organization Society, Count Rumford (1753-1814), who ordered a house-by-house examination of the poor families of Munich. The Denmark Hill "syndrome" gives a personal quality of distortion to his vision of the welfare state.[19]

<p style="text-align:center">5</p>

Ruskin's pioneering description of the shape of things to come does not end with his outline of the bureaucratic, legal, and informational structure of the new state. It reaches into the controversial problem of marking the boundary of the public and private realms. As early as the 1860's, he proposes that the state enter the sphere of industry and transportation as an owner and describes with extraordinary accuracy the kind of relationship which exists between public and private enterprise in England today.

Ruskin's first discussion of this question occurs in an addendum to *The Political Economy of Art,* written in 1857. His proposal is as follows:

There ought to be government establishments for every trade, in which all youths who desired it should be received as apprentices on their leaving school; and men thrown out of work received at all times. At these government manufactories the discipline should be strict, and the wages steady . . . and the yearly surplus of commodities should be the principal means of government provisions for the poor. (16.112-113)

Ruskin's emphasis is on the remedial and educational function of public enterprise. In the 1862 preface to *Unto This Last,* he includes "manufactories and workshops for the production and sale of every

necessary of life" and touches on the relationship between public and private enterprise. He does not wish to interfere with the latter but intends to leave the private sector "to do its best" and "beat the government if they could." His purpose is still remedial. The unemployed will be retrained in government training schools and set to work at a fixed rate of wages. But now government enterprises will set standards of quality for the private sector: "There should, at these Government manufactories and shops, be authoritatively good and exemplary work done, and pure and true substance sold; so that a man could be sure, if he chose to pay the Government price, that he got for his money . . . work that was work."[20]

In *Munera Pulveris,* Ruskin suggests that public enterprise will be more efficient than private enterprise. We have no right to complain of the cost of government, he remarks, so long as we set it *"to do precisely the work which brings no return,"* that is, make war. If the principles of political economy are accurate, we should trust them entirely and "take the war business out of the government's hands." "Let our future sieges of Sebastopol be done by contract—no capture, no pay. . . ." "On the other hand," he continues,

if we have so much suspicion of our science that we dare not trust it on military business, would it not be but reasonable to try whether some authoritative handling may not prosper in matters utilitarian? If we were to set our governments to do useful things instead of mischievous, possibly even the apparatus itself might in time come to be less costly.

His conclusion is optimistic:

Suppose it should thus turn out . . . that a true government set to true work, instead of being a costly engine, was a paying one? that your government, rightly organized, instead of itself subsisting by an income-tax, would produce its subjects some subsistence in the shape of an income dividend? (17.251-253)

Finally, in letters to the *Daily Telegraph* (1868) on the subject of railroads, Ruskin arrives at his full vision of the scope of public enterprise. In *Munera Pulveris,* he has complained of the great waste caused by private railway management. If the money spent in local mistakes and decorating stations with black and blue bricks had been "laid out, instead, under proper government restraint, on really useful railroad work . . . we might have been carried in swift safety . . . for half the present fares."[21] Ruskin repeats this theme in the letters to the *Daily Telegraph* and insists further that railway dividends are a form of usury—an unjust tax on goods and people. The waste of private enterprise warrants more drastic action:

Neither the roads nor the railroads of any nation should belong to any private persons. All means of public transit should be provided at public expense . . . and the public should be its own "shareholder."

Neither road, nor railroad, nor canal should ever pay dividends to anybody. They should pay their working expenses, and no more. All dividends are simply a tax on the traveller and the goods, levied by the person to whom the road or canal belongs, for the right of passing over his property. And this right should at once be purchased by the nation, and the original cost of the roadway . . . at once defrayed by the nation, and then the whole work of the carriage of persons or goods done for ascertained prices, by salaried officers, as the carriage of letters is done now. (17.530-531)

The proprietors of railroads "would gladly receive back their original capital, and cede their right of 'revising' prices of railway tickets." At any rate,

Let the public take it. . . . Then let them examine what lines pay their working expenses and what lines do not, and boldly leave the unpaying embankments to be white over with sheep, like Roman camps, take up the working lines on sound principles, pay their drivers and pointsmen well . . . and make it as wonderful a thing for a train, as for an old mail coach, to be behind its time. . . . (17.531)

In a classic letter to the *Daily Telegraph* (1868), Ruskin goes beyond the problem of railroads to that of industry in general:

All enterprise, constantly and demonstrably profitable on ascertained conditions, should be made public enterprise, under Government administration and security; and the funds now innocently contributed, and too often far from innocently absorbed, in vain speculation . . . ought to be received by the Government, employed by it, not in casting guns, but in growing corn and feeding cattle, and the largest possible legitimate interest returned without risk to these small and variously occupied capitalists, who cannot look after their own money. (17.533)

It will be the duty of the overseer of each district to collect information respecting sources of public profit, to represent the circumstances in Parliament, and, then, "with Parliamentary authority, but on his sole personal responsibility," to see that the enterprises are conducted efficiently. Ruskin suggests roads, mines, canals, gasworks, and harbor protections.[22]

Ruskin does not intend to abolish the private sector:

"Private enterprise" should never be interfered with, but, on the contrary, much encouraged, so long as it is indeed "enterprise" (the exercise of individual ingenuity and audacity in new fields of true labour), and so long as it is indeed "private," paying its way at its own cost, and in no wise harmfully affecting public comforts or interests. (17.533)

The distinction between experimental frontiers of enterprise and utilities or basic industries, "constantly and demonstrably profitable," appears later in programs of the Labour Party.

When Ruskin is captured by the past, to use Wilenski's phrase, he reinterprets his distinction between private and public sectors in terms of the guild system proposed in *The Political Economy of Art.* These guilds are institutions in a future society and should not be confused with Ruskin's Guild of St. George, a specific attempt at providing employment and reclaiming wasteland. They perform in a more voluntary way the regulatory functions assigned to public authority. In each trade, a guild will fix prices and wages and set standards of quality and simplicity. Ruskin's discussion of guilds elucidates the manner in which he hopes public enterprises will be managed. He would make all retail dealers "merely salaried officers . . . of the trade guilds; the stewards, that is to say, of the saleable properties of those guilds, and purveyors of such and such articles to a given number of families." It will be a matter of honor, not profit, with the retailer to serve his customers. All improvements and inventions will be examined by the guild and, if accepted, will be announced quietly in public reports without advertising. All books will be open for inspection, and the prices of articles will be printed with the percentages to every person employed in their production. There will be guild schools where artists, artisans, and apprentices can learn from one another. Every worker will pass an exam, "crucial, not competitive," and be registered. When unemployed, he will rely on the guild to find him work or relief.[23]

Ruskin's treatment of a guild system sheds further light on the boundary between public and private enterprise. Guild restrictions apply to guild members. Since membership is voluntary, there will be ample opportunity for free enterprise—for "the rogue to puff and cheat as he chooses." If consumers wish to buy from those who have refused to join an honest society, they should be allowed to do so for two reasons:

first, that it is always necessary, in enacting strict law, to leave some safety valve for outlet of irrepressible vice . . . second, that operations of trade and manufacture conducted under, and guarded by, severe law, ought always to be subject to the stimulus of such erratic external ingenuity as cannot be tested by law. . . . (17.385-386)

Ruskin also permits free enterprise within each guild. For "warranted" articles, prices are set annually and wages fixed so as to

define the master's profits closely. For other articles, "whether by skill of applied handicraft or fineness of material above the standard of the guild . . . every firm should be left free to make its own independent efforts and arrangements with its workmen."[24]

Once the principle of an enlarged public or regulated sector is admitted, Ruskin is flexible regarding the practical organization of industry. As he notes in Letter Eighty-nine of *Fors* (1880), this will vary according to circumstance. Final decision must wait on a thorough investigation into the institutions and habits of a country. It seems likely that Ruskin would accept a form of "rationalized" or modified capitalism in the management of industry as well as outright public ownership. Indeed, he suggests in *Time and Tide* that cooperation between firms in one branch of industry might be arranged informally to prevent underselling and establish a "just" price. He proposes that bankers join, as they have since done, "a great national body, answerable as a society for all deposits." He also suggests that each firm might, out of its own profits, make provision for the unemployed, the sick, and the aged instead of relying on public programs. If the head of the firm paid sufficient and regular wages, Ruskin sees no reason why he should not be "permitted to retain to his own use the surplus profits of the business." Unwilling to give the worker real power or influence, Ruskin prefers this form of enlightened "mastership" to schemes of cooperative profit-sharing. He is more flexible in his ideas than many of the people whom he influenced, for he views institutional change as the superficial expression of moral change. If Ruskin had involved himself in a practical way with the difficulties of social reorganization, he might have come to a different conclusion. He might have discovered that moral change or change of outlook on a large scale is possible only through rigorous institutional reform.[25]

6

The flexibility of Ruskin's position on the public sector makes it difficult to determine the source of his ideas. He seems to have picked them up from the wide spectrum of nineteenth-century reform. Most likely he did not, if his references to Xenophon's proposals for the public management of the Attic silver mines and his interest in the medieval guilds of Florence are any indication. Nonetheless, Ruskin's ideas have an acute relevance to his own time. He

stands in the vanguard of those in the nineteenth century who seek alternatives to the competitive economy.

By proposing both public and voluntary forms of organization, Ruskin joins the two strands of thought which form the intellectual conception of the welfare state. His vision of a broad program of public services and public ownership places him in the company of "state socialists": Charles Dupont-White, Rodbertus, Lassalle, or, earlier, Fichte and Sismondi. *The Communist Manifesto* (1848) also should be mentioned. Although Marx and Engels deny the rubric "state socialist," the nationalization of banking and transport, the introduction of state factories, and the levying of a heavy progressive income tax are among the goals which they set for the proletariat in the period before the state withers away. Similar programs were adopted by the British branch of the International Workingmen's Association in 1872 and by Hyndman's Social Democratic Federation in 1884.[26]

Marx and Engels are not the first to propose state ownership and management. The idea in its nineteenth- and twentieth-century guise springs from the ferment of the French Revolution. In England, there is a tendency for the proposals of early land nationalizers like Thomas Spence and Thomas Evans (1742-1784) to expand into the realm of mining, basic industries, and utilities. In his *Propositions of the National Reform League* (1850), Bronterre O'Brien summarizes these proposals. He urges, first, land nationalization and, then, gradually, the nationalization of mines, fisheries, railroads, canals, and basic industries. Although Ruskin is less willing to undermine private property, his government-owned and managed factories and his call for the nationalization of railways take their place in this tradition. Ruskin demonstrates an uncanny ability to remove the sting from radical proposals and place them before a wider audience at a time when the development of the economy and the growth of government power were making these proposals more realistic. His Biblical rhetoric and his appeals to the Ancients are a diversionary tactic. They conceal the radical implications of his proposals and flatter the religious and learned pretensions of his Victorian audience.[27]

Ruskin's revival of the guild idea seems a needless extension of this tactic. It distracts himself as much as his audience. Yet, his proposals are not as bizarre as they seem. Voluntary modes of economic reorganization find many more advocates in the nineteenth century than do forms of public ownership and management. On the Continent, Fichte, Sismondi, Fourier, J. A. Blanqui, and Lassalle describe

their proposals for association in terms of a guild system. The mention of Fichte, Sismondi, and Lassalle is a useful reminder that Ruskin is not the first to rely on a combination of voluntary and public projects.

Although not familiar with Continental theory, Ruskin could hardly have been unaware of the detailed programs of the English Owenites and Christian Socialists. Their voluntary producers' associations are indistinguishable from Ruskin's guilds. J. M. Ludlow was influenced by French cooperative thought. He compares producers' associations to medieval guilds and proposes that they set standards of quality and price and provide for the welfare of their members. Many years before the Christian Socialist activity of the 1850's, William Thompson and the Owenites make similar suggestions. Indeed, several trade-unions took up productive work and organized themselves into guilds. In 1833, the most important of these, the National Building Guild of Brothers, published a manifesto which anticipates Ruskin's proposals. The appeal of the guild idea is not surprising. Guild organizations, described by Joshua Toulmin Smith in his elaborate *English Guilds* (1870), existed in skilled crafts well into the eighteenth century. The traditional fabric of guilds, apprenticeship regulations, fixed wages, and poor relief was summarily dismantled in the late eighteenth and early nineteenth century. Ruskin's guild proposals and his demands for secure employment and maintenance stretch back to Tudor times. They suggest that what is new in the nineteenth century is not the first steps toward the welfare state but the brief and certainly utopian experiment with economic liberty.[28]

The attraction which voluntary forms of organization had for Victorian reformers as well as their awareness that such methods might be inadequate is seen in the work of John Stuart Mill. Mill shares Ruskin's vision of a future shaped by public and voluntary expansions of the regulated sector. Mill, however, shows greater distrust of state action than does Ruskin. The "qualified socialism" which he examines in the later editions of the *Principles* and in his posthumous "Chapters on Socialism" is not a state socialism. It is "the association of the labourers themselves on terms of equality, collectively owning the capital with which they carry on their operations." Mill expects this form of "self-acting unit" to multiply and "in the end to predominate . . . if mankind continues to improve." Mill sees in state socialism a threat to individual liberty and initiative. The voluntary association envisioned by Fourier and his followers, for example,

averts this danger. It encourages individual diversity and rewards capital and talent. Mill also has good words for the Owenite "villages" of cooperation. He agrees with Ruskin that voluntary associations might exist simultaneously with private enterprise.[29]

Although Mill prefers voluntary methods, he admits the need for state intervention. He urges the Government to assist workers' associations legally and financially. He had, perhaps, studied Louis Blanc's proposals for national workshops to be financed and regulated by the state before being put under the control of workers. This is a minor point. More important is the remarkably large sphere for public enterprise suggested by several of the exceptions Mill makes to *laissez faire.*[30]

The first concerns utilities. Natural resources are "the inheritance of the human race." To protect citizens from the dangers of monopoly, public authorities must control water, gas, and electricity. Railways, roads, and canals may be left to private agency, but, Mill insists, "it is the part of government to retain such power over the business that the profits of the monopoly may be obtained for the public." The state may grant temporary rights with reversion to the public, set maximum charges for service, or own canals and railways outright. A more interesting exception concerns private enterprises in which owners delegate authority to managers. "Whatever, if left to spontaneous agency, can only be done by joint-stock associations," Mill writes, "will often be as well, and sometimes better done . . . by the state." Managers of joint-stock companies seldom have a personal interest in efficiency. Government management, at least, is subject to public criticism and discussion. Mill's final exception to *laissez faire* is the most sweeping of all. It is that "anything which it is desirable should be done for the general interests of mankind . . . but which is not of a nature to remunerate individuals or associations for undertaking it, is in itself a suitable thing to be undertaken by the government." Mill mentions scientific expeditions and research. But he opens the door to public management of any industry which private persons have not undertaken. When government enters the economic sphere, it does not mean the exclusion of private enterprise. "There might be a national bank or a government manufactory without any monopoly against private banks or manufactories."[31]

Although Mill does not formulate his ideas on the public and private sectors of the economy as clearly as does Ruskin, the two men have much in common. Their differences are of preference, not of sober prediction. While Ruskin is willing to accept a large degree of

public management and proposes guild organizations more as an alternative than as a preference, Mill prefers voluntary action. This explains his casual approach to the distinction between public and private sectors. It also explains his failure to adopt Ruskin's broad criterion of basic industries—those "demonstrably profitable on ascertained conditions." Mill really wants as little government as possible. Still, if one can judge by the essay *On Liberty* and the much neglected essay *On Social Freedom* (1873), where Mill surrenders all areas to state intervention except freedom of thought, his realistic view of the future is not very different from Ruskin's vision of an expanded public sector. It is sad that Ruskin and Mill never got together on the organization of England's economy.[32]

When two men as personally and stylistically dissimilar as Mill and Ruskin hold similar views of the future, one suspects a limited choice of alternatives. This was the case. By 1860, the foundations of the welfare state had been excavated and a number of legal and bureaucratic blocks put into place. The common view of the period from 1830 to 1870 as one of rampant *laissez faire* is misleading. While this period witnessed the removal of traditional restrictions on economic activity, it also witnessed the introduction of new restrictions aimed at mitigating the social consequences of industrial capitalism. The twenty years from 1830 to 1850 saw, on the one hand, the New Poor Law of 1834 and the repeal of the Corn Laws in 1846 and, on the other hand, the Public Health Act of 1838 and the Factory Acts of 1833, 1842, and 1847. English domestic policy in the mid-nineteenth century is best viewed in terms of a graph with two curves— one falling and one rising, one representing the demise of bureaucratic archaisms and traditional restrictions on trade and one representing the growth of a new centralized bureaucracy and regulations pointing to the welfare state. Ruskin's vision of an expanded public sector was suggested by the Government's management of postal and telegraphic communication.[33]

Mill and Ruskin showed no great powers of clairvoyance. Like the Fabians at the end of the century, they had only to extrapolate from present developments. Mill deserves credit for recognizing this. He takes an active part in laying the legislative foundations of the welfare state and scouting the dangers of the edifice. Even Carlyle notes the attempts made by Parliament to interfere with the relations of workers and masters. Ruskin seems oblivious of the work of Parliament. Reading his pleas on behalf of the worker, one would think that he was writing in the early part of the century when the strain

of the industrial revolution was most painful. One would also think that he was writing in a country which had no parliament or government whatsoever. The only contemporary government to which Ruskin refers sympathetically is that of France's Louis Napoleon, who viewed government as the "beneficent mainspring" of social life. Ruskin was of the opinion, perhaps, that a Louis Napoleon could remedy the ills of English society. This failure to make contact with the political condition of his own country accounts for the aura of unreality pervading Ruskin's later social criticism. It helps explain the neglect which his perceptive outline of the welfare state has suffered at the hands of twentieth-century readers.[34]

<div align="center">7</div>

Ruskin's lack of interest in the work of Parliament reflects his belief that institutional change must be preceded by moral change if it is not to be mechanical. Projects for social reconstruction will succeed only when men have adopted the generous outlook of the social imagination. Ruskin proposes guild organizations because he sees in them an opportunity for workers to begin voluntarily the enlargement of the public sector. Members of trade-unions could easily transform their organizations into guilds. Personal or moral reform is central to Ruskin's vision.

Ruskin directs his moral appeal to the upper classes, commercial and landed. He agrees with Coleridge, Southey, and Carlyle that the landed class has become infected with the "commercial spirit." The abolition of the House of Lords will be discussed unless the Lords reform themselves and become true lords or leaders. They should live on the land and invest in their estates, granting fixed rent and secure tenure with compensation for improvements. The Guild of St. George has for its purpose the reformation of the aristocracy. It is not, according to Ruskin, a "product of frantic imagination" but a severely practical attempt to establish an example of enlightened land management.[35]

More interesting is Ruskin's appeal to the commercial classes. In the first chapter of *Unto This Last,* "The Roots of Honour," he returns to his suggestion for professionalizing artists in *The Political Economy of Art.* Now Ruskin demands the professionalization of commerce. He compares the contempt in which merchants are held with the esteem accorded physicians, soldiers, or pastors. While members of the professions are expected to sacrifice their interests and even their lives in the performance of their duties, the merchant is

"presumed to act always selfishly." However necessary his work, "the motive of it is understood to be wholly personal." Ruskin hopes to change the "base" conception of economic life. He would persuade the public that trade has its heroisms and that the man of business has duties and standards for which he must sacrifice himself. His chief duty is to provide for the nation. He must produce and distribute what he sells in the purest and cheapest forms. He must look to vital value, not profit. In a commercial crisis, he is "bound to take the suffering of it with his men, and even to take more of it for himself than he allows his men to feel; as a father would . . . sacrifice himself for his son." Ruskin foresees a time when merchants, industrialists, and landowners will be salaried employees of the state—civil servants or stewards, performing their duties to the public as "a point of honour." He implies that, if they were to act voluntarily in a professional fashion, this expansion of the public sector would be unnecessary.[36]

The consumer, too, must become a professional. Instead of satisfying immediate wants or "buying cheap," he must look to the broader social implications of his spending. He must be certain that the price paid is just to the producer and that his purchase can be put to "clear use, for food, knowledge, or joy." His demands in the market determine the quality of many people's lives. They are demands for life or death. He should view himself, and the public should view him, as a steward entrusted with the direction of labor. Ruskin puts it best in *The Political Economy of Art:*

The aspect which a rich man presents to the eyes of the world is generally that of a person holding a bag of money with a staunch grasp, and resolved to part with none of it unless he is forced, and all the people about him are plotting how they may force him. . . . Anybody who can invent a new want for him is supposed to be a benefactor to society: and thus the energies of the poorer people about him are continually directed to the production of covetable, instead of serviceable, things; and the rich man has the general aspect of a fool, plotted against by the world. Whereas the real aspect which he ought to have is that of a person wiser than others, entrusted with the management of a larger quantity of capital, which he administers for the profit of all, directing each man to the labour which is most healthy for him, and most serviceable for the community. (16.128)

Ruskin is neither the first nor the last to urge a change in the "aspect" of wealth. William Godwin describes wealth as a "trust" and the rich man as "administrator," not "proprietor." Godwin's anarchistic communism consists precisely in making this view of property general. Many years later, the theorist of abundance Simon Patten

hopes to prevent wasteful economic behavior by re-educating consumers and producers. Released from the struggle for immediate satisfaction or profit, they will discover the rewards of altruism and public service.[37]

Ruskin's criticism of the commercial spirit and his calls for the professionalization of economic life owe much to Carlyle. Carlyle is a key figure in the conjunction of the aristocratic ethic of honor, whose passing the Scottish philosophers Francis Hutcheson and Adam Ferguson regretted, with the "social service" ethic of the nineteenth and twentieth centuries. He calls upon the man of business, Plugson of Undershot, to cast off the coils of Mannonism. As a "Captain of Industry," he should treat the worker and consumer with honor and recognize that money is no measure of man's duties to man. In *Latter-Day Pamphlets* (1850), Carlyle applies a military metaphor to social reconstruction. He proposes that the state and private captains of industry undertake together the "regimentation" of industry:

Waste-land Industrials succeeding, other kinds of Industry, as cloth-making, shoe-making . . . in the end, all kinds of Industry, whatsoever, will be found capable of regimenting. Mill-operatives, all manner of free operatives, as yet unregimented, nomadic under private masters, they, seeing such example and its blessedness, will say: "Masters, you must regiment us a little . . . we will enlist with the State otherwise!" This will go on, on the one hand, while the State-operation goes on, on the other: thus will all Masters of Workmen, private Captains of Industry, be forced to incessantly co-operate with the State and its public Captains; they regimenting in their way, the State in its way, with ever-widening field; till their fields meet (so to speak) and coalesce, and there be no unregimented worker, or such only as are fit to remain unregimented, any more. (p. 141)

If Carlyle had returned to follow out the implications of this passage, he might have fashioned a view of the public and private sectors very similar to Ruskin's.[38]

John Stuart Mill was much interested in the Saint-Simonians' proposals for the "organization" of industry. He, too, shows a shrewd awareness of the need to change men's attitudes toward economic behavior. In a passage which could have been penned by Carlyle, Ruskin, or Saint-Simon, Mill declares that, "until labourers and employers perform the work of industry in the spirit in which soldiers perform that of an army, industry will never be moralized. . . ." This is the basis of his paradoxical view that capitalism has not had a "fair trial" and cannot be compared with socialism. Capitalism will de-

velop its potential for social utility only when controlled by men "inspired by a generous feeling for the public good." Mill's vision of a public-spirited or "moralized" capitalism is not very different from Ruskin's ideal of a professionalized industry and commerce. Mill would protest being associated with Carlyle or Ruskin. He sees in their writings the paternalistic exchange of "obedience for protection" which destroys personal development. Mill is right to mark the difference. But, from the vantage point of the self-conscious capitalism of the late twentieth century, the similarities in the attitudes of Mill, Carlyle, and Ruskin stand out as sharply as the differences.[39]

Ruskin's professional ideal has a psychological source which renders comparison with other thinkers irrelevant. Ruskin had observed the feeling of inferiority from which his father suffered as the merchant son of a bankrupt Edinburgh grocer. John James Ruskin wished his son John to be well educated and enter a profession like the clergy in order to remove the stigma of commercial origins from the Ruskin family. In the first chapter of *Unto This Last,* Ruskin is trying to settle the accounts in his father's favor. His father was, in fact, a most unusual businessman—more a dedicated professional or man of honor than an aggressive capitalist. After the struggle to pay off the family's debts and secure a place in London business, the elder Ruskin's relations with his wealthy sherry customers came to resemble his son's ideal of a guild steward. He was, on a large scale, purveyor of the incomparable products of the Domecq vineyards to an assured number of families in the British Isles. A vision rooted in John Ruskin's personal experience has striking relevance to the present with its ideal of professionalization and "corporate management."[40]

What effect, finally, does Ruskin's emphasis on moral reform—on changing the conception of economic roles—have on his constructive social criticism? The answer is both positive and negative. On the one hand, it prevents him from being rigidly attached to any program of institutional reform. Ruskin's outline of the welfare state and expansion of the public sector is tentative. It is one picture of what might be done to moralize economic life and realize the potentialities of an abundant society. There are other alternatives. The important thing is that men begin to act with sympathy and social imagination. The flexibility and variety of Ruskin's approach to institutional change give his writing a prescience which it would otherwise lack. For the present is a mixed phenomenon—part expanded public sector, part

voluntary association, and part private capitalism modified by a sense of professional responsibility. At the same time, Ruskin's reliance on an appeal to the better impulses of individuals prevented him from playing a major role in realizing the changes he predicted. These changes were brought about by slow, difficult labor at the levers of economic interest and political power. Ruskin's preoccupation with moral reform, with changing men's minds, blinded him to the crucial elements of interest and power. Although aware of the "great perpetual operations of death and pain in the universe," he was too optimistic.

XI The New Man

The vitality of Ruskin's social criticism does not spring from the farsightedness of his proposals for institutional reform. It springs from his endeavor to make these proposals serve the quality of life. Is it possible to capture the feeling of the abundant life Ruskin wishes man to lead?

The assumption of abundance shapes Ruskin's vision of the future. By expanding the public sector, he hopes to provide all men with "luxury" and "delight" in food, lodging, conditions of work, and environment. To be sure, one can find many references in his writings to the need for sacrifice and self-denial. Occasionally, he plays the modern Savanarola and calls for an end to luxuries and the concentration of resources on the provision of necessities for the poor. Ruskin urges this course of action "for now," not forever. His position is that of John Maynard Keynes. In 1867, he describes the England of the future with its pure air, clean earth, and art instruction for all but warns: "The political and physical questions needing painful decision in the struggle for immediate life would for a long period render this business of its art instruction a quite inferior and inconsiderable one." Ruskin believes that, with proper management, the seemingly intractable problems of society can be solved. "Luxury is indeed possible in the future—innocent and exquisite. . . ." The manic urgency of his social criticism stems in part from his vision of a promised land just out of reach.[1]

Ruskin's vision bears little resemblance to most conceptions of an abundant or affluent society. Beneath the surface of his writing, there runs a continuous call for a limitation, for a conscious retreat from the demands and achievements of Victorian society. Ruskin questions the value of mechanizing labor, diminishing distances, amassing knowledge, increasing population, rising in society, and acquiring wealth. In their full scope, Ruskin's strictures on the quality of life are as relevant to the present society of abundance as to his own society. This is not to say that Ruskin's vision of abundance is an unreal or hopelessly reactionary one. He intends to meet the needs of all men in health, education, leisure, and environment. It is at the higher reaches of abundance where quality shades off into

quantity that Ruskin's vision stands as a radical critique of modern society and its assumptions.

2

Machinery is the first and best known of Ruskin's targets. He opposes machinery and hopes to abolish it wherever possible. He would substitute human power and hand craftsmanship. Where machinery is necessary to prevent undue exertion and does not "supersede healthy bodily exercise, or the art and precision of manual labour," he would rely on a technology of clean, "natural" sources of power—water, wind, and electricity. Mechanical power based on combustion and polluting the atmosphere would almost cease to exist. In St. George's Guild, he permits steam or "heat-power" only outside pastoral zones and "under extreme or special conditions of need; as for speed on main lines of communication or raising water from great depths." Guild agriculture is intensive and by hand. Ruskin attempts to revive hand-spinning and weaving on the Isle of Man and in the Lake District. For the present, he urges consumers to avoid the products of fire and mine.[2]

Ruskin is not unaware of the usefulness of machinery in "shortening labour." Like Carlyle and Dickens, he admires the "infinite" ingenuity of the "blind, tormented, unwearied, marvellous" centers of English industry and praises the efficiency of railroads. He demands that the new industry be harnessed to serve less privileged areas of the world: "Let it be for the furnace and for the loom of England . . . still more abundantly to bestow, comfort on the indigent, civilization on the rude. . . ."[3] He can dream, with Francis Bacon or H. G. Wells, of

uses of machinery on a colossal scale in accomplishing mighty and useful works, hitherto unthought of, such as the deepening of large river channels;—changing the surface of mountainous districts;—irrigating tracts of desert in the torrid zone;—breaking up, and thus rendering capable of quicker fusion, edges of ice in the northern and southern Arctic seas, etc., so rendering parts of the earth habitable which hitherto have been lifeless. . . . (17.156)

But these projects aim at an extension of rural life.

Ruskin's ambiguous attitude toward machinery is evident in a passage in which he attempts a version of what has been aptly called the technological sublime:

I cannot express the amazed awe, the crushed humility, with which I sometimes watch a locomotive take its breath at a railway station, and think what work

there is in its bars and wheels, and what manner of men they must be who dig
brown iron-stone out of the ground, and forge it into THAT! What assemblage
of accurate and mighty faculties in them . . . Titanian hammer-strokes beating,
out of lava, these glittering cylinders and timely-respondent valves, and fine
ribbed rods, which touch each other as a serpent writhes, in noiseless gliding, and
omnipotence of grasp; infinitely complex anatomy of active steel, compared
with which the skeleton of a living creature would seem . . . a mere morbid
secretion and phosphatous prop of flesh! . . . But as I reach this point of rever-
ence, the unreasonable thing is sure to give a shriek as of a thousand unanimous
vultures, which leaves me shuddering in real physical pain for some half minute
following. (19.60-61)

As Herbert Sussman notes, Ruskin's use of vitalistic imagery is typi-
cal of the Victorian reaction to the machine. Painters of factories
place their subjects against eerie backgrounds of mountains and snow
squalls. In literature, Carlyle and Dickens compare machinery to seeth-
ing waterfalls or mad elephants. Ruskin's choice of writhing ser-
pents, shrieking vultures, and other figures of demonic import also
strikes a familiar note. Carlyle, Disraeli, and Mrs. Gaskell see in the
factory districts a modern Hell. In *The Old Curiosity Shop* (1840),
which Ruskin, perhaps, read before penning his description of the
locomotive, Dickens writes of "the strangest engines [that] spun and
writhed like tortured creatures; clanking their iron chains, shrieking
in their rapid whirl from time to time as though in torment unendur-
able." With Dickens and Carlyle, suggestions of the machine's evil are
balanced by pride in England's mechanical power. With Ruskin, the
demonic element prevails—so much so that the factory with its
"storm-cloud" of dead men's souls becomes a symbol of the evil at
once pervading English society and lurking in the recesses of his
madness. Ruskin stands with Blake at the Apocalypse.[4]

Ruskin's critique of machinery has several sources. The first is the
machine's destruction of the environment. Ruskin never loses the
Wordsworthian sense of a sacred quality in nature. Like Wordsworth,
he deplores the effect of factories on nature and on rural life. Pollu-
tion is literally a "desecration." Next, there is the theme developed
in *The Stones of Venice*—the effect of mechanized production on the
worker. Although Ruskin agrees with Dickens that machine-tending
stifles the better moral impulses of the heart, this is not his chief
concern. He is more interested in the quality of the productive pro-
cess itself and its effect on the happiness and creativity of the worker
as a worker. By demanding routine perfection and enforcing regular,
unnatural rhythms, machinery destroys the integration of phy-

sical skill and imaginative energy which is the human aspect of God's creative power. It also destroys the worker's "sensitive faculty," his ability to appreciate form and color. Machinery exacts a heavy toll in vital cost and leads to the production of riches instead of wealth.[5]

The third reason for Ruskin's hostility is that machinery and its products are ugly. He cannot accept a machine aesthetic because it violates the assumptions of his theory of beauty. The purpose of art is to follow nature—a nature not of the Newtonian or Palladian order but an organic nature of vital energy and changeful abundance. Ruskin's ideal remains constant: "the dependence of all noble design, in any kind, on the sculpture or painting of Organic Form." "Organic Form" or "form as the exponent of life" is not the regular, geometrical form which Piet Mondriaan sees beneath the protean surface of nature, but an imprecise, mysterious harmony in which curvilinear motifs rule. Only the imagination with its purity or "energy" of contemplation can grasp the energy in nature and follow organic form. The intellect or understanding can not. It is an "animal" faculty concerned with the logical relations of science and "the invention of mechanical structure," building as opposed to architecture. Ruskin's tendency to underestimate the role of the intellect in art limits his appreciation of a rationalized or scientific aesthetic. It inspires him to propound a Romantic aesthetic of specific ornament and historical association.[6]

Ruskin's reaction to a machine aesthetic is not as simple as one might expect. For he understands the aesthetic of engineering and technology long before it has any articulate advocates. Quoted out of context, Ruskin can be mistaken for an early apostle of modern architecture. "There is no law, no principle, based on past practice," he writes in *The Seven Lamps of Architecture,* "which may not be overthrown in a moment by . . . the invention of a new material. . . . The time is probably near when a new system of architectural laws will be developed, adapted entirely to metallic construction." But Ruskin cannot accept an architecture "as expansive as steam and as sparkling as electricity" when he sees it exemplified in the Crystal Palace: "You shall draw out your plates of glass and beat out your bars of iron till you have encompassed us all . . . with endless perspective of black skeleton and blinding square." He admits that architecture is an expression of the social environment. The factories, warehouses, and bridges of Victorian England, as well as her domes

of glass, reveal the technical proficiency "characteristic of the age." He sees the futility of decorating railway stations with Gothic ornament. "Railroad architecture has, or would have, a dignity of its own if it were only left to its work." A functional object like the steam engine possesses a certain beauty. Still, Ruskin cannot accept machine work or a "ferruginous" architecture of engineering as art. "Abstractedly, there appears no reason why iron should not be used as well as wood," he writes, but, appealing lamely to "the tendency of all present sympathy," he assumes that "true architecture does not admit iron as a constructive material." He fears that a functional, ferruginous architecture will have no place for sculpture. Machines can neither duplicate the vital irregularity of organic form nor express the personality of a God-made great man. The hand, guided by the imagination, can.[7]

Ruskin not only describes the aesthetic of technology and functionalism and predicts its success. Paradoxically, he states some of the most important principles of modern design in his discussion of Gothic. As John Rosenberg remarks, Frank Lloyd Wright owed much to Ruskin's belief that a great building will follow the lines of organic form and express the character of its surroundings. It will "sympathize with" and "mark the nature of the thing it has to deal with and conquer." It will also reveal honestly the nature of its materials and "the great secrets of its structure." The truism, "form follows function," has its counterpart in Ruskin's definition of vital beauty and in his surprising view that Gothic is the most "rational" or functional style because of its wide variety of dimensions and forms. In his early essay "The Poetry of Architecture," he insists that every building be designed to serve the needs and uses of life. It is ironic that Ruskin's study of Gothic leads him to develop principles which were to be applied by others only to an architecture having its roots in the Crystal Palace and industrial techniques.[8]

The final reason for Ruskin's opposition to machinery is a more practical one. Machinery displaces workers. Ruskin is well aware of the phenomenon of technological unemployment. He views it not as a temporary problem but as a permanent and inevitable result of the use of machinery. Unlike Carlyle and like recent students of automation, Ruskin does not believe technology capable of generating work for all. It eliminates jobs and "increases the possibilities of idleness," not of life. Redundant workers go on the dole, become criminals, or enter "vulgar" urban occupations. Ruskin refuses to see the in-

creased role of service industries in providing employment partly because, as Sussman suggests, such work is tinged with the sin of vanity. To reverse the tide of unemployment, Ruskin urges a return to hand labor. All public projects must be done by hand if they are to be educational. Even transportation or "porterage" should rely on healthy "living fuel." One of Ruskin's more incredible suggestions is that heavy goods be hauled along an expanded canal system by human power: "Instead of dragging petroleum with a steam-engine, put it on a canal, and drag it with human arms and shoulders. Petroleum cannot possibly be in a hurry to arrive anywhere." One could hardly withdraw farther from the advanced positions of Victorian England.[9]

The belief that machinery causes unemployment is a common one in the nineteenth century. Paine, Godwin, and Hall are among the first to study the problem of technological unemployment. Southey, Carlyle, and Dickens deplore the displacement of men by machines and the instability of the labor market. Even Ricardo, in the third edition of his *Principles* (1821), comes to the conclusion that, as the price of foodstuffs and, hence, of labor rises, there will be a growing tendency for capital to take the form of machinery. "Machinery and labour are in constant competition," he writes to the embarrassment of his fellow economists. The workers' hostility to machinery is not founded on "prejudice and error." Little wonder that John Gray, Thomas Hodgskin, and Karl Marx went to Ricardo for their economics.[10]

The difference between these writers and Ruskin is that they accept machinery as a positive force if managed properly while Ruskin does not. He would limit the use of machinery and restore many tasks to hand labor. Godwin, Owen, and the Ricardian socialists welcome the industrial revolution. They believe that unemployment is the result, not of machinery per se, but of its mismanagement under competition. With the Saint-Simonians, they rest their hopes for the future on a technology managed for social ends. Southey, Carlyle, and Dickens agree although, in certain moods, they accept machinery more as a historical inevitability than as a special blessing. In his remarkable chapter "Steam, War, and the Prospects of Europe" in *Sir Thomas More; or the Colloquies* (1829), Southey notes the great potential for good or evil of steam power. He goes on to pen a discussion between Montesinos and More on the social control of science and technology and on the social responsibility of

the scientist which has lost little relevance in the last one hundred and fifty years. Ruskin's response to the new technology is more visceral. He shares neither Carlyle's belief in the ethical and psychological possibilities of mechanized labor nor Dickens' hope of preserving islands of spontaneous feeling and imaginative sympathy in a mechanized world. He can neither follow a hero into the "immense Industrial Ages" nor join Sleary's circus troop. Instead, he would make all men horse riders to a degree. Alone of prominent nineteenth-century intellectuals, Ruskin refuses to accept the inevitability of the machine and its products. He calls for the sort of retreat from industrial civilization which could seem plausible only to one convinced that the struggle against scarcity has been won and that man is free to base his style of life on the dictates of health, happiness, and creativity.[11]

<div align="center">3</div>

The substitution of human for mechanical power would mean a slowing down of the tempo of life. This does not worry Ruskin. The second area in which he calls for a halt or limit is that of accelerating speed in communication and transportation, of diminishing distances, and of physical crowding in cities. These phenomena spring from modern technology, but their effect on the quality of life is different from that of machine industry. Ruskin views the new means of communication and transportation as just that—means, not ends. In themselves, they are useless or even harmful, for, by shortening time and space, they sacrifice quality of perception to quantity. A man who loves to travel slowly and see nature "would as soon consent to pack a day of such happiness into an hour of railroad, as one who loved eating would agree . . . to concentrate his dinner into a pill." Like Wordsworth before him, Ruskin staunchly opposed any extension of railroads into the Lake District.[12]

Ruskin's first criticism of the acceleration of modern civilization remains his best. It occurs toward the end of volume three of *Modern Painters* (1856):

The great mechanical impulses of the age, of which most of us are so proud, are a mere passing fever, half-speculative, half-childish. People will discover at last that . . . there are, in fact, no royal roads to anywhere worth going to. . . . Do we want to be strong?—we must work. . . . To be happy?—we must be kind. To be wise?—we must look and think. No changing of place at a hundred miles an hour . . . will make us one whit stronger, happier, or wiser. . . . And they will

at last, and soon too, find out that their grand inventions for conquering (as they think) space and time, do, in reality, conquer nothing; for space and time are, in their own essence, unconquerable, and besides did not want any sort of conquering; they wanted *using*. A fool always wants to shorten space and time: a wise man wants to lengthen both. A fool wants to kill space and kill time: a wise man, first to gain them, then to animate them . . . the really precious things are thought and sight, not pace. It does a bullet no good to go fast; and a man, if he be truly a man, no harm to go slow; for his glory is not at all in going, but in being. (5.380-381)

Ruskin repeats these questions, "What for?" and "Where to?", many times. "Telegraph signalling was a discovery," he writes, "and conceivably, some day, may be a useful one. . . . You knotted a copper wire all the way to Bombay, and flashed a message along it, and back. . . . Is India the better for what you said to her? Are you the better for what she replied?" Again, after describing what had once been a beautiful valley between Buxton and Bakewell, he continues,

You Enterprised a Railroad through the valley. . . . The valley is gone, and the Gods with it; and now, every fool in Buxton can be at Bakewell in half-an-hour, and every fool in Bakewell at Buxton; which you think a lucrative process of exchange—you Fools Everywhere. (27.85-86)

There is only one well-known English writer whose attitudes resemble Ruskin's on the question of speed. It is Matthew Arnold. Compare this from *Friendship's Garland* (1871):

Your middle-class man thinks it the highest pitch of . . . civilization when his letters are carried twelve times a day from Islington to Camberwell, and from Camberwell to Islington, and if railway-trains run to and fro between them every quarter of an hour. He thinks it nothing that the trains only carry him from an illiberal, dismal life at Islington to an illiberal, dismal life at Camberwell; and the letters only tell him that such is the life there. (p. 146)

In America, Ruskin finds a kindred spirit in Henry David Thoreau (1817-1862). Thoreau deplores the tendency to sacrifice quality of perception to quantity. "We live too fast and coarsely." There is a remarkable similarity between Ruskin's comments on the telegraph to Bombay and the railway to Bakewell in the fifth letter of *Fors* (1871) and a passage from *Walden* (1854). "We are in great haste," Thoreau writes, "to construct a magnetic telegraph from Maine to Texas; but Maine and Texas, it may be, have nothing important to communicate." Again, after studying "the process of exchange" between Concord and Fitchburg by railroad, Thoreau concludes that

"the swifter traveller is he that goes afoot." In the first case, both Thoreau and Ruskin may have turned to Emerson's poem "The World Soul" (1847): "The light-outspeeding telegraph / Bears nothing on its beam." Ruskin cites these lines in the third volume of *Modern Painters.* Still, it is possible that he had read *Walden* before writing the passage in *Fors.* In 1856, *Walden* was reviewed by George Eliot in the *Westminister Review.* If Ruskin's close friend Charles Eliot Norton did not call his attention to the book, the young American painter W. J. Stillman would have. Stillman, who travelled with Ruskin in the Alps, was inspired by *Walden* to build a cabin in the Adirondacks.[13]

The similarity between Ruskin's ideas and Thoreau's does not end with "speed." It extends into urban crowding and the effects of metropolitan civilization. Speed is not merely foolish but dangerous, for the "smallness" of the world corrupts the provincial sources of originality. "All great art . . . is *provincial.*" Ruskin fears the "infectious insanity for centralization throughout Europe." He wishes "to preserve as much as possible the innocent *sources* of novelty;—not definite inferiorities of one place to another . . . but differences of manners and customs, of language and architecture." Ruskin's preference for a Gothic variety of culture should be studied in conjunction with the concept of nationality suggested by Burke and Wordsworth. It reminds one of Matthew Arnold's fear of a uniform, "Americanized" society and John Stuart Mill's belief that freedom for diversity is necessary to cultural development. Scott puts the case for "provinciality" most bluntly:

Let us remain as nature made us—Englishmen, Irishmen, Scotchmen—with something like the impress of our several countries upon each! . . . The degree of national diversity between different countries is but an instance of that general variety which Nature seems to have adopted as a principle through all her works. . . .[14]

Ruskin looks askance at those who praise the railroad and telegraph for civilizing "savage nations." He has a few questions to ask:

If you know nothing but railroads, and can communicate nothing but aqueous vapour and gunpowder,—what then? But if you have any other thing than those to give, then the railroad is of use only because it communicates that other thing; and the question is—what that other thing may be. . . . Is it science? But what science—of motion, meat, and medicine? Well; when you have moved your savage, and dressed your savage, fed him with white bread, and shown him how to set a limb,—what next? Follow out that question. Suppose every obstacle

overcome; give your savage every advantage of civilization to the full; . . . what next? (5.381-382)

In 1845, Ruskin predicts what is next: "I see what the world is coming to. We shall put it into a chain-armour of railroad, and then everybody will go everywhere every day, until every place is like every other place." Just as the "endless perspective of black skeleton and blinding square" burst upon Ruskin's mind, so does a worldwide, metropolitan civilization homogenized by the "great net" of communications, "drawing and twitching" the various life of man into a "narrow, finite, calculating metropolis of manufactures." Ruskin's vision differs from Thomas Carlyle's. In *Sartor Resartus,* Carlyle remarks that the new means of communication are drawing men closer together. He considers this a positive phenomenon—a harbinger of the industrialized organic society which will rise from the chaos of competition. Ruskin's unwillingness to think in terms of positive growth and his hatred of the machine make it difficult for him to accept the new means of communication and transportation. The organic society which appeals to him is a static, traditional one.[15]

To the immediate pressures of urban civilization, Ruskin reacts violently. He condemns the absurdity of city life "in which the only object in reaching any spot is to be transferred to another; in which existence becomes mere transition." He compares the activity of the metropolis to the "nidification" of squirrels. More frequently, his reaction borders on panic. His metaphors fall on the negative side of the life-death, organic-decomposed antithesis. The city dweller is "one atom in a drift of human dust, and current of interchanging particles, circulating here by tunnels underground, and there by tubes in the air." In an erratic essay entitled *Fiction, Fair and Foul* (1881), Ruskin attributes the morbidness of modern fiction to "the hot fermentation . . . of the population crowded into large cities." He fears the "trampling pressure" and "pollution" of the "staggering mass that chokes and crushes" and threatens to melt him into mud. Occasionally, Ruskin turns from organic metaphors to electric ones. He speaks of the "galvanic restlessness" and "electric" quality of city life. In his own way, he grasps the essence of that urban tribalism based on electronic media which Marshall McLuhan describes. As with modern architecture and the "welding-together" of the earth's population, Ruskin's attitude is both prescient and reactionary. He

reacts against a phenomenon which many of his contemporaries never noticed.[16]

4

Ruskin admits that the only cure for the growth of cities and the destruction of rural life is the restriction of population. This is the third of his strategic retreats from the nineteenth century. It is one which he shares with a number of his contemporaries. Although Ruskin's vision of abundance prevents him from agreeing with Malthusians or the advocates of birth control Robert Dale Owen (1801-1877) and Charles Bradlaugh (1833-1891), he does believe that there is a definite limit to the number of people who can live in England. The important question is, "At what point will you stop?"

You have to consider first, by what methods of land distribution you can maintain the greatest number of healthy persons; and secondly, whether, if, by any other mode of distribution and relative ethical laws, you can raise their character, while you diminish their numbers, such sacrifice should be made, and to what extent? (17.435)

Ruskin puts quality over quantity. In *The Political Economy of Art,* he warns that "it is possible to direct labour to the production of life, until little or none is left for that of the objects of life." He anticipates Matthew Arnold. The unlimited increase of population is an extension of "machinery," not an addition to the nation's vital wealth. He regrets that the "incontinent, selfish, and foolish" beget large families and urges the nation to give "some of the attention to the conditions affecting the race of man, which it has hitherto bestowed only on . . . cattle." Ruskin's interest in this question derives from Plato. For the present, he insists on strict regulation of marriage. The state should grant permission to marry only to young people who have completed their education and attained skill in a craft. In *Time and Tide,* he would call the young maidens receiving permission "Rosières" after his tragic love, Rose La Touche.[17]

5

Ruskin's fourth call for a limitation or retreat concerns learning, science, and education. In the third volume of *The Stones of Venice,* he distinguishes between the artist who sees and feels and the scientist who reflects and analyzes. While the scientist or thinker concentrates on one subject until he "gets to the bottom of it," the artist is

"bound to receive all things on the broad, white, lucid field of his soul." "The thoughtful man," he writes,

is gone far away to seek; but the perceiving man must sit still, and open his heart to receive. The thoughtful man is knitting and sharpening himself into a two-edged sword, wherewith to pierce. The perceiving man is stretching himself into a four-cornered sheet, wherewith to catch. (11.52)

The artist needs knowledge of nature and perspective, but "knowledge is good for him so long as he can . . . trample it under his feet, and out of his way, the moment it is likely to entangle him." Ruskin criticizes the artists of the Renaissance for displaying scientific knowledge at the expense of what is infinite and real. One is reminded of Wordsworth's fear that learning hinders a poet's ability to lose himself in contemplation.[18]

In the usual manner of his social criticism, Ruskin gives universal application to a principle first reached in his study of art. He believes that all men should let other considerations than mastery of a subject determine the limits of their knowledge and suggests as criteria

that it is the kind of knowledge they need for their duty and happiness in life; . . . that it has not cost too much time in the getting; that none of it, once got, has been lost; and that there is not too much to be easily taken care of. (11.63)

Knowledge is food for the spirit and liable to the same abuses as food for the body: "We no more live to know, than we live to eat. We live to contemplate, enjoy, act, adore. . . ." Knowledge is useful when it is tasted, not when it is stored up in the granaries of the mind. Ruskin's criticisms of the hoarding of knowledge parallel his strictures on the hoarding of capital. They illustrate again the remarkable integrity of his thought. Knowledge, like money, machinery, and speed, is not an end in itself but a means to life. The question is whether men are "vivified" or "paralyzed" by it.[19]

Ruskin believes that the "animating power of knowledge is only in the moment of its being first received, when it fills us with wonder." For this experience, the previous ignorance is crucial. Once thoroughly possessed, knowledge ceases to give pleasure. It deadens the imagination and inhibits "the original energy of the whole man." The genius "remains in great part a child, seeing with the large eyes of children, in perpetual wonder, not conscious of much knowledge . . . a fountain of eternal admiration. . . ."[20] Here, Ruskin strikes

a note familiar to Wordsworth, Novalis, and Carlyle. In his own fashion, he plays it before a wider audience:

All are to be men of genius in their degree,—rivulets or rivers, it does not matter, so that the souls be clear and pure; not dead walls encompassing dead heaps of things known and numbered, but running waters in the sweet wilderness of things unnumbered and unknown, conscious only of the living banks, on which they partly refresh and partly reflect the flowers, and so pass on. (11.66)

Ruskin could not comprehend, because he seldom experienced, the sort of insight which grows slowly after long years of research.

With more recent "flower children," he emphasizes the gain in social benevolence possible to those who limit their search for knowledge: "How much of a man's knowledge has cost him labour and time that might have been spent in healthy, happy action, beneficial to all mankind . . . how many warm sympathies have died within him as he measured lines or counted letters. . . ." Ruskin projected an essay on the "Uses of Ignorance."[21]

The worst offenders in the game of heaping up quantities of knowledge are scientists. Ruskin excoriates in Swiftian fashion the "cold avarice of knowledge" of the "scientific mob." They are destroying the emotions of wonder and faith. He resigns his professorship at Oxford over vivisection—a symbol of the "perverse inquisitiveness" and "meddling instinct" which Burke deplored. Even if scientific research were undertaken with modesty, in the spirit of the Gothic builder, Ruskin fears its "tendency to chill and subdue the feelings, and to resolve all things into atoms and numbers." "For most men," he writes,

an ignorant enjoyment is better than an informed one. . . . I much question whether any one who knows optics, however religious he may be, can feel in equal degree the pleasure or reverence which an unlettered peasant may feel at the sight of a rainbow. (5.386-387)

Ruskin disagrees with Matthew Arnold and John Stuart Mill. They deny any conflict between science and emotion and cite Wordsworth's description of poetry as "the impassioned expression . . . in the countenance of all Science."[22]

Once again, Ruskin's position is a study in ambivalence. In a letter to Sir Henry Acland on the Oxford Museum (1859), he reveres physical science as the source of utmost practical power in reducing disease, hunger, and pollution. At home or far away, the call is "equally instant" for more extended physical science. He himself pioneered in

placing natural science in the school curriculum. Ruskin's point seems to be that scientists should concentrate less on speculative questions and more on increasing "the comfort of lowly life." He strikes a modern note when he urges a moratorium on theoretical research and a focusing of energies on the application of discoveries already made. Even so, Ruskin dreads the future which science seems about to create—"a life entertained by scientific gossip, in a cellar lighted by electric sparks, warmed by tubular inflation, drained by buried rivers, and fed by the ministry of less learned and better provisioned races. . . ." He doubts that man will be happy when he has steam legs and a steel heart and has turned the world into a small gasometer, the replica of Carlyle's "one huge, dead, immeasurable Steam-engine."[23]

Ruskin's call for a limit to the acquisition of knowledge shapes his educational precepts. His reservations concerning reading, writing, and arithmetic spring in part from his conviction that the three R's "hinder children in the acquisition of *ideas.*" Reading does not help one see the skies, nor does writing help one remember them. In a McLuhanesque fashion, Ruskin criticizes the "present fury of print-ing." It destroys the value of things that depend for their beauty on sound and accent and so eliminates an entire dimension of man's experience. He hopes to restore this dimension through lessons in singing and elocution. Quixotically, he proposes to stop the glut of reading matter by teaching his pupils to write the kind of beautiful hand which will take from half-an-hour to an hour for a line. Ruskin's view of competitive examination and the forcing of educa-tion falls into this pattern. The "natural torpor of wholesome dull-ness" should not be disturbed by provocations. Most men are "not intended to be any wiser than their cocks and bulls,—duly scientific of their yard and pasture, peacefully nescient of all beyond."[24]

Ruskin's strictures do not apply only to the unintelligent. All men should restrain their intellectual ambition and limit the number of paintings, pieces of music, or works of literature to which they give their attention. Ruskin's purpose is not primitivistic or anti-intel-lectual. He fears the debilitating effect which the modern desire for cultural diversity has on one's powers of appreciation. It is better to study one great painting or read one great book than to encompass the vast amount of inferior work produced. Ruskin was speaking from experience. No Victorian attempted to pursue as many interests as did he. He complains that he is "perfectly overwhelmed under the

quantity of things which must be kept in my mind, now, going like a juggler's balls in the air—a touch first to one, then another." His criticism of the desire for variety is as much a product of self-criticism as of self-contradiction. It reveals an awareness that the Gothic variety of his own work has a dangerous effect on quality, an awareness, too, that the true genius must be more than a sparkling rivulet in "the sweet wilderness of things unnumbered and unknown." It is significant that Carlyle, the only man from whom Ruskin would accept criticism, described him in 1855 as a "beautiful bottle of soda water." In *Shooting Niagara*, Carlyle uses a similar phrase to condemn the tendency of modern literature to "fluff itself off into nothing."[25]

<div align="center">6</div>

Ruskin's final call for restraint was, perhaps, the most incomprehensible to his Victorian contemporaries. It lies in the sensitive area of social advancement or "getting-on." Ruskin denies the "gospel of whatever we've got, to get more" as vehemently as he does that of "wherever we are, to go somewhere else." In the final pages of *Unto This Last,* he urges his readers to remain content in the station in which Providence has placed them. "We need examples of people who, leaving Heaven to decide whether they are to rise in the world, decide for themselves that they will be happy in it, and have resolved to seek—not greater wealth, but simpler pleasure; not higher fortune, but deeper felicity. . . ." Deploring the restless anxiety of commercial life, he continues, "Care in nowise to make more of money, but care to make much of it." Here, Ruskin turns to the social implications of his belief that economics should be a science of spending as well as a science of getting. "Possession is in use only. . . ."[26]

Ruskin directs his counsels of contentment to both the lower and upper classes. In the case of the former, one suspects his motive, although he admits that there are some circumstances in which no man should be content and charges with blasphemy those who "call the confused wreck of a social order brought about by malicious collision . . . an arrangement of Providence." If the social order is just, the worker should seek his happiness in perfecting the manner of life "determined" for him. He should strive modestly to be a "true gentleman" or craftsman in his calling and abandon the "feverish hope of an entire change of condition." Ruskin's attitude reminds

one of Thomas Hardy's view of the "modern vice of unrest" in *Jude the Obscure* (1895). Jude, in fact, was a latter-day Gothic workman until ambitions for higher endeavor led to his self-destruction. Ruskin criticizes popular education for aggravating "the plague of this fermenting imbecility, striving to make for itself what it calls a 'position in life.' " Education should fit you for your place and make you happy in it. Ruskin shares this opinion with Kingsley, Maurice, and other leaders of the Working Men's College. Even John Stuart Mill regrets that most teaching in England concerns how to get on in life. He believes that "all instruction which is given, not that we may live, but that we may live well . . . calls for the care of Government."[27]

Ruskin's appeal to the upper classes is more credible and more original. He warns that money may be accumulated at the cost of life. He urges the rich to set an example for the poor by "checking the wing of accumulative desire in mid-volley." They should pause in mid-life and "say, 'Now I have enough to live upon, I'll live upon it; and having well earned it, I will also well spend it, and go out of the world poor, as I came into it.' " A businessman should fix the sum he desires to make annually and "stay when he has reached the limit . . . so obtaining due freedom of time for better thoughts." Ruskin would discourage the acquisitive spirit by taxing luxuries and by placing legal restraints upon the property and income of the wealthy. Introduced gradually and without violence, these restraints would have beneficial effects. They would encourage the rich man to spend all of his money and control the use made of it, "calculating the ebb tide of possession in true and calm proportion to the ebb tide of life." Inequalities of wealth would be reduced, the danger of speculative panics averted, and the problems of useless hoarding and insufficient demand remedied. Finally,

by withdrawal of those who had attained the prescribed limits of wealth from commercial competition, earlier worldly success, and earlier marriage . . . would become possible to the young; while the older men of active intellect . . . would be induced unselfishly to occupy themselves in the superintendence of public institutions. (17.322)

One might recall that, in Robert Owen's "New Moral World," the older men would leave industrial work to the young and devote their energies to regulating distribution and administering justice. Once again, the chaotic integrity of Ruskin's thought is apparent. His eco-

nomic analysis, his assumption of abundance, and his ideal of public service all contribute to his call for an end to "getting-on."[28]

Ruskin's attack on the gospel of social advancement and accumulation is original in degree, not in kind. It owes much to the Greek philosophers' emphasis on moderation and their belief that living well is a nobler enterprise than living without limit. The Biblical writers and Church Fathers take a similar view of wealth and praise the life of humble contentment and simplicity. Later, Sir Thomas More, Dean Swift, and Bishop Berkeley condemn the "new men" who never rest in their search for social advancement. In More's *Utopia,* the love of gold and silver would be dampened by using precious metals for the making of chamberpots. This attitude plays an important role in the work of John Millar, Adam Ferguson, and Adam Smith. Although the Scotsmen base their hopes for progress upon the desire of man to better his condition, they have grave doubts about the usefulness of wealth and cast wistful glances at the traditional virtues of moderation, propriety, and quiet contentment. The conflict between "passive" and "active" attitudes is particularly evident in Ferguson, who can endorse a discontented striving for advancement and, at the same time, condemn the "mercenary spirit" and urge a patient acquiescence in "the duties of our station." Ruskin also is torn between active and passive attitudes. On the one hand, he admires the infinite striving and "disquietude" of Gothic and, on the other hand, insists in *Modern Painters* that serenity characterizes the great work of art.[29]

In the nineteenth century, the call for moderation in the pursuit of material success is heard more often. Coleridge and Southey perceive an "overbalance" of the commercial spirit and agree with Wordsworth that

> The world is too much with us; late and soon,
> Getting and spending, we lay waste our powers.

Southey regrets that men cannot retire from business and learn the uses of leisure. "There is no floating in our society," he writes, "only struggle." In a passage quoted by Ruskin, Carlyle condemns "Mammon-worshippers" for whom Hell is failing to make money. They should learn how to live. Carlyle's comments find an echo in Arthur Helps' assertion that it would be better to "withdraw" from the commercial race than to put "money over life." Later, Matthew

Arnold describes wealth as a means to life, not an end in itself. He proposes a legal limit on inheritance and heavy taxation to discourage the spirit of accumulation.[30]

John Stuart Mill is remarkably close to Ruskin on this question of softening the harshness of competition and restraining acquisitiveness. "I confess," writes Mill,

> I am not charmed with the ideal of life held out by those who think that the normal state of human beings is that of struggling to get on; that the trampling, elbowing, and treading on each other's heels, which form the existing type of social life, are the most desirable lot of human kind. . . . (*Principles,* Bk. IV, ch. vi, sec. 2, p. 453)

The good society is that "in which, while no one is poor, no one desires to be richer" and "in which the greatest possible numbers . . . are contented with a moderate competency." Mill hopes that his ideal will be realized in the "stationary state." Unlike earlier economists, he does not fear the advent of the stationary state when further increases in production will be impossible. He views it as a time when the emphasis will shift to distribution and when industrial improvements will reduce labor, not increase wealth. This will permit "a much larger body of persons than at present . . . sufficient leisure . . . from mechanical details, to cultivate freely the graces of life" and improve the "Art of Living." Ruskin would feel at home in Mill's stationary state, provided that Mill himself were not present. He grants as much in *Unto This Last.* But Ruskin cannot wait for the economy to run down. He wishes industrial leaders to "check the wing of accumulative desire" voluntarily. In this respect, he resembles Godwin who hopes that, by a "revolution of opinions," wealth will come to be regarded as "petty and inconsiderable" and avaricious accumulation a sign of dishonor. In terms of serious thought given to restraining the desire to get on, Mill and Godwin seem closer to Ruskin than do Southey, Carlyle, or Matthew Arnold, a fact which might have astonished Ruskin himself.[31]

7

What distinguishes Ruskin from other writers who attack the idol of "getting-on" is the central place this critique occupies in his thought and the relation it bears to his perception of abundance. To Ruskin, "getting-on" is the chief manifestation of the Protestant ethic which Max Weber and R. H. Tawney diagnose more thoroughly. Although contentment with one's station sounds much like

the Protestant ideal of fulfilling one's calling, Ruskin expands the
meaning of the phrase to the point of rejecting the Protestant ethic.
"Contentment" means positive happiness or felicity, not stoic per-
formance of duty. Men should be happy in the present and delight in
their work. They should not strive dutifully in hope of future re-
ward. Admitting that he himself wants to be someone else, Ruskin
writes, "it is appointed for all to enjoy but few to achieve. . . . We
must try to do, not what is best, but what is easily within our
power. . . ." Ruskin warns his readers against the dangers of "over-
straining." Great artists and scholars apply their talents happily and
quietly. He rejects the sentiment of Longfellow's famous line, "Life
is real, life is earnest." Man should "play merrily in the little raree-
show of his life, so as to please the Gods." His "real duty" is to "live
in happy peace and play" like the lambs in Blake's *Songs of Inno-
cence.* In *The Political Economy of Art,* Ruskin criticizes nations
which sacrifice the arts of delight to "a mean lust of accumulation
merely for the sake of accumulation, or of labour merely for the sake
of labour."[32]

Ruskin does not stop with an implied rejection of the earnestness
or "obstinacy" of the Protestant ethic. In later writings, he relates
Protestantism to the acquisitive spirit. He deplores the "materialistic
temper of the Reformation" and the extinction of art "under the
mocking snarl and ruthless blow of the Puritan." In contrast, he finds
the ritual and Madonna-worship of Catholicism attractive. In a letter
to Charles Eliot Norton (1856), he suggests that the ruin and shad-
ows of Rome, "the very sense that nobody about you is taking
account of anything," must be a relief after "the scraped cleanliness,
business, and fussiness"–the "getting-on-ness"–of Protestant Amer-
ica. He describes Evangelicalism as "rather greasy in the finger;
sometimes with train oil." In *The Two Paths* (1859), he condemns
his fellow citizens for "lisping comfortable prayers . . . and counting
your pretty Protestant beads (which are flat, and of gold, instead of
round, and of ebony, as the monks' ones were)." Ruskin becomes
more explicit in *The Bible of Amiens* (1882). He insists that "mod-
ern Protestantism . . . sees, in the cross, not a furca to which it is to
be nailed; but a raft on which it, and all its valuable properties, are to
be floated into Paradise." "Quite one of the most curious colours of
modern Evangelical thought," he exclaims, "is its pleasing connec-
tion of Gospel truth with the extension of lucrative commerce!"[33]

Ruskin's most amusing remark occurs in one of the final bizarre

lectures which he gave at Oxford. The *Pall Mall Gazette* of November 17, 1884, reports as follows: " 'Here I have for you a type of the honest but not liberally minded Protestant,' said Mr. Ruskin, disclosing a sketch of a little porker. 'The little pig walks along, you see, knowing every inch of its ground, having in its snout a capital instrument for grubbing up things.' " The attack was inspired by Ruskin's antipathy to his mother's puritanism and by Rose La Touche's rejection of his marriage proposal on the grounds that he was not an orthodox Protestant. It takes on a different meaning when read in conjunction with his criticism of the economists' obsession with capital accumulation and production. "Men apply themselves to the task of growing rich, as to a labour of *providential* appointment. . . ." Ruskin's view of the relation between Protestantism and capitalism is far less acute than Weber's. Still, at the level of emotional or symbolic perception, he grasps the point and consigns the Protestant ethic to his list of undesirable traits.[34]

Ruskin was not the first to draw a connection between Protestantism and the commercial spirit. In the 1670's, William Petty had remarked that nearly all the most enterprising men in industry were Dissenters. It was not until the rise of Evangelicalism in the early nineteenth century and a corresponding Romantic nostalgia for the pre-Reformation Church that the connection was made in a pejorative sense. In his *Lay Sermon,* Coleridge regrets that religion no longer provides a bulwark against "the spirit of the world." The narrow Protestantism of the English middle classes with its emphasis on conduct and neglect of theology leaves the minds of its adherents vacant for temporal concerns. It encourages the pursuit of wealth. Robert Southey laments the tendency of the Reformation to "lower the standard of devotion . . . and prepare the way for the dominion of the worldly spirit of the commercial system." In the *Colloquies,* he notes that Mammon never acquires the undisputed supremacy in Catholic countries which he obtains in Protestant ones. In a less sophisticated vein, Cobbett attacks the Reformation for subjecting England to the rule of money-lust. Ruskin was not a little indebted to Cobbett's *History of the Protestant Reformation* (1824). In a letter of 1884, he declares that this book is "the only true one ever written as far as it reaches. . . ."[35]

Matthew Arnold stands out among Ruskin's contemporaries. Arnold traces the "Hebraism" of England's middle class—its emphasis on work, duty, and conduct and its neglect of beauty and intellectual

attainment—to its Puritan origins. He notes the special contribution which Hebraistic qualities make to the success of "our free-trading Liberal friends—mechanically worshipping their fetish of the production of wealth." The alliance of religious nonconformity and the spirit of commerce is the major obstacle to culture in England. John Stuart Mill also sees a connection between "commercial money-getting business and religious Puritanism." These are the "two influences which have chiefly shaped the British character." They are responsible for the Englishman's tendency to consider art a useless activity. In 1850, Mill criticizes Carlyle's "gospel of work" for reinforcing the Englishman's worst characteristics:

There is nothing laudable in work for work's sake. . . . He [Carlyle] revolves in an eternal circle round the idea of work, as if turning up the earth, or driving a shuttle or a quill, were ends in themselves, and the ends of human existence.

To the "gospel of work," Mill opposes the "gospel of leisure."[36]

In this passage, Mill has hit upon the feature of Carlyle's thought which distinguishes him from Ruskin and which casts their many similarities into shadow. Ruskin shares the gospel of work, but his version lacks the puritan thrust of Carlyle's. Work, for Ruskin, is a means of self-fulfillment as well as an exercise in duty. It should resemble art and engage the worker's "*manhood* in its entire and highest sense." Work should be less a painful struggle with scarcity than a joyful expression of the worker's personality in a sympathetic environment. It should be *opera,* not *labor,* and happiness is the chief criterion of "good" work. Carlyle takes a different view. Although he speaks of work as a means to self-knowledge and self-realization, he defines the end in terms of the means. "Labour is Life," declares Carlyle, and he means this quite literally. Only "so soon as Work fitly begins" is the "sacred, celestial Life-essence" of the worker called into being. "The Man is now a Man," he writes, the implication being that man is man only so far as he is a worker. For Ruskin, the "celestial Life-essence" resides in man *qua* man and demands to find expression in its *proper* work.[37]

Carlyle, unlike Ruskin, insists that work of any description—even "mammonish or mechanical"—is sacred. "In the meanest sorts of Labour, the whole soul of man is composed into a kind of real harmony. . . ." The next sentence indicates what kind of harmony this is:

Doubt, Desire, Sorrow, Remorse, Indignation, Despair itself, all these like hell-dogs lie beleaguering the soul of the poor dayworker, as of every man: but he

bends himself with free valour against his task, and all these are stilled, all these shrink murmuring far off into their caves. (*Past and Present,* pp. 197-198)

For Carlyle, labor is less a vehicle for the expression of man's chaotic, expansive impulses than a vehicle for their repression. On the rare occasions when he speaks of "capabilities" and self-development in the German sense of *Bildung,* he gives these concepts a puritan cast and directs attention from the desires of individuals to the need for immediate moral action. The puritan content of Carlyle's work ethic is obvious. He praises frugality, abstemiousness, and obstinacy and scorns art and fiction as instruments of the "soft" life. It is through "Self-annihilation," the "Worship of Sorrow," and doing "the Duty which lies nearest" that Teufelsdröckh achieves an affirmative attitude to life. The ascetic tone of Carlyle's thought appears in his remark that "the Fraction of Life can be increased in value not so much by increasing your Numerator as by lessening your Denominator." He mocks the desire to be happy. Man "can do without Happiness, and instead thereof find Blessedness!" "Love not Pleasure; love God." He deplores the fact that "every pitifulest whipster that walks within a skin has his head filled with the notion that he is, shall be, or by all human and divine laws ought to be, 'happy.' "[38]

Ruskin would have sympathized with the poor "pitifulest whipster." In spite of sporadic urges to bury himself in "well-doing," he renounces neither the search for personal happiness nor the attempt to increase both the numerator and the denominator of the life of the ordinary worker. He could never have uttered Carlyle's frantic demand, "Produce! Produce!"—a demand which epitomizes the scarce world of the Protestant ethic and classical economics. This appeal would be out of place in Ruskin's society of abundance where the priorities are a high quality of consumption, a varied leisure, and creative, not simply productive, work. Although a great admirer of Carlyle, Ruskin lives in a different world from that of his "master." No longer should his social criticism be considered Carlylean with a tincture of Ruskinian aesthetics. It is essentially Ruskinian with a tincture of Carlylean authoritarianism and puritanism.[39]

8

At first glance, there seems to be a contradiction between Ruskin's vision of abundance and his calls for retreat from the advances of the

nineteenth century with its belief in progress and production. The contradiction is resolved by the basic principle of his social criticism, the distinction between true and false wealth, vital and exchange value. "There is no Wealth but Life." By life, Ruskin means not a quantitatively satiated existence but a qualitatively satisfying one. He calls for a halt to the spiraling advances in production, speed, population, learning, and the acquisition of money because they are leading not to Utopia but to Kakotopia, not to an "extension of life" but to aesthetic, intellectual, and even physical impoverishment. With Matthew Arnold, he sees the vast "improvements" of the Age of Progress as mere machinery, at best irrelevant, at worst destructive of the quality of life. Since wealth consists of happy, healthy human beings, Ruskin can argue that true abundance will mean a discarding of things often considered wealth. For some people, true wealth will be sesame and lilies. "The sum of enjoyment depends not on the quantity of things tasted, but on the vivacity and patience of taste." In the twentieth century, Simon Patten, Edward A. Ross, John Kenneth Galbraith, and David Riesman would agree with Ruskin. One of the central themes of abundance thinking is the need for "restraint" or "limit." If the society of abundance is not to be destroyed by rampant "overconsumption" and the waste of natural and human resources, consumers must change their habits of spending and learn the value of aesthetic and altruistic pleasure.[40]

Our intention is not to justify Ruskin or absolve him of contradictions but to discover the quality of his thought and the quality of life he wishes man to enjoy. For this purpose, his calls for retreat or restraint have great significance. They go far beyond the point necessary to convince his reader of the difference between true and false wealth. The words peace, rest, calm, and quiet crowd Ruskin's pages as if to remind the reader of the disquiet their author was continually experiencing. In volume three of *Modern Painters,* he describes the art of life:

All real and wholesome enjoyments possible to man have been just as possible to him, since first he was made of the earth, as they are now; and they are possible to him chiefly in peace. To watch the corn grow, and the blossoms set; to draw hard breath over ploughshare or spade; to read, to think, to love, to hope, to pray,—these are the things that make men happy; they have always had the power of doing these, they never *will* have the power to do more. (5.382)

In volume five, Ruskin criticizes "three principal forms of asceti-

cism"–religious, military, and monetary. England is guilty of the last. She might, in fact, become one manufacturing town, "the furnace of the world." "I do not for a moment deny this," Ruskin adds,

but . . . the true perfection of the race, and, therefore, its power and happiness, are only to be attained by a life which is neither speculative nor productive; but essentially contemplative and protective, which . . . does not mortify itself with a view to productive accumulation, but delights itself in peace, with its appointed portion. (7.425)

He urges readers not to trample down the little mosses of the way-side but "to satisfy themselves" and seek "the art and joy of humble life." Volume five concludes on a note worthy of Christopher Marlowe. It is the Devil himself who tempts men to labor, instead of to rest; to possess, instead of to give; to be first, instead of last. The Americans and British, like the ancient Venetians, have succumbed to the Devil. They have become sources of restlessness instead of "Givers of Calm." They have forgotten that the word "State" means literally "the standing and stability of a thing" and that, for a nation to be a true "State," it must be "immovable." It is clear on which arm of Coleridge's balance of "Permanence" and "Progression" Ruskin stands.[41]

These prescriptions of peace might be considered the platitudes of a weary old man if they were not such a pervasive theme in Ruskin's thought, from the "crystal rest" of geology to the "repose" which is "the most unfailing test of beauty" in a work of art. Every appearance of restlessness and effort destroys beauty. Ruskin prefers organic, curvilinear structures to rectilinear ones because rounded surfaces "preserve the serenity" of nature. Reserve, ease, and simplicity are the chief characteristics of the great artist, the true gentleman, and the style of a great painting or poem. No contemplation of beauty is possible except under conditions of mental calm. Ruskin himself looks back on the peace of his childhood as its "best and truest" blessing. In *Praeterita* (1885), he writes, "I never had heard my father's or mother's voice once raised in any question with each other. . . . I had no conception of such a feeling as anxiety. . . ." Often, he expresses the desire of giving up social criticism and going out like a child "into the highways and hedges . . . to take rest."[42]

As his view of childhood suggests, Ruskin's search for peace and happiness leads back through the highways and hedges of a rural England to the ultimate sanctuary. "Backsliding, indeed! I can tell you, on the ways most of us go, the faster we slide back the better.

Slide back into the cradle, if going on is into the grave:—back, I tell you; back—out of your long faces, and into your long clothes!" Ruskin sees in childhood a paradigm of the virtues he values most: simple faith, unselfish charity, and honest self-expression like that of the Gothic craftsman. "It is among children only, and as children only," he writes, "that you will find . . . true wisdom for your teaching. There is poison in the counsels of the *men* of this world. . . . There is death in the looks of men. . . . There is death in the steps of men. . . ." Above all, childhood exemplifies that "happy contentment" and "capacity for wonder" which spring from desiring little and knowing less. Ruskin urges the virtues of "infantine self-satisfaction" on his readers: "You hear much of conversion now-a-days: but people always seem to think they have got to be made wretched by conversion,—to be converted to long faces. No, friends, you have got to be converted to short ones; you have to repent into childhood, to repent into delight, and delightsomeness." Innocent joy and lack of vanity Ruskin sees in Gothic architecture and in the art work of primitive or "childish" nations. He is, in fact, a pioneer in the appreciation of primitive art and the analysis of abstraction in sculpture and design.[43]

This primitive or childhood motif epitomizes the direction of Ruskin's lines of retreat. It provides convincing proof that he sees in the future not only an abundant society but also the drastic psychological changes which abundance might effect. Ruskin's ideal of personality, including the qualities of "free-heartedness," "innocent delight," and "undisturbed trust," is characterized by a flexibility and openness which can be found only in a society where life is not a constant struggle, a society where conditions of scarcity no longer require the "obstinacy" or "rigidity" of the Protestant ethic, a society, in short, which approaches the Gothic "generosity," and permits the "beautiful play," of an abundant childhood. In *Unto This Last*, Ruskin describes the opposing personality types in terms of those who succeed and those who fail in his own society of scarcity. Those who succeed are, "generally speaking, industrious, resolute, proud, covetous, prompt, methodical, sensible, unimaginative, insensitive, and ignorant." Those who remain poor are "the entirely foolish, the entirely wise, the idle, the reckless, the humble, the thoughtful, the dull, the imaginative, the sensitive, the well-informed, the improvident, the irregularly and impulsively wicked, the clumsy knave, the open thief, and the entirely merciful, just and godly person." Al-

though the adjectives are somewhat mixed and certainly old-fashioned, the intent of the passage is clear. In the society of the future, the balance of those who succeed and those who fail will be reversed. This vision joins Ruskin's more personal reactions to give his condemnation of "advertising Protestantism" its prophetic edge. The perversity of Ruskin's genius is apparent. While looking back to a peaceful, childlike life without machinery, he is, at the same time, the first Victorian to grasp the physical and psychological concerns of a society of machine-produced abundance.[44]

Ruskin's vision of a new man raises the question of whether earlier adherents of the child cult might be considered spokesmen for the psychological concerns of an abundant society. There is no "answer" to this question. One can only make tentative suggestions. William Godwin and Robert Owen rest their hopes for the future on abundance. Both describe the ideal man in terms of the trusting unselfishness, the spontaneous expansiveness, and the freedom from anxious striving which characterize the child. Godwin and Owen do not idealize the child to the extent that Ruskin does. For this one must turn to the Romantic poets.[45]

Wordsworth, Blake, and Coleridge view the child as the possessor of spontaneous intuition and generous emotion. Uninhibited by the "frost" of custom, his actions reveal an unselfconscious energy of body and soul. The poets also value tranquillity. They believe that the child shares with nature and domestic animals a happy simplicity and repose. Blake identifies the future era of peace and love on earth with that of "Eternal Childhood." The difference between Ruskin and the poets is that his idealization of the child is set against a background of economic analysis and social criticism which leaves no doubt about its connection with his vision of abundance. One suspects, however, that, below the surface, this connection is at work in the minds of the poets. Ruskin and the poets are sharers in a single enterprise. What the poets do for the literary imagination, Ruskin does for the painter's imagination and the visual sense. In both cases, it is a question of freeing an aspect of man's spirit from the demands of utility, necessity, and convention. It is a question of personal expansion, of cultivating powers and senses for their own sake, not for "any purposes of mere existence," as Ruskin puts it. It is a question of pleasures and emotions which are "an end in themselves" or "theoretic" in the sense of having no function to perform. They are "no means or instrument of life, but an object of life." One

suspects that the Romantic movement as a whole with its rejection of formal restraints and its delight in a sympathetic nature is the result of a relaxation of the walls of necessity—an expansion of that abundance which had hitherto been confined to the upper classes. The Romantic writers are predominantly of middle-class origins. They are the first fruit of the shift in the economics of authorship from aristocratic patronage to reliance on a market of increasingly prosperous middle-class readers.[46]

Ironically, it is the least middle-class and the least prosperous of the poets, William Blake, who most resembles Ruskin in his awareness of the relation between "Plenty" and a return to the "pure" energy and "Eternal Delight" of the child. Blake can express this awareness only in an opaque fashion. Like Wordsworth and Coleridge, he tends in later years to lose sight of the innocent spontaneity of the child. In Blake's case, this is part of a deepening obscurity at all levels and a movement underground in the face of economic and political repression. In the case of Wordsworth, Coleridge, and Southey, it is part of a deliberate abandonment of early revolutionary opinions and a moral ideal of self-realization in favor of political conservatism and an ideal of self-transcending duty. Serenity and peace, once the emblem of natural spontaneity, now become the reassuring sign of political and emotional order. It would not be rash to suggest that the changing economic environment had something to do with these changes in attitude. The strain of the Napoleonic Wars and the industrial revolution, so evident in the early decades of the nineteenth century, must have given a sharp setback to the poets' hope or, better, unconscious feeling that abundance had arrived, a feeling first encouraged by the enthusiasm of the French Revolution at the end of a century of unprecedented commercial expansion. By the 1850's and Ruskin's *Political Economy of Art*, the stresses of the early phase of the industrial revolution had subsided. With the evidence of mid-Victorian prosperity, the sixth sense of abundance could once more become active.[47]

If this interpretation is accurate, one might expect to find Victorians other than Ruskin who hold a vision of the new man. Matthew Arnold comes to mind immediately. The "Hellenism" which Arnold opposes to "Hebraism" as a main constituent of culture involves a harmonious development of all man's "aspirations and powers." Arnold contrasts the "flexibility," the "sweetness and light," the "happiness," and the free "spontaneity of consciousness" of the cultured

man with the narrow "strictness of conscience" of the Hebrew. Arnold believes that English society has emerged from the period of "concentration" or "contraction" of the Napoleonic Wars and is entering upon a period of "expansion" when man can afford to follow his "instinct for expansion" and develop all sides of his nature—his intelligence, his love of beauty, and his "social passion" as well as his "power of conduct" and sense of duty. Arnold is not alone among Ruskin's contemporaries in suggesting a new personality type more suited to an age of expansion or abundance. Samuel Butler's "unconscious knower" might be studied in this light, as might John Stuart Mill's ideal of "human development in its richest diversity." So might William Morris' *News from Nowhere* and Charles Fourier's "phalansterian" man, free to cultivate his instinctual richness.[48]

It is with trepidation that one mentions Karl Marx in the company of Matthew Arnold or even John Ruskin. In his unpublished manuscripts of 1844, Marx tentatively describes the effect which the new era when "all the springs of cooperative wealth flow more abundantly" will have on individual personality. Through the revolutionary act of "expropriating" the exploiting class, man will repossess those energies or powers which, at present, are controlled by an "alien, hostile force"—the usurping capitalist. The result will be a "regaining of self" (*Selbstgewinnung*), a "reintegration or return of man to himself," and the "transcendence of human self-alienation." In this stage of ultimate communism or "positive humanism," man will escape from the realm of necessity to the realm of freedom. Work will become the creative expression of a "totality of human life-activities." Marx's ideal of personal development is remarkably aesthetic in character. The rich man of acquisitive capitalism will be succeeded by "the *rich* man profoundly endowed with all the senses." The relationship of man to nature will no longer be that of exploiter to exploited or possessor to possessed. It will be that of an artist to his material. Man's perceptive faculties will be cleansed of the acquisitive attitude, the "sense of having" (*der Sinn des Habens*). They will be free to pursue their natural ends. To use Arnold's phrase, man will give more attention to "becoming something" than to "having something." Marx's vision of a post-historical, aesthetic man bears a striking resemblance to Ruskin's vision of a nonaggrandizing, noncompulsive man for whom art is the expression of joy in work and nature a source of delight as well as food. Marx and Ruskin

agree with Blake that life in the society of abundance will approach art.[49]

Neither Arnold nor Marx holds consistently to the vision of a new man. The "mixed" environment—part abundance and greater part scarcity—does not encourage sustained optimism. It leads to various forms of distortion and distraction. In Arnold's case, the distortion springs from an anxiety concerning the disruptive effect of releasing human energies. At the individual level, he insists that "conduct" is three fourths of life and collects sayings on duty and work to remind himself of the obligations of the practical world. He also emphasizes the static, almost neoclassical aspect of that inner harmony or perfection which is culture at the expense of the dynamic aspect, the "searching" and "becoming." In other words, he prefers the intellectual to the emotional aspect of culture—the element of control and "standards" to that of spontaneity. At the social level, Arnold's hesitation takes the form of an intense fear of the menace of Jacobinism and a call for the forces of order to restrain lower-class energies.[50]

In the case of Marx, the distortion is really more of a distraction. He never returns to pursue the exciting suggestions of his early manuscripts. The problems of dissecting and changing the old world overshadow the possibilities of the new. Compulsive, even aggrandizing by nature, Marx can indulge only momentarily in dreams of the new man. His early study of alienation in terms of individual personality is transposed entirely and irrevocably to the social realm. "Self-alienation" is objectified or "reified" into the historically determined struggle between Capital and Labor. With the aid of Ricardo, Marx escapes from the "realm of freedom" to that of "necessity." Neither Arnold nor Marx can give full credence to the sixth sense of abundance. In this, they resemble Ruskin, for in his writings no more than in theirs does the sixth sense carry all before it. Ruskin is not one of the new men.[51]

<center>9</center>

So far is Ruskin from being the man of his hopes that his vision of the new man is achieved at the cost of his sanity. Throughout his life, Ruskin is torn between new ideals and old realities. On the one hand, there is the man who has attained the flexibility and openness of a child, the man who is felicitously fulfilling his potentialities, who is able to express frankly his emotions and exercise his talents in happy, creative work. On the other hand, there is the man who views

life as a struggle and work as a painful duty, the man who is afraid to express himself in a niggardly, competitive environment, the man whose life's flow has hardened into the "impotence and rigidity" of moral dogma or economic routine. Ruskin's failure to hold steadfastly to a conception of positive organic growth and spontaneous energy makes his efforts to extricate himself from the "old moral world" less successful than they might otherwise have been. Or, perhaps, the reverse is true: his attachment to the old assumptions and values casts a distorting fault through his organic approach *and* his acceptance of the implications of abundance.

Ruskin lives out painfully the dichotomy of his vision. There is the Ruskin who takes an ecstatic "sensual" delight in the beauties of nature and art and who feels guilty enough about this pleasure to give away his Turners and clothe his art criticism in the garb of moral duty. Again, there is the Ruskin who writes home from Turin: "It is all very well for people to fast, who can't eat; and to preach, who cannot talk nor sing; and to walk barefoot, who cannot ride, and then think themselves good. Let them learn to master the world before they abuse it." At the same time, there is the Ruskin who fails to consummate his marriage and never leaves home. Finally, there is the Ruskin who, following the advanced tendencies of his time, rejects the doctrine of original sin and suggests that the Bible has "no more authoritative claim on our faith than the religious speculations and histories of the Egyptians." At the same time, there is the Ruskin who lives in dread of Satan's power and who mistakes the dictates of an Evangelical conscience for the urgings of a vital "energy." In the struggle between the two sides of Ruskin's nature, the time element is relatively unimportant. The biographer can trace periods when one or the other side dominates, but at no time is the victory a clear one. Every page of Ruskin's work is marked by a struggle conclusive only in insanity.[52]

The two sides of Ruskin's thought confront each other in his educational proposals. If Plato and Xenophon shaped the rhetoric of Ruskin's moral approach to education, the content is his own. It is suitably ambiguous. The meaning of "moral" in Ruskin's writings shifts between two poles. On the one hand, he agrees with Rousseau, Pestalozzi, and Blake that education should follow the child's natural development and encourage the spontaneous expression of his personality. It should be an enjoyable process, "infinitely various" in method, concerned more with stimulating the child's interest or "de-

light" than with disciplining his character or filling his mind. On the other hand, Ruskin is capable of taking a narrow view of education and preaching obedience, humility, and earnestness. His textbooks on geology and botany, while appealing to the child's interest, use the qualities of plants and stones to demonstrate a decidedly bourgeois ethic. Ruskin's comparison of education to the taming of an Alpine torrent is very apt, for Ruskin himself is never certain how closely to "fence" the "channels of early impulse."[53]

Ruskin's moral ambiguity appears more dramatically in his theories of art. The great artist, whom Ruskin often compares to a child, is a paradigm of the new man. He works "instinctively," expressing himself with ease. He is a free spirit, never consciously thinking. Unlike artists of the "purist" schools, whom Ruskin criticizes for narrowness of mind, the great artist has an open, receptive approach to the world. He does not preserve the hard, egotistical core of Blake's "Pebble" but fosters a "wise passiveness" which, "with equal and unoffended vision, can take in the sum of the world,—Straw Street and seventh heaven." His truth is universal, for he can quit his own personality and enter into good and bad, beautiful and ugly. The imaginative vision comes to him spontaneously, like a dream which must be caught. Since he "cannot comprehend the nature of rules," the great artist does not seek to control the "flow" of his vision. The only control exercised over the act of perception and creation is by "the sense and self-control of the whole man"—his quality as a human being. Ruskin describes this quality as "nobility." In order to produce grounds for noble emotions, the artist must himself "feel *nobly* and *strongly.*" He must be "nobly animal" as well as "nobly spiritual." He must realize that the "fountains" of his strength spring from a healthy integration of body and soul. The happiness of the ordinary worker in Ruskin's society of the future differs only in degree from this ideal of "intense humanity."[54]

At times, a different voice speaks from Ruskin's pages, giving the reader a glimpse of the direction in which the artist's "fiery, fantastic energies" are tending. One of the problems in Ruskin's attempt to relate art and morality is the difficulty he encounters in drawing the line between a broad morality of humanism and a narrow morality of religious piety and social respectability. This distinction is necessary if he is to explain the impiety of many great artists. In an unpublished fragment entitled "Notes on a Painter's Profession as Ending Irreligiously," a fragment justly compared with Blake's *Marriage of*

Heaven and Hell, Ruskin plays the devil's advocate in defending the "magnificent Animality" of a great painter.[55] The religious faith of most people, he writes, arises out of "world pain." They are grateful to God "not for what He has given but for what He has promised." No painter can have this sort of faith:

Observe first that a great painter must necessarily be a man of strong and perfect physical constitution. He must be intensely sensitive, active, and vigorous in all powers whatever. . . . Farther, he is gifted by his exquisite sensibility with continual power of pleasure in eye, ear, and fancy; and his business consists, one half of it, in the pursuit of that pleasure, and the other half in the pursuit of facts, which pursuit is another kind of pleasure. . . . (4.385-386)

The great painter will never seek consolation in Heaven for pain suffered on earth. His art is his only consolation, his only joy, and for this everything lies near at hand. He will not try to reform the world, nor will he seek happiness in family life or "simply useful occupations":

For consider the first business of a painter; half, as I have said, of his business in this world must consist in simply seeking his own pleasure, and that, in the main, a sensual pleasure. I don't mean a degrading one, but a bodily, not a spiritual pleasure. Seeing a fine red, or a beautiful line, is a bodily and selfish pleasure, at least as compared with Gratitude or Love—or the other feelings called into play by social action. And moreover, this bodily pleasure must be sought for Itself and Himself. Not for anybody else's sake. Unless a painter works wholly to please himself, he will please nobody;—he must not be thinking while he is at work of any human creature's likings, but his own. . . . But farther . . . our great painter must not shrink in a timid way from any form of vice or ugliness. He must know them to the full, or he cannot understand the relations of beauty and virtue to them. . . . You must be in the wildness of the midnight masque—in the misery of the dark street at dawn . . . on the moor with the wanderer, or the robber—in the boudoir with the delicate recklessness of female guilt—and all this, without being angry at any of these things . . . never even allowing yourself to disapprove of anything that anybody enjoys, so far as not to enter into their enjoyment. . . . Does a man die at your feet—your business is not to help him, but to note the colour of his lips; does a woman embrace her destruction before you, your business is not to save her, but to watch how she bends her arms. Not a specially religious or spiritual business this, it might appear. (4.387-389)

The great painter will express his abundant physical life in a bold, easy fashion. He will not be concerned with perfect finish or polish but will finish sufficiently to express his "idea" and, like a child, go on to something else. He will avoid the "undue regard for appearances" which is a sign of mechanism and vulgarity. His work will share with Gothic a roughness of handling which Ruskin describes as

peculiarly masculine. In a similar vein, the great architect will empha-
size the "weight" of masses of light and shadow at the expense of
delicacy of line. In "The Lamp of Power" in *The Seven Lamps,*
Ruskin praises the Byzantine treatment of light and shadow as "in-
contestably more grand and masculine" than the "artful" arrange-
ments of line which characterize Greek architecture. Although he
describes the Byzantines as barbaric in comparison with the Greeks,
he sees "a power in their barbarism of sterner tone . . . which con-
ceived and felt more than it created." Ruskin believes that his great-
est achievement is the discovery of the substitution of line for mass
which signalled the decline of Gothic.[56]

On the other side of the artistic ledger is Ruskin's own "purism."
In his criticism of art, he frequently confuses a broad, humanistic
morality with the narrow ideal of Victorian respectability. The nobil-
ity of the great artist whose "virtue" is life becomes the nobility of
the bourgeois gentleman whose "virtue" is conduct. Ruskin's
theories imply that excellence in art is relative to the artist's unique
"formative energy" and to the ethos of his society. "All good art is
the natural utterance of its own people in its own day." Ruskin's
practice implies that he alone can perceive right and wrong and de-
cide which emotions or impulses are worthy of expression. As Henry
Ladd remarks, he considers the sexual instinct irrelevant to art. It is
blind, mechanical, bestial—one of the "transient instincts of the
blood." He minimizes the sensual appeal of Greek art and attributes
the Greeks' achievements to moral discipline. Even the Venetians'
sensuality led to the degradation of Venetian art. All aspects of
human life considered "low" are dismissed from art: nudity, poverty,
violent passion, the actual life of the "lower orders." Ruskin con-
demns the worldliness of French painting and neglects the Impression-
ists whose principles he foreshadows in his defense of Turner and in
The Elements of Drawing (1857). Finally, while Ruskin criticizes
modern English art and life for its "petty neatness," its "shrivelled
precision"—in short, its lack of Gothic roughness and its concern for
line over mass—he himself emphasizes the intricately carved decora-
tions of Gothic architecture, praises the minute accuracy of the Pre-
Raphaelites, criticizes the "seemingly careless and too rugged lines"
of Browning's poetry, and, in later years, considers the "genteel" line
drawings of Kate Greenaway great art.[57]

The discordant views of man and life which blunt Ruskin's artistic
precepts have a disturbing effect on the meaning of words crucial to

his thought. The most important of these is "purity." "Pure," in Ruskin's vocabulary, is synonymous with "good" and used as frequently. Purity is the highest quality of the gentleman, the great artist, the healthy society, the well-composed painting, the mineral crystal, and the unpolluted stream. Purity means far more than spotlessness. It is a condition of organic wholeness in which all the parts of a thing or all the faculties of a person or all the citizens of a state function in harmony. It depends on the inherence of the vital energy which pervades the universe and prevents the dissolution of death or the "dullness" of living death. This energy is the medium which enables the imagination to connect with, sympathize with, or enter into the object of its contemplation, whether nature or man. An "organic" connection is what Ruskin means by "love." He believes that one can perceive and create beauty only through love and that the solution to society's ills is an imaginative sympathy or "energy of Love" on the part of all men. He describes this love as the "vital function" of our being.[58]

The difficulty with Ruskin's terminology is that he is using the common words of Victorian piety—purity, love, sympathy, charity— and giving them a vitalistic or naturalistic meaning which they never had for the ordinary Victorian. The greater difficulty is that Ruskin himself often suppresses the spontaneous, dynamic implications of his thought and adopts a static organicism which lures him back into the common usage. Purity becomes the spotlessness and cleanliness of Victorian moral prudery, and love, the ethereal emotion of Victorian romance or condescending charity. "Nobility" loses its biological connotation of "purity of race" and "felicitous fulfilment of function." It becomes the narrow chivalry of bourgeois respectability. Ruskin fails to hold to his conviction that "a man may be moral and yet do a great many things that would be disapproved of by Mrs. Grundy."[59]

Ruskin's moral dilemma elucidates the more confusing aspects of his writing. His hostility to machinery owes much to his partial capture by the prejudices of traditional respectability. So does his refusal to examine the recent discoveries of science, including evolution. Ruskin tends to repress his sense of the "morbid mystery and softness" of material nature and to bury the vitalistic implications of "purity" in the Biblical notion of "pure in heart." Finally, Ruskin's failure to realize fully the view of love as organic "energy" inspires his authoritarian approach to social reform. He retreats to the narrow

concept of gentleman and refuses to consider the worker an equal. Ruskin's ideal of peace and childhood contains suggestions of social paternalism and repression as well as hopes for a new man not bound by the restless striving of the Protestant ethic. It is an important battle which Ruskin wages within the confines of "purity" and "love." One wonders whether he did not select the words for camouflage.[60]

In the end, Ruskin's conflict springs from a fear of his own impulses. He both desires and fears the freedom, flexibility, and personal expansion which the society of abundance will make possible for man. Although brilliantly foreseeing this society and the ideal of personality which it may entail, he cannot with equanimity apply the vision to himself. He cannot accept the private abundance provided him by his father's sherry trade without pangs of guilt and fear of mismanaging the torrent of his talents and instincts. A loss of control is not unexpected. Ruskin travels down the road to "mountain gloom" many times before the final journey, testing the ground and the dangers. In published and unpublished passages, he explores the dynamics of the terrible, the dreadful, and the grotesque in art and life. His intention is to draw the line between a healthy and a morbid love of horror or, as he puts it with tragic accuracy, to "define the limits of insanity." Ruskin fears the hour when the "pure" energy of his life will flow out of control in the rapids of "impurity." He fears the hour when his voice will be drowned by the roaring of the machine and his vision blinded by the sulphurous plague-wind, "a wind of darkness . . . panic struck, and feverish." To avert disaster, Ruskin calls on the forces of order and authority to channel the purity of energy into the narrows of purism, or, in words more relevant to society, to organize organicism. The "Lord of Waste," the "Evil One," who polluted the Wandel springs of Ruskin's psyche, was not to be defeated so easily.[61]

Epilogue

The problem of Ruskin's influence remains. But now, at least, the stage has been set. Ruskin's social and economic ideas have been discussed in terms of their source in his personal concerns, in terms of their own development, and in terms of their originality. It should be clear that what is unique about the cathedral of Ruskin's thought is not the separate fragments of which it is composed but the Gothic wholeness of the result. Like a master-architect, Ruskin creates an original whole out of unoriginal parts by infusing into them a new life or "energy." The form which this "energy" takes is his perception of abundance. This perception or frame of reference allows him to skip, like a random electric charge or, more aptly, like a water spider, from one element of his social criticism to another without destroying the unity of the whole. Indeed, it is the ability to keep "all his irons in the fire," to use Charles Eliot Norton's phrase, which makes Ruskin an astute propagandist. The reader of any of his later works, from the bedside companion *Sesame and Lilies* to the more recondite letters of *Fors Clavigera,* finds himself magically placed in the center of Ruskin's vision. The most ephemeral product of Victorian civilization—if it suffers the misfortune of attracting Ruskin's attention—has the effect on his mental processes which a pebble thrown into a lake has on the surface of the water. The vibrations expand concentrically to include a criticism of the "vital cost" of industrial work, habits of consumption, educational practices, the quantitative production-bias of classical economics, and the competition and exploitation which divert the streams of social abundance.

This habit of mind is very contagious. Ruskin's greatness as a writer lies in his ability to diffuse a pattern of perception as well as a set of ideas. This may explain the disconcerting tendency of important figures in the early twentieth century, Clement Attlee in England, Charles Beard in America, and Mahatma Gandhi in India, to cite Ruskin as one of the chief influences on their thought and, at the same time, to be very vague in mentioning his specific criticisms or proposals. The degree of Ruskin's influence upon these men and upon others more commonly associated with his name, William Morris, Arnold Toynbee, John A. Hobson, William Smart, Patrick

Geddes, and the Guild Socialists, remains to be determined. So does the question of whether the wholeness and aesthetic quality of his perception survived the secular, sociological, and scientific sea-change which the language of social criticism underwent around the turn of the century. Hobson's work would be an excellent test case, but this lies in the future.[1]

Although the problem of Ruskin's influence on twentieth-century intellectuals, politicians, and working-class leaders is important, a more interesting question concerns the present relevance of Ruskin's ideas. At first glance, one would suspect that the work of a man who not only saw the implications of abundance as early as did Ruskin but also distinguished between quality and quantity in a way that has seldom been equalled would have great relevance. And, certainly, it does in this period when the middle and upper classes of the United States and western Europe are surfeited with comforts while large segments of the lower classes in these countries and the vast majority of the earth's inhabitants have difficulty finding the necessities of life. More than a hundred years after Ruskin turned to social criticism, the battle of abundance has still to be won for most men, not because of lack of resources and population growth, although Malthus may yet be proven right, but because of the mismanagement of resources presently available. The point has been reached when Ruskin's calls for retreat in technology, urbanization, and population are no longer the counsels of nostalgia or aesthetic preference but the demands of necessity if man is to avoid an ecological catastrophe. Even Ruskin's attacks on the accumulation of knowledge seem less wrong-headed today when the "vital cost" of the misuse of science has been demonstrated to be unacceptably high and when much of the Western world's scholarly work has become a form of retrospective cultural imperialism carried on to justify the business of education. As for Ruskin's critique of the wastefulness of war and armaments in an age of potential abundance, one feels at a loss for words. It should be evident that Ruskin's have served no purpose. If Ruskin were alive and sane, he would probably conclude that his reliance on the moral "word" was misguided. He might even agree with Southey's tragically astute observation that, if war were ever abolished, it would be the result not of moral conviction but of terror at the tremendous powers of destruction invented by man. What was considered pessimism in Southey's day has become the wildest optimism in the second half of the twentieth century.[2]

Appearances, or harsh realities, notwithstanding, Ruskin's rele-

vance has not survived a century of change unimpaired. His relevance is to the "old world," the world of public or political idealism, with its goals of peace and abundance for all. These goals can be traced to the period of the French Revolution when the attainment of "happiness" ceased to be the prerogative of the noble or rich. Today, with the ideals of the "old world" closer to realization than ever before, many men are rejecting these ideals as somehow demeaning. They seek their dignity not in happiness or pleasure but in a radical denial of the possibility or value of happiness. They take their cue from Dostoevski's "underground man," not from Ruskinian man working happily in an environment of social cooperation and abundance. Today, the "underground man," who asserts with pride that he will never be happy in the ideal society and who considers this a sign of his superiority, is too much in evidence to be considered "underground." Logically, he is pursuing some form of happiness, but his definition of it is framed in conscious opposition to the usual definition or even to a Ruskinian one. The *real* new man seems determined to achieve fulfillment through suffering and demands to be free to create the conditions of his suffering.[3]

The sources and implications of this change are difficult to determine. Perhaps, it is a passing phenomenon—a sign of disillusionment with the physical and psychological results of machine-produced abundance. If this is the case, Ruskin's emphasis on quality in consumption and creativity in work are very relevant. The attitude of the "underground man," however, is more complicated than this. He seems minimally susceptible to qualitative changes in the definition of happiness. Indeed, the true spring of his attitude may lie at a level where Freud's *Beyond the Pleasure Principle* would be a useful guide. If the sources of the change are difficult to assess, so is its direction. An assertion of human dignity or freedom which takes the form of a denial of man's attempt to better his condition is hardly a permanent state. Whether it will lead to a more positive form of spirituality or a resigned acceptance of public attempts to improve the quality of life or a combination of the two remains to be seen. The latter seems most probable. Many men already hold in a strange, unreconciled tension both a personal rage against the presumptuous attempt of social systems to make them happy and an unenthusiastic acceptance of the social ideals of abundance. Whatever its goal, this unexpected change in attitude toward "happiness" explains a common reaction to Ruskin's best writing: "How true, but it doesn't really matter."

To put it another way, what Ruskin's social criticism lacks for many readers is a quality of toughness or invincibility which sends one away unsatisfied and yet calls one back again and again. This quality does not spring from style alone. It is not a matter of "difficultness" but of outlook and approach to life. It is best described as a sense of tragedy or radical evil, a sense that there is something fundamentally out-of-joint in man's relation to his world, his fellow man, and himself. In his own life and in those lengthy portions of his work which are personal or confessional, Ruskin evinces such a sense. His struggle with the "Evil One," the "Destroyer," lies behind his moral dilemma and his ambiguous vision of the "new man." But Ruskin cannot bring this sense of mysterious and thwarting evil to the center of his constructive proposals. As if in reaction, he describes an ideal society where men cooperate harmoniously and realize their potentialities happily—a world in which men remain in Blake's state of "innocence" without passing through the shadows of "experience." To discover that this is not the world in which Ruskin dwells, the reader must tune to his private, not his public voice. Ruskin's struggle with the powers of evil is so intense that he cannot afford to grant them public recognition. His private tragedy is so acute that he cannot assimilate it to the rest of his experience and fashion out of it public or social tragedy.

The division between Ruskin's public and private voice explains the fascination which his personal life has exercised over readers in the twentieth century. Unable to find a toughness in his public guise, they turn to his private voice and find there a source of inexhaustible complexity. Divided themselves between a public role in which they propound a social idealism similar to Ruskin's and a private role in which their discontents are as relevant to the problems of an abundant society as Ruskin's "Evil One," they identify with Ruskin as one who shared their inner division. He was fortunate enough to make the private self public with little distortion or sublimation— without making it truly public. And so readers turn to Ruskin for the accuracy with which he portrays, not the division between the public and private sectors in an economy of abundance, but the division between the public and private sectors in the spiritual economy of modern man who wants what he does not want and does not want what he wants.

Selected Bibliography

Notes

Index

Selected Bibliography

The original sources on which my interpretation of Ruskin is based are amply cited in the notes. So are many secondary works of specific interest. The following books and articles will assist the reader wishing to pursue certain problems in more detail.

Among studies of Ruskin, I found these to be most useful:

Buckley, Jerome Hamilton. "The Moral Aesthetic," in *The Victorian Temper: A Study in Literary Culture.* Cambridge, Massachusetts: Harvard University Press, 1951.

Burd, Van Akin. "Ruskin's Quest for a Theory of Imagination," *Modern Language Quarterly,* XVII (March 1956), 60-72.

Fain, John Tyree. *Ruskin and the Economists.* Nashville, Tennessee: Vanderbilt University Press, 1956.

Goetz, Sister Mary Dorothea. *A Study of Ruskin's Concept of the Imagination.* Washington, D.C.: The Catholic University of America, 1947.

Hobson, John A. *John Ruskin: Social Reformer.* Boston, 1898.

Hough, Graham. "Ruskin," in *The Last Romantics.* London: Gerald Duckworth & Co., 1949.

Ladd, Henry. *The Victorian Morality of Art: An Analysis of Ruskin's Esthetic.* New York: Ray Long & Richard R. Smith, 1932.

Leon, Derrick. *Ruskin: The Great Victorian.* London: Routledge & Kegan Paul, 1949.

LeRoy, Gaylord C. "John Ruskin," in *Perplexed Prophets: Six Nineteenth-Century British Authors.* Philadelphia: University of Pennsylvania Press for Temple University Publications, 1953.

Roe, Frederick William. *The Social Philosophy of Carlyle and Ruskin.* New York: Harcourt, Brace & Co., 1921.

Rosenberg, John D. *The Darkening Glass: A Portrait of Ruskin's Genius.* New York: Columbia University Press, 1961.

Spence, Margaret E. "The Guild of St. George: Ruskin's Attempt to Translate His Ideas into Practice," *Bulletin of the John Rylands Library,* XL (September 1957), 147-201.

Sussman, Herbert L. "Art and the Machine: John Ruskin," in *Victorians and the Machine: The Literary Response to Technology.* Cambridge, Massachusetts: Harvard University Press, 1968.

Townsend, Francis G. *Ruskin and the Landscape Feeling: A Critical Analysis of His Thought During the Crucial Years of His Life, 1843-56.* (Illinois Studies in Language and Literature, Vol. XXXV, No. 3) Urbana, Illinois: University of Illinois Press, 1951.

Viljoen, Helen Gill. *Ruskin's Scottish Heritage: A Prelude.* Urbana, Illinois: University of Illinois Press, 1956.

Wilenski, R. H. *John Ruskin: An Introduction to Further Study of His Life and Work.* London: Faber & Faber, 1933.

Often overlooked are the informative and perceptive introductions penned by E. T. Cook and Alexander Wedderburn, editors of the Library Edition of *The Works of John Ruskin* (39 v. London: George Allen & Unwin, Ltd., 1903-1912).

The best way to enter into the background of Ruskin's thought is to read the original sources which Ruskin himself read. From the many books and articles on Romanticism, I found these helpful in clarifying crucial issues:

Abrams, Meyer H. *The Mirror and the Lamp.* New York: Oxford University Press, 1953.

Babenroth, A. Charles. *English Childhood: Wordsworth's Treatment of Childhood in the Light of English Poetry.* New York: Columbia University Press, 1922.

Baker, Herschel. *William Hazlitt.* Cambridge, Massachusetts: Harvard University Press, 1962.

Baker, James Volant. *The Sacred River: Coleridge's Theory of the Imagination.* Baton Rouge, Louisiana: Louisiana State University Press, 1957.

Bate, Walter Jackson. *Coleridge.* New York: Macmillan, 1968.

_____ "The Sympathetic Imagination in Eighteenth-Century Criticism," *ELH,* XII (1945), 144-164.

Brinton, Crane. *The Political Ideas of the English Romanticists.* London: Oxford University Press, 1926.

Bullitt, John M. "Hazlitt and the Romantic Conception of Imagination," *PQ,* XXIV (1945), 345-361.

Calleo, David P. *Coleridge and the Idea of the Modern State.* New Haven: Yale University Press, 1966.

Carnall, Geoffrey. *Robert Southey and his Age: The Development of a Conservative Mind.* Oxford: Clarendon Press, 1960.

Chapman, Gerald W. *Edmund Burke: The Practical Imagination.* Cambridge, Massachusetts: Harvard University Press, 1967.

Cobban, Alfred. *Edmund Burke and the Revolt against the Eighteenth Century: A Study of the Political and Social Thinking of Burke, Wordsworth, Coleridge, and Southey.* London: Allen & Unwin, 1929.

Eastlake, Charles L. *A History of the Gothic Revival.* London, 1872.

Frye, Northrop. *Fearful Symmetry.* Princeton: Princeton University Press, 1947.

Haller, William. "Southey's Later Radicalism," *PMLA,* XXXVI (June 1922), 281-292.

Harrold, Charles Frederick. *Carlyle and German Thought: 1819-1834.* (Yale Studies in English, LXXXII) New Haven: Yale University Press, 1934.

Kennedy, William F. *Humanist versus Economist: The Economic Thought of Samuel Taylor Coleridge.* (University of California Publications in Economics 17) Berkeley: University of California Press, 1958.

Kennedy, Wilma L. *The English Heritage of Coleridge of Bristol 1798: The Basis in Eighteenth-Century English Thought for His Distinction between Imagination and Fancy.* New Haven: Yale University Press, 1947.

Lovejoy, Arthur O. *Essays in the History of Ideas.* Capricorn Book ed. New York: G. P. Putnam's Sons, 1960.

Lyon, Judson S. *The Excursion: A Study.* New Haven: Yale University Press, 1950.

MacLean, Kenneth. "The Water Symbol in *The Prelude* (1805-06)," *University of Toronto Quarterly,* XVII (July 1948), 372-389.

McKenzie, Gordon. *Organic Unity in Coleridge.* Berkeley: University of California Press, 1939.

Needham, H. A. *Le développement de l'esthétique sociologique en France et en Angleterre.* Paris: H. Champion, 1926.

Rader, Melvin M. *Wordsworth: A Philosophical Approach.* Oxford: Clarendon Press, 1967.

Richards, I. A. *Coleridge on Imagination.* Bloomington, Indiana: Indiana University Press, 1960.

Sanders, C. R. *Coleridge and the Broad Church Movement.* Durham, North Carolina: Duke University Press, 1942.

Schorer, Mark. *William Blake: The Politics of Vision.* New York: H. Holt and Company, 1946.

Tennyson, G. B. *Sartor Called Resartus.* Princeton: Princeton University Press, 1965.

Thrall, Miriam. *Rebellious Fraser's: Nol Yorke's Magazine in the Days of Maginn, Thackeray, and Carlyle.* New York: Columbia University Press, 1934.

Trilling, Lionel. *Matthew Arnold.* New York: Columbia University Press, 1949.

Williams, Raymond. *Culture and Society, 1780-1950.* Garden City, New York: Harper & Row, Publishers, 1960.

Williamson, Eugene L. *The Liberalism of Thomas Arnold: A Study of His Religious and Political Writing.* Tuscaloosa, Alabama: University of Alabama Press, 1964.

Woodring, Carl Ray. *Politics in English Romantic Poetry.* Cambridge, Massachusetts: Harvard University Press, 1970.

The problems of scope and method in economics lose their sting upon acquaintance. The following books and articles establish a setting for Ruskin's criticism of the classical economists:

Blaug, Mark. *Ricardian Economics: A Historical Study.* New Haven: Yale University Press, 1958.

Coats, Alfred W. "The Historist Reaction in English Political Economy," *Economica,* New Series, Vol. XXI, No. 82 (May 1954), 143-153.

Cropsey, Joseph. *Polity and Economy: An Interpretation of the Principles of Adam Smith.* The Hague: M. Nijhoff, 1957.

Furniss, Edgar S. *The Position of the Laborer in a System of Nationalism: A Study in the Labor Theories of the Later English Mercantilists.* Boston: Houghton Mifflin Company, 1920.

Gide, Charles and Rist, Charles. *A History of Economic Doctrines.* B. Richards, trans. 2d ed. Boston: D. C. Heath and Company, 1949.

Halévy, Élie. *The Growth of Philosophic Radicalism.* Mary Morris, trans. London: Faber & Gwyer, 1949.

Hutchison, T. W. *Positive Economics and Policy Objectives.* Cambridge, Massachusetts: Harvard University Press, 1964.

Laistner, M. L. W., trans. *Greek Economics.* London: J. M. Dent & Sons, Ltd., 1923.

Mitchell, Wesley C. *Types of Economic Theory.* Joseph Dorfman, ed. New York: Kelley, 1967.

Myint, Hla. *Theories of Welfare Economics.* London: Longmans, Green & Co., 1948.

Myrdal, Gunnar. *The Political Element in the Development of Economic Theory.* Cambridge, Massachusetts: Harvard University Press, 1954.

Robbins, Lionel. *The Theory of Economic Policy in English Classical Political Economy.* London: Macmillan, 1952.

Robinson, Joan. *Essay on Marxian Economics.* 2d ed. London: Macmillan, 1966.
Schmoller, Gustav von. *The Mercantile System.* New York, 1896.
Schumpeter, Joseph. *History of Economic Analysis.* New York: Oxford University Press, 1954.
Small, Albion W. *The Cameralists.* Chicago: The University of Chicago Press, 1909.
Taylor, O. H. *A History of Economic Thought.* New York: McGraw-Hill, 1960.

A more specific problem concerns the decline of the labor theory of value and the development of a utility analysis stressing subjective demand. The following works are useful for the period before the rise of the marginal utility school. They help one understand the significance of Ruskin's much neglected suggestions on value theory:

Bell, John Fred. *A History of Economic Thought.* New York: Ronald Press, 1953. esp. pp. 243-295.
Bowley, Marian. *Nassau Senior and Classical Economics.* London: George Allen & Unwin, Ltd., 1937.
Howey, R. S. *The Rise of the Marginal Utility School.* Lawrence, Kansas: University of Kansas Press, 1960.
Hutchison, T. W. *A Review of Economic Doctrines, 1870-1929.* Oxford: Clarendon Press, 1953.
Roll, Eric. *A History of Economic Thought.* New York: Prentice-Hall, Inc., 1942. esp. pp. 348-411.
Taylor, W. L. *Francis Hutcheson and David Hume as Predecessors of Adam Smith.* Durham, North Carolina: Duke University Press, 1965.
Whittaker, E. *A History of Economic Ideas.* New York: Longmans, 1940. esp. pp. 416-445.
Worland, Stephen Theodore. *Scholasticism and Welfare Economics.* Notre Dame, Indiana: University of Notre Dame Press, 1967. esp. chs. i and viii.

The critique of Say's Law and the diagnosis of crises due to a disproportion between consumption and production form a relatively unexplored branch of early economics. The following, more detailed references will be of use to the reader wishing to pursue the history of "underconsumption" thinking:

Primary

Berkeley, George. *The Querist, containing Several Inquiries proposed to the Consideration of the Public, 1735-37.* Baltimore, 1910.
Chalmers, Thomas. *On Political Economy in Connexion with the Moral State and Moral Prospects of Society.* New York, 1832.
Cobbett, William. *Political Register* (11/30/16), cols. 362-392.
Coleridge, Samuel Taylor. *A Lay Sermon, The Complete Works of Samuel Taylor Coleridge.* W. G. T. Shedd, ed. (7 v. New York, 1884), VI, 172-176, 180-181.
Craig, John. *Elements of Political Science.* Edinburgh, 1814.
Laurie, David. *A Treatise on Finance.* Glasgow, 1815.
Ludlow, John M. *Christian Socialism and Its Opponents: A Lecture.* London, 1851.
Maitland, James, Earl of Lauderdale. *An Inquiry into the Nature and Origin of Public Wealth, and into the Means and Causes of its Increase.* 2d ed. Edinburgh, 1819. esp. pp. 208-271, 342-348.

Malthus, Thomas R. *Principles of Political Economy Considered with a View to their Practical Application.* Boston, 1821. esp. pp. 284-376, 413-435.

Mandeville, Bernard de. *The Fable of the Bees: or, Private Vices, Publick Benefits.* F. B. Kaye, ed. 2 v. Oxford: Clarendon Press, 1924.

Mill, John Stuart. *Essays on Some Unsettled Questions of Political Economy.* London, 1844. ch. ii.

Moffat, Robert Scott. *The Economy of Consumption: An Omitted Chapter in Political Economy.* London, 1878.

Owen, Robert. *A New View of Society and Other Writings.* Everyman's Library ed. London: J. M. Dent & Sons, 1907.

Rodbertus, Karl. *Overproduction and Crises.* Julia Franklin, trans. London, 1898.

Sismondi, J. C. L. Simonde de. *Nouveaux principes d'économie politique, ou de la richesse dans ses rapports avec la population.* 2 v. Paris, 1819. esp. Vol. I, Bk. IV.

Spence, William. *Tracts on Political Economy.* London, 1822.

Steuart, Sir James. *An Inquiry into the Principles of Political Oeconomy: Being an Essay on the Science of Domestic Policy in Free Nations.* 2 v. London, 1767. esp. I, 197-245, 321, 470-491.

Thompson, William. *An Inquiry into the Principles of the Distribution of Wealth most conducive to Human Happiness.* London, 1824.

Secondary

Ambirajan, S. *Malthus and Classical Economics.* Bombay, 1959. ch. ix.

Beer, Max. *A History of British Socialism.* 2 v. London: G. Bell and Sons, 1919. esp. I, 314-318.

Bowman, Mary J. "The Consumer in the History of Economics," *American Economic Review,* XLI (May 1951), Suppl. 1-18.

Dobb, Maurice. *Political Economy and Capitalism: Some Essays in Economic Tradition.* London: G. Routledge & Sons, 1937.

Hutchison, T. W. "Berkeley's *Querist* and Its Place in the Economic Thought of the Eighteenth Century," *The British Journal for the Philosophy of Science,* IV (1953), 52-77.

Macgregor, D. H. *Economic Thought and Policy.* London: Oxford University Press, 1949.

Nemmers, E. E. *Hobson and Underconsumption.* Amsterdam: North-Holland Publishing Co., 1956.

O'Leary, J. J. "Malthus and Keynes," *Journal of Political Economy,* III (November 1942), 901-919.

Paglin, Morton. *Malthus and Lauderdale: The Anti-Ricardian Tradition.* New York: A. M. Kelley, 1961. chs. iv and vi.

Robinson, Joan. "Marx on Unemployment," *Economic Journal,* LI (1941), 234-248.

Schumpeter, Joseph. *History of Economic Analysis.* New York: Oxford University Press, 1954. esp. pp. 170-178, 207-208, 749.

Seligman, Edwin R. A. "On Some Neglected British Economists," *Economic Journal,* XIII (1903), 335-363, 511-535.

Sen, S. R. *Economics of Sir James Steuart.* Cambridge, Massachusetts: Harvard University Press, 1957.

Tuan, Mao-Lan. *Simonde de Sismondi as an Economist.* New York: Columbia University Press, 1907.

My interpretation of Ruskin's position on the more familiar topics of social criticism—competition, exploitation, war, democracy, welfare—springs from a reading of his works in conjunction with those of the major figures: Blake, Coleridge, Wordsworth, Southey, Owen, Carlyle, Thomas Arnold, Matthew Arnold, John Stuart Mill, and Dickens. In addition, there are the writings of less well-known critics who anticipate Ruskin on a remarkable range of subjects:

Primary

Bray, John Francis. *Labour's Wrongs and Labour's Remedy: or, The Age of Might and the Age of Right.* Leeds, 1839.

_____ *A Voyage from Utopia.* London: Lawrence and Wishart, 1957.

Cobbett, William. *A History of the Protestant Reformation in England and Ireland.* London, 1824.

_____ *The Opinions of William Cobbett.* G. D. H. and Margaret Cole, eds. London: The Cobbett Publishing Co., Ltd., 1944.

_____ *Rural Rides.* G. D. H. and Margaret Cole, eds. 3 v. London: J. M. Dent & Sons, 1930.

Combe, Abram. *Metaphorical Sketches of the Old and New Systems.* n.p., 1823.

De Quincey, Thomas. *The Logic of Political Economy.* Edinburgh, 1844.

Disraeli, Benjamin. *Sybil, or the Two Nations.* London, 1845.

Fichte, Johann Gottlieb. *Die Geschlossene Handelstadt.* Vienna, 1801.

Fourier, Charles. *Selections from the Works of Fourier.* Julia Franklin, trans. London: S. Sonnenschein & Co., lim., 1901.

Godwin, William. *Enquiry Concerning Political Justice and Its Influence on Morals and Happiness.* F. E. L. Priestley, ed. 3 v. Toronto, 1946 (reprinted from the 3rd ed. 1798).

_____ *Of Population.* London, 1820.

Gray, John. *A Lecture on Human Happiness.* London, 1825.

Gray, Simon. *The Happiness of States.* London, 1815.

Hall, Charles. *The Effects of Civilization on the People in European States.* Phoenix Library ed. London, 1801.

Hazlitt, William. *A Reply to the Essay on Population, by the Rev. T. R. Malthus.* London, 1807.

Helps, Arthur. *The Claims of Labour.* 2d ed. London, 1845.

Hodgskin, Thomas. *Labour Defended Against the Claims of Capital.* G. D. H. Cole, ed. London: Workers' Library, ser. 1, 1922.

_____ *Popular Political Economy, from lectures delivered at the London Mechanic's Institution.* London, 1827.

Lalor, John. *Money and Morals.* London, 1852.

Marx, Karl. *The Economic and Philosophic Manuscripts of 1844.* Moscow, 1959.

Maurice, Frederick Denison and Ludlow, John M., eds. *Politics for the People.* No. 1-17 (May-July 1848).

Maurice, Frederick Denison. *Reasons for Cooperation: A Lecture: Delivered at the Office of the Society for Promoting Working Men's Associations.* London, 1851.

Morgan, John Minter. *The Revolt of the Bees.* London, 1826.

Ogilvie, William. *Essay on the Right of Property in Land.* 1782. Reprinted with notes by D. C. MacDonald as *Birth-right in Land.* London, 1891.

Owen, Robert Dale. *An Outline of the System of Education at New Lanark.* Glasgow, 1824.

Paine, Thomas. *Rights of Man: Being an Answer to Mr. Burke's Attack on the French Revolution.* Everyman's Library ed. London: J. M. Dent & Sons, 1915.

Ravenstone, Piercy. *A Few Doubts as to the Correctness of some Opinions Generally Entertained on the Subjects of Population and Political Economy.* London, 1821.

Sismondi, J. C. L. Simonde de. *Études sur l'économie politique.* 2 v. Paris, 1838.

Smith, Toulmin. *English Guilds.* London, 1870.

Spence, Thomas. *End of Oppression.* London, 1795.

Thompson, William. *Labour Rewarded.* London, 1827.

_____ *Practical Directions for the Speedy and Economical Establishment of Communities on the Principle of Mutual Cooperation, United Possessions and Equality of Exertions and of the Means of Enjoyments.* Cork, 1830.

Wallace, Robert. *Various Prospects of Mankind, Nature, and Providence.* London, 1761.

Whately, Richard. *Introductory Lectures on Political Economy.* London, 1831.

Williams, David. *Lectures on Education.* 3 v. London, 1789.

Secondary

Albrecht, William P. *William Hazlitt and the Malthusian Controversy.* Albuquerque, New Mexico: The University of New Mexico Press, 1950.

Armytage, W. H. G. *Heavens Below: Utopian Experiments in England 1560-1960.* London: Routledge & Kegan Paul, 1961.

Boner, Harold A. *Hungry Generations: The Nineteenth-Century Case Against Malthusianism.* New York: King's Crown Press, 1955.

Christensen, Torben, *Origin and History of Christian Socialism 1848-54.* Copenhagen: Aarhus, Universitetsforlaget, 1962.

Cole, G. D. H. *A History of Socialist Thought: The Forerunners, 1789-1850.* London: Macmillan, 1955.

Driver, Cecil. *Tory Radical: The Life of Richard Oastler.* London: Oxford University Press, 1946.

Halévy, Élie. *Thomas Hodgskin.* A. J. Taylor, trans. London: Benn, 1956.

Manuel, Frank E. *The Prophets of Paris.* Cambridge, Massachusetts: Harvard University Press, 1962.

Menger, Anton. *The Right to the Whole Produce of Labour.* London, 1899.

Monro, D. H. *Godwin's Moral Philosophy.* London: Oxford University Press, 1953.

Mueller, Iris, W. *John Stuart Mill and French Thought.* Urbana, Illinois: University of Illinois Press, 1956.

Rudkin, Olive D. *Thomas Spence and his Connections.* London: George Allen & Unwin, Ltd., 1927.

Schoyen, A. R. *The Chartist Challenge: A Portrait of George Julian Harney.* London: Heinemann, 1938.

Stewart, W. A. C. and McCann, W. P. *The Educational Innovators 1750-1880.* London: Macmillan, 1967.

Thompson, Edward P. *The Making of the English Working Class.* London: Gollancz, 1964.

The eighteenth-century school of Scottish social theorists also demands further attention. It is seldom realized how many later themes find their first disguised expression here:

Primary

Ferguson, Adam. *An Essay on the History of Civil Society.* 2d ed. London, 1768.

_____ *Principles of Moral and Political Science.* 2 v. Edinburgh, 1792.

Hume, David. *Essays, Moral, Political, and Literary.* T. H. Green and T. M. Grose, eds. 2 v. London, 1875.

Hutcheson, Francis. *An Essay on the Nature and Conduct of the Passions and Affections.* London, 1730.

_____ *Reflections upon Laughter and Remarks upon the Fable of the Bees.* Glasgow, 1750.

_____ *A Short Introduction to Moral Philosophy.* 2d ed. Glasgow, 1753.

Millar, John A. *The Origin of the Distinction of Ranks; or an Inquiry into the Circumstances which give Rise to Influence and Authority in the Different Members of Society.* Edinburgh, 1771.

Smith, Adam. *An Inquiry into the Nature and Causes of the Wealth of Nations.* J. R. McCulloch, ed. London, 1875.

_____ *The Theory of Moral Sentiments.* London, 1759.

Stewart, Dugald. *Elements of the Philosophy of the Human Mind.* G. N. Wright, ed. London, 1843.

_____ *Lectures on Political Economy.* Sir William Hamilton, ed. New York: A. M. Kelley, 1968.

Secondary

Bryson, Gladys. *Man and Society: The Scottish Inquiry of the Eighteenth Century.* Princeton: Princeton University Press, 1945.

Kettler, David. *The Social and Political Thought of Adam Ferguson.* Columbus, Ohio: Ohio State University Press, 1965.

Lehmann, W. C. *John Millar of Glasgow: His Life and Thought and his Contributions to Sociological Analysis.* Cambridge: Cambridge University Press, 1960.

Morrow, Glenn R. *The Ethical and Economic Theories of Adam Smith: A Study in the Social Philosophy of the Eighteenth Century.* New York: Longmans, Green & Co., 1923.

Pascal, Roy. "Property and Society: The Scottish Historical School," *The Modern Quarterly,* Vol. I (1938).

Small, Albion W. *Adam Smith and Modern Sociology.* Chicago: University of Chicago Press, 1907.

Finally, there is the theme of abundance. Readers wishing to pursue the development and implications of Ruskin's perception in the twentieth century should turn to D. M. Fox's *The Discovery of Abundance: Simon N. Patten and the Transformation of Social Theory* (Ithaca, New York: Cornell University Press, 1967). Though lacking historical perspective, the following books are also suggestive:

Chase, Stuart. *The Economy of Abundance.* New York: The Macmillan Company, 1934.

Galbraith, John Kenneth. *The Affluent Society.* Boston: Houghton Mifflin, 1958.

Hobson, John A. *Poverty in Plenty.* New York: The Macmillan Company, 1931.

Keynes, John Maynard. *Essays in Persuasion.* London: W. W. Norton Company, Inc., 1931.

Laski, Harold J. *Reflections on the Revolution of Our Time.* London: George Allen & Unwin, 1940.

Marcuse, Herbert. *Eros and Civilization.* New York: Vintage Books Division of Random House, 1962.

Myrdal, Gunnar. *Challenge to Affluence.* New York: Pantheon Books, 1964.

Potter, David. *People of Plenty.* Chicago: University of Chicago Press, 1954.

Riesman, David. *Abundance for What?* New York: Doubleday, 1964.

Riesman, David, with Nathan Glazer and Reuel Denney. *The Lonely Crowd.* New Haven: Yale University Press, 1950.

Ross, Edward A. *Social Control.* New York: The Macmillan Company, 1901.

Rostow, Walt W. *The Stages of Economic Growth.* Cambridge: Cambridge University Press, 1960.

Saidenberg, Roderick. *Post-Historic Man.* Chapel Hill, North Carolina: The University of North Carolina Press, 1950.

Notes

Chapter I Purity

1. *The Complete Works of Samuel Taylor Coleridge,* ed. W. G. T. Shedd (7 v. New York, 1884), II, 411; Letter to John Thelwall, 14 October 1797, *Collected Letters of Samuel Taylor Coleridge,* ed. Earl Leslie Griggs (4 v. Oxford, 1956), I, 349.

2. William Wordsworth, *The Prelude,* III, 590. Unless otherwise noted, references to *The Prelude* will be to the 1850 version in *The Poetical Works of Wordsworth,* ed. Thomas Hutchinson (London, 1936). Blake, "Auguries of Innocence," *The Poetry and Prose of William Blake,* ed. David V. Erdman (New York, 1965), p. 481; Thomas Carlyle, *Sartor Resartus and On Heroes, Hero-Worship, and the Heroic in History,* with intro. by W. W. Hudson (Everyman's Library ed., London, 1908), p. 334 ("The Hero as Poet"); *The Works of John Ruskin,* ed. E. T. Cook and Alexander Wedderburn (Library ed., 39 v. London, 1903-1912), 22.12, 222; 4.129, 147; 7.207; 20.79. All parenthetical citations in the text are to this edition.

3. Ibid., 4.64.

4. Ibid., 95, 240. Cf. Richard Hooker, *Of the Laws of Ecclesiastical Polity* (3 v. Oxford, 1886), I, xi, 1.

5. Aristotle *Poetics* viii. (1451ᵃ 30-35); Samuel Taylor Coleridge, *Biographia Literaria,* ed. J. Shawcross (2 v. London, 1907), II, 12, 230. Hereafter this work will be referred to as *BL.* Wordsworth, *Poetical Works,* p. 745; Ruskin, *Works,* 4.96.

6. Coleridge, *Complete Works,* I, 387; Coleridge, *BL,* I, 185; Thomas Carlyle, "Novalis," *Thomas Carlyle's Collected Works* (30 v. London, 1869), VII, 279; Thomas Carlyle, *Sartor Resartus* in *Past and Present, Chartism, Sartor Resartus* (New ed., New York, 1850), Bk. III, ch. vii, 190, 223. Hereafter any reference to *Past and Present, Chartism,* or *Sartor Resartus* will be to this edition.

7. Ruskin, *Works,* 4.129, 132-134; Coleridge, "The Eolian Harp," *The Complete Poetical Works of Samuel Taylor Coleridge,* ed. Ernest Hartley Coleridge (2 v. Oxford, 1912), I, 101 (l. 26); Wordsworth, *Prelude* (1805), III, 130-131; XIII, 71. Quotations from the 1805 version of *The Prelude* are from *The Prelude or Growth of a Poet's Mind,* ed. Ernest de Selincourt (London, 1928). Wordsworth, *Prelude* (1850), VII, 766-771; Wordsworth, *Excursion,* IX, 1-19. All references to *The Excursion* are found in *Poetical Works,* ed. Thomas Hutchinson.

8. Wordsworth, *Prelude,* II, 401; Wordsworth, *Excursion,* IX, 3; Wordsworth, "Tintern Abbey," *Poetical Works,* p. 164 (l. 96); Coleridge, "Destiny of Nations," *Complete Poetical Works,* I, 147 (l. 461); Carlyle, *Sartor,* Bk. I, ch. iv, 63-64; Ruskin, *Works,* 3.404; Blake, *Poetry and Prose,* pp. 34 ("Marriage of Heaven and Hell"), 590 (last note to Lavater's *Aphorisms* of 1788).

9. Ruskin, *Works,* 4.128, 131-133; Blake, *Poetry and Prose,* pp. 154, 156 ("Jerusalem"), 123 ("Milton"); Wordsworth, *Excursion,* IV, 962; Wordsworth, *Prelude,* X, 207-208.

10. *The Cambridge Platonists,* ed. E. T. Campagnac (Oxford, 1901), pp. 283-287; George Berkeley, *Siris; A Chain of Philosophical Reflexions and In-*

quiries Concerning the Virtues of Tar Water and Divers Other Subjects Connected together and Arising One from Another (Dublin, 1774), sec. 152, pp. 418-419; sec. 173, p. 427; Coleridge, *Statesman's Manual, Complete Works*, I, 451; Ruskin, *Works*, 4.128.

11. Ibid., 133-134. For an earlier discussion of this point, cf. Henry Ladd, *The Victorian Morality of Art: An Analysis of Ruskin's Esthetic* (New York, 1932), pp. 186-187.

12. Ruskin, *Works*, 4.64, 151; Aristotle *Metaphysics* viii. 2 (1042^b); Coleridge, *BL*, II, 244-245.

13. Ruskin, *Works*, 4.146, 156, 158-160.

14. Ibid., 7.209. In *Shooting Niagara: and After?* (1867), Carlyle adopts Ruskin's interpretation of "holy" when he writes: ". . . and the old adjective 'Healthy' once more becoming synonymous with 'Holy,'—what a conquest there!" Carlyle, *Col. Works*, XI, 388.

15. Coleridge, *Complete Works*, I, 390, 387-388, 470, 359, 363; VI, 140; Blake, *Poetry and Prose*, p. 267.

16. Ruskin, *Works*, 3.404; 4.176, 183; Francis G. Townsend, *Ruskin and the Landscape Feeling: A Critical Analysis of His Thought During the Crucial Years of His Life, 1843-56*, Illinois Studies in Language and Literature, Vol. XXXV, No. 3 (Urbana, Illinois, 1951), 15, 23; cf. John D. Rosenberg, *The Darkening Glass: A Portrait of Ruskin's Genius* (New York, 1961), p. 42. Henry Ladd was the first to point out the relevance of Ruskin's concepts of purity, unity, and vital beauty to his social criticism. Ladd, *Victorian Morality of Art*, pp. 177-178, 183-186.

17. Coleridge, *BL*, I, 107, 110; II, 228-232; Carlyle, *Sartor*, Bk. I, ch. xi, 57; Wordsworth, *Prelude*, I, 342-344; Edmund Burke, "On Conciliation," *The Works of the Right Honourable Edmund Burke* (Bohn's British Classics ed., 8 v. London, 1854), I, 509; Burke to Windham, October 1793, *Correspondence of Edmund Burke and William Windham with Other Illustrative Letters from the Windham Papers in the British Museum*, ed. J. P. Gilson (Cambridge, 1910), p. 72; Edmund Burke, *Reflections on the French Revolution* (Everyman's Library ed., London, 1910), pp. 93, 32, 191. Cf. Ruskin, *Works*, 17.75.

18. *Coleridge's Miscellaneous Criticism*, ed. T. M. Raysor (Cambridge, Massachusetts, 1936), p. 89; Carlyle, "Characteristics," *Col. Works*, VIII, 351.

19. This statement may be too strong. Wordsworth also speaks of nature in neo-Platonic terms as providing "types and symbols of eternity." *Prelude*, VI, 631-640. Both Coleridge and Carlyle admire the style of Hooker. *Reminiscences by Thomas Carlyle*, ed. Charles Eliot Norton (Everyman's Library ed., London, 1932), p. 195. No doubt, Arthur O. Lovejoy is right in asserting that the term Romanticism covers such a multitude of phenomena as to be practically useless. *Essays in the History of Ideas* (Capricorn Book ed., New York, 1960), p. xiii. One can only reply in the spirit of J. S. Mill that it is better to discover or draw out from within the complex meaning of a traditional category than to ask bluntly whether it is true or useful and discard it. John Stuart Mill, "Coleridge," *Dissertations and Discussions* (3 v. New York, 1874), I, 398-403.

20. Ruskin much admired the *Systema Naturae* of the eighteenth-century Swedish naturalist Karl von Linné. Ruskin, *Works*, 36.591. For references to Locke, see ibid., 3.91-92, 141, 159.

21. Ibid., 11.48; 25.390-391; 37.380; 4.107, 155n. In later years, Ruskin himself does not adhere to the Catastrophist theory, but his interest in erosion and glacier movement may owe something to Buckland's way of thinking. For a useful discussion of Buckland, see Charles Coulson Gillispie, *Genesis and*

Geology: A Study in the Relations of Scientific Thought, Natural Theology, and Social Opinion in Great Britain, 1790-1850 (Cambridge, Massachusetts, 1951), ch. iv. Ruskin's enthusiasm for maps and geographical models epitomizes the surface organicism characteristic of his scientific studies. Cf. Ruskin, *Works,* 37.454; 27.lxxi.

22. Wordsworth, "Lines Written in Early Spring," *Poetical Works,* p. 377 (l. 22); Ruskin, *Works,* 17.60; Bernard de Mandeville, *The Fable of the Bees: or, Private Vices, Publick Benefits,* ed. F. B. Kaye (2 v. Oxford, 1924).

23. Ruskin, *Works,* 4.42, 224, 272, 278, 233-236, 252-258; 7.215. Ruskin's theory of the imagination is a matter of debate for the few scholars who have discussed it in detail. Part of the controversy centers on Ruskin's view of the fancy and its relation to the imagination. Cf. Ladd, *Victorian Morality of Art,* pp. 202-224; Sister Mary Dorothea Goetz, *A Study of Ruskin's Concept of the Imagination* (Washington, D.C., 1947). My purpose is not to supplant these earlier and much fuller discussions but to give a brief summary of the salient points of Ruskin's theory in the light of the Romantic tradition.

24. *Anima Poetae: From the Unpublished Notebooks of Samuel Taylor Coleridge,* ed. E. H. Coleridge (London, 1895), pp. 142-143, 199; Coleridge, *BL,* II, 14, 19, 264n.; I, 107, 194; Wordsworth, *Prelude,* VI, 593; *The Prose Works of William Wordsworth,* ed. A. B. Grossart (3 v. London, 1876), III, 465; II, 62; Wordsworth, "Preface of 1815," *Poetical Works,* pp. 754-755; Ruskin, *Works,* 4.70, 224-225, 293-299, 254. Ruskin follows Wordsworth in using a "chemical" analogy to describe the unifying power of the imagination. Ibid., 234-235.

25. For the sources of this distinction, see Wilma L. Kennedy, *The English Heritage of Coleridge of Bristol 1798: The Basis in Eighteenth-Century English Thought for His Distinction between Imagination and Fancy* (New Haven, 1947), passim; Meyer H. Abrams, *The Mirror and the Lamp* (New York, 1953), pp. 156-177; Herschel Baker, *William Hazlitt* (Cambridge, Massachusetts, 1962), pp. 274-275. *The Literary Works of Sir Joshua Reynolds* (5th ed., 3 v. London, 1819), I, 128-130, 203; II, 142, 197, 113-115. For Ruskin's important differences with Reynolds, see Ruskin, *Works,* 5.46; 22.493-494, 498-500.

26. In the *Biographia,* Coleridge's tendency to stress the cognitive side of the imagination lands him in the bogs of Schellingean speculation on this subject. Coleridge, *BL,* I, 197-198; II, 9, 257-259. Wordsworth, "Preface to the Lyrical Ballads," *Poetical Works,* p. 737; Ruskin, *Works,* 4.241-242; 5.29; 7.210, 214.

27. Wordsworth, "Preface to the Edition of 1815," *Poetical Works,* pp. 775, 752; Ruskin, *Works,* 4.228, 293, 219. Ruskin shows his interest in the Wordsworth-Coleridge dispute in a letter to his college tutor, W. L. Brown, December 20, 1843. Ibid., 391.

28. Abrams, *Mirror and the Lamp,* pp. 58-60; Blake, *Poetry and Prose,* pp. 2, 67, 26-33, 385, 52, 372.

29. Ruskin, *Works,* 4.223, 229-230; 5.189; 12.345; 35.552. Cf. *Shelley's Literary and Philosophical Criticism,* ed. John Shawcross (London, 1932), p. 120. William Hazlitt, *Works,* ed. P. P. Howe (Centennial ed., 21 v. New York, 1930-1934), XVIII, 69; Thomas Carlyle, *On Heroes, Hero-Worship, and the Heroic in History,* ed. Archibald MacMechan (Boston, 1901), pp. 1-2, 15, 49, 90-91.

30. David Hume, *Essays, Moral, Political, and Literary,* eds. T. H. Green and T. M. Grosse (2 v. London, 1875), II, 19n.; Coleridge, *BL,* II, 12; Blake, *Poetry and Prose,* pp. 645, 647; Hazlitt, Works, *VIII,* 46, 84; Ruskin, *Works,* 5.438, 208. For an excellent discussion of the eighteenth century's mechanical theory of invention, see Abrams, *Mirror and the Lamp,* pp. 159-167.

31. Ruskin, *Works,* 18.344-345; 4.256-257, 148, 287; 7.464.

32. Wordsworth, *Poetical Works,* p. 590 (ll. 63-71); Wordsworth, *Prelude* (1805), VI, 672-674; Coleridge, *BL,* II, 257-258.

33. Ruskin, *Works,* 4.239, 122, 347; 28.146; *The Diaries of John Ruskin,* ed. Joan Evans and John Howard Whitehouse (3 v. Oxford, 1956-1959), I, 74. Francis Townsend also notes the importance of Ruskin's discovery at Lucca. Townsend, *Landscape Feeling,* p. 32.

34. Coleridge, *BL,* II, 258; I, 174, 183; Wordsworth, *Prelude,* II, 368-370; Wordsworth, "Intimations of Immortality," *Poetical Works,* p. 461 (ll. 155-156); Carlyle, *Sartor,* Bk. II, ch. ix, 151; Ruskin, *Works,* 4.7, 191, 287; 16.369-372; Blake, "Auguries of Innocence," *Poetry and Prose,* p. 484.

35. Ruskin, *Works,* 20.88; Wordsworth, *Excursion,* V, 1012; Wordsworth, *Prelude,* II, 389. Coleridge describes the interpenetration of individuals in society as follows: "Each man in a numerous society is not only co-existent with, but virtually organized into, the multitude of which he is an integral part. His *idem* is modified by the *alter.*" Samuel Taylor Coleridge, *Notes, Theological, Political, and Miscellaneous,* ed. Derwent Coleridge (London, 1853), pp. 391-392.

36. Blake, *Poetry and Prose,* pp. 201, 154 ("Jerusalem"); Wordsworth, *Poetical Works,* p. 738; Hazlitt, *Works,* VIII, 42-43; V, 47-50; IV, 271. For the eighteenth-century background of Hazlitt's view of the sympathetic imagination, see W. Jackson Bate, "The Sympathetic Imagination in Eighteenth-Century English Criticism," *ELH,* XII (1945), pp. 144-166.

37. Ruskin, *Works,* 4.148, 250-252, 257, 93, 183; 20.54, 90-92.

38. Edward Young, "Conjectures on Original Composition" (1759) in *Criticism: The Foundations of Modern Literary Judgment,* eds. Mark Schorer, Josephine Miles, and Gordon McKenzie (New York, 1948), pp. 6, 7, 11, 13, 21; Carlyle, *Sartor,* Bk. III, ch. viii, 204; Coleridge, *BL,* II, 257-258; *Inquiring Spirit: A New Presentation of Coleridge from his Published and Unpublished Prose Writings,* ed. Kathleen Coburn (New York, 1951), pp. 30-31; Coleridge, *Anima Poetae,* pp. 46, 206. For the recognition of the role of the unconscious in artistic creation, see Abrams, *Mirror and the Lamp,* pp. 184-225.

39. Ruskin, *Works,* 5.122; 34.110-111. From the cover of every volume of the Library Edition of Ruskin's *Works* stares the grim reminder, "Today."

40. Ibid., 4.29; 17.85; 7.189; Jonathan Swift, *Tale of a Tub to which is added The Battle of the Books and the Mechanical Operation of the Spirit,* eds. A. C. Guthkelch and D. Nichol Smith (Oxford, 1920), pp. 203 (sec. XI), 56 (Introduction).

41. Blake, *Poetry and Prose,* pp. 483, 1, 66, 46, 555, 484, 693, 73, 156.

42. Coleridge, *Complete Works,* II, 164, 469; I, 456; Coleridge, *Col. Letters,* I, 349; Wordsworth, *Prelude* (1805), XI, 123-126; XII, *A* 124-126 (The *A* refers to a MS so noted in De Selincourt's edition of *The Prelude.*); ibid., (1850), XIV, 189-192; Wordsworth, *Excursion,* IV, 1263, 961-962; Wordsworth, *Poetical Works,* pp. 377, 744. For the origins of the distinction between reason and understanding, see Charles Frederick Harrold, *Carlyle and German Thought: 1819-1834,* Yale Studies in English, LXXXII (New Haven, 1934), 120-146; A. O. Lovejoy, "Kant and the English Platonists," *Essays Philosophical in Honor of William James* (New York, 1908), pp. 265-302.

43. Carlyle, *Col. Works,* VII, 317, 333-334; Carlyle, *Sartor,* Bk. III, ch. iii, 173; *Autobiography of John Stuart Mill* (Columbia University ed., New York, 1924), pp. 77-78, 98-107; Mill, *Dissertations and Discussions,* I, 378.

44. Burke, *Reflections on the French Revolution,* pp. 83, 215; David Hume, *Treatise on Human Nature* (Oxford, 1896), Bk. I, ch. iii, 6; ch. iv, 1; George

Eliot, *Scenes of Clerical Life* (Edinburgh, 1858), pp. 393-394; Matthew Arnold, *Essays in Criticism: Second Series* (New York, 1896), p. 48; John Henry Newman, *An Essay in Aid of Grammar of Assent* (5th ed., London, 1881), p. 49; John Henry Newman, *The Difficulties of Anglicans* (4th ed., 2 v. London, 1876), I, 327-342.

45. Ruskin, *Works,* 11.48-52, 60-61, 65; 4.284; Hazlitt, "Why the Arts Are Not Progressive," *Works,* XVIII, 8; Wordsworth, *Poetical Works,* p. 737; Blake, *Poetry and Prose,* p. 39 ("Marriage of Heaven and Hell").

46. Ruskin, Letter to his Father, 12 September 1858, *Works,* 36.291.

Chapter II Drive to Humanity

1. Ruskin, *Works,* 3.665 (March 16, 1844). The best discussion of Ruskin's aesthetic theories and their originality is still Henry Ladd's *Victorian Morality of Art.* Although Ruskin the individual disappears in the dense cloud of Ladd's learning, the book repays careful reading.

2. Ruskin, *Works,* 3.87, 112; 7.257. Cf. Ladd, *Victorian Morality of Art,* pp. 332-339.

3. Ruskin, *Works,* 5.189, xix; 11.202-203.

4. Ibid., 4.27-29, 67.

5. Ibid., 3.666; 4.28; Percy Bysshe Shelley, *Defence of Poetry: On the Literature, Art, and Manners of the Athenians,* in *Prose Works,* ed. R. H. Shepherd (London, 1912), II, 29.

6. Cf. Ruskin, *Works,* 19.163-194; 20.73-94. Francis Townsend describes Ruskin's view of the relation between art and society as a "vicious circle." Townsend, *Landscape Feeling,* pp. 23-24.

7. H. A. Needham, *Le développement de l'esthétique sociologique en France et en Angleterre* (Paris, 1926), passim; Carlyle, *Heroes and Hero Worship,* ch. iii, 74; Thomas Carlyle, *Latter-Day Pamphlets* (Ashburton ed., London, 1885), p. 274.

8. Saint-Simon, *L'organisateur* (1819-20), *Oeuvres de Saint-Simon et d'Enfantin* (Paris, 1868-69), XX, 24, 191; XVIII, 83-87, 126-127; Charles Fourier, *Cités ouvrières: des modifications à introduire dans l'architecture des villes* (Paris, 1849), ch. iv, 17, 19-20; vii, 32; Pierre Joseph Proudhon, *Du principe de l'art et de sa destination sociale* (Paris, 1865), ch. xiv, 219-223; iii, 37; ix, 117; A Comte, *Discours sur l'ensemble du positivisme* (Paris, 1848), pp. 277, 294.

9. Adam Ferguson, *Principles of Moral and Political Science* (2 v. Edinburgh, 1792), I, 269; David Hume, "Refinement in the Arts" and "Rise and Progress of the Arts and Sciences" in *Essays, Moral and Political* (London, 1841-42); Johann J. Winckelmann, *Histoire de l'art chez les anciens,* trans. Huber (3 v. Paris, 1799-1803), I, Bk. I, ch. iii.

10. J. G. von Herder, *Idées sur la philosophie de l'histoire de l'humanité,* trans. Quinet (3 v. Paris, 1827-28), II, 413-423. For an interesting discussion of Ferguson's "static organicism" and a comparison of it with Herbert Spencer's dynamic theory, see W. C. Lehmann, *Adam Ferguson and the Beginnings of Modern Sociology* (New York, 1930), pp. 250-253.

11. Shaftesbury and Berkeley also use the word "moral" to describe the relationship between the work of art and society, but without Ruskin's emphasis or consistency. Cf. Anthony Ashley Cooper, 3rd Earl of Shaftesbury, *Miscellanies* (London, 1714); George Berkeley, *Alciphron* (Dublin, 1732). Ruskin, *Works,* 4.151.

12. Ibid., 3.48, 90-94, 112.

13. Ibid., 167, 169, 624, 134.

14. Ibid., 4.222, 47-49, 147-148, 257, 287.

15. Ibid., 64; 16.251, 341; 19.184; 20.107ff.

16. Ibid., 8.20; 16.347. Ruskin may have derived his idea that architecture is the art of society from Thomas Hope's *An Historical Essay on Architecture.* Hope believed that architecture is an art of "direct utility" and so depends much more than poetry or painting on the "peculiar institutions, habits, and customs" of the society "for which it labours." Thomas Hope, *An Historical Essay on Architecture* (3rd ed., 2 v. London, 1840), I, 457-458.

17. Ruskin, *Works,* 9.369-371; 11.228; 18.443-444. Augustus Welby Pugin hoped to use the controversy over classical and Gothic styles as a means of converting England to Catholicism. At his own expense, he published that remarkable piece of propaganda *Contrasts: or a Parallel between the Noble Edifices of the Fourteenth and Fifteenth Centuries and Similar Buildings of the Present Day; Shewing the Present Decay of Taste; Accompanied by Appropriate Text* (London, 1836). The Ecclesiologists were members of the Cambridge Camden Society organized by John Mason Neale for the purpose of improving church construction and preserving old churches. *The Ecclesiologist,* a journal put out by the society, exerted much influence. By the end of the forties, it had set the stage for Ruskin's *The Seven Lamps of Architecture* by acquainting Protestants with the virtues of the Gothic style and by making them suspicious of the Catholic overtones of Gothic. For Ruskin's part in the Gothic Revival and the influence of Pugin and the Camden Society upon Ruskin, see Townsend, *Landscape Feeling,* ch. v; C. H. Herford, "Ruskin and the Gothic Revival," *Quarterly Review,* CCVII (1907), 77-96; Graham Hough, *The Last Romantics* (London, 1949), pp. 83-92.

18. J. G. von Herder, *Von deutscher Art und Kunst* (1773), *Sämtliche Werke* (33 v. Berlin, 1891), V, 217-218. The extent to which Burke and Coleridge accept a cultural relativism is debatable. Cf. David P. Calleo, *Coleridge and the Idea of the Modern State* (New Haven, 1966), pp. 132-137; Gerald W. Chapman, *Edmund Burke: The Practical Imagination* (Cambridge, Massachusetts, 1967), pp. 74-75.

19. Ruskin, *Works,* 1.5. Ruskin's early essay, published serially in the *Architectural Magazine,* is full of contradictions. He declares that good architecture reflects a peculiar "national character" and geographical location and warns that education may compromise the architect's "closeness" to his native soil. But he also emphasizes what is common to men and declares that, in certain respects, all men are alike. Ruskin, *Works,* 1.74-77.

20. Ibid., 8.27, 138, 101, 10; 12.84-87.

21. Ibid., 8.30-31, 43, 39-40; Townsend, *Landscape Feeling,* pp. 44-48.

22. Ruskin, *Works,* 8.61, 72, 81-85.

23. Ibid., 190-191.

24. Ibid., 214; Blake, *Poetry and Prose,* p. 70 ("The First Book of Urizen"); Wordsworth, *Poetical Works,* p. 461. Ruskin cites Wordsworth in *Works,* 4.98; 17.233.

25. Ibid., 8.218; 4.257.

26. Ibid., 8.195-196.

27. Ibid., 197-199, 214; 4.135-136. The difference between Ruskin's description of "moderation" in the second volume of *Modern Painters* and his discussion of finish in "The Lamp of Life" should not be exaggerated. Ruskin's view of the imperfection of good art is a recognition of man's weakness, not a defense of carelessness. For his later inconsistencies on the subject of finish, cf. ibid., 7.356-358n.

28. Ibid., 8.215, 200, 204; Rosenberg, *Darkening Glass*, p. 75; Johann Wolfgang von Goethe, "Von deutscher Baukunst," *Sämtliche Werke* (40 v. Stuttgart, 1902-1907), XXXIII, 5-11; Wordsworth, "Preface to the Edition of 1814," *Poetical Works*, p. 589; Coleridge, *BL*, II, 14.

29. Ruskin, *Works*, 8.219-220; Blake, *Poetry and Prose*, p. 157.

30. Ruskin, *Works*, 8.200, 98.

31. Ibid., 224-229, 234.

32. Ibid., 255-256, 259-260.

33. Ibid., 264-265.

34. Ibid., 9.69, 289, 291; 10.213.

35. Ibid., 183-184.

36. Mme. de Staël, *De la littérature considérée dans ses rapports avec les institutions sociales* (2d ed., Paris, 1800), pp. 33, 165, 167; Ruskin, *Works*, 10.188, 190.

37. Ibid., 190-191, 202-203. Cf. Rosenberg, *Darkening Glass*, p. 96n.

38. *The Notebooks of Samuel Taylor Coleridge*, ed. Kathleen Coburn (2 v. New York, 1957), II, entry 1016; Coleridge, *BL*, I, 74, 189; Samuel Taylor Coleridge, *Coleridge's Shakespearean Criticism*, ed. T. M. Raysor (2 v. London, 1930), II, 103-104; Wordsworth, *Prelude*, II, 302-322. Ruskin also notes the importance of an "indistinctness of conception" to the work of the imagination. Ruskin, *Works*, 4.289-291, 252-253.

39. *The Correspondence of the Right Honourable Edmund Burke: between the Years 1744 and the Period of his Decease in 1797* (4 v. London, 1844), III, 512; *The Speeches of the Right Honourable Edmund Burke, in the House of Commons, and in Westminster Hall* (4 v. London, 1816), I, 130; Edmund Burke, *A Philosophical Enquiry into the Origin of our Ideas of the Sublime and Beautiful* (1757), *Works*, I, passim; Arthur O. Lovejoy, *The Great Chain of Being: A Study in the History of an Idea* (Cambridge, Massachusetts, 1936); Ruskin, *Works*, 3.99, 128; 4.108-110. Compare Ruskin's remark in volume one of *Modern Painters*: "The picture which has the nobler and more numerous ideas, however awkwardly expressed, is greater . . . than that which has the less noble and less numerous ideas, however beautifully expressed." Ibid., 3.91.

40. Ibid., 10.204; 11.226; Blake, *Poetry and Prose*, pp. 2, 156.

41. Ruskin, *Works*, 10.215, 237, 211-212; 11.201.

42. Ibid., 154, 157-159.

43. Ibid., 10.239-243.

44. Ibid., 243-244.

45. Ibid., 11.17-18, 74-75, 115-117, 119; 9.35, 426; 16.284.

46. Townsend, *Landscape Feeling*, pp. 27-31; Alexis François Rio, *De la poésie chrétienne dans son principe, dans sa matière et dans ses formes. Forme de l'art. Peinture* (Paris, 1836), pp. 2-6, 37-38. Ruskin read Rio's book during the winter of 1844-45. Ruskin, *Works*, 4.xxiii; 35.340; 11.70-71.

47. Blake, *Poetry and Prose*, pp. 267, 635-637, 632, 565; Ruskin, *Works*, 11.213-214; 5.181-185.

48. Ibid., 12.100; 10.189-193; 9.456.

49. Blake, *Poetry and Prose*, pp. 516, 214; Blake, Letter to John Linnell, 1 August 1826, *Poetry and Prose* (Keynes ed., London, 1927), p. 924; William Godwin, *Fleetwood: or the New Man of Feeling* (3 v. London, 1805), I, 277; Coleridge, *Complete Works*, VI, 64-65; Coleridge, *Notebooks*, II, entry 2557; Carlyle, *Sartor*, Bk. III, ch. viii, 204; Dickens' speech on behalf of education for factory workers quoted by Humphrey House in *The Dickens World* (London, 1960), p. 458; Charles Dickens, *Hard Times* (New York, 1895), pp. 541-542. On

one occasion, Ruskin admits that Stephen Blackpool is "a dramatic perfection, instead of a characteristic example of an honest workman" but insists that Dickens is "entirely right in his main drift and purpose." Ruskin, *Works,* 17.31n.

50. Edward P. Thompson, *The Making of the English Working Class* (London, 1964), pp. 832, 351 (Wedgwood quoted); Andrew Ure, *The Philosophy of Manufactures* (London, 1835), p. 15.

51. Robert Owen, "Report to the County of Lanark" (1820), in *A New View of Society and Other Writings* (Everyman's Library ed., London, 1907), pp. 274-285; Charles Hall, *The Effects of Civilization on the People in European States* (Phoenix Library ed., London, 1801), pp. 20-21; William Thompson, *Practical Directions for the Speedy and Economical Establishment of Communities, on the Principle of Mutual Cooperation, United Possessions and Equality of Exertions and of the Means of Enjoyments* (Cork, 1830), pp. 29, 181; John M. Ludlow, *Christian Socialism and Its Opponents. A Lecture Delivered at the Office of the Society for Promoting Working Men's Association on Wednesday, February 12th, 1851* (London, 1851), pp. 28-29; Adam Smith, *An Inquiry into the Nature and Causes of the Wealth of Nations,* with notes by J. R. McCulloch (London, 1875), Bk. V, ch. i, Pt. 3, art. ii, 616-617. Ruskin uses Smith's famous example of nail and pin manufacture to describe the disastrous effects of the division of labor. Ruskin, *Works,* 10.196; Smith, *Wealth of Nations,* Bk. I, ch. i.

52. Karl Marx, *Capital* (London, 1933), pp. 123n., 354, 361-362, 362n.; Karl Marx, *The Poverty of Philosophy* (Moscow, 1956), p. 845; Adam Ferguson, *An Essay on the History of Civil Society* (2d ed., London, 1768), pp. 277, 282, 353; Ferguson, *Principles,* II, 424; John A. Millar, *The Origin of the Distinction of Ranks; or an Inquiry into the Circumstances which give Rise to Influence and Authority in the Different Members of Society* (Edinburgh, 1771), in William C. Lehmann, *John Millar of Glasgow: His Life and Thought and His Contributions to Sociological Analysis* (Cambridge, 1960), Selection VI, pp. 380-381; Dugald Stewart, *Elements of the Philosophy of the Human Mind,* ed. G. N. Wright (London, 1843), pp. 310-334. Whether Smith or Ferguson deserves credit for priority in discussing the division of labor has been much argued. On the whole, Smith seems to have a slight edge. Although he did not publish his conclusions until 1776, the student notes of his *Lectures on Justice, Policies, Revenue, and Arms* indicate that he had developed his ideas as early as 1748-1751. Marx is certainly wrong when he describes Smith as a disciple of Ferguson. For a discussion of this problem, see A. Oncken, "Adam Smith and Adam Ferguson," *Zeitschrift für Sozialwissenschaft,* XII (1909), p. 129.

53. Roy Pascal, "*Bildung* and the Division of Labour" in *German Studies,* ed. Walter Horace Bruford (London, 1962), pp. 14-18; cf. K. W. von Humboldt, *Ideen zu einem Versuch, die Grenzen der Wirksamkert des Staats zu bestimmen,* ed. Kappstein (Berlin, 1917), pp. 274-278.

54. Friedrich Engels, *Herr Eugin Dühring's Revolution in Science* (Moscow, 1947), pp. 435-436; Karl Marx and Friedrich Engels, *Selected Works* (2 v. Berlin, 1955), I, 102, 439; II, 23; Marx, *Capital,* p. 713. *On Liberty* is found in *Three Essays by John Stuart Mill* (London, 1912).

55. Ruskin, *Works,* 8.197, 204; 10.192, 214. R. H. Wilenski was the first to remark upon the similarity between the mental characteristics of Gothic and Ruskin. R. H. Wilenski, *John Ruskin: An Introduction to Further Study of His Life and Work* (London, 1933), pp. 218-220. Cf. Rosenberg, *Darkening Glass,* p. 60.

56. *Letters of John Ruskin to Charles Eliot Norton,* ed. Charles Eliot Norton (2 v. Boston, 1905), 1, 17; Wilenski, *John Ruskin,* pp. 42-102, 192-242; Ruskin,

Works, 35.227, 350. Cf. John T. Fain, "Ruskin and his Father," *PMLA,* LIX (1944), pp. 236-242.

Chapter III Broken Circle

1. Townsend, *Landscape Feeling,* pp. 37-79; Rosenberg, *Darkening Glass,* pp. 22-45.

2. Ruskin, *Works,* 5.32, 48, 69, 187, 189; 7.235. Ruskin's interest in expression at the expense of representation involves no inconsistency in his aesthetic theory. From the very first, he implies that the artist's representation of truth and beauty inevitably expresses his personality. Cf. Ladd, *Victorian Morality of Art,* pp. 245-249, 389 (note 16).

3. Ruskin, *Works,* 7.319-320, 329-334, 342, 374-388, 454.

4. Ibid., 255, 259, 262, 435n. Cf. ibid., 8.102-103, 224.

5. Ibid., 7.262-263.

6. Ibid., 264, 257.

7. Ibid., 264, 267, 290, 296-297; 18.474.

8. Ibid., 4.374, 376; 10.224-225; 11.164.

9. Ibid., 5.56-57, 100-101, 107, 205; 11.157. Ruskin first distinguished between Purists and Naturalists in "The Nature of Gothic." Ibid., 10.221-225, 230-231.

10. Ibid., 6.409, 414, 416.

11. Ibid., 7.266, 268, 433; Rosenberg, *Darkening Glass,* p. 24.

12. Ruskin, *Works,* 36.67, 70; Ruskin, *Diaries,* II, 88, 113, 146. For Ruskin's interest in social problems at Crossmount in 1847, see *Works,* 35.429; Fain, "Ruskin and His Father," *PMLA,* LIX, 236-242.

13. Carlyle, *Past and Present,* Bk. I, ch. ii.

14. Ruskin, *Works,* 36.137-138. For a discussion of Ruskin's religious doubts, see Wilenski, *John Ruskin,* pp. 329-356; Townsend, *Landscape Feeling,* pp. 59-62.

15. Ruskin, *Works,* 6.388-389, 396, 402, 415-416.

16. Ibid., 7.266, 271, 315. Compare Ruskin's recognition of the *human* cost of the "picturesque" in ibid., 6.24n.

17. Ibid., 7.374, 385, 431ff. Cf. Rosenberg, *Darkening Glass,* p. 28.

18. Ruskin, *Works,* 7.271; 5.55, 101, 333-334.

19. Ibid., 36.450; 5.192-200, 325; 4.210; Townsend, *Landscape Feeling,* pp. 70-79.

20. Ruskin, *Works,* 5.231, 321-353; 11.223-226; 10.207.

21. Ibid., 5.354, 359, 361. In *The Stones of Venice,* Ruskin had suggested that landscape art holds little interest for men "engaged in active life." Ibid., 11.226.

22. Ibid., 5.365-366, 372, 376, 386.

23. Ibid., 6.385, 387-388, 425.

24. Ibid., 7.423, 441; 10.84-85, 124, 186; Letter to George Richmond, 30 August 1846, ibid., 36.65. Compare the questions Ruskin raises in *The Seven Lamps of Architecture,* ibid., 8.264. Throughout his career, he was much perplexed by "the apparent connection of great success in art with subsequent national degradation." Ibid., 16.261-269, 188-189, 196-197.

25. Ibid., 36.348. Cf. Rosenberg, *Darkening Glass,* pp. 101-102.

26. Ruskin's own view of Wordsworth had changed by the third volume of *Modern Painters.* He now believed that Wordsworth's love of nature was associated with his "weaknesses" and that the poet's "distinctive work" lay in his "analysis of the sources of politics and ways of men." Ruskin, *Works,* 5.362.

For the peculiar rigidities and biases of Ruskin's later art criticism, see Wilenski, *John Ruskin,* pp. 243-263. Graham Hough includes Ruskin in his useful book *The Last Romantics.*

Chapter IV Streams of Abundance

1. Ruskin, *Works,* 12.593-603; 11.258.
2. Letter of March 30, 1852, ibid., 12.lxxxiv; *Ruskin's Letters from Venice, 1851-1852,* ed. John L. Bradley, Yale Studies in English, Vol. CXXIX (New Haven, 1955), p. 177; Ruskin, *Works,* 5.xlix-1.
3. Ibid., 36.414 (July 20, 1862), 461 (December 16, 1863); *Letters of John Ruskin,* ed. Norton, I, 160 (February 25, 1862). For Ruskin's relationship with his parents at the time of his turn to social criticism, see Rosenberg, *Darkening Glass,* pp. 107-120; John Tyree Fain, *Ruskin and the Economists* (Nashville, 1956), pp. 28-34.
4. Ruskin, *Works,* 16.372-373, 435. Ruskin refers specifically to the ideals of the Christian Socialist F. D. Maurice.
5. Ibid., 434-436, 374; 11.74-75.
6. Ibid., 158; 6.455-456; 7.386-387, 341. A unique form of waste comes to haunt Ruskin's later years—the waste of "girl wealth." Ibid., 29.430-431, 447-448.
7. Ibid., 16.73-75; 6.456-459; 12.407, 431, lxiii.
8. Ibid., 16.335-336, 338-341.
9. Ibid., 17-18.
10. Ibid., 19. In the twentieth century, the distinction Ruskin makes between the two meanings of economy became a topic of debate among professional economists. Cf. T. W. Hutchison, *A Review of Economic Doctrines, 1870-1929* (Oxford, 1953), p. 246; D. H. Macgregor, *Economic Thought and Policy* (London, 1949), pp. 1-4; Gustav Cassel, *Fundamental Thoughts in Economics* (London, 1925), pp. 106, 183.
11. Ruskin, *Works,* 16.20-21.
12. Ibid., 22-23.
13. Ibid., 24-27, 112-116; 9.302. Cf. Wordsworth's essay on the Poor Law Amendment Bill, published as a "Postscript" to the 1835 edition of his poems, *Poetical Works,* p. 756; Carlyle, *Past and Present,* Bk. III, ch. v. Ruskin first proposed a "paternal" model for government in 1851. Ruskin, *Works,* 12.554; 11.261.
14. Ibid., 16.29.
15. Ibid., 30-32, 34, 115, 118-119; Blake, *Poetry and Prose,* pp. 570 (Pub. Address), 516 (Descriptive Cat., 1809); cf. Northrop Frye, *Fearful Symmetry* (Princeton, 1947), pp. 96, 408-409.
16. Ruskin, *Works,* 16.36, 38-40, 44-45.
17. Ibid., 48, 51, 53.
18. Ibid., 123-125.
19. Ibid., 57-58, 61, 64-79; Burke, *Correspondence of Burke and Windham,* p. 72. A "National Art Collections Fund" was established in 1903.
20. Ruskin, *Works,* 16.81-93, 98.
21. Ibid., 101-103, 127.
22. Ibid., 7.450, 454-455.
23. Ibid., 16.341-342.
24. Ibid., 343-345; 17.385.
25. Ibid., 7.207-208; 4.93, 183.
26. Ibid., 7.263-264; 16.388, 391. Ruskin saw in the sprawling suburbs a

further symbol of impure social relationships: "those gloomy rows of formalized minuteness, alike without difference and without fellowship, as solitary as similar." Ibid., 8.226.

27. Abram Combe, *Metaphorical Sketches of the Old and New Systems* (1823), pp. 40-51, 184.

28. Coleridge, *Lay Sermon, Complete Works*, VI, 209-210; Robert Southey, *Sir Thomas More; or, Colloquies on the Progress and Prospects of Society* (2 v. London, 1829), I, 57; II, 275-276; Carlyle, *Past and Present*, pp. 32, 66, 146, 180, 185, 274; Carlyle, *Chartism*, p. 375; Carlyle, *Sartor*, p. 182; Carlyle, "Signs of the Times," *Col. Works*, VII, 334. Arthur Helps and William Maginn of *Fraser's Magazine* describe the dangers of a mechanical, competitive society in terms similar to Carlyle's. Arthur Helps, *The Claims of Labour* (2d ed., London, 1845), pp. 35-36, 154-155, 247-249; William Maginn, *Fraser's Magazine*, I, 607; II, 161; III, 209-229.

29. Carlyle, *Past and Present*, p. 32; Carlyle, *Sartor*, Bk. III, ch. v, 133; Coleridge, *Complete Works*, VI, 129; Wordsworth, *Prose Works*, I, 272. Cf. Ruskin, *Works*, 17. 233-234.

30. Robert Southey, *Essays, Moral and Political* (2 v. London, 1832), II, 237; Southey, *Colloquies*, I, 60; II, 276; William Cobbett, *Rural Rides* (Everyman ed., 2 v. London, 1912), I, 179; Cecil Driver, *Tory Radical: The Life of Richard Oastler* (London, 1946), pp. 115-132; Burke, *Works* (Rivington ed.), V, 330-331; Burke, *Works* (Bohn's British Classics ed.), VI, 146-147; Edmund Burke, "Thoughts on French Affairs," in John Morley, *Burke: English Men of Letters* (New York, 1879), p. 165. For the nuances in Burke's organic approach to society, see Chapman, *Edmund Burke: The Practical Imagination*, ch. i.

31. Ferguson, *Essay on Civil Society*, pp. 6-7, 27, 85; Ferguson, *Principles*, I, 6; II, 411; John A. Millar, *A Historical View of the English Government from the Settlement of the Saxons in Britain to the Revolution in 1688* (4 v. London, 1803), I, 375-376.

32. Ruskin, *Works*, 37.189; 5.321-322; 16.341; Robert Owen, *The Book of the New Moral World* (6 Pts. London, 1836-44). Godwin, Owen, and the Co-operators propose solutions to the problem of social disintegration not drastically different in tone from those of the Romantics. The words love, sympathy, and unselfishness pervade both literatures. Godwin and Owen compare the society of the future to an extended family. Robert Owen, *The Life of Robert Owen* (2 v. London, 1857), IA, 114; Owen, *New View*, p. 123; William Godwin, *Enquiry Concerning Political Justice and Its Influence on Morals and Happiness*, ed. F. E. L. Priestley (reprinted from the 3rd ed., 1798; 3 v. Toronto, 1946), I, 162-163, 198; II, 177-178, 464, 504; William Thompson, *An Inquiry into the Principles of the Distribution of Wealth most Conducive to Human Happiness* (London, 1824), pp. 21, 44, 151-160, 578.

33. One should not interpret these remarks too strictly. Ruskin advocates freedom of foreign trade, and Byron and Hazlitt urge government action to remedy specific evils like child labor. Even the later Wordsworth believes that government should let economic processes take their course. Wordsworth, *Prose Works*, I, 159. Edmund Burke applies the liberal implications of organicism to the problem of the American colonies: "Through a wise salutary neglect . . . a generous nature has been suffered to take her own way to perfection." Burke, *Works*, I, 462.

34. Carlyle, *Sartor*, Bk. III, ch. vii. In later years, Carlyle waits impatiently for the "Industrial Ages" to "harden themselves into some organism." Carlyle, *Past and Present*, Bk. IV, ch. i, 250-251.

35. For the phrase "frame of reference," see Daniel M. Fox, *The Discovery of*

Abundance: Simon N. Patten and the Transformation of Social Theory (Ithaca, New York, 1967), p. vii. The question of whether abundance is potential or actual is an important one. In the nineteenth century, the distinction was not drawn. If pressed, Ruskin and his predecessors would almost certainly have declared that abundance was potential. For a discussion of this question and of the assumption of scarcity in the nineteenth and earlier centuries, see ibid., pp. 1-12, 163-178.

36. John Maynard Keynes, *The Economic Consequences of the Peace* (London, 1919), p. 21; John Maynard Keynes, *Essays in Persuasion* (Norton Library ed., New York, 1963), p. 334.

37. Fox, *Discovery of Abundance,* pp. 4, 77, 85, 144, 148, 177; John Maynard Keynes, *The General Theory of Employment, Interest and Money* (London, 1936), pp. 30-31. Keynes may have borrowed the phrase from John A. Hobson's *Poverty in Plenty* (New York, 1931).

38. Thomas Paine, *Rights of Man: Being an Answer to Mr. Burke's Attack on the French Revolution* (Everyman's Library ed., London, 1915), pp. 214, 274; Godwin, *Political Justice,* II, 462-463, 494; Hall, *Effects of Civilization,* p. 205; Thompson, *Inquiry,* pp. xv-xvi, 375; Owen, *Life,* I, 186, 188; Anton Menger, *The Right to the Whole Produce of Labour* (London, 1899), p. lxxxiv.

39. Coleridge, *Complete Works,* VI, 181, 196; Carlyle, *Past and Present,* Bk. I, ch. i, 6; Carlyle *Col. Works,* IX, 34. In a passage very similar to Carlyle's, Ruskin declares in *The Crown of Wild Olive* (1866): "Our cities are a wilderness of spinning wheels instead of palaces; yet the people have not clothes. We have blackened every leaf of English greenwood with ashes, and the people die of cold; our harbors are a forest of merchant ships and the people die of hunger." Ruskin, *Works,* 18.502. Cf. Southey, *Colloquies,* I, 145-146, 153-154; Hazlitt, *Works,* I, 314ff.; VII, 270. William Cobbett, on the other hand, contrasts a present scarcity caused by commercialism with a *past* abundance when the population was much larger and much better fed. Cobbett, *Rural Rides,* I, 187.

40. Blake, *Poetry and Prose,* pp. 67 ("The Song of Los"), 551 ("A Vision of the Last Judgment"); Ludlow, *Christian Socialism,* pp. 70-76.

41. Among the less well-known writers who attacked Malthus in the first half of the nineteenth century are Nassau Senior, George Ensor, T. R. Edmonds, Samuel Laing, Thomas Jarrold, Simon Gray, Archibald Alison, and James Grahame. Cf. Harold A. Boner, *Hungry Generations: The Nineteenth-Century Case Against Malthusianism* (New York, 1955); Kenneth Smith, *The Malthusian Controversy* (London, 1951).

42. The best study of the French utopians is Frank Manuel, *The Prophets of Paris* (Cambridge, Massachusetts, 1962). For the phrase "tough-minded," see Fox, *Discovery of Abundance,* p. 6.

43. Carlyle, *Past and Present,* pp. 154, 191.

44. Ruskin, *Works,* 3.665-666; 12.133; 18.150. Ruskin's marriage to Euphemia Chalmers Grey was annulled July, 1854.

45. To trace Ruskin's concern for his health and fear of encroaching death, a fear aggravated by religious doubts, see the entries in his *Diaries* from 1855 onward. In later years, he took to counting the diminishing number of days left to him. Ruskin, *Diaries,* I, 94, 140, 275. For "safe plenty," see Ruskin, *Works,* 36.567. A few of the many references to irrigation and flood control from this period are: ibid., 6.340ff., 391; 17.61, 97, 265-267, 270, 449; 18.176. For Hunter Street, see ibid., 27.169; 28.272; 35.15-16. Ruskin was not beyond testing his methods of irrigation in his backyard or elsewhere. At Fulking, Sussex, he was honored by a plaque commemorating his success in clearing a well and designing a small system of drainage. Ibid., 34.719; 35.317n.; 37.591. After a

visit to Italy in 1869, Ruskin urged his "Alpine plans" on both British and Italian authorities. Ibid., 19.lv-lvii, 445-448; 17.547-552.

46. After reading Ruskin's *Diaries,* one is tempted to declare that Freud could have drawn the raw materials for *The Interpretation of Dreams* from Ruskin. Ruskin's dreams include the following "symbols": various creatures turning themselves into snakes; snakes and women's breasts; innumerable streams, waterfalls, and rivers, sometimes turning into ice and sometimes sweeping Ruskin away; streams, snakes, leeches, blood, and young girls all associated; the grooves of railroad tracks; pianos, violins, and Ruskin's old nurse Anne, naked; spiraling towers and staircases, the ascent of which is blocked at a crucial moment by a huge cobweb; torrents, girls, and a fortress to which Ruskin cannot find the key. Without being presumptuous, one might conclude that one of Ruskin's problems was sex. Certainly it cannot all be in the mind of the beholder. Cf. Ruskin *Diaries,* III, 643-644, 646, 680-687, 690, 732, 738, 744, 746, 766, 788, 975.

47. References to streams, rivers, inundations, torrents, waterfalls, erosion, and clouds are listed in *General Index, Works,* 39. For Ruskin's use of stream imagery in his economic analysis, see infra, ch. vi.

48. Ruskin, *Works,* 35.612; Wordsworth, *Prelude,* VII, 4-12; IX, 1-8; XIV, 73-77; *Prelude* (1805), XIII, 57-73; Wordsworth, *Poetical Works,* pp. 296-303; Coleridge, *Anima Poetae,* p. 46; cf. Maud Bodkin, *Archetypal Patterns in Poetry* (Oxford, 1934), pp. 40-48. In a letter to Dr. John Brown (February 1847), Ruskin comments on his loss of delight in nature. He complains that his "fancy" is "fast evaporating or freezing, or sinking, as Wordsworth has it, from the *fountain* into the *comfortless and hidden well* . . . it pains me to be . . . ordered into the ice-house of mere philosophy. . . ." Ruskin, *Works,* 36.67.

49. Wordsworth, *Poetical Works,* p. 298; Wordsworth, *The Recluse, Poetical Works* (ed. de Selincourt), p. 728; Carlyle, *Sartor,* Bk. II, ch. iii, 82; Ruskin, *Works,* 35.15; 36.16, 21, 33, 66-67; Wordsworth, *Prelude* (1805), XIII, 172-176. In volume two of *Modern Painters,* Ruskin insists that the "value of passion is . . . as it breaks up the fountains of the great deep of the human mind." Ruskin, *Works,* 4.204.

50. Godwin, *Political Justice,* II, 111, 512; Combe, *Metaphorical Sketches,* pp. 40-51; Marx and Engels, *Selected Works,* II, 23; Coleridge, *Lay Sermon, Complete Works,* VI, 192, 173. Cf. Hazlitt, *A Reply to the Essay on Population* (1807), *Works,* I, 257.

51. Ruskin, *Works,* 16.473-474, 480, 486-487.

Chapter V Bastard Science

1. Ruskin, *Works,* 17.xxi, 131; 18.103.

2. Ibid., 17.85, 92; Wordsworth, *Excursion,* VIII, 285; Southey, *Essays,* I, 181; II, 210; Arthur Penrhyn Stanley, *Life of Thomas Arnold, D. D.* (New York, 1844), p. 68; Carlyle, *Latter-Day Pamphlets,* pp. 315-318. It is Matthew Arnold who strikes the most sympathetic chord. He describes political economy simply as "boring." Matthew Arnold, *Friendship's Garland: Being the Conversations, Letters, and Opinions of the Late Arminius, Baron Von Thunder-Ten-Tronckh* (London, 1871), p. 42.

3. Ruskin, *Works,* 7.448; 17.19; 27.95. Cf. ibid., 4.67. The connection between Ruskin's view of economic man and aesthetic man has been noted by other scholars: Wilenski, *John Ruskin,* p. 242; Rosenberg, *Darkening Glass,* p. 132.

4. Ruskin, *Works,* 17.25-26, 30-31.

5. Ibid., 67, 25-26.

6. Ibid., 29-30; Dickens, *Hard Times,* p. 475.

7. Ruskin, *Works,* 17.138; Karl Knies, *Die Nationalökonomie vom historischen Standpunkt* (2d ed., Brunswick, 1883), p. 23; Thomas E. Cliffe-Leslie, *Essays in Political Economy* (2d ed., Dublin, 1888), pp. 188, 175. Hildebrand is quoted by Charles Gide and Charles Rist, *A History of Economic Doctrines,* trans. B. Richards (2d ed., Boston, 1949), p. 394. For the development of historical economics, see Gustav von Schmoller, *Grundriss der allgemeinen Volkswirtschaftslehre* (2 v. Leipzig, 1900-1904); A. W. Coats, "The Historist Reaction in English Political Economy," *Economica,* New Series, XXI (May 1954), 143-153. For the *Methodenstreit* or Battle of Methods which reverberated in German scholarship for many years after 1880, see Joseph A. Schumpeter, "Epochen der Dogmen und Methodengeschichte" in *Grundriss der Sozialökonomik* (2d ed., Tübigen, 1924), I, ch. ii, 108.

8. Arnold Toynbee was one of the more enthusiastic of Ruskin's Hincksey diggers at Oxford, E. T. Cook, *The Life of John Ruskin* (2 v. London, 1911), II, 191. Wordsworth, *Prose Works,* I, 154.

9. Ruskin, *Works,* 17.27-28; Joseph Butler, *Three Sermons on Human Nature* (3rd ed., Oxford, 1855), pp. 8-9, 15, 61, 78, 99.

10. J. C. L. Simonde de Sismondi, *Nouveaux principes d'économie politique* (2d ed., 2 v. Paris, 1827), II, 171; J. C. L. Simonde de Sismondi, *De la richesse commerciale* (2 v. Geneva, 1803), I, xv; Albert Aftalion, *L'oeuvre économique de Simonde de Sismondi* (Paris, 1899), pp. 57-58. Ruskin refers to Sismondi's history in *Works,* 12.171n.; 23.73; 35.351. Henry C. Carey, *Principles of Social Science* (3 v. London, 1858), I, 192-193; Fain, *Ruskin and the Economists,* p. 112.

11. Southey, *Essays,* II, 112. Burke's criticism of Jacobin "theorists" and "alchemistical legislators," who reduce living men to "loose counters" and examine all questions from the standpoint of "substance and quantity," forms a persistent undertone to later Romantic criticism of the abstractions of political economy. So do Swift's strictures on economic "projectors" and abstract "systematizers." Burke, *Reflections on the French Revolution,* pp. 177, 59, 60; Jonathan Swift, "Some Free Thoughts upon the Present State of Affairs" (1714), quoted by Ricardo Quintana, *The Mind and the Art of Swift* (New York, 1936), ch. iv. Many years later, William Blake complains that, "since the French Revolution, Englishmen are all Intermeasurable One by Another," like counters in a till. Letter to George Cumberland, 12 April 1827, in Blake, *Poetry and Prose,* p. 707.

12. Samuel Taylor Coleridge, *Table Talk,* recorded by T. Allsop (London, 1901), pp. 198, 318; John Stuart Mill, essays on "Coleridge" and "Bentham," *Dissertations and Discussions,* I, 354, 366, 391; II, 37-38; Mill, *Autobiography,* p. 16; Carlyle, *Col. Works,* II, ch. ix, 126. In terms very similar to Ruskin's, Hazlitt insists that "to deprive man of sentiment, is to deprive him of all that is interesting to himself or others, except the present object and a routine of cant-phrases, and to turn him into a savage, an automaton, or a Political Economist." Hazlitt, *Works,* XII, 193ff. On the Continent, the Italian nationalist Joseph Mazzini complains that economists and Utilitarians have "broken up and shattered the human being into its social faculties." Mazzini, *The People's Journal,* II (1846), 362-364.

13. Owen, *New View,* pp. 8, 141; Thompson, *Inquiry,* pp. iii-vi. The essay "Social System" appeared in the *New Harmony Gazette* in 1827.

14. Ludlow, *Christian Socialism,* pp. 13, 17, 21, 27.

15. *Letters, Conversations, and Recollections of S. T. Coleridge,* ed. Thomas Allsop (New York, 1836), pp. 262-263; Southey, *Colloquies,* I, 66; Xenophon, *The Economist of Xenophon,* trans. Alexander D. O. Wedderburn and W. Gershom Collingwood, ed. John Ruskin (London, 1876), pp. 1-8, 84-85.

16. Ruskin, *Works,* 7.208; 17.44; 16.9, 116n. *Munera Pulveris* means "Gifts of the Dust" in reference to the orthodox economists who "take dust for deity." Ibid., 17.1xvi-viii, 282.

17. Ibid., 18, 148. Xenophon, *Economist,* pp. 8, 11, 60-66. Cf. Ernest Barker, *Greek Political Theory: Plato and his Predecessors* (London, 1918), esp. pp. 165-166, 318-326.

18. Sismondi, *Nouveaux principes,* II, 86; I, 20; Adam Müller, *Die Elemente der Staatskunst* (2 v. Berlin, 1809), I, 63-66; Friedrich List, *The National System of Political Economy,* trans. S. S. Lloyd (New York, 1928), pp. 141, 109-113; cf. Cliffe-Leslie, *Essays in Political and Moral Philosophy,* pp. 241-242. An awareness of historical relativity was not confined to the historical economists or such early figures as Sismondi and Richard Jones (1790-1855). John Stuart Mill accepted the relativity of social institutions and economic laws. John Stuart Mill, *Principles of Political Economy with Some of their Applications to Social Philosophy* (People's ed., London, 1888), Bk. II, ch. iv; Joseph A. Schumpeter, *History of Economic Analysis* (New York, 1954), pp. 544-545. Long before the rise of historical economics, Edmund Burke had recognized the relativism implicit in the historical approach. Although a believer in *laissez faire,* Burke was under no illusion concerning the absolute validity of economic laws. Burke, *Works,* II, 351-352. Ruskin, *Works,* 17.147.

19. Ibid., 44-46. Much earlier, the Ricardian socialist Piercy Ravenstone (possibly a pseudonym) described classical economics as "a cold and dreary system which represents our fellow-creatures as so many rivals . . . which builds our wealth upon their poverty. . . ." Piercy Ravenstone, *A Few Doubts as to the Correctness of some Opinions Generally Entertained on the Subjects of Population and Political Economy* (1821), p. 17.

20. Ruskin, *Works,* 17.46-52.

21. Ibid., 152; James Maitland, Earl of Lauderdale, *An Inquiry into the Nature and Origin of Public Wealth, and into the Means and Causes of its Increase* (2d ed., Edinburgh, 1819), pp. 40-44. The American economist Daniel Raymond (1786-1849), the French economist Charles Ganilh (1758-1836), and the Scottish emigrant to Canada John Rae (1796-1872) followed Lauderdale closely in distinguishing between national wealth and private riches.

22. Ruskin, *Works,* 17.92; J. C. L. Simonde de Sismondi, *Études sur l'économie politique* (2 v. Paris, 1836), I, 4, 99; II, 75, 235; Sismondi, *Nouveaux principes,* I, 190; II, 171.

23. *The Christian Socialist,* II, 315; Ludlow, *Christian Socialism,* pp. 22-26. For Ludlow's French background, see Torben Christensen, *Origin and History of Christian Socialism 1848-54* (Copenhagen, 1962), chs. i and ii.

24. Aristotle *Politics* i.2 (1253a 38), 8-10 (1256a 1-1258b 8).

25. Ruskin, *Works,* 17.80-81, 147; Mill, *Principles,* Bk. III, ch. i, sec. 2, p. 265.

26. Plato *Laws* v. 742-744; Aristotle *Ethics* i.2 (1094a 18-1094b 12); Aristotle *Politics* i.1 (1252a 1-24); Ruskin, *Works,* 16.20-24; 17.29, 147.

27. Cf. A. W. Small, *The Cameralists* (Chicago, 1909), pp. 306-307. Sir James Steuart, who was the first to use the term "political economy," defines his subject as follows: "Oeconomy, in general, is the art of providing for all the wants of a family with prudence and frugality. . . . What oeconomy is in a family

political oeconomy is in a state." Sir James Steuart, *An Inquiry into the Principles of Political Oeconomy* (2 v. London, 1767), I, 16.

28. *The Works, Political, Metaphysical, and Chronological, of the late Sir James Steuart of Coltness, Bart.* (6 v. London, 1805), I, 348-349; Steuart, *Inquiry*, I, 125, 460; George Berkeley, *The Querist, containing Several Inquiries proposed to the Consideration of the Public, 1735-37* (Baltimore, 1910), pp. 9-24, 69-71. Sismondi recognized that mercantilism could be adapted to a practical concern for social welfare and compared the mercantile system favorably to that of competitive capitalism.

29. Sismondi, *Nouveaux principes* (1819 ed.), II, 248-249.

30. List, *National System of Political Economy*, p. 113; Müller, *Elemente der Staatskunst*, I, 348, 474; II, 6; John K. Ingram, *A History of Political Economy* (London, 1915), p. 297; cf. Arnold Toynbee, *Lectures on the Industrial Revolution of the Eighteenth Century in England* (New ed., London, 1908), p. 23.

31. Fain's study is particularly useful in directing the reader's attention to the views of the later classical economists Senior and Cairnes. Fain, *Ruskin and the Economists*, ch. iii.

32. Thomas R. Malthus, *Principles of Political Economy Considered with a View to their Practical Application* (2d ed., London, 1836), pp. 1, 4, 8, 434; Sismondi, *Études*, I, 118. John Stuart Mill praised Smith for a shrewd awareness of the difficulty of applying abstract principles. Mill, *Principles*, Preface, pp. v-vi.

33. Smith's criticisms of the "man of system" remind one of Burke's and testify to his empirical approach. Smith, *The Theory of Moral Sentiments* (Edinburgh, 1849), pp. 342-343. Smith, *Wealth of Nations*, Bk. I, ch. ii, 26-27; Bk. II, ch. iii, 269-270; Bk. IV, ch. ii, 352-355; David Ricardo, *Principles of Political Economy and Taxation* (Everyman's Library ed., London, 1906), ch. xx, 182-183; James Mill, *Elements of Political Economy* (London, 1821), p. 1ff.; Smith, *Wealth of Nations*, Bk. I, ch. ii, 17; Jane Marcet, *Conversations on Political Economy* (1816), ed. J. L. Blake (Boston, 1828), p. 23. Ruskin was also familiar with the work of Harriet Martineau. Ruskin, *Works*, 29.361-362.

34. Nassau W. Senior, *An Outline of the Science of Political Economy* (6th ed., London, 1872), pp. 1, 5-6; Nassau W. Senior, *Introductory Lecture on Political Economy* (London, 1827), p. 30. This lecture was delivered December 6, 1826.

35. John Stuart Mill, "On the Definition of Political Economy," *Collected Works of John Stuart Mill* (Toronto, 1963), IV, 319-320.

36. John Elliot Cairnes, *The Character and Logical Method of Political Economy* (3rd ed., London, 1888), pp. 35, 54, 59; Richard Whately, *Introductory Lectures on Political Economy* (London, 1854), pp. 2-4; Ruskin, *Works*, 17.92. For a reason not unlike Whately's, the Ricardian socialist Thomas Hodgskin also objects to the name "political economy." Thomas Hodgskin, *Popular Political Economy* (London, 1827), p. 36.

37. Senior, *Introductory Lecture*, p. 28; Senior, *Lectures* (1847), cited in Marian Bowley, *Nassau Senior and the Classical Economists* (London, 1937), p. 55.

38. Mill, *Collected Works*, IV, 312, 326, 332, 337; John Stuart Mill, *A System of Logic: Ratiocinative and Inductive* (London, 1852), Bk. VI, ch. ix, sec. 3, p. 587; sec. 5, p. 592; ch. v, secs. 3 and 6; Mill, *Principles*, Bk. II, ch. iv, sec. 2, p. 148; Mill, *Autobiography*, p. 165. Unlike Comte, Mill insists that economics is a separate branch of sociology. J. S. Mill, *Auguste Comte and Positivism* (2d ed., London, 1866), pp. 80-83. Earlier, Sismondi had noted the limited validity of the economists' assumption of perfect competition. Sismondi, *Nouveaux principes*, I, 302, 336.

39. Lionel Robbins, *The Theory of Economic Policy* (London, 1952), pp. 1-67.

40. Smith, *Wealth of Nations,* Bk. IV, ch. viii, 523-524; ch. ix, 545; Bk. I, ch. x, Pt. 2, 116; James Bonar, *Malthus and his Work* (2d ed., London, 1924), Bk. II, ch. iv.

41. *The Works of Jeremy Bentham,* ed. John Bowring (11 v. Edinburgh, 1838-43), III, ch. iii; IX, 7. It is no accident that Herbert Spencer (1820-1903) combined his advocacy of extreme individualism with a rejection of Bentham's Utilitarianism and a return to the theory of natural rights. Herbert Spencer, *Man Versus the State* (New York, 1916), passim.

42. Bowley, *Nassau Senior,* pp. 247-248, 265; John E. Cairnes, *Essays in Political Economy, Theoretical and Applied* (London, 1873), p. 244.

43. Mill, *Principles,* Bk. V, ch. xi, sec. 7, p. 573; ch. i, sec. 2, p. 482; ch. xi, sec. 2-6, pp. 568-573; sec. 9-15, pp. 577-590; *The Earlier Letters of John Stuart Mill: 1812-1848,* ed. Francis E. Mineka (2 v. Toronto, 1963), I, 151-152. The statement beginning "there is scarcely anything" was made by Mill in the House of Commons in 1868 in reply to Robert Lowe's view that political economy embodied an absolute set of rules. It is quoted in Macgregor, *Economic Thought and Policy,* pp. 86-87.

44. Senior, *Introductory Lecture,* pp. 8-9.

45. Mill, *Collected Works,* IV, 322, 336-337; John R. McCulloch, *On the Principles of Political Economy and Taxation* (Edinburgh, 1843), Preface, p. vii.

46. Mill, *Autobiography,* pp. 111-112. Ruskin's use of chemical analogies in his discussion of the imagination takes on further significance in the light of his disagreement with Mill.

47. Fain, *Ruskin and the Economists,* esp. ch. v. Fain gives many examples of Ruskin's tactics.

48. Smith, *Wealth of Nations,* Bk. IV, ch. viii, 523-524; Ruskin, *Works,* 17.20, 43-46; 27.516.

49. Ibid., 17.33, 134. The Christian Socialist J. M. Ludlow is more circumspect than Ruskin in his attacks on the economists. He is careful not to accuse the leading economists of bad intentions and asserts that "nothing can be more striking—I might almost say, often more revolting—than the contrast between the sentiments of those men themselves and those of the many who only borrow from them a few axioms and phrases, for the sake of systematizing their own selfishness." Ludlow, *Christian Socialism,* p. 51.

50. For a discussion of Ricardo's use of "suppositious cases," see Wesley C. Mitchell, *Types of Economic Theory* (New York, 1967), pp. 323-325, 355-356, 379-380. Bowley, *Nassau Senior,* p. 236.

Chapter VI Shattered Majesty

1. Marx, *Capital,* I, Pt. 1, ch. i, sec. 4.

2. Ruskin, *Works,* 17.114, 149; 7.430.

3. Ibid., 17.18-19, 164; Bentham, *Works,* III, 28-29; Smith, *Wealth of Nations,* Bk. I, ch. iv.

4. Ruskin, *Works,* 17.84-85, 151-153. Ruskin first attempts a vital definition of wealth in ibid., 16. 129-134.

5. Smith, *Wealth of Nations,* Bk. I, ch. iv, 37; Ricardo, *Principles,* pp. 5-6; Aristotle *Politics* i.9 (1257a 6-13). For an excellent discussion of "value in use" in Aristotle and St. Thomas Aquinas, see Stephen Theodore Worland, *Scholasticism and Welfare Economics* (London, 1967), chs. i and viii. Ruskin, *Works,* 17.85, 165. Unlike his predecessors Samuel von Pufendorf and Francis Hutch-

eson, Adam Smith occasionally propounds an objective, ethically tinged view of "value in use" similar to Ruskin's. Smith, *Wealth of Nations,* Bk. I, ch. iv, 37.

6. Ruskin, *Works,* 17.166; Patrick Geddes, *John Ruskin, Economist,* The Round Table Series III (Edinburgh, 1884). For a different interpretation of Ruskin's concept of vital value, see John A. Hobson, *John Ruskin: Social Reformer* (Boston, 1898), pp. 101-104.

7. Ruskin, *Works,* 17.87-89, 167. Cf. ibid., 16.133.

8. Ibid., 17.288; Aristotle *Oeconomica* 1344b; Adam Müller, *Versuche einer neuen Theorie des Geldes* (Hardflamma Series ed., Leipzig, 1816), p. 46; Coleridge, *Table Talk,* p. 45. Even John Stuart Mill suggests that property, especially land, should be in the hands of him who can best use it. Mill, *Auguste Comte and Positivism,* p. 161; Mill, "The Right of Property in Land," *Dissertations and Discussions,* IV, 289ff.

9. Ruskin, *Works,* 17.87; 27.542.

10. Smith, *Wealth of Nations,* Bk. II, ch. ii, 230, 236; Ronald L. Meek, "Physiocracy and the Early Theories of Under-consumption," *Economica,* XVIII, 71 (August 1951), 229-269; Ruskin, *Works,* 17.48. It is significant that Quesnay was a practicing physician.

11. Ibid., 94-95, 151, 182-185.

12. Cf. Mitchell, *Types of Economic Theory,* pp. 332-334. Smith, *Wealth of Nations,* Bk. I, ch. v, 38; Mill, *Principles,* Bk. I, ch. i, sec. 1, p. 15. Mill, to be sure, recognizes the possibility of positive, creative labor which "ends in immediate enjoyment." Though "useful," such labor does not increase the "accumulated stock" of material products and so does not contribute to economic value. Ibid., Bk. I, ch. iii, sec. 4, p. 31.

13. Ruskin, *Works,* 17.96-98, 151-152.

14. Ibid., 105, 148-150, 156. Ruskin refers to Wordsworth's line, "We live by Admiration, Hope, and Love." Wordsworth, *Excursion,* IV, 763.

15. Berkeley, *Querist,* pp. 13, 68, 24; Müller, *Theorie des Geldes,* p. 66; Müller, *Elemente der Staatskunst,* I, 356-357, 348, 374; Aftalion, *L'oeuvre économique de Simonde de Sismondi,* p. 48; Ludlow, *Christian Socialism,* p. 23; Coleridge, *Notebooks,* I, entry 893; Owen, "Observations on the Effect of the Manufacturing System" (1815), *New View,* p. 127; Ruskin, *Works,* 10.196. Ruskin's style of argument owes much also to the Evangelical distinction between "nominal" and real, or "practical," Christianity.

16. Bentham, *Works,* X, 214-215; Carlyle, *Sartor,* Bk. I, chs. v and viii. Carlyle borrowed the metaphor from Swift, *Tale of a Tub,* sec. II, 76-86.

17. Ruskin, *Works,* 17.171-174, 208-216. Ruskin's ability to reel off quotations on any subject stems from his habit of keeping notebooks in which he entered passages from whatever author he happened to be reading. One notebook entitled "Topics" had notes on Price, Commerce, Production, Poverty, Government. Ibid., 12.xlix.

18. Ibid., 17.174-175, 154-157. Compare the distinction drawn by Ruskin in *The Political Economy of Art* between property which sustains "life," or "being," and property which contributes to "the objects of life," or "*well* being." The latter "gives pleasure or suggests and preserves thought." Ibid., 16.129-130.

19. Ibid., 17.178.

20. Ibid., 174, 160-161, 180-181.

21. Ibid., 81-83.

22. Ibid., 64, 94, 83-84; 16.86; cf. Victor E. Smith, "The Classicists' use of 'demand,' " *Journal of Political Economy,* LIX, 3 (1951), 242-257. Ruskin's analysis of the role of demand in the determination of price has been neglected

by scholars. They mistake his assertion that price is "counted" or "measured" in terms of the buyer's labor for an assertion that price is entirely dependent on or determined by the producer's labor. Ruskin, *Works,* 17.153, 182-183, 186n.; 27.471.

23. Ibid., 17.94, 187. By asserting that the consumer's choice is relative and dependent on all the commodities available to him, Ruskin unwittingly foreshadows F. Y. Edgeworth's revision of W. S. Jevon's pleasure-pain calculus. Cf. Hutchison, *Review of Economic Doctrines,* p. 114; George J. Stigler, "The Early History of Empirical Studies of Consumer Behavior," *JPE,* LXII (April 1954), 95-113.

24. Ruskin, *Works,* 17.83-84n., 187. Cf. Whately, *Introductory Lectures;* Samuel Mountifort Longfield, *Lectures on Political Economy* (Dublin, 1834); William Forster Lloyd, *Lecture on the Notion of Value, as Distinguished not only from Utility but also from Value in Exchange* (Oxford, 1837). For the histories of economic thought most helpful in clarifying the background of utility analysis outlined in this and the preceding paragraphs, see the Selected Bibliography.

25. W. S. Jevons and Carl Menger, the pioneers of the marginal utility school, did not themselves adopt publicly the assumption of abundance. Nonetheless, they fashioned methods of analysis which directed the attention of later economists to the implications of abundance. Cf. Fox, *Discovery of Abundance,* pp. 10-11.

26. Ruskin, *Works,* 17.174, 194.

27. Ibid., 202-203, 54, 157-158; 16.17, 134-135. Ruskin takes the side of Malthus in his debate with Ricardo over the nature of currency. Malthus denies that currency is a mere "veil" or medium of exchange. Thomas Robert Malthus, *An Investigation of the Cause of the Present High Price of Provisions* (London, 1800), reprinted in *The Canadian Journal of Economics and Political Science* (May 1949), p. 201.

28. Ruskin, *Works,* 17.189.

29. Ibid., 496-497, 490; Fain, *Ruskin and the Economists,* pp. 129-130.

30. Ruskin, *Works,* 17.197-200; Sir Thomas More, *The Utopia* (1516), in H. Goittein, ed., *Sir Thomas More: The Utopia; Francis, Lord Bacon: The New Atlantis* (Broadway trans., London, n.d.), pp. 113-114, John Wheatley, *An Essay on the Theory of Money and Principles of Commerce* (London, 1807); Joseph Lowe, *The Present State of England* (London, 1822); John Rooke, *Principles of National Wealth* (Edinburgh, 1825). Cf. Edwin R. A. Seligman, "On Some Neglected British Economists," *Economic Journal,* XIII (1903), 511ff. Ruskin may have derived his idea of relating currency to the value of basic commodities from Bishop Berkeley or Dugald Stewart. Berkeley, *Querist,* pp. 13, 80; Dugald Stewart, *Lectures on Political Economy* (Edinburgh, 1877), pp. 362-363.

31. Ruskin, *Works,* 17.201, 158-159, 496-497.

32. Berkeley, *Querist,* pp. 34, 39, 99, 111; S. R. Sen, *The Economics of Sir James Steuart* (Cambridge, Massachusetts, 1957), ch. vii. Hume, though a critic of mercantilism in other respects, believed that an increasing amount of money is beneficial to industry. David Hume, *Essays and Treatises on Several Subjects* (2 v. London, 1772), I, 297-298; II, ch. xv. Henry Thornton, *An Inquiry into the Nature and Effects of the Paper Credit of Great Britain* (London, 1802), pp. 259-264, 287-289; Thomas Attwood, *The Remedy, or Thoughts on the Present Distress* (London, 1816); Owen, "Report to the County of Lanark," *New View,* pp. 245-298; John Gray, *The Social System: A Treatise on the Principle of Exchange* (Edinburgh, 1831), ch. v; Combe, *Metaphorical Sketches,* pp. 40-57.

33. Ruskin, *Works,* 17.205-207, 168-169.

34. Nicholas Barbon, *A Discourse of Trade* (London, 1690), p. 62; Mandeville, *Fable of the Bees,* pp. 83, 102-107, 197-198; Sen, *Economics of Sir James Steuart,* ch. ix. For Hume, cf. Mary Jean Bowman, "The Consumer in the History of Economics," *American Economic Review,* XLI (May 1951), Suppl. 1-18. Malthus, *Political Economy* (1820 ed.), pp. 326, 417, 465; Lauderdale, *Inquiry into the Nature and Origin of Public Wealth,* pp. 220-224, 227-230; Sismondi, *Nouveaux principes,* II, 9, 15; Ruskin, *Works,* 17.101.

35. Ibid., 98, 78; Mill, *Principles,* Bk. I, ch. iii, 28-33. Mill does not disparage "unproductive consumption."

36. Ruskin, *Works,* 17.98-99, 101-102. Ruskin describes capital as the fountain or "well-head" of wealth, "as the clouds are the well-heads of rain." When the clouds are without water, they issue in "lightning instead of harvest." Ibid., 100.

37. Smith, *Wealth of Nations,* Bk. IV, ch. viii, 523-524; James Mill, *Elements of Political Economy* (3rd ed., London, 1826), p. 219.

38. John Stuart Mill, *Essays on Some Unsettled Questions of Political Economy* (London, 1844), p. 132. Mill can also protest against the "idol of production" in terms very like Ruskin's. J. S. Mill, "The Negro Question," *Fraser's Magazine,* XLI (January 1850), 27. Smith, *Wealth of Nations,* Introduction, p. 19. Only the isolated chapters vii and x of Book I of Smith's treatise lend support to an allocative interpretation of free competition. They are not typical of Smith's train of thought as Book II indicates. For an excellent discussion of the classical economists' emphasis on productivity, see Hla Myint, *Theories of Welfare Economics* (London, 1948), chs. i-vi.

39. Ruskin, *Works,* 18.245; Marx, *Capital,* I, Pt. 7, ch. xxiv, sec. 3, p. 652; Smith, *Wealth of Nations,* Bk. IV, ch. ii, 259-261; Bk. II, ch. iii, 270-274.

40. Ruskin, *Works,* 27.247. In this passage (1872), Ruskin specifically criticizes Jevons' pleasure-pain calculus.

41. Frédéric Bastiat, *Harmonies of Political Economy,* trans. from the 3rd French ed. by P. J. Sterling (2d ed., Edinburgh, 1880), pp. 338, 419; Ruskin, *Works,* 27.24-25; 29.200; Sismondi, *Nouveaux principes,* II, 318, 329; William Thompson, *Labour Rewarded* (London, 1827), pp. 39, 52-55, 124; Hodgskin, *Popular Political Economy,* pp. 23, 36, 43. For Proudhon, see G. D. H. Cole, *Socialist Thought: The Forerunners, 1789-1850* (London, 1955), pp. 206-214. Many years earlier, Bishop Berkeley asked whether Fancy "doth not most cruelly torment and delude those poor Men, the Usurers, Stockjobbers . . . and Projectors of content to themselves from heaping up Riches, that is, from gathering Counters, from Multiplying Figures . . . without having a proper Regard to the Use, or End, or Nature of things?" Berkeley, *Querist,* pp. 61-62.

42. J. B. Say, *Traité d'économie politique* (2 v. Paris, 1803), I, 148-165; II, 175; Malthus, *Political Economy,* pp. 361-363, 369, 316-325.

43. James Mill quoted in R. L. Meek, "Physiocracy and the Early Theories of Under-consumption," p. 244; Say, *Traité,* II, 175; Smith, *Wealth of Nations,* Bk. II, ch. iii, 271; *The Collected Works and Correspondence of David Ricardo,* ed. Piero Sraffa (9 v. Cambridge, 1951-52), II, 449.

44. Ruskin, *Works,* 17.103n.; Mill, *Principles,* Bk. I, ch. v, sec. 9. Elsewhere, Mill admits the possibility of a discrepancy between demand and production. Ibid., Bk. III, ch. xviii, sec. 1, p. 480. Say, *Traité,* II, 179; cf. Schumpeter, *History of Economic Analysis,* p. 568.

45. Ruskin, *Works,* 17.186n., 47-48.

46. The unity of classical economics should not be overemphasized. Passages can be cited from both J. B. Say and J. S. Mill which suggest a different type of

analysis from that of the "law of markets." Say, *Traité*, I, chs. vii, xi, xv, xvi; Mill, *Principles*, Bk. III, ch. xii, sec. 2, p. 317; ch. xiv, sec. 2, p. 337; Mill, *Unsettled Questions*, ch. ii; D. H. Macgregor, *Economic Thought and Policy*, pp. 94-95, 115-116, 125-126.

47. Ruskin, *Works*, 17.559, 380, 545-546; 18.390-391; Godwin, *Political Justice*, II, 152-165; Hall, *Effects of Civilization*, pp. 36-37; Berkeley, *Querist*, pp. 60-61; Steuart, *Inquiry*, I, 392. Coleridge, significantly, compares fiscal policy to the sun which takes moisture from wet places and rains it down in life-giving streams on dry areas. Coleridge, *Complete Works*, VI, 172-176; Southey, *Essays*, II, 26-29.

48. Hume, *Essays and Treatises*, I, 149; Smith, *Moral Sentiments*, I, 107.

49. Ruskin, *Works*, 17.168.

50. Thomas De Quincey, *Reminiscences of the English Lake Poets* (Everyman's Library ed., London, n.d.), pp. 197-198; Isaiah Berlin, *The Hedgehog and the Fox* (New York, 1953). For a list of references useful to anyone wishing to explore further the history of underconsumption analysis, see the Selected Bibliography.

51. Smith, *Wealth of Nations*, Bk. I, ch. viii; Malthus, *Political Economy*, pp. 224-225; Ricardo, *Principles*, p. 96; J. R. McCulloch, *The Principles of Political Economy* (5th ed., London, 1864), pp. 316-320, 326.

52. J. S. Mill, Review of *On Labour: Its Wrongful Claims and Rightful Dues, Its Actual Present and Possible Future* by W. T. Thornton, *Fortnightly Review*, New Series, V (May 1, 1869), 505-518. For a qualified version of the wages-fund theory much like Mill's, see Malthus, *Political Economy*, p. 234.

53. Fleeming Jenkin, "Trade-Unions: How Far Legitimate," *North British Review* (1868), reprinted in *The Graphic Representation of the Laws of Supply and Demand and Other Essays on Political Economy* (London, 1931), pp. 21-22; Ludlow, *Christian Socialism*, pp. 44-45.

54. Francis A. Walker, *The Wages Question* (New York, 1876), p. 264; Seligman, "On Some Neglected British Economists," p. 354; Thomas Hodgskin, *Labour Defended Against the Claims of Capital*, ed. G. D. H. Cole (London, 1922), p. 38; Mill, *Principles*, Bk. I, ch. v, sec. 1, p. 39; sec. 9, p. 49. For another early attack on the wages-fund from the standpoint of labor's productivity, see Hazlitt, *A Reply*, *Works*, I, 320-325.

55. Ruskin, *Works*, 17.176-177.

56. Ibid., 177, 538; 27.380; Mill, *Principles*, Bk. I, ch. v, sec. 9, p. 51.

57. Ruskin, *Works*, 17.137, 537. For a discussion of the subsistence theory of wages held by most mercantilists and physiocrats, see Edgar S. Furniss, *The Position of the Laborer in a System of Nationalism* (Boston, 1920), ch. vii; Schumpeter, *History of Economic Analysis*, pp. 266-268.

58. Ricardo, *Principles*, pp. 7, 74; Malthus, *Political Economy*, pp. 247-249, 472. Cf. S. Ambirajan, *Malthus and Classical Economics* (Bombay, 1959), pp. 130-136.

59. Ruskin, *Works*, 17.105-107, 73.

60. The Webbs give Lloyd Jones (*Beehive*, July 1874) credit for originating the term "living wage." Beatrice and Sidney Webb, *Industrial Democracy* (London, 1926), pp. 586-589. Yet, as early as 1851, the much neglected J. M. Ludlow speaks of "living wages" in his lecture on *Christian Socialism*, p. 56. Ruskin, *Works*, 17.148-150, 111, 433. For a more recent view of the population problem very similar to Ruskin's, see John Maynard Keynes, *The End of Laissez-Faire* (London, 1927), pp. 46-49. Suggestions of an "optimum population" can be found earlier in the work of Sir James Steuart and Dugald Stewart. Sen, *Econo-*

mics of Sir James Steuart, p. 44; Stewart, *Lectures on Political Economy,* pp. 63-65.

61. Ruskin, *Works,* 17.33-34; Ludlow, *Christian Socialism,* pp. 33-34, 40. Ruskin may also have used a passage from J. S. Mill. Mill, *Principles,* Bk. II, ch. xiv, sec. 7, p. 244; Fain, *Ruskin and the Economists,* p. 116.

62. Ruskin, *Works,* 17.33, 35-36.

63. Robbins, *Theory of Economic Policy,* Lecture iii.

64. Ruskin, *Works,* 35.43, 35-37; Rosenberg, *Darkening Glass,* pp. 110-112.

65. Ruskin, *Works,* 17.62, 64-68.

66. For the concepts of commutative and distributive justice in Aristotle and St. Thomas Aquinas, see Worland, *Scholasticism and Welfare Economics,* ch. viii. Hall, *Effects of Civilization,* pp. 55-56; Thompson, *Inquiry,* p. 127; John Francis Bray, *Labour's Wrongs and Labour's Remedy* (Leeds, 1839), pp. 32-33, 61, 67. On one occasion only does Ruskin suggest that labor be rewarded for its "fruitfulness." Ruskin, *Works,* 17.65.

67. Ibid., 90-93, 45; 16.116n. Ruskin refers to the belief that there can be profit in exchange as the "heresy of the Tables." Ibid., 29.225n.

68. Aristotle *Ethics* v. 4 (1132b 15-25); Worland, *Scholasticism and Welfare Economics,* pp. 17-20, 253-255; Ruskin, *Works,* 17.63-64.

69. M. L. W. Laistner, trans., *Greek Economics* (London, 1923), pp. 106-177, 194-198; Gide and Rist, *History of Economic Doctrines,* pp. 12-18; Smith, *Wealth of Nations,* Bk. IV, ch. ii, 358-362.

70. Long before Ruskin, Charles Hall fashioned a critique of competitive acquisitiveness out of the perception that businessmen consider exchange the only way to gain wealth in a scarce or limited economy. He even used the terms "minuses" and "pluses" to describe the situation. Hall, *Effects of Civilization,* pp. 82-83.

71. Ruskin, *Works,* 17.218, 221-222, 224-227. In an appendix to this section, Ruskin compares the derivation of words to that of rivers: "There is one real source . . . far up among the hills; then, as the word flows on and comes into service, it takes in the force of other words from other sources, and becomes . . . a word as it were of many waters. . . ." Ibid., 292.

72. Ibid., 135, 449, 503, 522, 63n.; Carlyle, *Past and Present,* pp. 186, 149-150. Cf. Hazlitt, *Works,* XII, 193, 298.

73. Sismondi, *Nouveaux principes,* I, 306ff.; Ludlow, *Christian Socialism,* pp. 45-47; Mill, *Principles,* Bk. III, ch. i, sec. 1, pp. 264-265; Ruskin, *Works,* 17.532.

74. Mill, "Tocqueville," *Dissertations and Discussions,* II, 6-7.

Chapter VII System of Iniquity

1. Ruskin, *Works,* 19.38; 20.83.

2. Ibid., 95-96, 107-110. Cf. Ladd, *Victorian Morality of Art,* pp. 322, 338.

3. Ruskin, *Works,* 27.186; 20.201ff., 39, 93; 19.266, 467; 23.52; Thomas Arnold, *Miscellaneous Works* (First American ed., New York, 1845), p. 430; Helps, *Claims of Labour,* p. 270. When Ruskin republished *The Political Economy of Art* as *A Joy for Ever* (1880), he did so in reference to his belief that "the beauty which is indeed to be a joy for ever, must be a joy for *all.*" Ruskin, *Works,* 20.212.

4. Ibid., 19.165-167, 389-393, 34; 20.39; 18.434.

5. Ibid., 34.603, 51n.; 20.107, 111-115; 27.159; 28.14; Blake, *Poetry and Prose,* p. 272 (commentary on the Laocoön engraving).

6. Ruskin, *Works,* 28.649, 179; 27.15, 531; 34.529; 18.51; 33.511; Carlyle, *Past and Present,* Bk. III, ch. iii, 151-154.

7. Ruskin, *Works,* 29.470-471, 395n.; 27.42, 432; 26.560-561; 17.168. For the meaning of the title *Fors Clavigera,* see ibid., 27.xix-xxiii.

8. Blake, *Poetry and Prose,* pp. 156 ("Jerusalem"), 375 ("The Four Zoas"); Ruskin, *Works,* 27.91-92; 19.24; 28.175, 463-464; 34.38, 40; 10.193. For other comments on water pollution, cf. ibid., 20.110; 27.607; 28.37, 301, 615, 689. For air pollution, cf. ibid., 16.339; 27.133, 661; 31.226; 34.572. J. U. Nef, *The Rise of the British Coal Industry* (2 v. London, 1932), I, 19-20; J. H. Clapham, *An Economic History of Modern Britain* (2d ed., 3 v. Cambridge, 1950-52), I, 431; III, 162, 167; Rosenberg, *Darkening Glass,* pp. 212-214. If Ruskin did not use the term smog, he identified the phenomenon: "the air one loathsome mass of sultry and foul fog, like smoke." Ruskin, *Works,* 34.37.

9. Ibid., 28.464; 18.406; 27.436.

10. William Cobbett, *Political Register* (2/22/23), cols. 480-484, (7/12/23), col. 91; Southey, *Colloquies,* I, 108, 201-202. (All *Political Register* dates are to the 1800's.)

11. Carlyle, *Sartor,* Bk. III, ch. vi, 190; cf. Robert Southey, *Letters from England* (n.p., 1807), p. 198.

12. Helps, *Claims of Labour,* pp. 126, 129-140, 193-212, 225-226; Southey, *Essays,* II, 230-235. For Ruskin's admiration of Helps, see *Works,* 5.334, 427; 36.327.

13. Cobbett, *Rural Rides,* I, 134-135; II, 55-56, 223-224; Robert Blake, *Disraeli* (New York, 1967), p. 765; Ruskin, *Works,* 18.48; Letter to his mother from Baveno, 6 May 1869, ibid., lxi.

14. Ibid., 36.416, 590; 29.562; 27.14, 509; 19.401-406.

15. Ibid., 27.31-33; 17.102-103n.; Mill, *Principles,* Bk. I, ch. v, sec. 9. Leslie Stephen considered the "complete apprehension" of Mill's dictum to be "perhaps the best test of an economist." Maurice Dobb, *Political Economy and Capitalism: Some Essays in Economic Tradition* (London, 1937), pp. 43-44; Leslie Stephen, "Mr. Ruskin's Recent Writings," *Fraser's Magazine,* June 1874. For an excellent discussion of Mill's dictum from a strictly economic point of view, see Schumpeter, *History of Economic Analysis,* p. 144.

16. Ruskin, *Works,* 7.250; 4.284, 9; 27.627; 20.92.

17. Ibid., 28.695; 27.75, 80-81; Carlyle, *Past and Present,* Bk. III, ch. vii, 171-172. The radical journalist William Benbow also rejected the term "overproduction." Max Morris, ed., *From Cobbett to the Chartists: Nineteenth Century Vol. I: 1815-1848* (London, 1948), pp. 84-86.

18. Ruskin, *Works,* 17.185, 46, 73; 18.412, 427; 27.261-262.

19. Ibid., 17.388, 148, 53.

20. Ibid., 18.387-389. For Ruskin on the "ethics" of iron railings, see ibid., 16.388-391; 27.34-37, 43. Before arriving at the Croydon pub, he had passed the polluted "pools" of Carshalton, one of the sources of the River Wandel. Ibid., 18.385-386.

21. Ibid., 17.165, 58; 28.16-17; 27.124, 320; 23.207n.; Carlyle, *Shooting Niagara,* p. 345.

22. Ruskin, *Works,* 17.389, 277n.; 27.473; Coleridge, *Complete Works,* VI, 196, 208-210. Cf. F. D. Maurice, *Learning and Working* (Cambridge, 1855), p. 113.

23. Ruskin, *Works,* 18.225; 17.389-390. It is this shift from the ethical to the aesthetic which distinguishes Ruskin's critique of commerical practice from Carlyle's.

24. Ibid., 28.121-122; Aristotle *Politics* i.10 (1258b).

25. Ruskin, *Works,* 27.316-319; 29.572-573.

26. Ibid., 571, 573; 34.xxxvii.

27. Ruskin refers to W. C. and R. G. Sillar many times. Ibid., 39.565. For a list of pamphlets written by the Sillar brothers, see ibid., 17.220n. Ruskin's view of interest has been ably criticized by J. A. Hobson in *John Ruskin,* pp. 144-152.

28. Smith, *Wealth of Nations,* Bk. I, ch. vi, 57; Bk. II, ch. iv, 286; Mill, *Principles,* Bk. V, ch. ii, sec. 5; Bk. IV, ch. iii, sec. 15; Ricardo, *Principles,* pp. 66ff. Cf. Menger, *Right to the Whole Produce,* pp. li-lii; Élie Halévy, *Thomas Hodgskin,* trans. A. J. Taylor (London, 1956), p. 63.

29. George Bernard Shaw, *Everybody's Political What's What?* (New York, 1944), p. 179; Ruskin, *Works,* 36.251, 450; 22.267; 18.415; 28.426; 34.407; 27.39.

30. Ibid., 10.194; 16.482, 484; 28.485; 27.127. Ruskin's statue of the "Goddess of Getting-on" bears a family resemblance to Carlyle's statue of George Hudson, the railway magnate, in *Latter-Day Pamphlets* (1850). Ruskin, *Works,* 29.151.

31. Ibid., 33.38, 230; 17.436-437, 560; 28.491.

32. Ibid., 27.117, 377; 28.127-128; 29.317.

33. Ibid., 28.364; 29.108, 590; 34.413, 205; 33.43.

34. Southey, *Colloquies,* I, 194, 111; Carlyle, *Sartor,* Bk. II, ch. iv, 96; Bk. III, ch. iv, 180. Earlier, William Godwin compared the condition of the British worker unfavorably to that of cattle. Godwin, *Political Justice,* II, 455; cf. Karl Marx, *The Economic and Philosophic Manuscripts of 1844* (Moscow, 1959), pp. 71, 105.

35. Blake, *Poetry and Prose,* pp. 27 (London), 396, 313-314 ("The Four Zoas"), 48 ("Visions of the Daughters of Albion"); ibid. (Keynes ed., 1948), pp. 897, 664, 275.

36. Paine, *Rights of Man,* p. 278; Godwin, *Political Justice,* I, 50, 86, 113-115, 278; II, 594, 788; Hall, *Effects of Civilization,* p. 168; Owen, *New Moral World,* Pt. IV, 45; Thomas Hodgskin, *Natural and Artificial Rights of Property Contrasted* (London, 1832), pp. 46-47, 67-73, 152; Cobbett, *Political Register* (4/20/05), cols. 597-598; (8/14/19), col. 8; *The Opinions of William Cobbett,* eds. G. D. H. and Margaret Cole (London, 1944), pp. 23, 69, 178, 299; Carlyle, *Past and Present,* Bk. III, ch. vi, 168; ch. x, 189.

37. Schumpeter, *History of Economic Analysis,* p. 43; Robbins, *Theory of Economic Policy,* pp. 20-22, 171-174; Karl Mannheim, *Essays on Sociology and Social Psychology,* ed. Paul Koeskemeti (New York, 1953), p. 74.

38. Smith, *Wealth of Nations,* Bk. I, ch. viii, 91; ch. ix, 116; Bk. IV, ch. iii, 385; Bk. V, ch. i, Pt. 2; J. S. Mill, "Newman's Political Economy" (1851), *Collected Works,* V, 444; cf. Mill, *Principles,* Bk. V, ch. ix, sec. 5. In writings published posthumously, Mill deals sympathetically with the socialist critique of capitalism. J. S. Mill, *Socialism,* ed. W. D. P. Bliss (New York, 1891), pp. 60-97.

39. Ruskin, *Works,* 17.555; 28.391; 27.70-71, 184.

40. Ibid., 29.185-186; 27.364; 28.139, 425; W. G. Collingwood, *The Life of John Ruskin* (London, 1900), p. 289.

41. Ruskin, *Works,* 17.cx, 437; 19.xxv; 30.143-145.

42. Ibid., 27.100, 195, 257-258, 353; 28.204-205. For details concerning Ruskin's publishing experiments, see ibid., 27.lxxxii-vi; Hobson, *John Ruskin,* pp. 280-283.

Chapter VIII War and Empire

1. Wilenski, *John Ruskin,* pp. 304-305, 309-311. Cf. Ruskin, *Works,* 5.327n., 410-417; 9.446-448, 456; 18.459-465; 19.397.

2. Ibid., 27.364, 74; 18.515, 470-471, 466; 34.525; 19.398.

3. Ibid., 34.524; 27.43, 142; 29.17.

4. Ibid., 27.137; 34.414-415.

5. Ibid., 27.75; 28.641.

6. Ibid., 17.103-104n., 142, 207; 27.127; 36.412-413. For other references to capitalists as the cause of war, cf. ibid., 18.103, 368, 416; 34.445, 525.

7. Ibid., 18.477-481, 500; 17.433n., 448; 19.401-402; Plato *Laws* 624, 634A; More, *Utopia,* pp. 40-41, 64-67.

8. Ruskin, *Works,* 17.474; 36.439; 18.480, xxiii-vi.

9. Ruskin cites Byron in ibid., 34.328, 397; Carlyle in ibid., 18.468-469; and Helps in ibid., 471-472. Carlyle, *Past and Present,* Bk. III, ch. x, 191; Carlyle, *Sartor,* p. 84; Ruskin, *Works,* 16.26; 19.402; 20.42. "Armies of thinkers, instead of armies of stabbers!" is Ruskin's goal. Ibid., 18.103.

10. Paine, *Rights of Man,* pp. 212, 241, 271-272; Godwin, *Political Justice,* I, 35; II, 150-158, 168, 179; Blake, *Poetry and Prose,* p. 26 ("London"), 378 ("The Four Zoas").

11. Ibid., p. 310 ("The Four Zoas"); Letter to William Haley, 7 August 1804, ibid. (Keynes ed., 1927), p. 897; Coleridge, *Table Talk,* pp. 392-398; Cobbett, *Political Register* (10/25/23), col. 213; (1/11/06), col. 41; *The Prose Works of Jonathan Swift,* ed. Herbert Davis (Oxford, 1937), VI, 10, 59; Godwin, *Political Justice,* II, 465-466; Hall, *Effects of Civilization,* pp. 130-137; Thompson, *Practical Directions,* pp. i-iii.

12. Smith, *Wealth of Nations,* Bk. II, ch. v, 298; Mill, *Principles,* Bk. IV, ch. iv; ch. v, sec. 2; Richard Cobden, *Speeches on Questions of Public Policy* (2 v. London, 1870), esp. II; John Bright, *Speeches on Questions of Public Policy* (London, 1869), pp. 224-276, 459-465. Cf. Donald Read, *Cobden and Bright: A Victorian Political Partnership* (London, 1967), pp. 115-131. John A. Hobson was aware of Ruskin's view of the "financial origin of modern wars." Hobson, *John Ruskin,* pp. 324-325.

13. Ruskin, *Works,* 20.43; 18.500-501. In the year of Ruskin's Inaugural Lecture, J. A. Froude linked imperialism and social reform in a different way. Froude's argument was that, if England did not have the support of all her citizens, she would be unable to defend an empire. Froude, "The Colonies Once More," *Fraser's Magazine,* September 1870. Alfred Milner (1854-1925) was one of Ruskin's Hincksey diggers. Ruskin, *Works,* 20.xiv.

14. The phrase "systematic colonization" was adopted by the "colonial reformers" Gibbon Wakefield, Charles Buller, William Molesworth, and J. S. Mill to describe the projects which they urged upon the Colonial Office. Mill and Buller were influenced by Carlyle. Cf. Edward Gibbon Wakefield, *View of the Art of Colonization* (London, 1841). For earlier emigration proposals, see Steuart, *Inquiry,* I, 67-81, 385-400; More, *Utopia,* p. 102; Barbon, *Discourse of Trade,* p. 24.

15. Coleridge, *Table Talk,* pp. 86, 216; Arnold, *Miscellaneous Works,* pp. 199-200, 493; Carlyle, *Chartism,* pp. 385-386; Carlyle, *Past and Present,* Bk. IV, ch. iii, 263, 267; Southey, *Essays,* II, 265; Robert Owen, *The New Existence of Man upon the Earth* (8 v. London, 1854-55), V, 65-78. The early land reformers William Ogilvie, Robert Wallace, and Thomas Spence also urged a program of overseas expansion. Cf. Robert Wallace, *Various Prospects of Mankind, Nature, and Providence* (London, 1761), pp. 112, 287-288.

16. Ruskin, *Works,* 28.92, 133; 29.415; 18.485n.

17. Lionel Robbins, "Conception of Stationary Equilibrium," *Economic Journal,* XL, 158 (June 1930), 194-214; Southey, *Colloquies,* II, 244, 191; Owen,

"Observations," *New View*, p. 122.

18. Ruskin, *Works*, 28.105; 29.212, 273, 403; 34.419-420; 33.473, 89.

19. Ibid., 27.451.

20. Ibid., 17.72n., 318; 19.228; John A. Hobson, *Richard Cobden: The International Man* (New York, 1919). Goldwin Smith (1823-1910) and Frederic Harrison (1831-1923) also criticize imperial mismanagement. Goldwin Smith, *The Empire* (Oxford, 1863), pp. 78, 147-149; Frederic Harrison, "Empire and Humanity," *Fortnightly Review*, June 1880. Ruskin was familiar with the work of Goldwin Smith and knew Harrison personally. Ruskin, *Works*, 17.479; 28.466, 618. For a more radical critique of empire, see Hall, *Effects of Civilization*, pp. 71-72, 170; John Francis Bray, *A Voyage from Utopia* (reprinted London, 1957), pp. 101, 139-140.

21. Ruskin, *Works*, 18.409, 432; 17.285, 381, 447; 29.148; 27.126; Xenophon, *Economist*, ed. Ruskin, p. xxix.

22. Ruskin, *Works*, 22.148; 20.92-93; 23.390; 27.130, 126. Ruskin's sense of the organic texture of responsibility in the "body politic" leads him to suggest to Gladstone in 1878 that, whenever a murder is committed, the inhabitants of the district might "draw lots to decide who should be hung for it." Ibid., 36.lxxxii; 17.233. For Ruskin's personal sense of responsibility, see ibid., 411; 28.757; 36.436.

23. Ibid., 18.126, 140ff., 447; 19.201. Much earlier, Wordsworth and Schiller praise the sympathetic powers of women. Wordsworth, *Prelude*, XII, 151-173, 203-224; Friedrich Schiller, *Würde der Frauen*, *Werke* (16 v. Berlin, 1879), VIII, 125-126. Hobson discusses this lecture but fails to consider Ruskin's fondness for ironical exaggeration. Hobson, *John Ruskin*, pp. 321-323.

Chapter IX The Insolence of Reaction

1. Ruskin, *Works*, 27.116; 29.400. Cf. ibid., 17.436; 18.496; 27.176, 661. Godwin, *Political Justice*, I, 107; II, 462-466; Stanley, *Life of Thomas Arnold*, p. 242; Owen, "Observations," *New View*, pp. 124-125; Letter from J. S. Mill to J. P. Nichol, September 30, 1848, *Fortnightly Review*, LXVII (January-June 1897), 677; Walter E. Houghton, *The Victorian Frame of Mind* (New Haven, 1957), pp. 54-58.

2. Ruskin, *Works*, 29.401; 17.9; 27.129.

3. Ibid., 107, 127, 52; 28.151-153.

4. Ibid., 29.16; 27.380-381; 17.554, 564-565, 539, 264. Ruskin compares drastic changes in the social structure to the circulation of water in "a great lake or sea." Ibid., 235.

5. Ibid., 326-328; 29.258.

6. Ibid., 17.537, 539; 29.409, 411.

7. Ibid., 36.318; 29.408; 27.380; 17.70-71. For Chamberlain, see G. M. Trevelyan, *British History in the 19th Century: 1782-1919* (Harper Torchbook ed., New York, 1966), p. 383.

8. Southey, *Essays*, I, 178; II, 182-183, 292; J. S. Mill, Review of Arthur Helps' *The Claims of Labour*, in *Edinburgh Review*, LXXXI (April 1845), 509-512, 524-525; Mill, *Collected Works*, V, 656-666; Cobbett, *Political Register* (1/7/32), cols. 109-113; (1/1/32), cols. 155-159. Thomas Carlyle was one of the first to propose a profit-sharing scheme. Carlyle, *Past and Present*, Bk. IV, ch. vi, 281-282. The early advocates of public ownership in land William Ogilvie, Thomas Spence, and Charles Hall also recognized the virtue of small allotments.

9. Ruskin, *Works*, 34.612.

10. Ibid., 17.438, 487; 18.105; 27.191, 116, 122-123.

11. Ibid., 381; 17.106-107n.; Carlyle, *Sartor*, p. 123; Carlyle, *Past and Pre-*

sent, Bk. III, ch. xii, 207; cf. Richard K. P. Pankhurst, *The Saint-Simonians Mill and Carlyle: A Preface to Modern Thought* (London, 1957).

12. Cole, *Socialist Thought,* p. 148; Owen, *New View,* p. 67; Christensen, *History of Christian Socialism,* pp. 60, 77-78; Frederick Denison Maurice, *Reasons for Co-operation* (London, 1851), pp. 17-18; William Cobbett, *Paper against Gold* (London, 1815), Letter iii (September 11, 1810); Cobbett, *Opinions,* p. 13.

13. David Hume, *Enquiry Concerning the Principles of Morals* (1748), in *Essays, Moral, Political, and Literary,* III, 179-192; Mill, *Principles,* Bk. II, ch. ii, sec. 6; Mill, "Right of Property in Land," *Dissertations,* IV, 289; "Coleridge," ibid., I, 455. Cf. Mill, *Principles* (3rd ed.), Bk. II, ch. i.

14. Ruskin, *Works,* 17.402.

15. Ibid., 18.500; 19.li; 28.207, 220; 27.649; Carlyle, *Chartism,* p. 343; Carlyle, *Latter-Day Pamphlets,* pp. 320-324, 331; Arthur Penrhyn Stanley, *The Life and Correspondence of Thomas Arnold, D.D.* (13th ed., 2 v. London, 1882), I, 330; II, 41; Swift, *Prose Works,* XII, 65; Matthew Arnold, *Culture and Anarchy,* edited with intro. by J. Dover Wilson (Cambridge, 1935), pp. 105-109. For Ruskin's important role in the Jamaica Case (1866), see Bernard Semmel, *The Governor Eyre Controversy* (London, 1962). Further examples of Ruskin's attitude toward the "mob" or "criminals" can be found in *Diaries,* I, 29, 104, 108, 139, 166; II, 653, 759. In *Time and Tide,* Ruskin adopts the more reasonable view that crime can be prevented only by education, employment, and reward—"by letting no man grow up a criminal." He declares that "punishment is the last and worst instrument . . . for the prevention of crime." Ruskin, *Works,* 17.392, 542.

16. Ibid., 74, 236; 27.14, 230, 178; 28.343.

17. Ibid., 17.248, 253, 319, 432; 27.167-168; 23.115; J. S. Mill, *Considerations on Representative Government* (London, 1867), pp. 174-175. Compare Ruskin's definition of social "Unity" in volume two of *Modern Painters, Works,* 4.93, 183. For an excellent, although partisan, discussion of his critique of democracy, see Hobson, *John Ruskin,* pp. 185-193, 204-209. More entertaining are the questions posed by a reader of *Fors* (1873) in Ruskin, *Works,* 27.544.

18. Owen, *New View,* p. 111; "Report to the County of Lanark," ibid., p. 287; Cobbett, *Political Register* (4/15/09), col. 550; (11/11/17), col. 937. For the difference between Ludlow and Maurice on this question, see Christensen, *History of Christian Socialism,* pp. 42, 96, 301-305. J. S. Mill, *Dissertations,* II, 6-9, 14-21, 395; J. S. Mill, *On Liberty* (London, 1859), passim; Matthew Arnold, *Mixed Essays, Irish Essays, and Others* (London, 1904), pp. 6, 8-9, 319-321; Arnold, *Culture and Anarchy,* pp. 109-111.

19. Letter to Lady Cowper-Temple, 6 June 1869, *The Letters of John Ruskin to Lord and Lady Mount-Temple,* ed. John Leavis Bradley (Columbus, Ohio, 1964), p. 210; Ruskin, *Works,* 17.431; 27.30; Carlyle, *Latter-Day Pamphlets,* pp. 266, 275, 364-376; Carlyle, *Chartism,* p. 345. Ruskin was well aware of his debt to Carlyle. After his father's death in 1864, he came to look upon his older friend as a second father. Ruskin, *Works,* 5.427; 17.476; 27.179; Frederick William Roe, *The Social Philosophy of Carlyle and Ruskin* (New York, 1921), pp. 141-148.

20. Ruskin, *Works,* 31.122; 19.126; 16.408. The identification of liberty with alienation or "isolation" is a prominent theme in Carlyle's *Past and Present.*

21. Ruskin, *Works,* 10.192-194; Young, "Conjectures on Original Composition," in *Criticism,* ed. Schorer, pp. 13, 16; Coleridge, *BL,* II, 44; Coleridge, *Complete Works,* II, 408-409.

22. Ruskin, *Works,* 19.121, 123-124. Cf. ibid., 16.407-408, 413.

23. Ibid., 19.125-127, 129; 17.165; 10.194; James Fitzjames Stephen, *Liberty, Equality, Fraternity* (London, 1873), passim. In a passage quoted by Carlyle, Ruskin attributes the "follies of Modern Liberalism" to its neglect of intrinsic value—its "refusal to discern worth and unworth in anything." Ruskin, *Works*, 27.247-248; Thomas Carlyle, *Early Kings of Norway* (London, 1875), ch. xvi.

24. Ruskin, *Works*, 10.193; 17.256, 403, 438; 18.549; 19.104.

25. Carlyle, *Col. Works*, IX, 348-385; Anthony Ashley Cooper, Earl of Shaftesbury, *Children in Factories* (London, 1838), p. 13; William Maginn in *Fraser's Magazine*, VII 709(a); Hall, *Effects of Civilization*, p. 97; Southey, *Essays*, II, 224; Southey, *Colloquies*, I, 147; Stanley, *Life of Thomas Arnold*, pp. 490, 527-528, 763; Cobbett, *Political Register* (18/30/22), col. 513; (8/30/23), col. 522; (4/16/14), col. 481; (4/25/08), col. 646.

26. Ruskin, *Works*, 17.254-256, 521; 27.14, 514-516, 519-520; 18.424; Carlyle, *Latter-Day Pamphlets*, pp. 159, 166, 293; Carlyle, *Shooting Niagara*, p. 383. On one occasion, Ruskin does suggest that "a nation once utterly corrupt can only be redeemed by military despotism. . . ." Ruskin, *Works*, 18.484. In more moderate moods, he insists that his purpose is "to make people not merely *do* the right things, but *enjoy* the right things." Ibid., 435. For Ruskin's defense of Carlyle on "mights" and his ambivalent view of Prussian militarism, see ibid., 27.230; 17.260; 18.515-516.

27. Owen, *New View*, pp. 74, 260; John Minter Morgan, *The Revolt of the Bees* (London, 1826), passim; Guy Kendall, *Charles Kingsley and His Ideas* (London, 1937), p. 66; cf. Maurice, *Reasons for Co-operation*, pp. 15-18.

28. Arnold quoted in Gaylord C. LeRoy, *Perplexed Prophets: Six Nineteenth-Century British Authors* (Philadelphia, 1953), p. 67; Arnold, *Culture and Anarchy*, pp. 204-205; J. F. Stephen, *Liberty, Equality, Fraternity*, pp. 30-34, 46-54.

29. Ruskin, *Works*, 36.414. For the social and cultural background of Ruskin's parents, see Helen Gill Viljoen, *Ruskin's Scottish Heritage* (Urbana, Illinois, 1956). Brief suggestions of the interpretation offered in this section can be found in LeRoy, *Perplexed Prophets*, pp. 87-89, 91-92; Rosenberg, *Darkening Glass*, pp. 108, 119-120.

30. Ruskin, *Works*, 16.25, 115; 27.471.

31. Ibid., 296. For details concerning the Guild, see ibid., 28.18-23, 417-437; 30.xxi-xli; Hobson, *John Ruskin*, pp. 283-291; Roe, *Social Philosophy*, pp. 271-288.

32. Ruskin, *Works*, 28.425, 644, 648; 29.273; 17.lxxii-iii. Ruskin hoped to build a dam to collect snow water.

33. Sigmund Freud, *The Ego and the Id* (1923) in *The Major Works of Sigmund Freud, Great Books of the Western World*, ed. Robert Maynard Hutchins (54 v. Chicago, 1952), LIV, 702. Ruskin's verdict on his education is also of interest: "It was at once too formal and too luxurious; leaving my character, at the most important moment for its construction, cramped, indeed, but not disciplined; and only by protection innocent, instead of by practice virtuous." Ruskin, *Works*, 35.46.

34. Thomas Carlyle, *The French Revolution* (3 v. London, 1837), I, 211, 288, 169; III, 172; Carlyle, *Latter-Day Pamphlets*, pp. 17-18; James Anthony Froude, *Thomas Carlyle: A History of the First Forty Years of His Life 1795-1835* (2 v. London, 1891), II, 50; James Anthony Froude, *Thomas Carlyle: A History of His Life in London* (2 v. London, 1890), I, 73; Ruskin, *Diaries*, II, 760. Cf. Ruskin, *Works*, 18.497; 37.72.

35. Ibid., 17.111, 446, 326n., 144; 27.378. Compare this remark in *Unto This Last*: "Riches are a form of strength. . . . The socialist, seeing a strong man oppress a weak one, cries out—'Break the strong man's arms'; but I say, 'Teach him to use them to better purpose.' " Ibid., 17.107n.

36. Blake, *Poetry and Prose*, p. 376 ("The Four Zoas"); Carlyle, *Past and Present*, Bk. I, ch. iii, 22-23; ch. vi, 33; Bk. II, ch. vii, 87; Carlyle, *Latter-Day Pamphlets*, p. 360; Ruskin, *Works*, 17.324, 328; W. G. Collingwood, *The Life and Work of John Ruskin* (2 v. London, 1893), I, 126. Kingsley's placard is cited in Arthur V. Woodworth, *Christian Socialism in England* (London, 1903), p. 9. Even J. M. Ludlow insists that Christian Socialism is a "spiritual movement," not concerned with "political and social mechanism." Ludlow, *Christian Socialism*, p. 3; Christensen, *History of Christian Socialism*, p. 78.

37. M. Arnold, *Essays in Criticism*, III, 30; Arnold, *Culture and Anarchy*, p. 13.

38. Coleridge, *Complete Works*, VI, 225. Cf. ibid., 148, 217; Southey, *Colloquies*, II, 357-363, 412, 425. It is significant that increasingly favorable references to Edmund Burke accompany the poets' tendency to stress moral over institutional reform. Wordsworth, *Prelude* (1850), VII, 527-530.

39. Mill, "A Few Observations on the French Revolution," *Dissertations*, I, 56-57, 59; Mill, *Autobiography*, pp. 166-168, 163; Mill, *On Liberty*, p. 207.

40. Owen, *New View*, pp. 65, 89, 110; "Address" in ibid., pp. 148-152; Thompson, *Labour Rewarded*, pp. 564-566; Godwin, *Political Justice*, I, 122, 303; II, 366-367, 438, 515-529. That Owen's faith in moral enlightenment contradicts his assumption that a man's character is formed "for him" by the environment and not "by him" seems only to drive Owen further toward reliance on a sudden, almost millenarian change of heart. For an early criticism of Owen's position, see William Hazlitt in *Examiner*, 4 August 1816; Hazlitt, *Works*, VII, 97ff.

41. Southey quoted in William Haller, "Southey's Later Radicalism," *PMLA*, XXXVI (June 1922), 289; Charles Kingsley, *Letters to the Chartists*, in Christensen, *History of Christian Socialism*, p. 76. For discussions of Ruskin's reliance on moral reform, see Hobson, *John Ruskin*, pp. 193-204; Rosenberg, *Darkening Glass*, pp. 139-143.

42. Ruskin, *Works*, 17.232; 28.655; 11.261; 18.503,55; 19.lvi; 27.296. For detailed studies of Ruskin's ideas on education, see Hobson, *John Ruskin*, pp. 232-265; Hilda Boettcher Hagstotz, *The Educational Theories of John Ruskin* (Lincoln, Nebraska, 1942); E. T. Cook's introduction to Vol. 27 of Ruskin's *Works*, lx-lxxvi. These should be read in conjunction with W. A. C. Stewart and W. P. McCann, *The Educational Innovators: 1750-1880* (New York, 1967).

43. Ruskin, *Works*, 27.149-152; 22.243; 37.337; 16.121. Cf. Hagstotz, *Educational Theories*, pp. 272, 284-287.

44. Ruskin, *Works*, 16.120; 29.496-497; 22.206, 268; 28.752.

45. Mandeville, *Fable of the Bees*, I, 143-144; Robert Dale Owen, *An Outline of the System of Education at New Lanark* (Glasgow, 1824), pp. 9-13, 16, 25, 35-36; *Crisis*, III, 7 and 8 (12 and 19 October 1833); Thompson, *Practical Directions*, pp. 205, 224-225; E. T. Craig, "Socialism in England: Historical Reminiscences," *American Socialist*, II (13 December 1877); III (10 January 1878); John Lalor, Prize Essay in *The Educator: Prize Essays on the Expedience and Means of Elevating the Profession of the Educator in Society* (London, 1839), pp. 100-101; Helps, *Claims of Labour*, pp. 88-90; *Report from the Select Committee on Education in England and Wales, Parliamentary Papers* (1835), pp. viii, 177-179.

46. Ruskin, *Works*, 27.296, lxii, 61; 18.502; 11.263.
47. Ibid., 8.155-156; 22.244; 16.90-92, 180; 18.66. For an earlier and similar criticism of the three *R*'s, see Owen, *Life*, I, 318-319, 325; Robert Owen, *Report of the Proceedings at the Several Public Meetings held in Dublin* (Dublin, 1823), pp. 79-81. Ruskin took little interest in educational theories other than his own. In this, he compares unfavorably with Dickens, whose periodicals *Household Words* and *All the Year Round* eagerly reported innovations in education.
48. Ruskin, *Works*, 11.72; 26.328-329; 34.517.
49. David Williams, *Lectures on Education* (3 v. London, 1789), II, 310-311.
50. Ruskin, *Works*, 25.xlix; 19.168; 20.18; Letter to H. G. Liddell, 2 September 1869, ibid., xxi; J. F. C. Harrison, *A History of the Working Men's College, 1854-1954* (London, 1954), pp. 22-28, 60; John Henry Newman, *The Idea of a University* (London, 1885), passim. In 1857, Ruskin proposed in detail a "judicious involution" of the university curriculum. Ruskin, *Works*, 16.449-453.
51. Ibid., 18.107; 28.655; 5.71; 17.21, 399. For Ruskin's Hincksey project and emphasis on manual labor, see ibid., 20.xl-xlv; 16.111; 17.426. Ruskin practiced what he preached—whether attempting unsuccessfully to build one of the interior brick pillars at the Oxford Museum or pottering symbolically with a miniature system of Alpine irrigation at Brantwood. Ibid., 29.346-347; 35.427. Ruskin's desire to integrate manual labor into the educational process reminds one of the earlier work of Johann Heinrich Pestalozzi (1746-1827) and P. E. von Fellenberg (1771-1844). Ruskin was aware of Fellenberg's experiments at Hofwyl, Switzerland. Ibid., 28.685; 35.592.
52. Ibid., 11.263; 16.128; Mill, *System of Logic*, Bk. VI, chs. vi and vii. Cf. Owen, *New Moral World*, Pt. I, 65-78; Owen, *New View*, pp. 17, 49; Stanley, *Life of Thomas Arnold*, pp. 34, 75, 106. The Utilitarians also consider education an instrument of social reform. F. A. Cavenagh, *James & John Stuart Mill on Education* (Cambridge, 1931), pp. 11-12, 48-52, 71-75.
53. Ruskin, *Works*, 11.261; 16.452; 22.500. Cf. ibid., 9.22; 18.126; 20.381; 24.203. Marc L. B. Bloch, *The Historian's Craft* (New York, 1953). Ruskin urges study of contemporary sources: "*Restored* history is of little more value than restored painting or architecture." Ruskin, *Works*, 11.265. He foresees "noble groups of constellated schools," each giving its scholars a "general idea" of the world's history but concentrating, "as its own special duty," on one place or period. Ibid., 16.93.

Chapter X Public Thing

1. Ruskin, *Works*, 17.137, 451; 28.81; 27.193, 279. Ruskin's break with Octavia Hill occurred after she used such adjectives to describe him. Ibid., 29.356-358.
2. Ibid., 17.289; John Kenneth Galbraith, *The Affluent Society* (Boston, 1951), p. 257; Arnold, *Culture and Anarchy*, pp. 21, 86, 135; Matthew Arnold, "A French Eton," *The Works of Matthew Arnold* (reprinted from the *Edition de Luxe* of 1903-1904, 15 v. New York, 1970), XII, 55-61; Burke quoted by M. Arnold in "Democracy," ibid., X, 40; Coleridge, *Complete Works*, VI, 55. For a similar play on the word "commonwealth," cf. More, *Utopia*, pp. 75, 185-186. In America, Ruskin remarks, there has never been "any such thing as a *res-publica*, but only a multitudinous *res-privata.*" Ruskin, *Works*, 17.246.
3. Ibid., 423, 426-427, 21; 16.111. Cf. Roe, *Social Philosophy*, pp. 211-222. Ruskin urges those who complain of the cost of universal public education to consider the annual bill for poor relief, punishment, war, or private luxury. Ruskin, *Works*, 18.502-505.

4. Ibid., 17.428, 423, 407, 234-236, 22; 27.127; 28.644; Mandeville, *Fable of the Bees*, II, 346-349, 370.

5. Ruskin, *Works*, 27.148; 16.115ff.; 17.320, 397; 11.262-263; Coleridge, *Complete Works*, VI, 58-59, 216. On one occasion, Ruskin suggests that class distinctions are biologically determined. Elsewhere, he insists that they are due only to "difference in occupation" or "direct maltreatment." The apparent contradiction is resolved by his belief that "both moral and physical qualities are communicated by descent." Ruskin, *Works*, 7.343-345; 17.150, 405.

6. Ibid., 541-546; 18.507-508; 19.406; 30.24-26; Coleridge, *Complete Works*, II, 215; Southey, *Essays*, II, 26-29, 96, 122; Southey, *Colloquies*, I, 183, 192; Malthus, *Political Economy*, p. 430; Steuart, *Inquiry*, I, 512-513, 519; Berkeley, *Querist*, pp. 66, 74. For the more usual mercantilist attitude toward full employment, see Furniss, *Position of the Laborer in a System of Nationalism*, chs. iii and iv. Ruskin may well have looked to Xenophon, Sir Thomas More, or Swift for his ideas concerning public works, although, with Swift, one returns to the mercantilists.

7. Ruskin, *Works*, 27.19, 142; 17.289; 29.19-20; 18.182-183.

8. Ibid., 16.110, 113-115; 17.22; 18.94; 11.263; J. S. Mill, "The Poor Laws," *Examiner*, 9 March 1834, p. 145; Paine, *Rights of Man*, pp. 247-254; Owen, *Life*, IA, 286; Southey, *Essays*, I, 98; II, 216; Carlyle, *Past and Present*, Bk. III, ch. vi, 167; ch. xii, 204-206. Cf. William Godwin, *Of Population* (London, 1820), pp. 542-549; Coleridge, *Complete Works*, VI, 69-70, 216. For less well-known supporters of a right to assistance, see Smith, *Malthusian Controversy*, pp. 100-110, 210-215, 300-305.

9. Ruskin, *Works*, 11.151ff.; 17.335, 184, 111; 18.424; 27.118, 496; Carlyle, *Past and Present*, Bk. III, ch. v, 161-162; Bk. IV, ch. iii, 263.

10. Ruskin, *Works*, 18.183; 17.110; 8.226; More, *Utopia*, pp. 84, 89; Bacon, *New Atlantis*, ed. H. Goittein, p. 244; Owen, "Report to the Committee for the Relief of the Manufacturing Poor" (1817), *New View*, pp. 156-169; Richard K. P. Pankhurst, *William Thompson* (London, 1914), pp. 133-135. For Buckingham, see W. H. G. Armytage, *Heavens Below* (London, 1961), pp. 209-223. Ruskin relies much on the pastoral visions of Bacon and More. He regrets that the word "utopia" has become "the byeword of fools." Ruskin, *Works*, 18.513-514; 28.23.

11. Ibid., 19.216-227; 16.475-480; 17.390; 18.104. For a detailed description of the museum at Sheffield, see Hobson, *John Ruskin*, pp. 291-298.

12. Ruskin, *Works*, 17.441; 18.72-73; 28.652. As early as 1852, Ruskin predicts that the social service state "must have an authority . . . of which we now do not so much as dream." Ibid., 11.263; 17.377.

13. Ibid., 12.547-558; Coleridge, *Complete Works*, VI, 51-54, 67-68; C. R. Sanders, *Coleridge and the Broad Church Movement* (Durham, North Carolina, 1942), pp. 77, 114, 116; Southey, *Colloquies*, I, 85-86; II, 312, 319. For Ruskin's "Protestant Convent Plan," cf. *Works*, 30.lv-lvi; 36.186; 18.44.

14. Carlyle, *Past and Present*, Bk. IV, ch. v, 279; Carlyle, *Latter-Day Pamphlets*, pp. 92-93, 121, 284; Bentham, *Works*, IX, 7; cf. M. Arnold, "Democracy," *Works*, X, 40-43.

15. Ruskin, *Works*, 17.373, 237-239, 241-243, 544. Élie Halévy first remarked on the connection between a negative view of labor and *laissez faire*. Élie Halévy, *The Growth of Philosophical Radicalism* (Boston, 1955), p. 119. Comparing the rule of law to the management of streams, Ruskin claims that "liberty is lost only when interference hinders, not when it helps." Ruskin, *Works*, 17.289n., 548.

16. Ibid., 29.495; 17.439, 241; 12.598-599; 27.128, 368; Paine, *Rights of Man*, p. 263; Coleridge, *Table Talk*, pp. 70, 200. Cf. Sen, *Economics of Sir James Steuart*, pp. 113-129.

17. Coleridge, *Two Addresses on Sir Robert Peel's Bill* (privately printed by T. J. Wise, 1919), p. 20; M. Arnold, *Mixed Essays*, p. 465; Mill, *Principles*, Bk. II, ch. i, sec. 2; Mill, "Land Tenure Reform," *Collected Works*, V, 689-695.

18. Ruskin, *Works,* 17.379-380; 18.505; 27.139; *Ruskin's Letters from Venice,* p. 293. Ruskin denies that there is anything "un-English or tending to espionage" in his proposals. Ruskin, *Works,* 17.379.

19. Erich Strauss, *Sir William Petty: Portrait of a Genius* (London, 1954), pp. 196, 214, 231; Berkeley, *Querist,* pp. 69-70; Southey, *Essays,* II, 270-275; Owen, *New View,* pp. 83-84; Carlyle, *Chartism,* pp. 313-314, 374; Carlyle, *Past and Present,* Bk. II, ch. xvii, 138. For a description of Rumford's pioneering but somewhat bizarre activities in Munich, see G. E. Ellis, *Memoir of Sir Benjamin Thompson, Count Rumford* (Boston, 1870), pp. 178-190. Cf. Ruskin, *Works,* 27.502.

20. Ibid., 17.21-22. Ruskin's government workshops would assist in the rehabilitation of criminals. Ibid., 542. They would also act as an economic "control," tempering the cycle of glut and scarcity. Ibid., 16.112-113.

21. Ibid., 17.252-253.

22. Ibid., 380; 29.218. In these passages, Ruskin draws out the full implications of his remark in *Munera Pulveris* that government should be an "improving" as well as a "conservative" or "destructive" power. Ibid., 17.172.

23. Wilenski, *John Ruskin,* p. 322; Ruskin, *Works,* 16.97, 179; 17.384-387, 427; 28.433; 29.113, 341. Ruskin suggested twenty-one classes of work which might be organized into guilds. Ibid., 410.

24. Ibid., 17.386.

25. Ibid., 29.405; 17.317, 319-320. For earlier discussions of Ruskin's view of social and industrial reorganization, see Hobson, *John Ruskin,* pp. 154-185; Roe, *Social Philosophy,* pp. 224-248. Also useful is E. T. Cook's brief outline in Ruskin, *Works,* 17.xcviii-cii.

26. Karl Marx and Friedrich Engels, *The Communist Manifesto* (Little Marx Library ed., New York, 1948), pp. 41-42. The German historical economists active in the *Verein für Socialpolitik*—Lujo Brentano, Karl Knies, Wilhelm Roscher, Gustav von Schmoller, and Adolf Wagner—also proposed a broad range of public services.

27. Harold J. Laski's essay in F. J. C. Hearnshaw, ed., *The Social & Political Ideas of Some Representative Thinkers of the Revolutionary Era* (London, 1931), pp. 201-233; Olive D. Rudkin, *Thomas Spence and his Connections* (London, 1927), p. 152; Bronterre O'Brien in Cole, *Socialist Thought,* pp. 155-156.

28. J. M. Ludlow, *Tracts on Christian Socialism No. IV: The Working Associations of Paris* (1850); Christensen, *History of Christian Socialism,* pp. 59-162; G. D. H. Cole and A. W. Filson, *British Working-Class Movements: Select Documents 1789-1875* (London, 1951), pp. 435-441; Thompson, *Labour Rewarded,* pp. 87-93. For the Building Guild, see Max Morris, ed., *From Cobbett to Chartists,* pp. 89-92. Ruskin was familiar with George Jacob Holyoake's *A History of Co-operation in England* (2 v. London, 1875-79). Ruskin, *Works,* 29.414-415.

29. Mill, "Chapters on Socialism," *Collected Works,* V, 746, 748; Mill, *Principles,* Bk. IV, ch. vii, sec. 6, p. 465; Bk. II, ch. i, sec. 4; J. S. Mill, "On Punishment," *Monthly Repository,* VIII (1834), 734. Cf. Mill, *Autobiography,* pp. 124-125.

30. Mill, "The French Revolution of 1848," *Dissertations,* II, 391; Louis Blanc, *L'organisation du travail* (Paris, 1841), pp. 40-77; Iris W. Mueller, *John Stuart Mill and French Thought* (Urbana, Illinois, 1956), pp. 206-212. For Ruskin on the French experiments of 1848, see *Works,* 16.432-433; 28.653.

31. Mill, *Principles,* Bk. V, ch. i, sec. 2, p. 480; ch. xi, sec. 11, p. 580-581; sec. 15, p. 590; sec. 1. Cf. Mill, *Collected Works,* V, 730.

32. Mill, *On Liberty* (1859 ed.), pp. 26-27; John Stuart Mill, *On Social Freedom* (reprinted from the *Oxford and Cambridge Review,* June 1907), intro. by Dorothy Fosdick (New York, 1941), pp. 41-52.

33. Ruskin writes in *Munera Pulveris:* "Already the Government, not unapproved, carries letters and parcels for us; larger packages may in time follow;— even general merchandise—why not, at last, ourselves?" Ruskin, *Works,* 17.252.

34. Carlyle, *Past and Present,* Bk. IV, ch. iii, 264; Louis Napoleon, *Les idées napoléoniennes,* quoted in J. M. Thompson, *Louis Napoleon and the Second Empire* (New York, 1955), p. 233. Cf. Ruskin, *Works,* 12.55n., 421; 27.171-172.

35. Ibid., 17.430-431; 18.498; 28.155, 421-425; Coleridge, *Complete Works,* VI, 215-218; Southey, *Colloquies,* I, 79; Carlyle, *Past and Present,* Bk. III, ch. viii, 179-181. In *Munera Pulveris,* Ruskin fashions a model of agricultural "mastership" out of the response of landowners to flooding. Ruskin, *Works,* 17.265-268.

36. Ibid., 36-42. For a less innocuous use of the soldier-shopkeeper comparison, see ibid., 18.483-484. Ruskin's call for the professionalization of industry is repeated by Thorstein Veblen and R. H. Tawney. *What Veblen Taught: Selected Writings of Thorstein Veblen,* ed. Wesley C. Mitchell (New York, 1936), pp. 110, 425ff.; R. H. Tawney, *The Acquisitive Society* (New York, 1920), p. 96.

37. Ruskin, *Works,* 12.67; 17.113, 162, 268, 275; 18.426; Godwin, *Political Justice,* II, 429-430, 433, 437-438; Simon N. Patten, *The Stability of Prices* (Baltimore, 1888), pp. 62-64.

38. Carlyle, *Past and Present,* Bk. III, ch. viii, 178, 181; ch. xii, 208-209. Arthur Helps urged manufacturers to wage a "Thirty Years' War" against poverty. Helps, *Claims of Labour,* pp. 13-14, 20-23, 268.

39. Mueller, *John Stuart Mill and French Thought,* chs. iii and iv; Mill, *Auguste Comte and Positivism,* p. 149; John Stuart Mill, *Letters,* ed. H. S. R. Elliot (2 v. London, 1910), I, 172 (7/7/52); Mill, Review of *The Claims of Labour* by Arthur Helps, *Collected Works,* V, 363-389, esp. 375.

40. Helen Gill Viljoen, *Ruskin's Scottish Heritage,* chs. iv, v, and viii. For Ruskin's opinion of the origins of his family, see *Works,* 28.147-148. There is another side to Ruskin's view of his father: he spent a good part of his inheritance on a guild where there were to be no middlemen at all—St. George's Guild. Ibid., 30-31.

Chapter XI The New Man

1. Ruskin, *Works,* 19.229; 17.114, 278.

2. Ibid., 30.48; 17.543; 20.113; 28.21, 138, 655. No "machine-stitching" was permitted in the early editions of Ruskin's books. Roe, *Social Philosophy,* p. 270. Ruskin's idealistic imperialism involved consigning heavy industry to "inferior races" far from a rural England. Ruskin, *Works,* 18.513; 19.228; 20.290.

3. Ibid., 17.156; 28.267; 11.199-200; 16.345.

4. Herbert L. Sussman, *Victorians and the Machine* (Cambridge, Massachusetts, 1968), pp. 23-32, 43-48, 50, 100-101; Charles Dickens, *The Old Curiosity Shop* (New York, 1897), p. 316; Ruskin, *Works,* 28.177; 29.548. For Ruskin's

many references to the novels of Dickens, including *The Old Curiosity Shop,* see *General Index,* ibid., 39.161. He was also familiar with the novels of Elizabeth Gaskell. Ibid., 34.103; 36.170.

5. Wordsworth, *Excursion,* VIII, 254-262, 288-290; Ruskin, *Works,* 12.173; 16.385; 20.96.

6. Ibid., 16.251, 353-354; 20.244; 9.67; 26.338. Cf. Rosenberg, *Darkening Glass,* pp. 74-75.

7. Ruskin, *Works,* 8.21, 66-67, 160; 12.84, 420; 16.348-349, 434. On rare occasions, Ruskin admits that there is an "art of making machinery"—a "mechanical Art"—and that "your manufactures become base, because no well-educated person sets hand to them," but this is not his usual view. Ibid., 294; 19.60; Wilenski, *John Ruskin,* p. 220. Ruskin's failure to see the role of imagination in designs for machinery is the more remarkable since he tended in later years to emphasize the practical utility and industrial sources of art.

8. Ruskin, *Works,* 15.174-176; 8.61; 10.212; 16.212, 222. Ruskin was not the first to demand that form follow function. Cf. A. W. Pugin, *Contrasts,* p. 1. For Ruskin's curious position in the history of modern architecture, see Rosenberg, *Darkening Glass,* pp. 64-78.

9. Ruskin, *Works,* 27.87; 18.508-511; 28.135, 248; 17.543-544; *Victorians and the Machine,* p. 96. Ruskin always considered himself most useful "as an iconoclast." Ruskin, *Works,* 36.384.

10. Ricardo, *Principles,* pp. 239, 241, 383, 386; Hall, *Effects of Civilization,* pp. 123, 175; Southey, *Essays,* I, 110-111; II, 217, 270; Carlyle, *Chartism,* pp. 337-338; Dickens, *Hard Times,* p. 422; cf. Owen, "Observations," *New View,* pp. 120-130. For a detailed discussion of Ricardo's position, see Schumpeter, *History of Economic Analysis,* pp. 680-687.

11. Southey, *Colloquies,* I, 77, 100, 201-208; Carlyle, *Chartism,* p. 382. Sismondi is a possible exception, for he proposed legislative restrictions to limit and delay the introduction of machinery. Sismondi, *Nouveaux principes,* II, 318, 324, 433; Sismondi, *Études,* I, 43, 60, 191.

12. Ruskin, *Works,* 5.371; 28.129; 34.135-147. On one occasion, at least, Wordsworth hailed the new developments in transportation. Wordsworth, "Steamboats, Viaducts, and Railways," *Poetical Works,* p. 477.

13. Thoreau quoted in Holbrook Jackson, *Dreamers of Dreams: The Rise and Fall of 19th Century Idealism* (London, 1948), p. 241; Henry David Thoreau, *Walden, or Life in the Woods and On the Duty of Civil Disobedience* (Signet Classic ed., New York, 1963), p. 40; *The Complete Works of Ralph Waldo Emerson* (14 v. Boston, 1903), IX, 15-16. Ruskin not only cites Emerson, whose works he much admired, but, in an appendix, anticipates the charge of plagiarism. Ruskin, *Works,* 5.381, 427. For Ruskin's relationship with W. J. Stillman, see ibid., 17.477; 36.123, 210, 346.

14. Ibid., 33.397; 5.371; 6.456. For the idea of nationality in Burke, Wordsworth, and Coleridge, see Alfred Cobban, *Edmund Burke and the Revolt against the Eighteenth Century* (2d. ed., London, 1960), chs. iv, v, vi. Arnold, *Works,* X, 22; Walter Scott, *Miscellaneous Prose Works* (6 v. Boston, 1829), XXI, 373-374. E. T. Cook cites Ruskin's conversation with Gladstone on the "unmaking" of Scotland as a result of new means of communication. Cook, *Life of John Ruskin,* II, 552.

15. Ruskin, *Works,* 4.394, 31; Carlyle, *Sartor,* Bk. III, ch. vii, 193-197. A passage remarkably like Ruskin's (5.381) is found in Charles Hall, *Effects of Civilization,* p. 243.

16. Ruskin, *Works,* 19.24; 34.268-269, 314. For Ruskin's amusing view of the

historical cause and consequences of urban growth, see ibid., 27.175; 28.132-137, 140.

17. Ibid., 16.131-132; 17.419-421; 11.138; Arnold, *Culture and Anarchy*, pp. 50, 182, 186. Sismondi also advocated state regulation of marriage. Sismondi, *Nouveaux principes* (1819 ed.), II, 307-309. Cf. Steuart, *Inquiry*, I, 67-81.

18. Ruskin, *Works*, 11.51-52, 58, 61-62.

19. Ibid., 63-65, 204. Behind Ruskin's comments lurk More's "scholastics," Swift's "peds," Pope's "dunces," and Scott's "morbus eruditorums." Among Victorians, Newman, Tennyson, and Browning agree that man is not "a reasoning animal" but "a seeing, feeling, contemplating, acting animal." More, *Utopia*, p. 120; Swift, *Tale of a Tub*, pp. 80, 152-156, 170; *The Journal of Sir Walter Scott*, ed. J. G. Tait (Edinburgh, 1950), pp. 40-41; John Henry Newman, *The Tamworth Reading Room* (London, 1841), p. 34.

20. Ruskin, *Works*, 11.65-66.

21. Ibid., 67; Ruskin, *Diaries*, II, 416 (1849). Compare the eulogy of "darkness" in Ruskin, *Works*, 11.262.

22. Ibid., 20.88; 22.529; 28.532; 25.56, 163; Wordsworth, "Preface" (1800), *Poetical Works*, p. 738; Arnold, *Essays in Criticism*, p. 3; Mill, *Earlier Letters*, II, 43-44.

23. Ruskin, *Works*, 16.220, 454; 7.431; 26.560, 339; 33.87; 28.86; Carlyle, *Sartor*, p. 129. Ruskin frequently regrets the "retardation of science by envy." Ruskin, *Works*, 17.67n.; 18.23.

24. Ibid., 29.483, 486, 498; 27.164, 148-149. Cf. William Cobbett, *Advice to Young Men and (incidentally) to Young Women* (London, 1829), pars. 286-330; Cobbett, *Political Register* (6/17/09), col. 911; (2/23/11), col. 450.

25. Ruskin, *Works*, 16.57-59, 182; 25.xxii; Thomas Carlyle, *New Letters of Carlyle*, ed. Alexander Carlyle (2 v. London, 1904), II, 177; Carlyle, *Shooting Niagara*, p. 366.

26. Ruskin, *Works*, 18.99; 34.314-315; 17.112-113, 168.

27. Ibid., 320-321; 16.432, 474; 29.484, 496; Thomas Hardy, *Jude the Obscure* (London, 1895), pp. 98, 393; J. S. Mill, "Notes on the Newspapers," *Monthly Repository*, VIII (1834), 592, 443.

28. Ruskin, *Works*, 17.149, 276-278, 322-323, 421; 18.415; Owen, *New Moral World*, Pt. V. Laws limiting accumulation fall under "meristic law." Their success depends upon a redefinition of the aims of industry: "A nation which desires true wealth, desires it moderately...." Ruskin, *Works*, 17.144, 165; 18.106.

29. Plato cited in ibid., 456-458; 28.23-24. Swift, *Prose Works*, XII, 47; Berkeley, *Querist*, p. 21; More, *Utopia*, p. 114; Ferguson, *Essay on Civil Society*, pp. 274, 392-393. Cf. David Kettler, *The Social and Political Thought of Adam Ferguson* (Columbus, Ohio, 1965), pp. 144-155, 283-284, 290-291.

30. Coleridge, *Complete Works*, VI, 149, 182; Wordsworth, *Poetical Works*, p. 206; Southey, *Colloquies*, II, 257-259, 252-253; Ruskin, *Works*, 17.281; Helps, *Claims of Labour*, pp. 41, 217; Arnold, *Culture and Anarchy*, pp. 175-180; Arnold, "Equality," *Mixed Essays*, p. 92. The early radicals Paine and Hall proposed heavy taxation to limit acquisitiveness. Paine, *Rights of Man*, pp. 250, 468; Hall, *Effects of Civilization*, pp. 55-56. Hall's suggestion that it might be best for mankind to return to a stage between civilization and savageness is an unusual "call for retreat." Ibid., pp. 206-207.

31. Mill, *Principles*, Bk. V, ch. ix, sec. 2, p. 538; Bk. IV, ch. iv; Ruskin, *Works*, 17.110; Godwin, *Political Justice*, II, 111, 441, 473. Although Mill never discards Ricardo's assumption of scarcity, it is not a vast step from his "stationary

state" to J. M. Keynes' "Era of Stabilization," the era which will succeed that of "Abundance." Keynes, *Essays in Persuasion,* pp. 334-335. How misguided is Ruskin's description of Mill as a "mischievous person," a "goose," or a "flat-fish —one eyeless side of him always in the mud!" Ruskin, *Works,* 28.623, 664; 29.204; 27.180. Certainly, on the "ideal of national life," Ruskin and the flat-fish are speaking the same language. Ibid., 16.115; 20.21.

32. Ibid., 17.111; 28.211; 22.184; 29.233-234; 16.21.

33. Ibid., 28.82; 36.251, 276; 16.410; 33.112, 494.

34. Ibid., 509; 16.138. Elsewhere, Ruskin compares capitalists scrambling for money to "so many pigs rooting up the ground." Ibid., 19.466.

35. C. H. Hull, ed., *The Economic Writings of Sir William Petty* (2 v. Cambridge, 1899), I, 263; Coleridge, *Complete Works,* VI, 194, 197, 205; Southey, *Colloquies,* I, 153-155; Southey, *Essays,* I, 96-98; Ruskin, *Works,* 37.503.

36. Arnold, *Culture and Anarchy,* pp. 142-143, 152, 195; J. S. Mill, "Inaugural Address at St. Andrews" (1867), in Cavenagh, *James & John Stuart Mill,* pp. 191-192; J. S. Mill, "The Negro Question," *Fraser's Magazine,* XLI (January 1850), 27. Arnold cites the case of the devout Puritan who killed himself because he thought his commercial failure signified spiritual damnation. Arnold, *Friendship's Garland,* p. 85.

37. Ruskin, *Works,* 11.201-203; 16.183, 355; Carlyle, *Past and Present,* Bk. III, ch. xi, 197-198. Ruskin specifically rejects Carlyle's preferred model for industrial regimentation—the monastery. "Our large trading cities," he writes, "bear to me very nearly the aspect of monastic establishments . . . the merchant rising to his Mammon matins with the self-denial of an anchorite. . . ." They are cities in which "the object of men is not life, but labour." Ruskin, *Works,* 7.424-425; 16.138; 19.24.

38. Carlyle, *Sartor,* Bk. II, ch. ix, 140-152; Carlyle, *Past and Present,* Bk. III, ch. iv, 154. For Carlyle's ambiguous use of Goethe's concept *entsagen,* see Harrold, *Carlyle and German Thought,* pp. 214-230. Ruskin's idea of "moderation" as "self-restrained liberty" in volume two of *Modern Painters* is closer to what Goethe meant by *entsagen* than Carlyle's "renunciation." Ruskin, *Works,* 4.138.

39. Ibid., 5.71; 17.149, 336; Carlyle, *Sartor,* Bk. II, ch. ix, 152. An emphasis on production distinguishes the Christian Socialists from Ruskin. "Consumption," J. M. Ludlow writes, "is the merely human element in life; production, the divine. God is the Eternal Producer." Ludlow in *Economic Review,* II, 227.

40. Ruskin, *Works,* 27.144; 29.423; 17.114. Ruskin points to the phrase "quality not quantity" as the key to his social criticism. Ruskin, *Diaries,* I, 251. Fox, *Discovery of Abundance,* pp. 44-79; E. A. Ross, *Social Control* (New York, 1901), pp. 34, 314-315; Galbraith, *Affluent Society,* pp. 123, 143, 291, 356; David Riesman, *Abundance for What?* (New York, 1964), passim. The term "overconsumption" is Patten's. S. N. Patten, *The Consumption of Wealth* (Philadelphia, 1889), p. 24. Ruskin and the later theorists of abundance are exploiting an old and well-worn theme. One of the remarkable features of modern utopias, from Sir Thomas More's through the Owenite experiments of the 1820's and 1830's to Ruskin's Guild of St. George, is the persistent tone of nostalgia for a simple life where pleasures are spiritual, not physical. The "scale of happiness," for example, suggested by William Godwin, who fully accepts the new technology, resembles that of Plato or the Stoics. A suspicion that quality and simplicity go together is not limited to utopians. John Stuart Mill brings to Utilitarianism a concern for "quality" as well as "quantity" of happiness and cites Ruskin in support of the view that the "mental pleasures" of imaginative sym-

pathy are superior to "lower pleasures." More, *Utopia*, pp. 96-100, 129-133; Godwin, *Political Justice*, I, 444-448; Mill, *Earlier Letters*, II, Appendix A, 381; J. S. Mill, "On Genius," *Monthly Repository*, VI (1832), 657; Ruskin, *Works*, 16.133-134; 28.21-22.

41. Ibid., 7.424-427, 460; 5.383; 17.112; 18.110; Coleridge, *Complete Works*, VI, 30ff. The last chapter of *Modern Painters* V is entitled "Peace."

42. Ruskin, *Works*, 18.340; 4.117; 8.124; 7.249; 35.43; 29.293.

43. Ibid., 18.431-432; 19.27; 9.288. For Ruskin's interest in the problem of "abstraction," cf. Ladd, *Victorian Morality of Art*, pp. 213-220; Wilenski, *John Ruskin*, pp. 225-226, 238-239.

44. Ruskin, *Works*, 18.399, 405, 430; 17.90; 30.512. Ruskin's vision of a new man attuned to conditions of abundance foreshadows, in certain respects, the thinking of Herbert Marcuse. Marcuse, *Eros and Civilization* (New York, 1962), pp. 1, 12-16, 32-34, 85, 143.

45. Owen, *New Moral World*, Pt. V, 65-78; IV, 20, 54; Godwin, *Political Justice*, II, 464.

46. Wordsworth, *Prelude*, V, 507-512; XII, 272-280; Wordsworth, "Intimations of Immortality," *Poetical Works*, pp. 460-462 (often quoted by Ruskin); Blake, *Poetry and Prose*, pp. 371-392 ("The Four Zoas"); Coleridge, *Shakespearean Criticism*, II, 91, 148; Ruskin, *Works*, 4.45-47. Graham Hough suggests that *Modern Painters* is a lengthy attempt to release and re-educate the Victorian visual sense. Hough, *Last Romantics*, pp. 9, 11-12, 31. Even after his loss of the "landscape feeling," Ruskin speaks of nature as an artist delighting man by beautiful effects of form and color as well as by practical adaption to his needs. Ruskin, *Works*, 5.384-385; 7.13-16; 27.84.

47. Blake, *Poetry and Prose*, pp. 50-58 ("America"). Ruskin was familiar with Blake's *Songs of Innocence* and *Auguries of Innocence*. Ruskin, *Works*, 19.56; 34.521-522. Cf. Wordsworth, "Ode to Duty," *Poetical Works*, p. 385.

48. Arnold, *Culture and Anarchy*, pp. 162, 132, 83, 45; Arnold, *Works*, X, vi-viii; IX, 304, 308; *Letters of Matthew Arnold*, ed. G. W. E. Russell (2 v. London, 1900), II, 192; Samuel Butler, *Life and Habit* (London, 1877); *John Stuart Mill: A Selection of His Works*, ed. John M. Robson (Toronto, 1966), p. 1; William Morris, *News from Nowhere, or an Epoch of Rest* (London, 1891); Manuel, *Prophets of Paris*, pp. 164-168.

49. Marx, *Economic and Philosophic Manuscripts of 1844*, pp. 98-114; Karl Marx and Friedrich Engels, *Historisch-Kritische Gesamtausgabe* (5 v. Berlin, 1927-1938), III, 89-91, 113, 118-123; Marx, *Poverty of Philosophy*, p. 157; Arnold, *Culture and Anarchy*, p. 48.

50. Arnold, *Literature and Dogma*, *Works*, VII, 15; Arnold, *Culture and Anarchy*, pp. 47-48, 65-66; cf. *Letters of Matthew Arnold to Arthur Hugh Clough*, ed. Howard Foster Lowry (New York, 1932), p. 142.

51. For a discussion of this shift in Marx's thought, see Robert C. Tucker, *Philosophy and Myth in Karl Marx* (Cambridge, 1961), Pt. IV.

52. Ruskin, *Works*, 35.619; 7.xli ("Notes on the Turin Gallery"-1858); 17.349, 359ff. For an excellent, if somewhat unsympathetic, discussion of Ruskin's "moral conflict" and its influence upon his aesthetic and social attitudes, see Ladd, *Victorian Morality of Art*, pp. 295-327.

53. Ruskin, *Works*, 11.261-263; 7.429; 17.368; 29.484-485. Cf. Johann Heinrich Pestalozzi, *How Gertrude Teaches Her Children*, trans. L. E. Holland and F. C. Turner (London, 1894), pp. 156-157.

54. Ruskin, *Works*, 5.117-119, 123-125, 32; 19.64; 7.359.

55. Ibid., xl-xli; 4.385. One suspects that, if Ruskin's fragment, written some-

time between 1856 and 1870, had been published, it would have rivalled Walter Pater's "Conclusion" (1868) to *The Renaissance* as the manifesto of art for art's sake.

56. Ruskin, *Works,* 7.353; 8.216, 134, 120-121. Cf. Ruskin's lecture on "The Flamboyant Architecture of the Valley of Somme" (1869), ibid., 19.243.

57. Ibid., 34, 81, 418; 4.63n., 194ff.; 22.235; 8.136; 6.447; Ruskin, *Diaries,* II, 511-512; Ladd, *Victorian Morality of Art,* pp. 299-302. In order to deny the "typical beauty" of the naked body and so dismiss it from art, Ruskin comes to the awkward conclusion that "vital" and "typical" beauty may conflict. For an interesting discussion of this point, see ibid., pp. 199-201.

58. Ruskin, *Works,* 4.131-133, 287; 16.369; 20.91-93; 18.436.

59. Ibid., 476; 20.18-19n.; 34.640.

60. Ibid., 342; 17.243-244. Ruskin was shrewd enough never to reject the theory of evolution as a scientific issue. His usual reaction was to declare that man's present moral condition is much more important than his origins. Ibid., 24.177.

61. *Letters of John Ruskin to Charles Eliot Norton,* II, 34-35; Ruskin, *Works,* 34.33-34. For the "Evil One," see Ruskin's frightening account of his first attack of madness (1878). Ibid., 38.172-173. The first chapter of Ruskin's autobiography *Praeterita* is entitled "The Springs of Wandel" after the source of the River Wandel near his mother's childhood home in Croydon. After Margaret Ruskin's death in 1871, Ruskin cleaned one of the springs and set up a memorial tablet dedicating the "well" to his mother. The stream soon became polluted. Ibid., 35.13, 609; 18.385-386; 22.xxiv; 28.204. The play on the word organic is my own, not Ruskin's. There is a tenuous precedent for it in the writings of Coleridge and Carlyle. Coleridge writes, "Whatever is organized from without is a product of mechanism; whatever is mechanized from within is a production of organization." A similar tension between "organization" and "organic expansion" is at work in Carlyle's assertion that "all new epochs, so convulsed and tumultuous to look upon, are 'expansions,' increase of faculty not yet organized." He refers specifically to the nineteenth century: "We will now quit this of the hard, organic, but limited Feudal Ages; and glance timidly into the immense Industrial Ages, as yet all inorganic, and in a quite pulpy condition, requiring desperately to harden themselves into some organism!" He hopes that the industrial ages will soon "get themselves 'organised.'" Samuel Taylor Coleridge, *Miscellanies Aesthetic and Literary,* ed. T. Ashe (London, 1892), p. 385n.; Carlyle, *Chartism,* p. 382; Carlyle, *Past and Present,* Bk. IV, ch. i, 250-251.

Epilogue

1. For a brief discussion of Ruskin's influence, see Frank Daniel Curtin, "Aesthetics in English Social Reform: Ruskin and his Followers" in *Nineteenth-Century Studies,* ed. H. Davis, W. C. DeVane, R. C. Bald (Ithaca, New York, 1940), pp. 199-245.

2. Southey, *Colloquies,* I, 224-225.

3. The idea or, better, the feeling behind this paragraph was crystallized by a reading of Lionel Trilling's exciting essay "The Fate of Pleasure" in *Beyond Culture* (New York, 1965), pp. 57-87.

Index